D1591464

The publisher gratefully acknowledges the generous support of the following:

The Art Endowment Fund of the University of California Press Foundation, which was established by a major gift from the Ahmanson Foundation

The Richard and Harriett Gold Endowment Fund in Arts and Humanities of the University of California Press Foundation

IRON MUSE

IRON MUSE

Photographing the Transcontinental Railroad

Glenn Willumson

UNIVERSITY OF CALIFORNIA PRESS
Berkeley Los Angeles London

University of California Press, one of the most distinguished university presses in the United States, enriches lives around the world by advancing scholarship in the humanities, social sciences, and natural sciences. Its activities are supported by the UC Press Foundation and by philanthropic contributions from individuals and institutions. For more information, visit www.ucpress.edu.

University of California Press
Berkeley and Los Angeles, California

University of California Press, Ltd.
London, England

© 2013 by The Regents of the University of California

Library of Congress Cataloging-in-Publication Data
Willumson, Glenn Gardner.
 Iron muse : photographing the Transcontinental Railroad / Glenn Willumson.
 pages cm
 Includes bibliographical references and index.
 ISBN 978-0-520-27094-7 (cloth : alk. paper)
 1. Photography of railroads—United States—History. 2. Hart, Alfred A., 1816–1908. 3. Russell, Andrew J. 4. Central Pacific Railway Company—Photograph collections—History. 5. Union Pacific Railroad Company—Photograph collections—History. 6. Railroads—United States—History—19th century—Sources. I. Title.
 TR715.W55 2013
 779'.9385—dc23 2012037751

Manufactured in the United States of America

22 21 20 19 18 17 16 15 14 13
10 9 8 7 6 5 4 3 2 1

The paper used in this publication meets the minimum requirements of ANSI/NISO Z39.48-1992 (R 2002) (*Permanence of Paper*).

CONTENTS

ACKNOWLEDGMENTS

The research for this book took place over many years and in two distinct phases. It began more than twenty-five years ago as a master's thesis about the life of the Central Pacific Railroad photographer Alfred Hart. Pauline Grenbeaux first brought my attention to Hart and generously shared her research with me; Jerome Hart, Patricia Moore, and other members of the Hart family graciously provided the information they had gathered about their ancestor. My thesis committee at the University of California, Davis, Seymour Howard, Harvey Himelfarb, and Joseph Baird, oversaw my initial approach to the transcontinental railroad photographs and directed me to the archives that would sustain my interest and support this much larger project. The questions surrounding the photographs of the transcontinental railroad remained an interest of mine but were put aside for several years as I completed my doctoral research on the photographer W. Eugene Smith and worked on different research projects and exhibitions at the Getty Research Institute and the Palmer Museum of Art at Penn State. A National Endowment for the Humanities grant allowed me to take time off from my duties as a curator and look into the purposes and intentions behind Hart's production, as well as expand my research and include Andrew Russell's photographs of the Union Pacific Railroad.

 In thinking back on the intellectual debts that I owe, it is very difficult to single out individuals, because so many contributed to my thinking about the railroad photographs. I am grateful to Ulrich Keller, who offered encouragement and helpful suggestions when I had reached an impasse. Conversations with William Deverell, Rich-

ard White, and participants in the Huntington Library's National Endowment for the Humanities Summer Institute offered invaluable insight about the historical context for the photographs. A research leave from the University of Florida and a senior fellowship at the Smithsonian American Art Museum allowed me to complete a draft of the manuscript. And conversations with William Truettner and Toby Jurovics at Smithsonian American Art Museum; Frank Goodyear, National Portrait Gallery; Will Stapp, independent scholar; and Carol Johnson, Library of Congress, all helped place the railroad photographs in the broader context of nineteenth-century art and photography of the West. I will be forever grateful for their enthusiasm for my project. William Truettner and Richard Orsi offered sage advice about early drafts of the manuscript. Douglas Nickel's insightful comments about the late stages of the text were invaluable, and Ari Keller's and Eric Segal's comments about particular chapters provided new perspectives on the historical context and ways to approach the photographs. I am not a railroad historian, and, recognizing that, I appreciated the willingness of Wendell Huffman and Robert Spude to review sections of the manuscript for accuracy. They offered valuable suggestions, and any remaining inaccuracies are mine.

A project of this scope and complexity would not have been possible without the generous support of many individuals and institutions. I owe an immense debt of gratitude to the librarians, archivists, curators, and collectors who made their materials available to me over the two decades that I conducted my research. The matchless archives of the California State Railroad Museum proved crucial. Ellen Halteman, head librarian, has been unfailing in her support of my research. Scott Shields, curator at the Crocker Museum of Art, shared his knowledge of California painting and provided scholarly assistance on many occasions. Alfred Harrison Jr., owner of Northpoint Gallery, contributed his vast knowledge of nineteenth-century painting in the North American West and generously allowed me access to the gallery's research files. Susan E. Williams, who has done extensive biographical research about the life of Union Pacific photographer Andrew Russell, kindly directed my first tentative steps toward understanding the Union Pacific photographs. I am grateful for conversations with George Miles, curator of the Western Americana collection at the Beinecke Rare Book and Manuscript Library, who pointed out the Sedgwick papers and raised questions about his relationship with Andrew Russell. Wendell Huffman, Nevada State Railroad Museum; Kyle Wyatt and Walter Gray, California State Railroad Museum; and Robert Spude, National Park Service, all helped me understand specific aspects of the railroad construction. The diaries of O.C. Smith, Union Pacific cashier, offered a contemporary perspective and rich details about Russell's photographic practice. Karen Curran worked tirelessly to help me track down the Smith diaries, and Pat Morris and her daughters, Kyle and Dyane, were generous in sharing Pat's transcriptions with me. Other members of the Morris family, most notably Gene and Fran Morris and Robert Morris, kindly allowed me to read their original O.C. Smith diaries.

Many other scholars aided with my research, and I am very grateful for their help:

Drew Johnson and Marcia Eyeman, Oakland Museum; Gary Kurutz, California State Library; Patricia Labounty, John Bromley, and Don Snoddy, Union Pacific Railroad Museum; Jennifer Watts, Huntington Library; David Haberstick, Smithsonian American History Museum; Cynthia Mills, Smithsonian Museum of American Art; Roxanne Nilan, Stanford University Archives; John Sutton, Westlake Conservators; Michael Duda, William Gerhts, the late Peter Palmquist, Bradley Richards, Michael Schroeder, and Tom Southall. I also express my appreciation to the collectors who welcomed me into their homes and archives: Dr. Abbott Coombs, Bill Eloe, John Garzoli, Ron Gustafson, Jerry Hart, Mead Kibbey, Andrew Moore, S. Hart and Pat Moore, Rusty Norton, Barry Swackhammer, and Len Walle. Barry Swackhammer, Bill Eloe, Ron Gustafson, Andrew Moore, and Andrew Smith generously shared images from their collections for this publication.

Over the years of this project, my research has taken me to archives and collections across the continental United States. There are too many to name individually, but I thank the librarians, archivists, and curators whose guidance and assistance made this book possible. I offer heartfelt appreciation to the staff members at the American Geographical Society Collection, University of Wisconsin, Milwaukee; Bancroft Library, University of California, Berkeley; Beinecke Rare Books and Manuscript Library, Yale University; California Historical Society; California State Library; California State Railroad Museum; Crocker Art Museum; Colorado Historical Society; De Golyer Library, Southern Methodist University; University of Florida; George Eastman House; Harold B. Lee Library, Brigham Young University; Hearst Art Gallery, St. Mary's College; Huntington Library; Special Collections, University of Iowa Libraries; Getty Research Institute; Joslyn Art Museum; Library of Congress; Marriott Library, University of Utah; Nebraska State Historical Society; New York Public Library; Oakland Museum; Sacramento Archives and Museum Collection Center; Smithsonian American Art Museum Library; Society of California Pioneers; Stanford University Department of Special Collections and University Archives; Steuben Historical Society; Union Pacific Railroad Museum; University of California, Los Angeles, Special Collections Library; Utah State Historical Society; Wyles Collection, University of California, Santa Barbara.

My initial research was supported by grants from the University of California, the Huntington Library, the Northern California Railroad and Locomotive Society, and the College of Arts and Architecture at the Pennsylvania State University. In addition to the Smithsonian fellowship, the later stages of my project received invaluable research support from the Beinecke Rare Books and Manuscript Library, Yale University; and the Bill Lane Center for the Study of Landscape in the North American West, Stanford University; and research grants from the College of Fine Arts, University of Florida. The fellowship at the Beinecke allowed me to work with their unparalleled collection of travel literature, the Stephen Sedgwick archives, and their outstanding collection of Andrew Russell prints and albums. The Stanford University Special Collections holds a wealth of photographs and archival materials concerning the early years of the railroad,

including the early account books of the Central Pacific Railroad. A grant from the Lane Center made it possible for me to take advantage of these rich resources.

Finally, I thank my editors: Stephanie Fay for her early and sustained support for the book, and Jacqueline Volin and Kari Dahlgren who guided the manuscript through the final stages of publication. The manuscript benefited immeasurably from the thoughtful comments of two anonymous readers. I am very grateful for the care with which they read the text and the suggestions they made for its improvement.

I was fortunate to have grown up at a time when gasoline prices were low enough to allow middle-class Americans to take their families on driving holidays, whether day trips on Sunday or two-week vacations. My parents, second-generation Californians, always included stops at historical markers, monuments, museums, and historic houses throughout the Southwest. These excursions instilled in me a lifelong fascination with the history of the North American West. This book is dedicated to my parents, Donald and Aileen Willumson, and their intellectual curiosity about the rich history of California and the West.

INTRODUCTION

"Dot, dot, done." Contact between the telegraph wire attached to Leland Stanford's silver maul, and a second wire attached to a railroad spike, dramatically announced to cities across the United States that the first transcontinental railroad had been completed (see map). Cheers rang out from the spectators at the ceremonies in the desolate high desert at Promontory, Utah, and, simultaneously across America, loud celebrations took place. The Central Pacific and Union Pacific Railroad companies had taken great care to arrange the instantaneous transfer of the momentous event and captured the imagination of the entire country. Far more lasting, however, was an equally instantaneous moment—the exposure of a photographic negative. Long after the clicking of the telegraph key had ceased and the cheers had faded into silence, a photograph would represent both the moment and the metaphor of America's first transcontinental railroad.

It is easy to understand the popularity of the photograph *Meeting of the Rails, Promontory, Utah*. It is a seemingly transparent window into a significant moment in the history of the United States (pl. 1).[1] The photograph was made at the official celebration of the railroad's completion at Promontory, Utah, on May 10, 1869. The viewer sees two powerful locomotives facing each other as zealous men clamber aboard the engines and jockey for position along the railroad track. A phalanx of the remaining workers lines up on the right and left, pointing to the middle of the image, where the architects of this accomplishment, the chief engineers of the Central Pacific Railroad and the Union Pacific Railroad, shake hands as they turn to face the camera. Above them, standing on the cowcatcher of each locomotive, enthusiastic men stretch bottles of celebratory

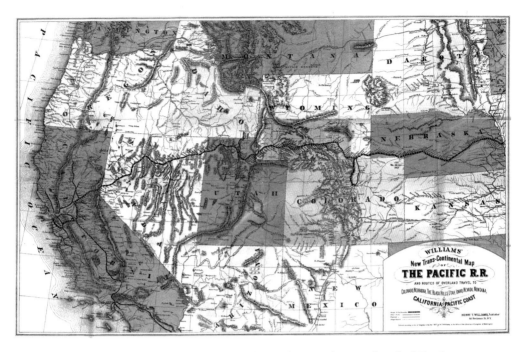

Henry T. Williams, *New Trans-Continental map of the Pacific R.R. and Routes of Overland Travel to Colorado, Nebraska, the Black Hills, Utah, Idaho, Nevada, Montana, California and the Pacific Coast,* c. 1877. Library of Congress, Geography and Map Division.

champagne across the empty space, reenacting with their bodies the movement of the rails west from Omaha and east from Sacramento. Looking at *Meeting of the Rails* today, viewers feel that they share the experience of that historical moment and the sense of national triumph.

But we must acknowledge that the photograph as evidence of a historic event is ambiguous and, therefore, unreliable, marked as much by what is *not* said as by what *is* said. In *Meeting of the Rails,* the alignment of men mimics the orthogonal lines of a railroad track receding into an infinite distance; but here the locomotives and crowds of men arrest the pictorial movement forward. The low camera angle eliminates the hills surrounding the Promontory celebration, and the land that has been unified by the railroad disappears from the picture. Men and machines become a new horizon of productive labor and an imagined settled landscape. The railroad officials who paid the photographers and who commissioned their extensive photographic record of the railroad construction are not included. The company of soldiers presumably sent west to maintain order at the ceremonies, and to assure there were no violent clashes between Union Pacific and Central Pacific workers, was also excluded. These tensions are lost from history in a photograph that celebrates happy, anonymous laborers, left outside while managerial celebrations took place inside specially appointed train cars. This

depiction obscures the serious labor difficulties that the Central Pacific and Union Pacific Railroads experienced during construction and which continued to divide management and labor in the years after completion.

In fact, the ceremony at Promontory was delayed because workers, angry at not having been paid, blocked the Union Pacific vice president's special train from continuing to the Promontory celebration until they were paid their back wages.[2] The photograph erases racial relations as well. The native inhabitants of the Great Basin are absent from the photograph, not surprising given the expansionist ideology of Manifest Destiny and its characterization of the lands between the Missouri River and the West Coast as an empty landscape available for European-American development. The absence of the Chinese workers who were largely responsible for building the railroad through the Sierra Nevada is more surprising. They had the honor of carrying in the last rail and placing it for Stanford's famous "golden spike ceremony" but not the glory of posing for photographs.[3] *Meeting of the Rails* produces instead a historical moment when white laborers celebrate the unification of the East and West Coasts of the United States.

Earlier historical studies of the railroad have provided important factual information and a rich explanation of the details that led to the celebration at Promontory.[4] Too many, however, accept uncritically the veracity and objectivity of photography, failing to acknowledge the complex interaction of photograph, text, company, and construction, preferring instead to use the railroad photographs uncritically as transparent illustrations of specific historic moments and locations. This privileging of the photograph as neutral evidence can be all-encompassing, so that the materiality and physical differences between the photographs is ignored—for example, when one image from a stereographic pair is reproduced as if it were a large plate photograph.[5] As a result, the social production of the original images is disregarded, and the historical importance of entire branches of photographic production—notably stereography—is overlooked.

Despite the marked association of *Meeting of the Rails* with a specific historical moment, museum exhibitions have attempted to recontextualize it, and other photographs of the transcontinental railroad, within an aesthetic framework that claims transcendence from historicity. The first museum publication to consider the photographs in depth was the catalogue of the seminal exhibition *Era of Exploration,* held at the Metropolitan Museum of Art in New York 1975. It was one of the first exhibitions to call public attention to the formal beauty of western landscape photography.[6] As an important part of this strategy, the curators selected five photographers and reproduced individual portfolios in the exhibition catalogue. One of the five was the photographer who made *Meeting of the Rails*, Andrew Russell.[7] Later studies moved beyond this monographic treatment to place the railroad photographs into thematic presentations of the history of western imagery.[8] These exhibitions tended to celebrate the technical mastery of photographers working in harsh conditions and producing strong prints of a pristine wilderness landscape. Both the exhibitions and the publications perform the important task of placing these photographs in a history of art and visual representation, but they

are most often monographic or broadly focused on the whole of nineteenth-century photography. Furthermore, because of the aesthetic traditions of museum spaces, even the most inclusive exhibitions tend to disregard stereographs, although the latter made up the bulk of nineteenth-century photographic production.[9]

While historic document and aesthetic object represent two extremes of photographic interpretation, the photographs of the transcontinental railroad are more commonly situated within a middle ground that celebrates the historic association of the photograph and transforms it into metaphor. As metaphor, it is connected to its temporal subject but acts outside its historical context and is used by future generations to write their own stories as they relate the historical past to their present moment.[10] For this approach, *Meeting of the Rails* represents not just a moment of celebration in Utah but also the triumph of America's Manifest Destiny as the railroad linked the two coasts and enabled the settlement of the center of the country. Gazing at the looming locomotives, and at the men triumphantly facing the camera in the Utah desert while shaking hands and sharing champagne, we may view the idea of "American progress" as a logical and natural consequence.[11] This interpretation of the photograph as Manifest Destiny happened almost immediately. It was originally published in *Frank Leslie's Illustrated Newspaper* on June 5, 1869, and carried a lengthy descriptive caption: *The Completion of the Pacific Rail Road—The Ceremony at Promontory Point, Utah, May 10th, 1869—The Locomotives Jupiter of the Central Line, and 119, of the Union Line, Meeting at the Junction, after the Driving of the Last Spike.*[12] A year later, when it came time to scratch a title onto the negative, however, the photographer changed the descriptive title to one rich with allusion.

East and West Shaking Hands at Laying Last Rail looks not only to the United States' future settlement but also to its recent Civil War past. Russell's title replaces the description of the time and place found in *Leslie's Illustrated* and *Meeting of the Rails* with echoes of the new federal nationalism. Because it is the engineers who actually shake hands in the photograph, titling the image *East and West Shaking Hands* abstracts the gesture of the handshake by referring not to the railroad officials but to geographic direction. The engineers become ciphers for the reorientation of the national geography, moving Americans away from the North-South opposition that had dominated life for more than a generation and replacing it with a new East-West conceptualization of nation. The composition of the photograph echoes this reading of a new national reality. If one looks at the photograph as a flat image, like a map, the north and south quadrants are blank with sky and arid earth. In contrast, the right and left sides, east and west, team with life as men strain toward the center of the picture. *East and West Shaking Hands at Laying Last Rail* offers up technology and private industry, under the direction of the federal government, as instruments of a project that united and realigned a formerly divided nation.

The celebration of the completion of the transcontinental railroad produced, arguably, one of our most historically significant photographs, but it was just one of hundreds of

photographs commissioned by the Union Pacific and Central Pacific Railroads. Photographs were a frequent topic in the correspondence between Central Pacific Railroad attorney Edwin B. Crocker and company vice president Collis P. Huntington. During the critical year of 1867, with the railroad construction stalled at the western summit above Donner Lake and company finances in a perilous state, Crocker wrote to Huntington: "We have just got about 25 to 30 copies of each of the new stereoscopic views printed, & will send them off soon to you. Some of them are remarkably fine. I am busy preparing the papers for the report between [miles] 74 + 94."[13] This brief excerpt tells us a great deal about the relationship among company, photographer, and image. Putting aside the awkward grammar, the active voice of the verb and the assertive tone of "we have just got . . . views printed" reveal the importance of the photographs and the authority that the railroad exercised over its imagery.

That pragmatic view of the railroad photographs is balanced by the fact that Crocker also calls Huntington's attention to the quality of the stereographs: "some of them are remarkably fine." Highlighting their aesthetic appeal goes beyond the instrumental needs of the railroad and acknowledges the control of the Central Pacific photographer, Alfred A. Hart. Finally, the letter situates the photographs as part of a mélange of documentation: stereographs, papers, and reports—an archive of information. This last characterization of the views carries more significance than might be expected of such a mundane communication. These photographs—and hundreds of others—formed an archive that would not only record the activities of the railroad but also shape the efforts of future historians and the popular memory of America's first transcontinental railroad.

The construction of photographic archives is not a simple process. A single individual may be responsible for selecting the images, but that action alone does not produce an archive. Rather, archives result from the interactions of photographer, patron, and imagined audience. The Central Pacific Railroad was the first corporation in the United States to engage a photographer, to purchase negatives, and to form a corporate photographic archive. The men central to this effort were the hardworking corporate attorney E. B. Crocker and the gifted photographer Alfred Hart. Almost immediately after beginning construction, the Central Pacific commissioned photographs to catalog railroad progress through the mountains. Unfortunately, we have no record of Hart's thoughts about photography or about his work for the railroad. What little is known about his relationship with the Central Pacific must be pieced together from payment vouchers, Crocker's correspondence with Huntington, and the evidence found in the formal qualities of Hart's stereographs. Over a three-and-a-half-year period, Hart made more than 400 negatives of the railroad, 364 of which were purchased by the Central Pacific, numbered, titled, and placed in the archive.

The Central Pacific's rival, the Union Pacific, also commissioned photographs. Although there is no direct evidence of who was responsible for financially supporting the photography of the Union Pacific Railroad, its cunning vice president, Thomas

Durant, seems to have played a central role. He hired the Chicago photographer John Carbutt in 1866 to join a VIP excursion on a newly opened section of the fledgling railroad and, a year and a half later, presumably sent the accomplished Civil War photographer Andrew Russell west to capture the final stages of the railroad construction. Beginning his work in the spring of 1868, Russell documented both the last year of construction and the months after the opening of the transcontinental railroad. He was a prodigious worker, generating more than 620 stereographs and 227 large format photographs. Historical evidence of the relationship between Russell and the Union Pacific is even scantier than that of Hart and the Central Pacific. Russell's papers were thrown out by his studio assistant in 1871, and the Union Pacific corporate files are incomplete and scattered. Research indicates that Durant did not purchase negatives, allowing the photographers to maintain their own archives. Nonetheless, it appears that Durant was able to exercise a certain amount of authority over the distribution of the photographs before 1870.

These two extraordinary photographic archives, from the Central Pacific and the Union Pacific Railroads, are the subjects of *Iron Muse*. While archives may bear the mantle of straightforward, even innocent records, they are the product of a number of complex relationships. Before a photographer exposes the negative, he makes myriad choices: format, camera location, lens, and composition, to name a few. In these and other ways, the agency of the photographer is located in the negative and, ultimately, in the finished print. With that said, photographs are subject to a variety of external influences as well. Something as simple as adding a title can affect meaning in ways that the photographer may not have intended. Placing the photograph alongside a lengthy text, reproducing it for publication, or displaying it in a particular location all limit potential meaning and impose other contingencies on the image quite separate from the ideas of the photographer. The photographic archive is one of the critical, and too often overlooked, contexts that reflect intentionality and affect meaning.

The photographic archives of the Central Pacific and Union Pacific Railroads bear the traces of photographer, client, and corporate bureaucracy. Neither individual photographs nor assembled archives are neutral vehicles of documentary information: each photograph and archive imposes its own system for conveying meaning, each editorializes, and each reflects its producer. Many of the photographs with which this book is concerned were made for archival purposes, and their materiality—sequences, titles, and mounts—bears the marks of that function. The archive gathers together photographs and organizes them into a constellation of images that responds to each railroad company's unique needs and desires. When these photographs leave the archive as stereographic sequences, in albums, or through the popular press, they invite new interpretations that reflect interests beyond those of the photographer or corporate curator. This action complicates our understanding of the agency of the photographer, who shares authority over the meaning of images first with railroad officials and, later, with a variety of potential clients.

Earlier scholarship on archives laid the groundwork for this sustained consideration of the photographs of the transcontinental railroad. Rosalind Krauss's articulation of how visual information can be organized and put to work through the system of the archive is a touchstone for all later discussion of the topic.[14] Characterizing Timothy O'Sullivan's photographs as either "landscape" or "view," Krauss describes the former term as an approach that fits the aesthetic requirements of museum display, and the latter, in contrast, as a representation of the nineteenth-century perception of photographic realism. Views, according to Krauss, lend themselves to archival organization based on topography. This distinction is useful in thinking about the differences between the space of the exhibition and that of the archive, but her binary opposition, that photographs engage either the discourse of art or of science, landscape or view, seems unnecessarily reductive. Furthermore, Krauss's argument finds photographic meaning exclusively in the archival system. She calls for the reinscription of O'Sullivan's photographs into the archive in an effort to recover meaning that is intentionally ignored by later, contemporary interventions. This approach fails to take account of the agency of the photographer and viewer and the ambiguity of photographic meaning whether found in the museum, the archive, or at the moment of the camera exposure.

In "Photography between Labor and Capital," Allan Sekula offers a more promising path between an aesthetic appreciation and a historical positioning.[15] For Sekula, the meaning of the documentary, archival photograph is suspended between these two poles.[16] Sekula agrees with Krauss that the aesthetic understanding of the photographs requires the removal of the image from the archive and the inscription of a new, aesthetic context. Rather than privilege the historical rendering of photographic meaning, however, Sekula points out the error of considering photographs to be unbiased historical documents. The photograph's reductive representation of history, and the necessity for the viewer to disregard the social or economic interests that preserved the photograph and brought it to public attention, challenge the idea that images can operate as accurate and truthful representations of historical events. For Sekula, the archival photograph resides in the space between the discourses of art and science, "staking its claims to cultural value on both the model of truth upheld by empirical science and the model of pleasure and expressiveness offered by romantic esthetics."[17] The photograph in the archive, then, operates between these two potentials, and its meaning is held in suspension awaiting a specific context of use. This articulation of the conceptual space of the archive acknowledges the ambiguity of photographic meaning and calls for an analytical practice that addresses social and economic conditions of scientific and artistic work.

In a later essay, Sekula further refines his argument in his consideration of police files, where he demonstrates how certain belief systems are inscribed in archive function.[18] Contrasting a statistical, meticulously organized archive of individual criminal portraits with an archive of mug shots used to create composite images of typical criminals, Sekula shows how each organizational method represents the belief system of

its organizer. His articulation of how belief systems shape archives, and how archives circle back to shape interpretation, is a critical text for understanding how the archive works. To make his argument, however, Sekula has selected an extreme example. Mug shots allow little room for the agency of the photographer, and the organization of police archives makes an express effort to thwart the possibility of interpretation. Nonetheless, total control is never possible. Extreme examples like police archives negate the agency of the photographer and viewer and so are only partially helpful in considerations of other, more traditional archives. The positions of the photographer and the viewer of the photograph cannot be excluded from the way most photographic archives are created and understood.

Iron Muse integrates photographer, archivist, and audience in considering the function of the photographs. Martha Sandweiss takes up these questions in Print the Legend, where she examines how photographic meaning changes from one audience to another and from one era to the next.[19] She is particularly sensitive to the distribution systems that made the photographs available, and she extrapolates from these mechanisms the narrative meaning of the photographs. Her attention centers on the reception of photographs and on the workings of captions and texts in structuring photographic interpretation. Iron Muse follows a similar methodology, offering a close reading of the archival titles and texts that sought to circumscribe meaning in and out of the archive and attending to the later press accounts that reinterpreted these visual messages. This book, however, recognizes that the caption is just one of the framing devices used by the archive, and that questions about the archive are just one of the interpretive mechanisms that provide meanings for photographs. The archive does not so much impose meaning from the outside as it does highlight certain aspects of the work that are latent within the photograph. In contrast to Sandweiss's admirable embrace of all nineteenth-century western photography, Iron Muse is narrowly focused on the formation of two specific archives. This focus allows for the examination of the intended audiences for the photographs, as well as of the agency of the photographers, the bureaucracies that curated the archives, the bureaucratic means by which photographs were interpreted, and the immediate uses to which the photographs were put.

Archives, for Sandweiss, are simply one of the sources she mines; they are central to Robin Kelsey's Archive Style.[20] Kelsey considers three government picture archives, one of which contains the photographs that Timothy O'Sullivan made for the King survey, contemporaneous with the railroad photographs that are the basis for this book. Kelsey collapses the differentiation between photographer and archive by arguing that O'Sullivan internalized the archival function, and this knowledge, in turn, influenced the formal appearance of his photographs. Kelsey's stylistic reading of O'Sullivan's images considers the agency of the photographer within an archive of expeditionary photographs at the same time that it acknowledges the government bureaucrats who mined the archive. Iron Muse shares an interest in the agency of photographers, but Kelsey's argument about this important factor is problematic in the context of the rail-

road photographers. Unlike O'Sullivan, Hart's and Russell's work was not for a single agency. Negatives that the railroad corporations did not buy were sold to others, and those photographs that were included in the archive were available to a variety of interpretive forces, including editors, book publishers, travelers, and the general public. This significantly complicates the question of photographic agency.

Unfortunately, Hart left no documentation behind, and only a few newspaper articles represent Russell's thinking about the railroad project. Where historical records do not exist, this book relies on historically plausible circumstantial evidence to interpret the relationship between the photographer and archive. In short, *Iron Muse* recognizes that the question of photographers and railroad archives is a complicated one, and for this reason it acknowledges the impact of the photographer on the interpretation of the railroad landscape, but concentrates its attention on the formation and early distribution of photographs in the archive. *Iron Muse* presents a case study of the photographs of the transcontinental railroad in order to tease out different moments in the production of meaning—from the click of the shutter, to the archival selection, to the engagement with contemporaneous viewers in specific formats and historical situations.

Iron Muse furthers the debate about archives by engaging the social and economic conditions that surrounded the photographs, and by addressing the questions about the creation and curation of this important archive and the distribution systems for its photographs. The Central Pacific and Union Pacific Railroads employed different photographers, and each approached the questions raised by photography and the archive from a unique perspective. Engaging the interpretative strategies of the photographers and the managers of the corporate archive as they asserted their interests in and meanings for the photographs, *Iron Muse* acknowledges that the archival context is just one of many factors that interpret and provide meaning for the photographs. This consideration of the railroad photographs teases out, particularly in their contemporary reproduction in the illustrated press, the public functions, and malfunctions, of the photographic archives, how interpretations were made and suppressed, and how the photographs resisted their archival limitations. In doing so, it demonstrates the ambiguity of photographic meaning and how changing contexts of presentation and text can shift recognition in ways that may not have been intended by either the makers or the owners of the photographs.

Attention to audience and reception modifies archival choices. As Robin Kelsey has pointed out, archives embrace both the private and the public.[21] The railroad collected its archives—maps, reports, and imagery—from a wide variety of sources, including engineers, construction contractors, attorneys, and photographers. These materials were kept and organized by the corporate bureaucracy first for confidential consideration. In the private sphere, the photographs of the Central Pacific and Union Pacific Railroads are evidence of the corporations' desire to observe and control the construction effort, and this study demonstrates the unique pathways each company took to reach that goal. Information that advanced the interests of the corporation was released to various

constituencies, including government officials, political and religious leaders, investors, industrial suppliers, and the general public; negative information was suppressed. Seldom, however, were "public" and "private" completely separate. For the railroad companies, these two spheres had permeable boundaries that were difficult to police. This was particularly true when photographs were released for publication in the illustrated press. In reproduction, the railroad images engaged a fresh set of authors, patrons, and audiences.[22] In the process of transferring the photograph onto a wood block, editors might change the composition, add details, or move figures. These alterations, and the important accompanying text, shifted the meaning of the photograph in ways that could not always be controlled by the corporations. *Iron Muse* considers this rapid appropriation of photographs by the illustrated press and, after the completion of the railroad, by travel guides; it discusses the ways in which these images, divorced from context and released from company control, acquired new layers of meaning.

Historians have analyzed the financial organization of the railroad companies that built the first railroad across the North American continent, and have documented the stages of the railroad's construction and completion, but they have failed to understand the vital role that photography played in this effort. Rather than offering representations of historical details or a recapitulation of American mythology about the West, *Iron Muse* situates the railroad photographs between evidence and evocation, arguing that they are the products of a series of cooperative social relationships whose interaction has been unexamined or overlooked by previous studies. This book attempts to locate the agency of the photographer and that of the railroad bureaucracy in an effort to recover a sense of the complexity that attended the making of these important photographic archives. When the photographs are situated within the railroad's collection, their meaning is deferred and, as a result, the archive contains both the residual meaning of the photograph as a record of a specific time and place, and a potential meaning, whose power is controlled, in part, by the individuals who organize the photographs or who use the photographs in new contexts. Focusing on the railroad photographs as a case study offers an opportunity to outline a critical history of how archives interact with prints, paintings, and wood engravings to ameliorate the tragedy of the Civil War, serve corporate interests, and support a variety of attitudes about the West. This study analyzes both the power that photography held during the construction of America's first transcontinental railroad and the archives' continued relevance in the years immediately following completion. It concludes with an epilogue that traces the history of the railroads' photographic archives and the elevation of *East and West Shaking Hands at Laying Last Rail* to mythic status in American visual culture. Placing emphasis on the traditionally marginalized or ignored, but socially powerful, media (stereographic photographs, popular prints, and newspaper illustrations), this book introduces an array of colorful patrons, photographers, laborers, and travelers who construct and reconstruct meanings for the transcontinental railroad photographs.

1

PREPARING THE GROUND

"Bound for the Mountains"—this affirmation summarized the aspirations of the Union Pacific and Central Pacific Railroads. The Union Pacific route called for track across hundreds of miles of Nebraska prairie before it reached the challenging Rocky and Uinta Mountains in Wyoming and Utah. The Central Pacific had only a few dozen miles of flat land before it began to lay track in the foothills and then the rugged slopes of the Sierra Nevada. Despite such difficulties and the ongoing Civil War, officials from both the Union Pacific and the Central Pacific broke ground in 1863 and began construction of the nation's first transcontinental railroad. The phrase "Bound for the Mountains" expressed an implicit expectation and also served as the title of an extraordinary photograph made shortly after construction began: *Bound for the Mountains, 12 mile tangent—4 miles from Sacramento* summarized, visually and verbally, the railroads' hopes, aspirations, and determination (pl. 2).

The locomotive, sunlight gleaming on its polished surface, seems to rush away from the viewer and down an apparently infinite line of straight track called a tangent.[1] Aligning the metal smokestack of the locomotive precisely along the left edge of the rail creates a vector that projects into deep space. This compositional precision, and the smoke that pours from the stack, combine to give the impression of the railroad's force and speed. In fact, the locomotive was stationary. Nineteenth-century photographic emulsion was not sensitive enough to stop the movement of a train, but by climbing to the top of the locomotive and making the boiler project from the foreground of the image, the photographer deceives the viewer into thinking that the train is in motion. This effect

produces a visual manifestation of ambition and optimism, but it is the contrived and manipulative aspects of the photographic presentation that are the most indicative of the years leading up to the groundbreaking for North America's first transcontinental railroad and the decades that followed its completion.[2] Just five years earlier, the project had seemed impossible.

In 1858, Jefferson Davis, senator from Mississippi, addressed the question of the transcontinental railroad on the floor of the Senate: "In Congress, with all due respect to my associates, I must say the location of this road will be a political question. It should be a question of engineering, a commercial question, a governmental question—not a question of partisan advantage or of sectional success in a struggle between parties and sections."[3] Davis was lamenting Congress's inability to ratify a report he had authored three years earlier as secretary of war. In 1853, Davis assigned army exploration parties to establish the best passage for a transcontinental railroad. The resulting reports began the process of establishing the route, raising significant questions about geography—for example, the best way to get through the Rocky Mountains and the Sierra Nevada. But the politics of expansion and regional rivalries prevented congressional agreement. Ultimately, it was the Civil War that settled the question of the route to California, and it was the development of a set of photographic practices outside the studio and the visual articulation of that national struggle that foreshadowed the way the railroad corporations would use photographs during the construction of the transcontinental railroad.

Early reports about the country through which the railroad would be built were not promising. In 1819, Major Stephen Long and his exploration party followed the Platte River from the Missouri River to the Rocky Mountains, the same area the Union Pacific would later use to construct the eastern leg of the transcontinental railroad. Although he did not search for a pass through the mountains, Long did describe the territory: "We do not hesitate in giving the opinion, that it is almost wholly unfit for cultivation, and of course uninhabitable by a people depending upon agriculture for their subsistence."[4] His map, a primary source for explorers and emigrants for the next twenty years, labeled the area as the "Great American Desert." Two decades later, John Fremont led an expedition over the Rocky Mountains, into the Great Basin of the Salt Lake Valley, and through the Sierra Nevada to the Pacific Coast. One of his goals was to follow the Oregon Trail and search for passes through the Rocky Mountains. The land to the east of Fort Laramie in the Black Hills, the area through which the Union Pacific eventually would drive its tracks, Fremont described as arid and dry, a country of stunted pines and dry creeks that gave him a feeling of desolation. This characterization remained in the popular imagination until the 1860s, and Union Pacific promotional efforts battled this idea of the land as inhospitable.

After resting in Oregon, Fremont marched south following the eastern side of the Sierra. Coming upon the Truckee River in an area that later would be graded by the Central Pacific Railroad, Fremont turned west to cross the mountains. It was a disastrous

decision that resulted in the near starvation of the party, which Fremont dramatically recounted: "The mountains all are higher [than those in the East], more numerous, and more distinctly defined in their ranges and directions. . . . [The Sierra Nevada and the Coast Range present] higher elevations and peaks than any which are to be found in the Rocky mountains themselves. In our eight months' circuit, we were never out of sight of snow; and the Sierra Nevada, where we crossed it, was near 2,000 feet higher than the South Pass in the Rocky mountains."[5] The lithographic illustration titled *Pass in the Sierra Nevada* shows a tattered band of explorers trudging through deep snow. They are dwarfed by large trees and face seemingly impenetrable mountain ranges. One of the lasting impacts of Fremont's exploration was the publication of a large map that produced the most comprehensive picture of the Sierra Nevada, showing it as a more formidable barrier than had been indicated on earlier maps.[6]

If the geographic imagination of the West was created by the army explorations and cartographic representations, popular imagination, especially of the Sierra Nevada, was inflamed by the story of the Donner Party. This group of emigrants had traveled west by wagon train in 1846. Because of a series of delays, they found themselves crossing the Sierra Nevada near Fremont's pass in November 1846, when an early snowstorm stopped the travelers east of Donner Lake. Soon they exhausted their food supplies and faced slow starvation. To stave off their hunger they ate the frozen carcasses of the starved oxen that had pulled their wagons, boiled the bones of horses to make soup, and some, according to contemporary reports, resorted to cannibalism. When they were finally rescued in February 1847, only forty-eight of the original eighty-seven members of the party were alive.[7] The sensational story of starvation, death, and cannibalism resonated with the public imagination and demonstrated viscerally the impenetrability and destructive power of the Sierra Nevada. This impression of the Sierra Nevada had to be overcome if the Central Pacific Railroad was to successfully lure investors.

The most immediate antecedent for the railroad, however, was a series four simultaneous explorations begun in 1853, sponsored by the federal government, expressly for the purpose of locating the best route for the first transcontinental railroad. When it first commissioned the surveys, Congress hoped that they would end the partisan arguments surrounding railroad development; instead, the published reports only intensified animosities. By the 1850s, questions of sectionalism and slavery had become integral to the debate over the railroad. When Asa Whitney proposed a transcontinental railroad in 1844, a host of cities vied for the right to be "the gateway to the West."[8] Choosing which city would be the eastern terminus, however, was only part of the political problem: the latitude the railroad's route would trace was far more decisive. Northern politicians wanted a northern or a central route, hoping to funnel raw materials and trade to the factories in the northeast. Southern leaders promoted a southern route with the expectation that it would guarantee their region's economic independence and open up new territory to slavery.[9] And both regions envisioned their cities and ports as vital links between Asia and Europe.[10] Not surprisingly, the politics of expansion and the ten-

sion between the North and South played a decisive role in the debate over the location of the transcontinental railroad.

Stephen Douglas, a senator from Illinois, offered the most consistent congressional support for a transcontinental railroad.[11] Douglas favored a central route for political and personal reasons. As a recognized champion of the interests of the Northwest and chairman of the Senate Committee on Territories, Douglas presided over the organization of territorial governments and understood that there would be political advantage in opening up new lands for settlement. He hoped that as farmers replaced the Plains Indians, they would become new Democratic voters and would open new markets in need of a railroad. In 1852, however, the landscape west of the Missouri River and north of Texas had been set aside for Indians and was, therefore, off-limits to European American settlement. As a first step, therefore, Douglas fought to create a new territory, hoping to negate the title the Indians held to the land and to open it for white settlement and government railroad subsidies. Douglas appeared to have the opening he needed when the House passed a bill calling for the organization of the Nebraska territory in early 1853. When Douglas brought the bill before the Senate, however, southern senators refused to support it and threatened a filibuster. They had good reason to fear Douglas's proposal. Because the new territory of Nebraska was north of latitude 36 degrees 30 minutes, the Missouri Compromise of 1820 closed it to slavery; consequently, its eventual incorporation as a state would increase the power of the North in Congress. Faced with an impasse, the Senate tabled the bill indefinitely, effectively killing Douglas's railroad proposal.

In the face of southern opposition, in 1853, Senator Richard Broadhead of Pennsylvania offered a compromise amendment to the army appropriation bill that provided for government-funded surveys of all the potential railroad routes.[12] The federal government had been underwriting army exploration of the West since 1804, institutionalizing the exploratory impulse in 1838 with the formation of the Army Corps of Topographical Engineers.[13] Earlier explorations surveyed wagon roads through the western territory, but the expeditions funded by the army appropriations bill of 1853 would be the first to look for a railroad route. Senators from both northern and southern states supported Broadhead's amendment. They hoped that the explorations would provide objective data and move the question of a transcontinental railroad beyond the divisiveness of sectional politics.

Despite the seeming equanimity of this solution, the appointment of Jefferson Davis as secretary of war in 1853 polarized the question once again. Davis, a staunch supporter of the southern cause and future president of the Confederate States of America, selected the routes to be surveyed, named the members of the exploratory parties, and published their findings. For many northern politicians his involvement prejudiced the surveys from the beginning, but some historians have argued that Davis acted equitably.[14] They point to his nomination of northern men to head most of the surveys and to the "geographical realities" that guided his decision about which routes to explore.[15]

However, Davis's letters, the sequence of the reports' publication, and the contradictions between images and text provide evidence of the subtle ways the information he presented favored a southern route for the railroad.

Senators favoring a central or northern route had good reason to suspect Davis. Two years earlier he had written to President Millard Fillmore about the boundary between the United States and Mexico:

> Past reconnoissances [sic] have taught us that a practicable route for waggons [sic], or Railroad might be found from the Paso del Norte to the Gila River and thence to the Colorado, and great hope and expectation have thus been excited. . . . I suppose then it may be said that the great object to be gained in the location of this boundary line was to secure on the side of the United States a practicable route for a military road, ultimately perhaps the construction of a rail road connecting the Mississippi valley with Southern California.[16]

Davis suggested the appointment of Major William Emory to head the reconnaissance of the southern border. Emory had strong southern political connections and was an acknowledged advocate of a southern route for the railroad. Davis wanted Emory's report to demonstrate the necessity of further land concessions that would allow a railroad to bypass the steep inclines of the Gila River region. Davis got his way. Fillmore named Emory the leader of the boundary commission, and three years later, the Gadsden Treaty added the territory Davis needed for a southern railroad route.[17]

In 1853, as the new secretary of war, Davis appointed three exploration parties to search for a route from the Mississippi River to the West Coast. They ignored the southernmost route, and none of them explored the land on which the transcontinental railroad would eventually be built. Issac Stevens, an engineer on an earlier Pacific Coast survey and the governor of the Washington Territory, led the northernmost exploration along the 47th and 49th parallels. Lieutenant John W. Gunnison, assistant to Howard Stansbury during his survey of the Great Salt Lake in 1849–50, explored the central landscape, on the 38th and 39th parallels. Lieutenant Amiel Whipple, assistant astronomer on Emory's Mexican boundary survey three years earlier, led an exploration along the 35th parallel. With the three reconnaissance parties in the field, Davis secured additional appropriations and, in late 1853, sent Lieutenant John Parke and Captain John Pope to extend Emory's earlier explorations and to do further mapping along the 32nd parallel. In addition to these east-west explorations, Davis assigned Lieutenant John Williamson to search for passes through the southern Sierra Nevada and to survey the West Coast from Los Angeles to the Columbia River. These "surveys," however, did not chart the landscape but provided a sense of the topography along certain latitudinal parallels. As such, these were "reconnaissance" trips more than surveys.

While the exploration teams were still in the field, Stephen Douglas maneuvered a new bill through the Senate. Stifled by the bitter sectional debate between North and South, in January 1854 Douglas offered a plan to gain southern legislative support. He

agreed to introduce legislation to repeal the Missouri Compromise of 1820 in exchange for southern support for the new territory of Nebraska.[18] His proposed law negated the earlier legislation that had barred slavery north of latitude 36° 30´, and it allowed each newly admitted state to decide whether it would be free or slave. Despite resistance from the majority of northern senators opposed any increase in slave-holding states, Douglas persuaded enough northern Democrats to repeal the Compromise of 1820 and was rewarded with southern support for the new territory of Nebraska. The opening of the center of the country to settlement, Douglas felt, presaged the ultimate success of a central railroad route.

Southerners, including Jefferson Davis, saw the possibility of a double victory: opening up new territory to slavery through the repeal of the Missouri Compromise and securing a southern route for the first transcontinental railroad by making effective use of the Pacific railroad surveys. Davis wrote to the Mississippi Democrat William Cannon, outlining his calculation about the transcontinental railroad:

> The country on the Pacific is in many respects adapted to slave labor, and many of the citizens desire its introduction. . . . [This] has led me to ask why the advocates of domestic slavery should not have acquired the control of California and Oregon. The answer has seemed to me to be this: The only convenient route for emigrants is now by sea and across the Isthmus, and the vessels for this line of communication start from Northern ports, thus shutting out those who must take with them their servants, their flocks and herds and [thus] securing a Northern Immigration to that country which would first unite our population. If we had a good railroad and other roads making it convenient to go through Texas into New Mexico, and through New Mexico into Southern California, our people with their servants, their horses and their cows would gradually pass westward over fertile lands into mining districts, and in the latter, especially, the advantage of their associated labor would impress itself upon others about them and the prejudice which now shuts us out of that country would yield to the persuasion of personal interest.[19]

Davis understood the question of the railroad route to be central to the political questions of slavery and political power.

With slavery now possible in the new territories, Davis turned his attention to the Pacific railroad explorations. The reports from the army expeditions were published in twelve volumes over a five-year period, with the first eight printed under the watchful eye of Jefferson Davis.[20] The first five volumes, published in 1855 and 1856, establish the antebellum context for the transcontinental railroad. Volume 1 serves as both introduction and conclusion as it begins with Davis's recommendations followed by brief descriptions of the explorations of the 47th and 49th parallels, the 41st and 42nd parallels, the 38th and 39th parallels, the 35th parallel, and the 32nd parallel. Not surprisingly, Davis argues for a southern route:

A comparison of the results stated above, and those exhibited in the tables referred to, conclusively shows that the route of the 32nd parallel is, of those surveyed, "the most practicable and economical route for a railroad from the Mississippi river to the Pacific ocean."

This is the shortest route; and not only is its estimated cost less by a third than that of any other of the lines, but the character of the work required is such that it could be executed in a vastly shorter period.[21]

Davis claimed that he based his judgment on the review of each of the proposals, and he used the publication of the *Pacific Railroad Reports* to support his conclusion.

The publication of volume 2, in 1855, was meant to defuse the challenge of Davis's most strident political opponent, Thomas Hart Benton of Missouri. Senator Benton's powerful position in the Senate and his strong support of a central route for the railroad made the survey of the 38th and 39th parallels a political necessity. The published volume included detailed reports of Davis's favored southern route—the 32nd parallel—and Benton's preferred route. Lieutenant E. G. Beckwith, the ranking officer of the survey party of the central route, supported the latter as a viable route for the railroad. He wrote about the obstacle of the Rocky Mountains: "A railroad . . . would cross the summit-level near the base of these peaks, and, taking advantage of the winding slopes, pass down the right of the creek to Turret rock, to where the park becomes a gorge, and thence be confined to the little valley, from one hundred and fifty to three hundred feet in width, where it could be constructed along the foot of the hills with great ease."[22] Although Beckwith's written report supported the route Benton favored, the lithographic illustrations included in Volume II did not bolster Beckwith's argument.[23]

Beckwith's report was the first to contain illustrations. Significantly, these eleven lithographs represented just two areas covered by the 38th parallel survey—the passes through the Rocky Mountains and the landscape around the Green River.[24] Formally, the lithographs use pictorial codes that attempt to strengthen their connection to the reality of the landscape. The color shifts from more vibrant foregrounds to muted backgrounds, a technique designed to suggest atmospheric perspective. This effect is furthered by detailed foregrounds that give way gradually to vaguely defined background spaces. In *Sangre De Cristo Pass, From near the Summit, looking down Gunnison's Creek,* there are a few trees, and the hillsides are barren of the timber that would be needed to build a railroad. Furthermore, the stacking of the peaks, and the deep river gorge leading to the background, creates gaps in the receding mountains that suggest a rugged, noncontinuous landscape (fig. 1). There is nothing in this lithograph to suggest that a railroad could be built here "with great ease."

The lithographs showed the topography of the West to congressmen who would never see the actual landscape, but who would nonetheless decide whether it was suitable for a railroad. Rather than illustrating the written report, the prints served instrumentally as a parallel text, visually representing rugged mountains and an inhospitable land. Few

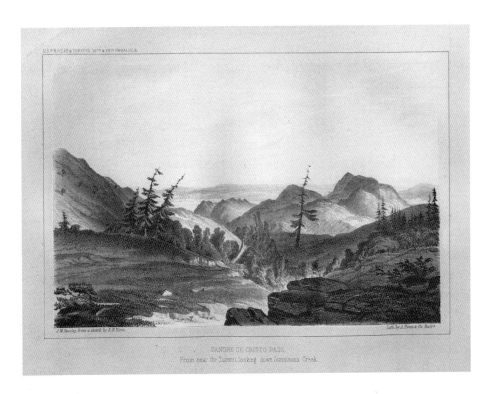

FIG. 1

Richard Kern, *Sangre De Cristo Pass, From near the Summit, looking down Gunnison's Creek,* from "Report by Lieutenant E. G. Beckwith, Third Artillery, upon the Route near the Thirty-Eighth and Thirty-Ninth Parallels, Explored by Captain J. W. Gunnison, Corps of Topographical Engineers" in *Reports of Explorations and Surveys, to ascertain the most practicable and economic route for a railroad from the Mississippi River to the Pacific Ocean,* vol. 2 (Washington, D.C.: Beverley Tucker, 1855). Color lithograph, 8½ x 11¼ inches (page). George A. Smathers Libraries at the University of Florida.

of the 38th-parallel lithographs show a landscape suitable for a railroad. The foreground detail of *Rock Hills between Green and White Rivers,* for example, included cactus and yucca plants, both associated with desert country and a lack of water and timber.[25] This botanical rendering as well as the descriptive title "Rock Hills" would have discouraged any proposal to place a railroad in such a wilderness. In contrast, Beckwith's written report presents a very different description of the area: "In a few instances the strata of red, yellow, gray, and white sandstone were observed bent; but they were generally in right lines, with a dip to the east-northeast. We passed occasional masses of conglomerate rocks, and on the hills scattering cedar trees and some fine fields of bunch-grass."[26]

The lithographs of the 38th and 39th parallels showed a landscape not conducive to railroad construction, whereas the report about the southern 32nd parallel route included no illustrations, allowing the description of a flat, readily accessible landscape to stand on its own and suppressing information about the harshness of the deserts of

southern New Mexico and Arizona. More than a decade before the Central Pacific Railroad commissioned photographs to support its construction project, the Pacific Railroad Reports demonstrate the ways in which images could be used to buttress particular political positions.[27]

Volumes 3 to 5, published in 1856, bolstered Davis's recommendation of the route along the 32nd parallel. Volumes 3 and 4 outlined the topography, geology, and zoology along the 35th parallel.[28] These volumes, among the most visually lively of the reports, included both full-page lithographs and wood engravings set within the text. The lithographs display large flat expanses of land, but also present high mountain ranges, providing visual evidence for Davis's assertion that the route was unfavorable because of "the large sum of ascents and descents."[29] In addition to recording geography, the 35th parallel reports chronicle the cultural landscape, offering a glimpse of racial politics that formed a subtext of the *Pacific Railroad Reports*. Several of the illustrations depict the indigenous peoples as peaceful and domesticated and dressed in European-style clothing. Although the text could have described such dress, illustrations carried greater force. These images of peaceful tribes with their familiar habits stand in direct contrast with the nomadic and warlike tribes of the Plains, where a central railroad route would be built. Volume 5 suggested possible routes through the southern Sierra to the Pacific Ocean. Specifically, Davis charged Captain Williamson with finding routes through the southern Sierra Nevada along the 35th and 32nd parallels. He reported favorably on the several mountain passes, all of which could connect with the 32nd parallel route. In this case, the majority of the lithographs and wood engravings that illustrated his report showed wide spaces and rolling hills that could easily accommodate a railroad.

Public interest in the transcontinental railroad extended beyond the political sphere. In 1853, the same year that Jefferson Davis sent army surveyors west, Asher B. Durand's *Progress (The Advance of Civilization)* was displayed at the annual exhibition of the National Academy of Design (pl. 3).[30] Durand's patron for the painting, Charles Gould, was an official of the Ohio & Mississippi Railroad, and although Gould's railroad interests were regional, certain of the painting's compositional details and its implicit narrative of European-American advancement link it to the national debate about a transcontinental railroad.[31] *Progress* summarized the aspirations of Americans who saw in the construction of the railroad the possibility for national unity and cultural identity. The painting's narrative begins in the lower left, in an undeveloped wilderness from which Indians look down on a landscape transformed by European-American settlers. The technologies associated with roads, canals, and railroads transform the landscape. The composition leads the eye into the deep space of the painting, where a busy port city, shimmering like gold, is the culmination of the progress described by the work's title and the destination of empire. An extensive wilderness, like that in the center of the antebellum United States, separates settlements in the foreground from the distant city of light.

Plumes of smoke from a tiny train, barely visible as it moves across a bridge in the middle ground, can be seen on the right side of the canvas, where the billowing cloud

of ash suggests the train's speed as it moves toward the wilderness in the center of the painting. The artist reconciles technology and nature in an oddly disquieting scene in which the train seems to come from nowhere and has no pathway for continuing its journey. Nonetheless, the force of the composition connects the train with the idealized city in the distance by means of an imagined route that leads from the cultivated foreground into a nondescript wilderness and, finally, to the shimmering port city. Durand's *Progress* naturalizes the expansionist rhetoric that governed the congressional debates, linking the Jeffersonian farmers in the foreground with the industrialized city dwellers in the distance, a connection visually carried, in part, by train technology. The inevitability of European-American progress, implied by the Indians who have been pushed to the margins of the painting, was echoed in the halls of Congress. Stephen Douglas's argument for the Nebraska territory proposed native displacement in order to open the landscape of the plains to European-American settlement. What remained unresolved in Congress, and in the painting, was the exact route the locomotive would take to the vision of prosperity in the distance.

All of this attention to possible railroad routes did little to reconcile the arguments about the location of the transcontinental railroad. If Congress hoped that the Pacific railroad surveys would take politics out of the decision about where to build the railroad, its members were misguided. Jefferson Davis understood the value of the transcontinental railroad in social, political, and economic terms. Even after he left his post as secretary of war, he continued, as the senator from Mississippi, to advocate the 32nd parallel route. James Buchanan made his support of the construction of a transcontinental railroad a plank in his presidential campaign, and calls for the railroad were renewed when he was elected president in 1856. Buchanan agreed to provide federal support for the construction, and a Senate select committee reported a bill to the full Senate in the 1857–58 session and again the following year. Each time it was proposed, sectional differences doomed the appropriation. Southerners opposed it because they believed it favored a northern route and left the South without a railroad. Northerners were unwilling to support any bill that might make a southern route the single railroad to the West.[32] These congressional divisions, evident from the first mention of a transcontinental railroad, were not resolved until after the secession of the southern states and the advent of the Civil War.

The conflict brought together several factors that would serve the railroad companies and may have influenced their attention to imagery. Before the war, train travel in the United States was disorganized and disconnected. With the advent of the conflict and the need to transport massive amounts of troops and supplies, Tom Scott, vice president of the Pennsylvania Railroad, created a centralized system of railroads in the North. The standardization of the track, and the federal government's need for financial capital, brought about the creation of financial institutions that would become models for financing the railroad after the war.[33] Concomitantly, photography also streamlined and standardized certain aspects of its practice. Seeking to document the war visually,

Mathew Brady organized teams of photographers and sent them into the field. The photographs these men produced demonstrated the power that imagery could exert on a general audience. Although Brady sold the photographs his men produced, often without crediting the photographer, some of these images found outlets as wood engravings in illustrated newspapers. This relatively new genre of news production flourished during the war by bringing news to a public that understood itself increasingly in terms of nation rather than region.

Politically, the loss of Southern Democrats in Congress meant that sectional gridlock ended. The second session of the Thirty-Seventh Congress passed legislation that put the federal government at the forefront of socioeconomic development and laid the blueprint for modern America.[34] The Republican majority passed landmark legislation, including the Homestead, Morill, and Pacific Railroad Acts. These circumstances settled the location of the transcontinental railroad along a central route; new organizational models of photographic practice laid the groundwork for the photographic documentation of the transcontinental railroad. Specialized firms had mass-produced photographs for more than a decade, but most of those images had been made in the studio. Photographic equipment was difficult to transport; the wet-collodion process was cumbersome; and, because of the long exposure time, plates were incapable of capturing action. Nonetheless, entrepreneurs like Mathew Brady believed that the public would want photographic images of the war, and he applied the techniques of large-scale industrial production to photography. Shifting his attention from a regional to a national audience and reorganizing his studio-based practice to support teams in the field, Brady established a new practice of outdoor photography. He replaced individual labor with organized, communal effort, creating supply stations for teams of photographers in the field and collecting their negatives in his studios in New York and Washington, D.C. In this dehumanized framework, Matthew Brady's name as the supervisor appeared on his team's photographic documentation of the Civil War, although he made none of those photographs.[35]

The public perception of the camera's veracity allowed photographers to re-create the war as a visual spectacle, which often included dead bodies in the aftermath of a battle. Brady's corps of photographers gave people on the home front the immediacy, vividness, and authenticity that appealed to them. Reviewing the Brady photographs of Grant's Virginia campaign in 1864, *Harper's Weekly* commented, "The actuality of these views, the distinct detail, and the inflexible veracity, make them invaluable to every student of the campaign; while all who follow the army with their private hearts as well as their public hopes will see with curious satisfaction the roads, the fields, the woods, the fences, the bridges, the camps, and the streams, which are the familiar daily objects to the eyes of their loved soldier boys."[36] The public craved the affective experience of imagery, but the veracity of photography could be disturbing. A *New York Times* story about the exhibition of Brady's images of Antietam photographs conveyed their impact on the contemporary audience:

Mr. BRADY has done something to bring home to us the terrible reality and earnestness of war. . . . Of all objects of horror one would think the battle-field should stand preeminent, that it should bear away the palm of repulsiveness. But, on the contrary, there is a terrible fascination about it that draws one near these pictures, and makes him loath to leave them. You will see hushed, reverend groups standing around these weird copies of carnage, bending down to look in the pale faces of the dead, chained by the strange spell that dwells in dead men's eyes.[37]

The experience of viewing Brady's Civil War photographs was made all the more shocking by the fact that most of them were stereographs.[38] Stereographs use a twin-lens camera to create negatives spaced two and a half inches apart, replicating the distance between a human's eyes.[39] These paired images are printed and mounted side by side on thick pasteboard. To create the stereographic effect, one looks into a special device that blocks out all peripheral vision and causes the two images to merge optically into a single photograph with dramatic three-dimensional depth. The visual space of the image seen in the stereoscopic viewer is layered with information in the foreground, middle ground, and background. Exploring the stereograph, the eye moves from plane to plane, object to object, savoring the three-dimensional illusionary space.[40]

The hyperreality of this form of photography could delight the beholder, as Oliver Wendell Holmes described in 1859: "The first effect of looking at a good photograph through the stereoscope is a surprise such as no painting ever produced. The mind feels its way into the very depths of the picture. The scraggy branches of a tree in the foreground run out at us as if they would scratch our eyes out. . . . Then there is such a frightful amount of detail, that we have the same sense of infinite complexity which Nature gives us."[41] When it came to viewing stereographs of the war, however, this delight quickly turned to distress. Holmes, for one, found the stereograph's emotional reality too painful to look at: "It was so nearly like visiting the battlefield to look over these views, that all the emotions excited by the actual sight of the stained and sordid scene, strewed with rags and wrecks, came back to us, and we buried them in the recesses of our cabinet as we would have buried the mutilated remains of the dead they too vividly represented."[42] Three years later the Central Pacific Railroad would depend on stereography's ability to create visceral images to record its spectacle of technology.

The United States military also documented the war in photographs but sparingly and primarily for utilitarian purposes. Early in the war General Herman Haupt, a brilliant railroad engineer and tactician, employed the photographer Andrew J. Russell to make photographs for an instruction manual, *Photographs Illustrative of Operations in Construction and Transportation*. The book would be distributed to army officers and, to ensure continued support for Haupt's efforts, to members of Congress as well.[43] The manual's eighty-two photographs illustrate "experiments made to determine the most practical and expeditious modes to be resorted to in the construction, destruction, and reconstruction of roads and bridges."[44] Russell, later the photographer of the Union

Pacific Railroad, was the only official military photographer of the Civil War.[45] His photographs for Haupt showed the calculation, discipline, and efficiency of the military workforce. Russell's photographs also show the preparation, measurement, and mechanization necessary for a modern railroad. Here, too, one finds the dehumanization of the men pictured. These lessons about organizing a workforce and mechanizing its production would soon be applied to the construction of the transcontinental railroad.[46]

In addition to the widespread practice of outdoor photography, the war also coincided with the rising social importance of illustrated newspapers.[47] In 1860, New York supported three such papers: *Harper's Weekly, Frank Leslie's Illustrated Newspaper,* and *New York Illustrated News*. Although these publications struggled before the war, public interest in news and a thirst for pictorial illustration meant all three newspapers flourished after 1861.[48] In addition to the weekly publication of large numbers of images—a *Leslie's Illustrated* editor boasted of his paper's publication of nearly three thousand pictures of the war by 1864—both *Leslie's Illustrated* and *Harper's Weekly* produced commemorative books of wood engravings that had previously been published in the newspapers.[49] Sketch artists provided most of the war illustrations for the papers' editors, who rushed them to the engraver for transfer to a wood block and publication alongside the textual descriptions.[50] This public hunger for information and the resulting increase in circulation would later be exploited by the Union Pacific and Central Pacific Railroad companies.

The rise in the sales of illustrated newspapers also indicated a shift of American interests from region to nation. As the ferocity of the war increased, Americans turned from the local and regional issues that had dominated antebellum public discussions to more national concerns. Oliver Wendell Holmes personifies the railroad as the metaphor for this new nationalism:

> War is a new thing to all of us who are not in the last quarter of their century. We are learning many strange matters from our fresh experience. And besides, there are new conditions of existence which make war as it is with us very different from war as it has been.
>
> The first and obvious difference consists in the fact that the whole nation is now penetrated by the ramifications of a network of iron nerves which flash sensation and volition backward and forward to and from towns and provinces as if they were organs and limbs of a single living body. The second is the vast system of iron muscles which, as it were, move the limbs of the mighty organism one upon another.[51]

The movement for a transcontinental railroad benefited from this more nationalistic focus. In place of the regional North-South agenda that had dominated American politics, a new East-West orientation was born out of America's emergent national interest.

In the face of the disheartening war news found in Brady's photographs and on the pages of northern newspapers, the opening of the American West offered the possibility of renewal in a new, innocent landscape. When Nathaniel Hawthorne visited

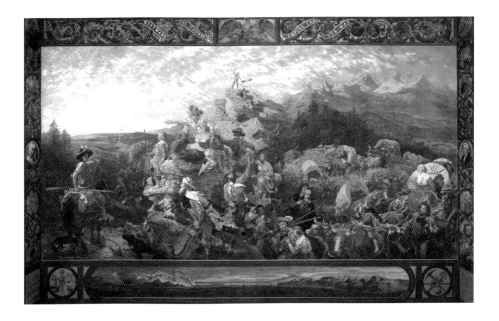

FIG. 2

Emanuel Leutze, *Westward the Course of Empire Takes Its Way [Westward Ho!]*, 1862. Water-glass painting, 20 × 30 feet. House wing, west stairway, United States Capitol, Washington, D.C.

Washington in early 1862, he delivered a pessimistic report on the health of the nation: "A railway-train met us, conveying a regiment out of Washington to some unknown point; and reaching the capital, we filed out of the station between lines of soldiers, with shouldered muskets, putting us in mind of similar spectacles at the gates of European cities. It was not without sorrow that we saw the free circulation of the nation's life-blood (at the very heart, moreover) clogged with such strictures as these."[52] The only hopeful sign that Hawthorne reported was a mural by Emanuel Leutze: "It looked full of energy, hope, progress, irrepressible movement onward[,] . . . and it was most cheering to feel its good augury at this dismal time, when our country might seem to have arrived at such a deadly stand-still."[53] The subject of Leutze's mural was the American West, and it decorated a stairway in the United States Capitol building. The twenty-by-thirty-foot painting *Westward the Course of Empire Takes Its Way [Westward Ho!]* (fig. 2) celebrated westward migration and allowed the eastern men like Hawthorne to turn away from the despair and gloom of the war and remember the optimism of American exceptionalism and promise.[54]

Leutze's ability to spark a sense of hope lay in his formal means of representation and in his chosen subject matter of the North American West. As he struggled to finish the mural, the human cost of the war confronted Leutze daily when military necessity dictated that the Capitol building be used as a makeshift hospital for wounded soldiers. One can see several references to the effect of the war in his composition and iconog-

raphy.[55] Contemporaries noted the location of the emigrants on the Continental Divide and the contrast between the color tonality on the left and right sides of the painting: "At the right is a snowy peak, the gold of the sunlit snow barred by cool blue shadows. All behind them is gloom where the mists are gathering, and all before them a sunny dream."[56] The location atop the Rocky Mountains placed the party in the center of the continent. Behind them lay the ravages of the Civil War, and in front of them the West beckoned with dreams of a prosperous future. In contrast to the commercial development of Durand's golden city, in Leutze's painting the distant landscape is latent and innocent, awaiting the spread of progress.

The public unveiling of *Westward the Course of Empire* in December 1862 brought multiple reviews—all of them similar in tone and content. The newspaper *Boston Transcript* invoked Bishop Berkeley, the author of the phrase that served as the title of the mural, and singled out the two men carrying the American flag to the top of the rock: "Two of the party are emulous to plant the Stars and Stripes upon the topmost peak, and, in these dark days of trial, we felt the beauty of the whole marvelous production almost as a prophetic conviction that the idea of our "manifest destiny" could not perish. The eye follows the finger of the foremost figure, over miles and miles of mountain tops. 'Alp upon Alp,' marked by the signal fires of the Indians, into the dim and distant future."[57] Leutze's mural offered hope that Americans would recover from the war, and that a new sense of national purpose could be found by looking to the West. The transcontinental railroad provided access to this bright promise. But exactly what type of access was open to question. If Leutze's painting is considered in relationship to Russell's photographs for General Haupt, it becomes clear how outmoded the scene in the mural was. Leutze depicts dramatic, individual actions and a triumphal march over the Continental Divide. Russell's photographs present a new social model—a communal effort by a disciplined labor force mechanistically working together to accomplish a goal in which they had no personal investment.

The Civil War brought the question of a railroad to the Pacific to renewed public attention. Images of the railroad were imprinted on patriotic envelopes and painted in the dome of the United States Capitol Building.[58] Prodded by concerns about the loyalty of the states along the West Coast, a desire to unite the country, and the lobbying of corporations hoping to benefit from the construction of the railroad, the House and Senate passed the Pacific Railroad Act of 1862. The act chartered the Central Pacific Railroad to build east from Sacramento, California, and the Union Pacific Railroad to build west from Omaha, Nebraska; they would meet at a point to be determined at a later date by each company's progress. The bill offered incentives to those companies; it gave extensive land grants and provided funding in the form of thirty-year U.S. government bonds. Congress authorized bonds for each mile of completed track: sixteen thousand dollars for the relatively flat areas west and east of the Sierra Nevada and Rocky Mountains, thirty-two thousand dollars for track between the two mountain ranges, and forty-eight thousand dollars for construction in the mountains.

Despite these guarantees, the railroad companies found it difficult to raise the necessary capital. In response to intense lobbying and its own desire for a transcontinental railroad, Congress amended the Pacific Railroad Act in 1864, allowing the railroads to issue their own bonds, doubling the amount of land awarded for completed sections of the railroad, granting the companies the right to issue bonds on every twenty-mile section (versus each forty-mile section as authorized in the earlier bill), giving up mineral rights to coal and iron, and making the grants unconditional.[59] Further, the government guaranteed the bonds and assured investors, in the event of forfeiture, that individual bondholders would take precedence over debt to the government. As Richard White has pointed out, the construction of the transcontinental railroad, like the Civil War, required great risk, tremendous costs, a sense of national purpose, and the efforts of a powerful national government.[60] In the case of the railroads, however, the effort was made not in the service of a broad, national cause but for personal gain in pursuit of an imagined public service. Like a magician's trick, the railroad photographs called attention to the public-service aspect of the railroad construction while distracting from the corruption and the personal wealth simultaneously being gathered by a few cunning men.

2

MAKING THE PHOTOGRAPHS

The extensive photographic archives of the Central Pacific and Union Pacific began with the efforts of individual photographers. *Bound for the Mountains, 12 mile tangent—4 miles from Sacramento* is indicative of the way in which photographers combined compositional finesse with an understanding of the needs of the railroad and created their dynamic photographs (see pl. 2). The standard view of a train was snapped at ground level, at right angles to the track, where you could see the locomotive and the line of train cars behind. The Central Pacific photographer, however, inverted this compositional formula, elevating his camera above and behind the locomotive. The camera operator's position, looking down on the track, took advantage of the formal qualities of spatial recession inherent in the stereograph. His efforts created a dynamic composition that approaches the metaphoric.

To gain the engineer's perspective, the photographer dragged his heavy camera equipment up and onto the roof of the locomotive cab and composed the scene on the ground glass at the back of the camera. Because the wet-plate process photographers used in the 1860s required them to expose the negative while it was still wet, the Central Pacific's photographer had to set up the camera, climb down to his portable darkroom, and prepare the glass plate negative. There, the photographer held a sheet of clean glass at one corner and poured a viscous mixture of collodion over the surface of the plate; rocking it gently to be sure the emulsion produced an even coating. The prepared glass was then placed in a holder and dipped into a bath of silver nitrate. This sensitized the plate and made it ready for exposure in the camera. To protect it from sunlight on the climb back to the top of the locomotive, the photographer placed the prepared plate in a holder, carefully moved back to the top of the locomotive, slid the plate into the camera,

FIG. 3
Unknown photographer, untitled
[portrait of Alfred Hart], ca. 1845. Modern
copy photograph of a daguerreotype,
5 × 3 inches. Private collection.

removed the lens cap, and counted the exposure time. He then replaced the lens cap, removed the plate holder from the camera, climbed back down off the locomotive, and placed the negative in the developing bath before the collodion had a chance to dry. The plate was developed and fixed in a few minutes, then washed, dried, and varnished to protect the negative.[1]

The photographer who made *Bound for the Mountains* was a New England entrepreneur named Alfred A. Hart (fig. 3).[2] A recent arrival to California, Hart had lived and worked as an artist in Connecticut for more than two decades before moving west. Being an artist, in Hart's case, was a working vocation. A portrait painter with considerable promotional skills, he traveled throughout New England in the 1830s and 1840s, advertising his services in local newspapers.[3] This Maine advertisement was typical:

Mr. A. Hart, Portrait Painter, (Pupil of Sig. Tomasco Falvano, of Rome), respectfully tenders his services as an artist to the citizens of Saco and Biddeford, and solicits patronage.

From an experience of ten years constant practice in his profession, in some of the principal cities of the Union, he flatters himself that he shall be enabled to give satisfaction to such as require his services.[4]

Little is known about Hart's training as an artist, but Tomasco Falvano seems to have been a fabricated name. Hart was probably self-taught, but he disguised that fact and promoted himself as cosmopolitan by inventing a European pedigree and exaggerating his experience.

Hart's entrepreneurial efforts branched into popular entertainment in 1853, when he painted and exhibited moving panoramas. We know about them from newspaper advertisements, one of which read: "Professor Hart's Great Moving Panoramic Mirror of the New Testament and Scenes in the Holy Land, has arrived and will be on exhibition at the Lecture Room. . . . This great and magnificent work of art, the largest in the world, has been painted at an immense outlay of money, and has never been equaled in the interest it has excited, or the favor with which it has been received. Prof. Hart will deliver lectures descriptive of the painting. Appropriate music will accompany the Exhibition."[5] Hart, who seems to have struggled to support his family on his earnings as an artist, tried a series of related occupations, working with a daguerreotypist in Hartford and as a merchant of art supplies in Cleveland, Ohio, in the late 1850s and early 1860s. Through all his career changes, Hart continued to paint. Although he was best known as a portrait painter, one of his extant landscape paintings offers insight into the aesthetic approach that he brought to his photographs.

An untitled painting of a scene inspired by James Fenimore Cooper's novels is one of Hart's most noteworthy works on canvas (pl. 4).[6] It is a landscape in which two men, small in relation to the forest surroundings, appear in a spotlighted clearing. Although a narrative is implied, without a title to guide the viewer the story is ambiguous. One of the men, dressed in buckskin and presumably a trapper, leans against his rifle and looks down at an Indian, who is bare-chested and seated with his back against a rock, his body slack and at rest. Hart's painting displays a sophisticated understanding of light, which falls from the right side of the painting, and of the treatment of space. The foreground vegetation is carefully delineated; as the spectator's attention leaves the two men in the middle ground and follows the curving river back into the mountainous portion of the painting, the detail diminishes. Perhaps the most striking thing about the painting, however, is its dramatic quality. Not only are the two men placed on a stagelike setting and illuminated by a bright light, but the trees on the right and left side of the canvas arch over the scene, framing it. This theatricality was consistent with Hart's expressed belief that achieving unity and effect in landscape painting was comparable to writing a drama.[7] It was a sentiment that he also brought to his work as a photographer.

It's not known exactly when or where he learned to make photographs, but by 1863, at the age of forty-four, Hart had changed careers once again and was working in California as a photographer. He used a specially equipped wagon to travel through mining camps, where he offered his services as an itinerant portraitist, now using a camera instead of a brush. Aside from a single advertisement in a small mining town's newspaper, Alfred Hart's practice as a photographer before 1865 is undocumented.[8] His stereographs of the Central Pacific Railroad are the only substantial images credited to him. There is evidence, however, that he worked as a photographer from 1863 to 1870, producing a body of work that includes stereographs of San Francisco and other cities and towns throughout the Bay Area and of Sacramento, the Calaveras Big Trees (the sequoia forest north of Yosemite in Calaveras County), and Yosemite. Significant circumstantial

evidence, as well as Hart's history as a savvy artistic entrepreneur, suggests that he was the primary, though unaccredited, photographer for the largest photographic firm in the West, Lawrence and Houseworth.[9]

Lawrence and Houseworth's substantial photographic archive makes it impossible to know the photographer of every negative in its catalogue. Nonetheless, Thomas Houseworth is reported to have said that one photographer was principally responsible for the firm's stereographic production between 1865 and 1867—and visual evidence suggests that it may have been Alfred Hart.[10] In 1864, the San Francisco firm wanted to expand its photographic publishing business and advertised: "Wanted—Stereoscopic Negatives of every place of interest on the Pacific Coast for which a fair price will be paid,"[11] and in 1865, the firm sponsored a photographic excursion through the Sierra and into Nevada. A wagon identical to the one in the Central Pacific Railroad stereographs appears in several images from this trip. Furthermore, Hart and Thomas Houseworth and Co., successor to Lawrence and Houseworth, published duplicate and variant images of such similarity that there is little doubt of their having been made within minutes of each other.[12] If Hart was the primary photographer for the firm, he would have been responsible for the stereographs that were awarded a bronze medal at the Universal Exposition in Paris in 1867, the first time photography of the North American West had been honored at an international exposition—a significant historical achievement and a testament to the photographer's skill and status as an artist.

At the same time that he was selling negatives to Lawrence and Houseworth, Hart was also working for the Central Pacific. Even though he has been considered by historians to be the official photographer of the Central Pacific Railroad, there is no evidence that the railroad ever directly employed him. He seems to have worked as an independent contractor, photographing along the rail line at least once a year. But he was more than simply a photographer for hire. He was the only person from whom the Central Pacific Railroad bought photographs or negatives between 1866 and 1870. The railroad transported his photographic wagon, and he stopped trains, posed workers, and accompanied official excursions to the end of the track. He might be gone from Sacramento for a few days, photographing a company excursion train, or weeks at a time, covering the latest progress through the mountains or on the Nevada deserts.

While he was photographing the railroad, Hart would also advertise his independent photographic trade in local newspapers and, on occasion, arrange for exhibitions of his work.[13] His newspaper announcement in Reno, Nevada, cannily refers to his connection to the railroad: "ALL ABOARD FOR THE PHOTOGRAPH GALLERY. . . . Come in time, and do not lose this opportunity of getting a good photograph of yourself and family, as I shall only remain a few days. . . . Call immediately and see the Stereoscopic views of the Central Pacific Railroad. All pictures at Sacramento prices. Views of residences, etc., executed in a superior manner."[14] When he returned to Sacramento, Hart sold negatives to the Central Pacific and to Lawrence and Houseworth. Although the negatives he sold to the Central Pacific were owned by the railroad, Hart printed and sold stereographs

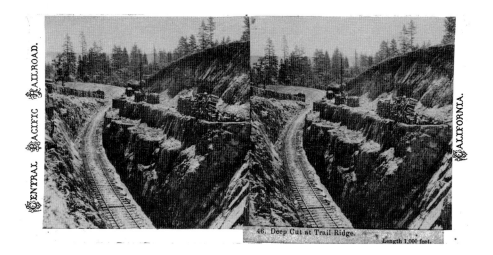

FIG. 4

Alfred Hart, *Deep Cut at Trail Ridge. Length 1,000 feet,* 1866 (no. 46). Albumen stereograph, 3½ × 7 inches. Library of Congress Prints and Photographs Division.

from both his studio at 65 J Street in Sacramento and Thomas Houseworth and Co.'s establishment in San Francisco.[15]

There were other photographers in the Bay Area who would have been pleased to have the Central Pacific's business. What was it about Hart's stereographs that appealed to the railroad? Hart brought a compositional control, a flare for the dramatic, and a sense of narrative to his work as a photographer. In most cases the story that his stereographs told was not a traditional narrative, but an account of the railroad that included a sense of past and implied progress in the future. He captured the organization of men and land and indicated the railroad's momentum through careful control of his compositions. In Hart's stereographs, railroad work regulates the rugged wilderness of the Sierra. Cuts, bridges, and tracks often begin in the lower edges of the frame and lead gently into deep space. Especially in the mountains, Hart adopted a camera position that kept one end of the roadbed, track, or train within the frame of the image. He confined and embedded his subject in the wilderness. In a stereograph like *Deep Cut at Trail Ridge. Length 1,000 feet,* for example, Hart placed his camera high above the excavation and pointed it down to magnify the depth of the cut (fig. 4).[16] Although his subject was the amount of earth removed, he organized his composition around the track, which begins at the lower edge of the image and creates a swooping curve up and into the deep space of the stereograph. This powerful perspective and adjusted composition also contains elements of a temporal narrative. On the right side of the image, the viewer sees a landscape in transition. The terraced hillsides that railroad work crews used to open the cut have begun to deteriorate; the edges have eroded, and debris has fallen from the terrace above. Stacks of cordwood wait for the locomotives

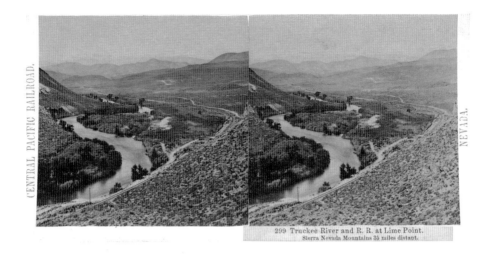

CENTRAL PACIFIC RAILROAD.

NEVADA.

299 Truckee River and R. R. at Lime Point.
Sierra Nevada Mountains 35 miles distant.

FIG. 5
Alfred Hart, *Truckee River and Railroad at Lime Point. Sierra Nevada Mountains 35 miles distant* (no. 299), 1868. Albumen stereograph, 3½ × 7 inches. Library of Congress Prints and Photographs Division.

that will soon move through this cut and on to the next stage of work, beyond the curve in the depth of the image.

Hart went to great lengths for this compositional clarity, and in some photographs, he portrayed the railroad as assimilated into a picturesque landscape. For example, Hart would climb up a mountainside, far away from the comfort of road and wagon, in order to obtain a panoramic perspective of the railroad in the landscape. In *Truckee River and Railroad at Lime Point, Sierra Nevada Mountains 35 miles distant* (fig. 5), the foreground falls off abruptly and the river and railroad lead the eye back into the depth of the composition and the mountains in the distance. The high horizon line minimizes the blankness of the skies and creates an image full of geographical detail, embedding the track in the wilderness. From this elevation, one sees how the railroad reorganized the landscape and created a new space of sweeping curves that contrast to the serpentine bends of the river beside it. Following these curves, the viewer confronts the formidable Sierra Nevada and is reminded of both the popular assumption that these mountains were impenetrable and the triumph of the Central Pacific engineers who were now working on the eastern side of the range.

Hart's attention to dramatic compositions and the control he exercised over the arrangement of his subject matter were qualities he shared with San Francisco painters, many of whom traveled the newly opened railroad line in search of mountainous panoramas. As early as 1867 and 1868, Fortunato Arriola, Norton Bush, Ransom Holdredge, William Keith, William Marple, and Juan Wandesforde all made trips into the Sierra Nevada.[17] It is likely that the Central Pacific Railroad provided railroad passes to encourage the sketching trips, and that the artists took advantage of the opportunity

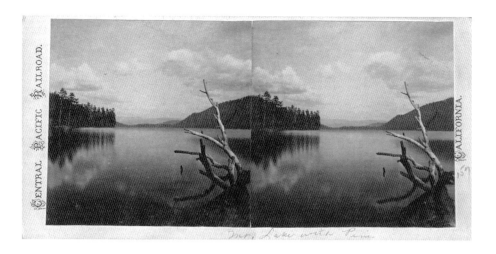

FIG. 6

Alfred Hart, *View of Donner Lake. Altitude 5,964* (no. 130), 1866. Albumen stereograph, 3½ × 7 inches. Private collection.

with the expectation of sales to railroad barons or transcontinental travelers. For example, Fortunato Arriola painted Donner Lake as a picturesque site of tourist recreation in 1868 (pl. 5).[18] Even though its date coincides with railroad construction above the lake, there is no suggestion of the clamorous work crews or belching locomotives. Instead, the painting's subject is the light at sunset, its play across the lake's mirrorlike surface, and the boaters enjoying the final hours of daylight. The painting's atmosphere and tranquility echo a passage published in the *California Weekly Mercury* a year earlier: "Towering woods, and bright, crystal water, and magnificent picturesque mountains make up, in the vicinity of Donner Lake, one of the grandest possible natural pictures of the sublime and beautiful. . . . The mind, too, through the eye, is constantly receiving new and grateful surprises in meditating upon the bold beauties which nature has so lavishly bestowed upon this favored region."[19] Arriola's light-filled atmosphere, reflective surface, and depiction of personal amusement was a radical departure from the morose association of the lake with the fate of the Donner Party, after whom the lake was named.[20]

Like Arriola's painting, in Hart's *View of Donner Lake. Altitude 5,964,* the lake and its pristine, glassy surface fill the frame (fig. 6). The elevation included in the title served as a reminder of the Central Pacific Railroad's audacious endeavor. But this stereographic negative was not generated for its informational qualities, for it transported the spectator far from the sites of railroad construction in 1866. The jagged branch and its reflection activate the foreground plane and contrast with the soft, reflective surface of the lake in the middle ground, with the trees along the lakeshore framing the distant mountain range. The picturesque qualities of this photograph are accentuated by the clouds, a great rarity in collodion negatives because of the emulsion's sensitivity to blue

light.[21] The mirrorlike luminescence of the lake's surface and the silver shimmer at the edges of the clouds seem more at home among Luminist landscape paintings than corporate industrial photographs, but this is just one of several stereographs in the Central Pacific series that reveals the aesthetic qualities of the landscape without reference to the railroad. Picturesque compositions like *View of Donner Lake* constitute a singular genre apart from the more instrumental images that capture the dissection of the mountainscape by railroad construction.

There is little doubt that the primary purpose of the stereographs was informational, but the aesthetic appeal of the images was also important to railroad executives. Company attorney E. B. Crocker indicated his appreciation for the quality of Hart's stereographs in a letter to Huntington:

> I inclose [sic] some stereoscopic views recently taken—with a descriptive list. The No's. you will find on the back of the views in a corner. Some of them were taken while considerable sun still remained on the high points. As a work of Art they cannot be surpassed. . . .
>
> I sent a full set of our views by Richardson to Brigham Young & he was highly pleased with them. He had some from the Union Pacific, but they did not compare with ours.
>
> I have more new views, to send soon.[22]

Crocker's tastes tended toward the picturesque and pastoral, but some artists viewed the landscape as more threatening.

William Keith took a different approach to the landscape when he took the train to the end of the line in 1867. The *San Francisco Bulletin* reported, "Keith has been to the summit of the Sierra Nevada by railroad, and made numerous water color and oil sketches of the grand scenery which characterizes the vicinity of Cisco. As snow still lies deeply on the peaks his elaborate views will have some fine Alpine effects. He is engaged in working up some of his studies in water color, and is likely to produce from these mountain sketches his most striking pictures."[23] Keith's watercolor of the Yuba River, *Mountain Cascade near Cisco,* is the only known example of this early work (pl. 6). The Yuba River was a favorite of Hart's as well, and the subject of several stereographs in 1866.

In contrast to Keith, Hart portrays the cascades of the Yuba River from a distance and includes the surrounding High Sierra landscape. In *Cascades on the Yuba River, near Crystal Lake,* the foreground trees on the left frame the river as it rushes over the granite boulders and, moving from the curtain of trees in the background, cascades over rocks as it winds its way through the landscape (fig. 7). The stereograph's point of view is one of quiet contemplation, above the landscape and in control. Rather than offering an elevated perspective like Hart's, Keith places his spectator in the path of the river and conveys a sense of the sublime by creating a vision of powerful, churning rapids in the foreground. Reminiscent of Thomas Housewarth and Co.'s stereograph *Falls on the Yuba River, near Cisco, Placer County,* Keith's watercolor depicts a curving river leading

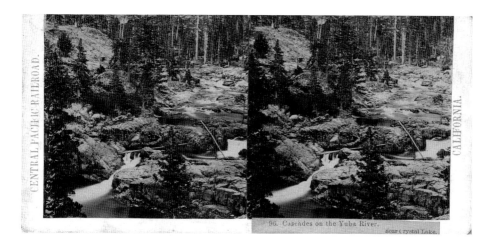

FIG. 7
Alfred Hart, *Cascades on the Yuba River, near Crystal Lake* (no. 96), 1866. Albumen stereograph,
3½ × 7 inches. Private collection.

the eye from foreground cascade into mountainous background.[24] The comparison of
Keith's painting and Hart's stereograph highlights one of the stylistic traits of the Cen-
tral Pacific stereographs. Even when Hart's landscape stereographs exclude the railroad,
they control the landscape. In Keith's watercolor, the river is forceful and dominant; in
Hart's stereographs nature is contained and regulated.

Hart's sweeping compositions conform to an artistic tradition of representing the
railroad in a panoramic space, but his celebration of technology in stereographs such as
*American River Canyon from Cape Horn. River below Railroad 1400 feet, 57 miles from Sac-
ramento* and his acknowledgement of landscape destruction mark a significant depar-
ture from this aesthetic tradition.[25] In Asher Durand's *Progress* (see pl. 3) and Jasper
Cropsey's painting of the New York and Erie Railroad, *Starrucca Viaduct, Pennsylvania,*
for example, the train does not affect its natural surroundings but coexists with nature
(fig. 8). The bridge and train are central in *Starrucca Viaduct* but tiny in relationship
to the work of God as represented in the autumnal surroundings. Cropsey uses such
traditional compositional devices as the *repoussoir* trees, foreground figures, a body of
water in the middle ground, and distant mountains to idealize the setting. His painting
epitomizes the easy assimilation of the railroad into the landscape; early paintings of the
Central Pacific Railroad appear to have shared this approach.

Norton Bush studied with Jasper Cropsey before moving to San Francisco, where he
was one of the city's leading painters in the late 1860s.[26] *Cape Horn* memorializes one
of the most treacherous places in the Sierra Nevada route, where the railroad's track bed
is cut into the side of a cliff, high above the American River, and makes a sharp turn
around the mountainside (pl. 7).[27] It reminded those who had traveled to California by
sail of their trip around Cape Horn at the tip of South America. This bend of the railroad

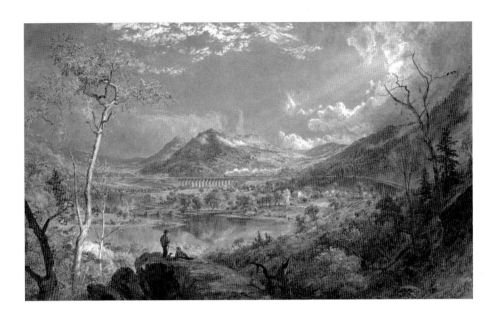

FIG. 8

Jasper Cropsey, *Starrucca Viaduct, Pennsylvania,* 1865. Oil on canvas, 22⅜ × 36⅜ inches. Toledo Museum of Art (Toledo, Ohio). Purchase with funds from the Florence Scott Libbey Bequest in Memory of her Father, Maurice A. Scott, 1947.58. Photo credit: Photography Incorporated, Toledo.

was a frightening and thrilling experience for passengers and a favorite spot for tourists, photographers, and artists. Bush was one of the first to immortalize it in a painting, but in this work by Bush the train is tiny and represents only a small part of the landscape composition. For Bush, Cropsey, and Durand, the railroad is not an active agent organizing nature. In these paintings, the train is so diminished that it scarcely intrudes in its wilderness surroundings.[28]

Rather than look up at the train and the vast panorama of the mountains to the east, as the spectator does in Bush's painting, the viewer of *American River & Canyon from Cape Horn. River below Railroad 1,400 feet, 57 miles from Sacramento,* looks down from a position of control above the track and back toward what has been accomplished (fig. 9). Hart foregrounds the locomotive against the vastness of the Sierra Nevada. The viewer looks first at the locomotive, then past it, to the landscape beyond, so that human agency, technology, and the success of construction, fourteen hundred feet above the river and fifty-seven miles from Sacramento, are all made manifest. Unlike Bush's painting, here the train is not integrated into the landscape; it is visually enormous, dominating the space and establishing its forceful presence. Rather than depicting the railroad as tiny in the vast wilderness, Hart's stereographs present the viewer with a new sense of scale. He contrasts locomotives and engineered spaces against a primitive mountain wilderness. The Central Pacific stereographs demonstrate spatial and mechanical organization and display the railroad's success in creating a new technological space.

FIG. 9

Alfred Hart, *Am[erican] River & Canyon from Cape Horn. River below Railroad 1,400 feet, 57 miles from Sac[ramento]* (no. 44), 1866. Albumen stereograph, 3½ × 7 inches. Union Pacific Railroad Museum.

FIG. 10

Alfred Hart, *Shoshone Indians looking at Locomotive on Desert* (no. 323), 1868. Albumen stereograph, 3½ × 7 inches. Courtesy Barry A. Swackhammer Collection.

In 1868, as the Central Pacific work crews graded the eastern side of the Sierra and the high desert of western Nevada, Hart experimented with more allegorical compositions. Conceptualizing the railroad as "progress," Hart updated motifs seen earlier in Durand's painting.[29] *Shoshone Indians looking at Locomotive on Desert* shows a small group of railroad workers and Indian men and women standing beside a massive loco-

ACROSS THE CONTINENT.
"WESTWARD THE COURSE OF EMPIRE TAKES ITS WAY"

FIG. 11

Currier and Ives (Frances Palmer), *Across the Continent: "Westward the Course of Empire Takes Its Way,"* 1868. Color lithograph, 17⅝ × 27⅛ inches. Joslyn Art Museum, Omaha, Nebraska, gift of Eugene Kingman, 1963.499.

motive (fig. 10). All are dwarfed by the enormous engine, with the workers standing in a line facing the camera, visually connected to the locomotive; the Indians stand alongside the machine seemingly oblivious to the camera or the railroad men, in awe of the technological wonder. The implications inherent in the contrast between the size and power of the locomotive and the astonishment of the Shoshone beholders are the inevitable force of the railroad and a rendering of technology as commanding and authoritarian.

Creating metaphoric photographs that represented the railroad as a forerunner of European-American civilization was an extremely unusual project for nineteenth-century photography; in the visual arts, this theme was explored primarily in prints and paintings. The same year that Hart photographed the Shoshone Indians alongside the locomotive, Currier and Ives published *Across the Continent: "Westward the Course of Empire Takes Its Way"* (fig. 11). This well-known print updated the idea of American westward migration and anticipated the new realities of railroad travel. It was a theme that the print publishers, and their artist Frances Palmer, had taken up two years earlier in *Rocky Mountains—Emigrants Crossing the Plains* (fig. 12).[30] The two lithographs share many similarities, including compositions that are divided diagonally by the activity in the lower left, and a right side that displays a wilderness landscape in which a river zigzags back into space. Two Indians on horseback observe the action and, like Hart's

THE ROCKY MOUNTAINS.

FIG. 12

Currier and Ives (Frances Palmer), *Rocky Mountains—Emigrants Crossing the Plains*, 1866. Color lithograph, 17½ × 25⅞ inches. Joslyn Art Museum, Omaha, Nebraska, museum purchase, 1953.195.

Shoshone Indians looking at Locomotive, are impotent bystanders observing the progress of American settlement. In *Rocky Mountains* they watch as the emigrants' wagon train moves through their land. In *Across the Continent* they stand opposite the white settlement. The train blocks them from the log cabins and settlers, and, in a visual metaphor acknowledging their fate, the locomotive belches black smoke that obscures their view of the open landscape and, by implication, of their future. One can easily imagine that the smoke, in a foreshadowing of the plight of the Indians, will soon envelope them and render them invisible.

Across the Continent and the Central Pacific stereographs share certain compositional strategies. *Rocky Mountains* places the spectator close to the land, consistent with the dirt roads and the slow pace of the ox-drawn wagons. *Across the Continent,* however, echoes the high camera perspectives Hart used throughout 1866 and 1867. Frances Palmer gives viewers an elevated position, as if the energy and speed of the railroad has literally lifted the viewer up and away from the earth. This dynamic force is also carried in the sharp, straight diagonal of the train track.[31] The people in the passenger cars rush to an uncertain future, exemplified by the indistinct background toward which the train speeds. Here as in many of the railroad stereographs, the train conceptually connects the present with an imagined future.

Capturing the progress of construction and combining it with the popular belief in the railroad as the advance of civilization, the Central Pacific stereographs helped mask the brutal instrumentality of the railroad's practices. They rationalized the corporate corruption that was beginning to be associated with the construction of the first transcontinental railroad and invoked the metaphoric language of Manifest Destiny. The flat desert evident in the stereographs, however, bore little resemblance to the fertile plains in the Currier and Ives prints and was a far cry from the heavily wooded landscape of Durand's painting. But while the details of the geography differed significantly, the sense of triumph shared by all media was the leitmotif of Hart's final set of photographs at the celebration of the completion of the railroad on May 10, 1869.

UNION PACIFIC RAILROAD PHOTOGRAPHED

Unlike the Central Pacific landscape, which Hart systematically photographed between 1865 and 1869, the Union Pacific Railroad was photographed on only one occasion before 1868—at the Union Pacific Excursion to the One Hundredth Meridian. From April to October 1866, the Union Pacific Railroad pushed the track west from Omaha across the flat plains of Nebraska, bridged the Loup Fork River, passed Fort Kearney, and reached the hundredth meridian. This milestone was a practical as well as symbolic accomplishment. Because of the political struggle over which city would serve as the eastern terminal, the Pacific Railroad Act of 1862 chose the hundredth meridian as the official beginning of the eastern portion of the transcontinental railroad. The act allowed railroads to be built with government subsidies from Omaha, Kansas City, Sioux City, and Atchison, Missouri, to that point. Although it did not face any serious competition, reaching the hundredth meridian assured the Union Pacific Railroad of exclusive government support for the remainder of the construction west.

To celebrate this accomplishment, Thomas Durant, Union Pacific Railroad vice president, invited politicians, financiers, and reporters on an excursion to the hundredth meridian.[32] Durant was a financial speculator who had become involved in railroad building in 1851, when he joined Henry Farnum in constructing the Michigan and Missouri Railroad. Soon, he and Farnum initiated a project to build a railroad across Iowa. A man with a strong personality, a tremendous amount of energy, and a heightened sense of self-importance, Durant used his experience with the Iowa enterprise to gain support for a much grander project and a new company, the Union Pacific Railroad. He and Farnum felt that a combination of public interest in the transcontinental railroad and government guarantees would allow them to easily secure financing for the construction.[33] With this in mind, Durant devised a scheme in which Credit Mobilier of America, a shell corporation controlled by the Union Pacific, was granted the construction contract. It presented bills for inflated estimates of construction costs, which were paid to the company. The Credit Mobilier then subcontracted the work to the lowest bidder and kept the difference between the inflated estimate and the actual cost.[34]

In October 1866, Durant seized upon the extension of track from Omaha to the hundredth meridian to organize an excursion for invited guests and to advertise the success of the railroad. He made sure that the event would be reported "correctly" by writing press releases and inviting the Chicago photographer John Carbutt to record the excursion in stereographs.[35] Durant's reasons for choosing Carbutt are not known, but Carbutt was a logical choice. The photographer had an established reputation in Chicago and on the East Coast. He was a frequent contributor to the leading photographic magazine of the day, the *Philadelphia Photographer,* where he published an article describing a new way to tone photographic prints. Carbutt also patented a dry plate process for making photographic negatives and patented a set of plans for a solar enlarger. Most germane to his work for the railroad, he had ventured far from Chicago, photographing sites along the Mississippi River, and had invented a lightweight developing box that allowed him to more easily make photographs away from the studio.[36] His first photographs for the Union Pacific excursion began with the arrival of steamboats carrying the excursionists to Omaha.[37] For the 140 people who accepted Durant's invitation, the methodical thump of the paddle wheel was soon replaced by the quick-paced click of the rails as the train conveyed the excursionists west.

When they arrived at their first camp, the guests found tents, buffalo robes, wood for bonfires, cases of champagne, and more than a hundred Union Pacific employees prepared to serve the group. The first night they built a bonfire in the camp, and, to allay any concerns of the East Coast visitors about Indians, Durant paid a group of Pawnees to amuse the excursionists with a "war dance." The entertainment played up the rough exoticism of the West, but at night the Union Pacific Railroad treated its guests to luxury accommodations in the latest "Pullman Palace Sleeping Cars." These arrangements juxtaposed the modernity of the railroad with the primitive Indian entertainers and the wilderness landscape, creating an understanding of the railroad as civilization and progress. The latter was also a primary subtext of Carbutt's stereographic series, although few of the images addressed it explicitly. *Group of Pawnee Warriors and palace Cars of U.P.R.R.* was one that tried, but the camera was too far away from the group, and the rigid pose of the Indians, excursionists, and railroad workers diluted the visual impact of the image (fig. 13). In the context of the series, it was just another stereograph of posing participants. Only the title notes the social, cultural, and technological contrasts in the events and images at the hundredth meridian excursion.

The compositional simplicity of Carbutt's Union Pacific stereographs conveys information, but it lacks the theatricality or narrative implications one finds in Hart's stereographs of the Central Pacific. Whereas Hart highlights the difficulties the company faced integrating railroad technology in the mountainous wilderness, Carbutt was primarily concerned with providing private souvenirs for the excursionists. Putting men before machines, Carbutt's group portraits efface the image of the train (fig. 14). Silas Seymour, a consulting engineer for the Union Pacific Railroad, made note of one of those occasions:

FIG. 13

John Carbutt, *Group of Pawnee Warr[ior]s. & palace cars of U.P.R.R.* (no. 204), 1866. Albumen stereograph, 3½ × 7 inches. Courtesy Barry A. Swackhammer Collection.

Professor Carbutt was now in great demand. Everybody wanted to be taken just as they appeared at the breaking up of the camp. The Professor finally succeeded in obtaining some excellent groupings, as well as camp and landscape views before the train started eastward. . . .

The train was halted for nearly an hour directly opposite the monument designating the point where the line of the road crosses the one hundredth meridian of longitude, for the purpose of enabling Professor Carbutt to photograph some views representing the excursion train, with groupings of Government officers, members of Congress, Directors of the road, and excursionists, coming to this point *from the west.*[38]

Contending with a significantly less interesting landscape than Hart, Carbutt used a straightforward, studio-based approach to composition. In a stereograph such as *Group of Distinguished Guests of U.P.R.R. at 100th Meridian,* the horizon line divides the composition in half and blank skies stretch out above the gathered assembly of guests. Because Carbutt consistently places his subjects in the middle ground, the depth of his compositions also divides the space in half. When he had the opportunity to use track or train to enhance the dramatic impact of stereoscopic space, Carbutt rarely took advantage, preferring to align the train parallel to the picture plane.

Faced with a similar visual problem of memorializing a railroad excursion, Hart chose a different solution. In spring 1866, he accompanied a group to the end of the Central Pacific track. Just as the Union Pacific would do in October, the Central Pacific stopped the train to let its occupants peer over the edge of the track and pose for the man with the camera. Unlike the Union Pacific Railroad stereographs, however, *Excursion Train at Cape Horn, 3 Miles above Colfax,* is a portrait of railroad progress, not individual

John Carbutt, *Gro[u]p of distin[guished] guests of U.P.R.R. at 100h mer[idian]* (no. 221), 1866. Albumen stereograph, 3½ × 7 inches. Courtesy Barry A. Swackhammer Collection.

Alfred Hart, *Excursion Train at Cape Horn, 3 Miles above Colfax* (no. 57), 1866. Albumen stereograph, 3½ × 7 inches. Union Pacific Railroad Museum.

attendees (fig. 15). For his stereograph, Hart set his camera above the track so that he looked down at a slight angle on the train and the crowd. He captured the curve around the mountain at Cape Horn and the tiny figures of the unidentifiable excursionists, oblivious to the camera, eagerly peering down over the ledge and into the American River canyon hundreds of feet below. Compositions like these celebrate the success of

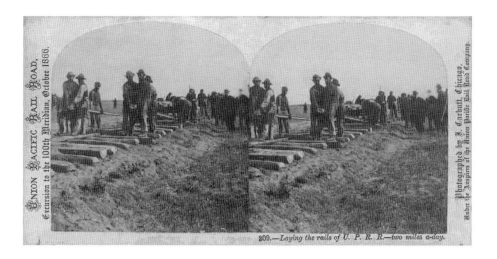

FIG. 16

John Carbutt, *Laying the rails of the U.P.R.R.—two miles a-day* (no. 209), 1866. Albumen stereograph, 3½ × 7 inches. Courtesy Barry A. Swackhammer Collection.

railroad technology rather than the individual tourists and the invisible milestones that are the principle subjects of Carbutt's stereographs.

In most cases, Carbutt's stereographs are about the present moment rather than an implied future. For example, *Laying the rails of the U.P.R.R.— two miles a-day* is the only image to show construction in Carbutt's Union Pacific Railroad series. The subject offered the opportunity to suggest the ongoing construction of the railroad across the flat plains of Nebraska, but instead of providing a geographical context in which to understand the railroad work, Carbutt moves in close, obscuring the horizon, so that the railroad workers become the new skyline (fig. 16). This composition stresses details of men, ties, and rail; it is intimate and momentary. In contrast, Hart's photograph of the Central Pacific's construction of a tunnel and retaining wall in the Sierra is more abstract, showing work, not workers, and a mountain in the process of being transformed into a technological landscape (fig. 17). In *Horse Ravine Wall, and Grizzly Hill Tunnel. 77 miles from Sacramento,* the earthen bed awaits the ties and track, and the huge retaining wall, built to create a straight pathway for the train, is only partially covered with the earth that will prevent its erosion. The stereograph carries the implication that it is only a matter of time before the wall is covered, the ties and track are laid, and the locomotive whistle is heard echoing through the Sierra Nevada canyons.

Carbutt's stereograph of a single figure at the end of the track is one of the few works he produced during the excursion to the hundredth meridian that suggest the future and the broader context of the Union Pacific work. For this image, Carbutt placed his camera in the center of the graded roadbed and photographed a man standing in profile. His upright figure is silhouetted against the horizontal Nebraska prairie (fig. 18). The

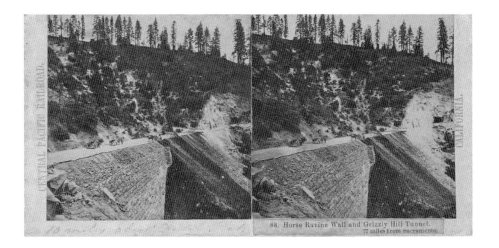

FIG. 17

Alfred Hart, *Horse Ravine Wall, and Grizzly Hill Tunnel. 77 miles from Sacramento* (no. 88), 1866.
Albumen stereograph, 3½ × 7 inches. Union Pacific Railroad Museum.

identity of the figure is open to conjecture. Many have identified him as the surveyor
and construction engineer Samuel Reed. Although it is true that Reed was at the end
of the track in October 1866, he was preoccupied with completing a railroad bridge
at North Platte.[39] Visual evidence from the Carbutt series suggests that the figure is
Thomas Durant; he can be seen in several other Carbutt stereographs wearing the same
gray hat, with a rifle strapped to his back.[40] He is not identified here because the image
is intended to be more than a simple portrait. Paraphrasing Bishop Berkeley's famous
statement, "Westward the course of empire takes its way," *Westward, the Monarch Capital Makes its way* proposes a new reality for the post–Civil War environment. Political
leaders no longer establish empires; private capital does. In this new entrepreneurial
world, money provides influence, and technology manifests that power. The single figure of the shrewd investor stands alone. Although small in comparison with the endless
expanse of western landscape, he is in control of the space because of the railroad. Or
so it seems in the stereograph. In fact, the reality of the railroad financing was such
that guarantees by the federal government were a necessity to insure the flow of private
capital.

The Central Pacific construction was documented with hundreds of images between
late 1865 and 1868, but the Union Pacific had not been photographed for more than a
year and a half when, in spring 1868, Andrew Russell headed west to record the railroad
between Cheyenne, Wyoming, and Salt Lake City, Utah.[41] Russell's approach to his subject matter is evident in photographs like *Granite Canon, from the Water Tank* (fig. 19).[42]
Unlike Carbutt's stereographs, this image shows a greater panoramic sense of space,
and it takes as its subject matter an empty landscape and completed track, not posed

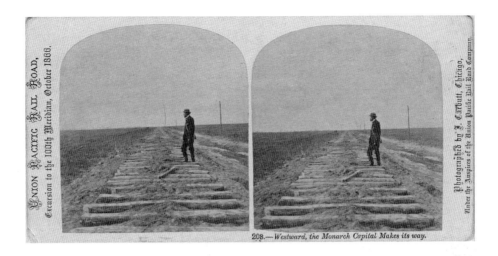

208.—*Westward, the Monarch Capital Makes its way.*

FIG. 18

John Carbutt, *Westward, the Monarch Capital Makes its way* (no. 208), 1866. Albumen stereograph, 3½ × 7 inches. Library of Congress Prints and Photographs Division.

dignitaries. Superficially, it shares many compositional similarities with the Central Pacific's *Bound for the Mountains* (see pl. 2). Both men elevate their cameras, looking down on a barren landscape, telegraph poles, and, most important, a railroad track that begins in the foreground and pulls the eye into the deep space of the image. Both photographs are images of the success of the construction effort, but *Granite Canon* lacks the compelling narrative and technological thrust of the Central Pacific stereograph, despite the fact that the contrast between the meandering river on the left and the sharp diagonal authority of the railroad vector conveys a similar message of technological determination. *Bound for the Mountains* communicates its message explicitly in the title, and implicitly in the locomotive that seems to rush into the frame. In contrast, the title of Russell's image lacks the specificity associated with the Central Pacific stereograph. Even the extended title, *Granite Canon, from the Water Tank,* positions the photographer rather than providing information about the railroad, and as a result, the treeless, desolate landscape comes to represent the Union Pacific lands in Wyoming or, for a less discerning viewer, all the land adjacent to the Union Pacific.

The most significant difference, however, is physical. The Central Pacific image is a stereograph and the Union Pacific's is a photograph that measures 10 × 13 inches, a format at which Russell excelled. Consequently, *Granite Canon* lacks the dramatic plunge into space that one would see in *Bound for the Mountains,* where format choice and photographic perspective together animate the image, point to the future, and literally foreground railroad technology. Despite its deep vanishing point, the Union Pacific photograph is flat in comparison, a record of completed work, of the past, and of another mile of track laid in the race west. The large format Union Pacific photograph, however,

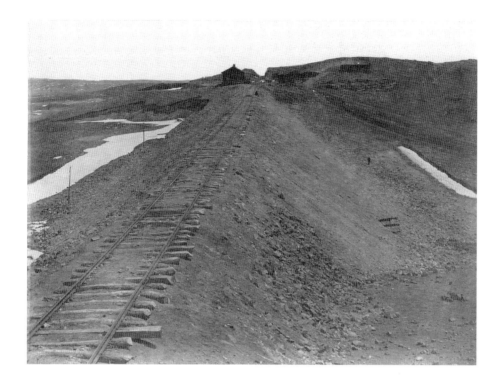

FIG. 19
Andrew Russell, *Granite Canon, from the Water Tank* (no. 10), 1868. Later known as *Granite Cannon, Embankment*. Albumen print, 10 × 13 inches. Yale Collection of Western Americana, Beinecke Rare Book and Manuscript Library.

could be appreciated without the aid of a stereoscope or other viewing device. Its size allowed it to be mounted in albums, where viewers could closely inspect details, which worked both for and against the railroad. In *Granite Canon,* the twisted and uneven ties on which the track rests, suggest slipshod construction and stand in direct contradiction to the suggestion of railroad progress.

Andrew Russell, who created *Granite Canon,* was born in Walpole, New Hampshire on March 20, 1829. In the 1850s he taught drawing and enjoyed a regional reputation in upstate New York as a landscape painter. Russell's painting style is indicative of at least some of the differences between the two photographers. Where Hart's painting is dramatic and metaphorical (see pl. 4), Russell's is topographical and factual. Painting a panorama of the Cohocton Valley and the town of Bath, New York, Russell takes a position high on a hilltop overlooking the river basin (pl. 8).[43] His surrogate can be seen in the lower left, sketching the scene. The town along the river is rendered with enough detail that buildings housing certain businesses can be identified to this day. The painting is ambitious and shows a wonderful feel for color, but stylistically *View of Bath from the West* is less sophisticated than Hart's painting. The contrasts between

light and shadow are harsher, and it displays some difficulties in the treatment of perspective.

The most telling difference, however, is the contrast between painting as a form of dramatic narrative, which we see in Hart, and painting as topographical description. Russell's painting captures the physical details of a town along the Cohocton River. By all accounts, *View of Bath from the West* was a successful painting; it received regional attention and critical praise: "During a recent sojourn of a few days in New-York, we strolled into the studio of A. J. Russell. . . . One [painting] struck our attention as particularly meritorious. It is a view of the Cohocton Valley, near Bath, in Steuben County, and is exceedingly truthful in its representation. It is a summer scene, and never did the golden harvest appear in richer luxuriance and perfection, or the forest foliage more beautiful, or the summer sky more enchanting than they rest in this instance upon the canvass, as the achievement of a wonderful art. This picture speaks volumes in praise of the artist, whose prospects are just budding, and whose future, if life and health shall be spared him, is full of honorable success."[44] Unfortunately for his career as a painter, circumstances precluded Russell from attaining the "honorable success" predicted by the writer.

With the outbreak of the Civil War, Russell returned to the Genesee Valley and shifted to new forms of picture making. He collected photographs and used them to paint "Panorama of the War for the Union," which he exhibited in upstate New York in late 1861 and 1862, shortly before he enlisted in the 141st Regiment of the New York Infantry.[45] On March 2, 1863, he was reassigned to permanent duty as photographer of the U.S. Rail Road Construction Corps, headed by General Herman Haupt.[46] Russell traveled throughout Virginia, photographing railroad operations, life in military camps, battlefields, and the aftermath of the battles of Fredericksburg and Richmond. After the war, Russell returned to New York City where he opened a studio and advertised a variety of pictorial practices: oil painting, watercolor, photograph coloring, and studio photography. It is unclear the extent to which he was able to support himself and his family with such work, but given the wide diversity of his endeavors, it seems likely that he welcomed the opportunity to photograph the construction of the Union Pacific Railroad.

There is no known document outlining the circumstances of Russell's appointment, but he was probably chosen at least in part because of his service in the Union army. The Union Pacific ranks were full of Civil War veterans. Grenville Dodge, the chief engineer, and Jack Casement, lead track laying contractor, had both been generals in the Union army; construction contractors and the consulting engineer were former Union officers; and both Union and Confederate veterans were prominent in the railroad's labor force.[47] Russell was the only official military photographer in the war, and it is likely that his activities brought him into contact with some of the men directing the construction of the Union Pacific. Grenville Dodge, who was the Union Pacific's chief engineer, had been with the military railroad; and Silas Seymour, who was a consulting engineer for

the Union Pacific and a confidant of the Union Pacific vice president Thomas Durant, had been the chief engineer of the New Long Bridge across the Potomac River, which Russell had photographed during the war.[48]

There are no records of the Union Pacific paying Russell a salary, but he must have received some type of financial support from the railroad, given the distance from his New York studio, the cost of outfitting a photographic expedition to the West, and the length of time he remained in Wyoming and Utah. We know that Russell billed the Union Pacific, but we don't know what those payments were for. Check stubs indicate that in April 1869 Durant paid the photographic supply firm of E. and H. T. Anthony more than $600 for photographic supplies, and that he paid Russell $242.13.[49] In the field he acted as the company photographer. He photographed federal delegations sent to inspect the construction, as well as the railroad's directors and construction foremen; and when army generals, government commissioners, and officials met at Fort Sanders, Russell was there to record the momentous meeting. A further indication that there must have been some type of exclusive agreement between Russell and the Union Pacific is that Ferdinand Hayden, hoping to include Russell's photographs in his geological survey of Wyoming, wrote to Durant asking for permission to have Russell make the prints.[50]

Whatever the details of their relationship, Russell left New York City in spring 1868 and traveled five hundred miles west of company headquarters in Omaha to Cheyenne, Wyoming. He devoted himself to photographing in the West for most of the year, returning in November with both stereographic negatives and masterful large format negatives. Unlike Hart's stereographs of the Central Pacific, Russell's images of construction indicate a greater interest in the laborers who built the railroad than in the equipment that would use it. In *Deep Cut, Bitter Creek, near Green River* (fig. 20), Russell chooses a camera position similar to the one Hart used in *Bound for the Mountains* (see pl. 2); but rather than a locomotive rushing out into the picture space, the viewer sees a workman and cart move rocks out of the cut and toward the end of the fill in the distance. Similarly, for *Wilhelmina Pass, from the west, building Piers for Bridges,* Russell organizes the composition so that the work product, stone piers for bridging the Weber River, is located in the foreground, while the masons who cut the stone pose in the middle ground with the tools of their labor (fig. 21).

In Russell's photographs one finds a variety of Union Pacific workers, including laboring men, clerks, engineers, and construction supervisors. This choice of men over machines demystifies the taming of the landscape; Russell's stereographs bring to the viewer the individuals who are altering the land in the name of progress. In contrast to Russell's photographs of the men who built the railroad, Hart's Sierra views show technology as the transformative agent; railroad labor appears in only a select few images, and construction workers, even when the subject of the stereograph, are not identified by name. There are few portraits of railroad workmen or engineers; there are, instead, portraits of individual locomotives, such as the *Gov. Stanford, Nevada, Huntington,* and

FIG. 20

Andrew Russell, *Deep Cut, Bitter Creek, near Green River* (no. 60a), 1868. Later known as *Carmichael's work on Bitter Creek, Green River* (no. 169). Albumen stereograph, 3½ × 7 inches. Private collection.

Atlantic. Further, stereographs like *American River & Canyon from Cape Horn, River below Railroad 1,400 feet, 57 miles from Sacramento* (see fig. 9) blatantly display technology, not railroad labor, as the transformative force. In Russell's photographs, particularly those made in 1868, locomotives play a significantly smaller role. Rather than stopping trains like Hart, Russell halted work and posed the anonymous men for the camera.

These differences in subject matter and presentation may relate, in part, to the nature of the labor of the two photographers. Hart worked independently, returning to his studio in Sacramento after his photographic excursions along the Central Pacific. He usually traveled for days or weeks in the field, returning to Sacramento after each excursion. Although he used a photographic wagon, as did Russell, Hart's was much larger and was occasionally transported by train to the end of the rail line.[51] Furthermore, Hart continued to think of himself as an artist-painter rather than a railroad worker; during the time that he was making stereographs for the railroad, he also created large-scale paintings in his studio (see pl. 4). Russell, in contrast, stayed in the West for months at a time, following the work crews and moving among construction sites during the spring, summer, and fall of 1868.[52] While the lines between labor and management in this situation are permeable, Russell's practice is literally and stylistically closer to railroad labor, while Hart's seems to have more in common with railroad management. Like the laborers and foremen he photographed, Russell was in the West to perform a job, and, unlike Hart, Russell seldom worked alone.[53]

Shortly after he arrived in Cheyenne, Russell struck up a friendship with a cashier for the Union Pacific Railroad, O. C. Smith. That April, Smith accompanied Russell to the Dale Creek Bridge, where he assisted Russell in making the photographs of the bridge in the snow.[54] Smith was not the only person that Russell befriended; he traveled exten-

No. 86—Wilhelmina Pass, from the west, buil...ng Piers for Bridges.

FIG. 21

Andrew Russell, *Wilhelmina Pass, from the west, building Piers for Bridges* (no. 86), 1868. Later known as *Building First Bridge over Weber* (no. 380). Albumen stereograph, 3½ × 7 inches. Private collection.

sively and created a network of associates. Russell accompanied the geologist Ferdinand V. Hayden and the United States Geological Survey to Wyoming in late summer 1868.[55] He also went to Salt Lake City, where he met with the photographer C. R. Savage, with whom he would work for several weeks in 1868 and 1869. It was logical that Russell would have sought out the Salt Lake photographer. Two years earlier, Savage had left his partner, the painter George Ottinger, and taken a three-month trip to the East Coast to meet with New York photographic manufacturers, purchase photographic equipment, and establish contacts with East Coast newspapers and publishers.[56] Returning to Salt Lake City with a new photographic wagon and supplies, Savage became one of the most important assets for early photographers in the West. By all accounts, he welcomed visiting cameramen and enjoyed the camaraderie of photographic excursions. Although the details of the relationship between Savage and Russell are speculative, they are worth considering for what they suggest about collaborative photographic practice in the West in the mid-nineteenth century.[57]

Adapting the model of the history of fine art painting, many scholars have considered nineteenth-century photography to be a solitary practice, when often that was not the case. The photographs that Russell made alongside Savage suggest a close working relationship that was collegial rather than competitive. Direct evidence that Russell and Savage worked together can be found in images they made of each other in the field and in the similarity of their photographic point of view.[58] They followed a working method that seems to have benefited them both. When Russell photographed the Mormon laborers digging a tunnel through a mountainside in Weber Canyon, Savage photographed alongside him.[59] When Savage could not attend the groundbreaking of the Utah Central Railroad, connecting Salt Lake City with the transcontinental railroad,

FIG. 22
Andrew Russell, *Mormon Family, Great Salt Lake Valley* (no. 131b), 1868. Albumen print, 10 × 13 inches. Yale Collection of Western Americana, Beinecke Rare Book and Manuscript Library.

Russell photographed the event and gave "one or two" negatives to Savage.[60] Russell also provided Savage with access to the Union Pacific work crews, and it's possible that Savage assisted Russell in gaining access to Mormon locations and subject matter. Savage was a prominent member of the Mormon community, and he may have introduced Russell to the Mormon family shown in *Mormon Family, Great Salt Lake City Valley* (fig. 22). Here, as they did many times, Russell and Savage set their cameras side by side, with Russell exposing a large format negative and Savage making a stereograph. Although it is possible that Russell made both the large format and stereograph, there is evidence to suggest that Savage gave Russell the stereographic negative. The image is rare on a Savage and Ottinger stereographic card, but an extant example is identical to the Russell stereograph in the Union Pacific series.[61] Such an exchange makes logical sense. Savage, with his studio in Salt Lake City, would not have needed a negative of a Mormon with three wives (the title of the stereograph); but Russell, with clients on the East Coast, would have found a market for its sensational subject matter.[62]

"IT IS FINISHED":
PHOTOGRAPHING THE PROMONTORY CELEBRATION

It is hard to imagine a more nondescript location for the celebration of one of the greatest engineering feats of the nineteenth century. Promontory was neither an established town nor an important railroad location; it was simply a plateau in the mountains north of a small peninsula that jutted into the Great Salt Lake. The land was high desert,

forty-nine hundred feet above sea level with mountains rising another thousand to fifteen hundred feet on three sides of a valley. The location had no water, and the night temperatures in May dipped well below freezing. Sagebrush and scrub cedar covered the desolate landscape. The "town" of Promontory was similar to many of the towns that sprang up to accommodate the railroad construction—a single street with canvas tents and rough board shacks. Nonetheless, this desolate spot was the location of America's first great media event, on May 10, 1869.

As the Central Pacific and Union Pacific neared completion, there was little thought given to a media celebration. In early 1869, competition for the government bonds that accompanied each mile of finished track continued unabated as each company pushed into Utah. The Central Pacific Railroad sent survey parties far beyond their track graders, to the mouth of Weber Canyon in Utah; the Union Pacific Railroad sent its engineers past the Central Pacific graders and west to Humboldt Wells in Nevada. Soon the companies were grading parallel track beds in Utah, while in Washington, D.C., Collis Huntington and Grenville Dodge engaged in furious lobbying efforts to certify their construction progress. For the first three months of 1869, threats, lawsuits, and lies characterized the relationship between the Central Pacific Railroad and the Union Pacific Railroad as each jockeyed to maximize its federal subsidies. Finally, on April 8, 1869, threatened with congressional action, Huntington and Dodge met in Washington to resolve the issue. After much haggling the two men agreed that the railroad would meet at Promontory summit (about fifty miles away from the end of the track of each company).[63] Congress quickly passed a joint resolution that ratified the agreement.

Who conceived the idea to celebrate the completion of the railroad is not entirely clear. Huntington was certainly not in favor of it. He wrote to the Central Pacific Railroad treasurer, Mark Hopkins: "Of course you will do as seems best to you about running an excursion train over the Central Pacific, but if it was left to me there would be no such train run. I have told all that have asked me when it would run that there would be no such train. They are expensive, and, besides that, do much harm and no good."[64] Huntington understood all such events through the lens of finance, and he could think of no financial advantage in celebrating the completion of the railroad. Worse, he feared that any publicity would bring unwanted attention to the corporation. It was far better to complete the railroad without fanfare.

Huntington was not alone in his dismissal of a formalized celebration of the railroad. Of the other members of the Central Pacific Railroad directorate—Leland Stanford, Mark Hopkins, E. B. Crocker, F. H. Miller, A. P. Stanford, and Charles Marsh—only Leland Stanford and Marsh attended the ceremonies. The others may have found the completion anticlimactic or, like Huntington, simply unnecessary. Stanford, however, felt differently. Stanford wanted national publicity and may have been encouraged by his wife's brother-in-law, David Hewes, who presented Stanford with a solid gold spike that he proposed be the ceremonial last spike of the transcontinental railroad.[65]

The celebration combined the immediacy of the telegraph, the voyeurism of pho-

FIG. 23

Alfred Hart, *The First Greeting of the Iron Horse. Promontory Point, May 9th, 1869* (no. 354). Albumen stereograph, 3½ × 7 inches. Crocker Art Museum, E. B. Crocker Collection.

tography, and the narrativity of newspaper prose. Twenty-seven journalists attended the ceremonies.[66] For those who were there, the event was modest in scope, but it was organized less for those who attended than for remote audiences. The Central Pacific built a temporary telegraph transfer station at the location of the last rail so that the strike of the hammer on the final spike would be instantaneously sent across the United States. Alfred Hart recorded the event for the Central Pacific; the Union Pacific Railroad brought two photographers to the ceremonies—Andrew Russell and C. R. Savage. Stanford and Durant planned a Saturday ceremony, and the Central Pacific Railroad sponsored elaborate programs in San Francisco and Sacramento. Furthermore, a Saturday ceremony ensured the companies maximum press coverage in the Sunday newspapers across the country. Pastors were given Leland Stanford's speech in advance, and many of them made the transcontinental railroad the subject of their Sunday sermons.[67]

The Central Pacific Railroad delegation boarded the train in Sacramento on Wednesday morning, May 5. The excursion included the Central Pacific Railroad president, Leland Stanford, selected railroad commissioners, the chief justice of the California Supreme Court, the governor of Arizona, a newspaper publisher, prominent citizens, and the company photographer, Alfred Hart.[68] Hart immortalized the arrival of the party at Promontory on May 7 in *The First Greeting of the Iron Horse. Promontory Point, May 9th, 1869*, a triumphal stereograph made from above the engine and wood car (fig. 23).[69] He had used a similar camera position for the first time in *Bound for the Mountains* (see pl. 2), and had repeated this compositional trope in several other Central Pacific stereographs, because it offered a panoramic perspective and gave the viewer the illusion of power, sitting above the locomotive, appearing to straddle the train as it whistled its arrival into the railroad camp. The elevation of the camera and the steam

rising from the whistle captured the jubilation of the excursionists after a two-day ride, but the faces of the workers in the bottom half of the image display no such jubilation. Their slumped shoulders and sullen expressions attest to the fact that for them the journey was just another day of arduous, physical labor. Shortly after his arrival, Stanford learned that the Union Pacific delegation had been delayed and that the ceremonies would have to be postponed.[70] With nothing to do, the Central Pacific passengers entertained themselves with trips to the Great Salt Lake and to Ogden.

Andrew Russell was still in New York in late April when Durant telegraphed his private secretary from Wyoming: "Cpt. Russell was to go west this week. He better not put it off if he proposed to photograph mountain scenery this spring."[71] A few days later, Silas Seymour, Union Pacific Railroad's consulting engineer, visited Salt Lake City photographer C. R. Savage and gave him ten dollars to photograph the ceremonies at Promontory.[72] It is possible that Seymour invited Savage in hopes of currying favor with Brigham Young and the Mormons, but it seems more probable that Savage was hired at Russell's suggestion. Because of his friendship with the Salt Lake City photographer, Russell may have seized the opportunity of the Promontory celebration to secure additional employment for Savage and to ensure maximum photographic coverage for the railroad. This supposition is supported by the fact that Savage photographed alongside Russell for most of the afternoon.[73]

The railroad companies had the foresight to provide rich media coverage, but they did not appreciate the power of the camera enough to stage the proceedings for photography. In most cases crowds blocked the photographer's line of vision and so all three photographers produced stereographs of a large crowd with their backs turned to the camera and pushing into the space between the two locomotives. Consequently, Hart, Russell, and Savage needed to represent what was largely invisible to them on May 10, 1869.[74] *The Last Rail—The Invocation. Fixing the Wire, May 10th, 1869* is an example of both problem and solution (fig. 24). Here, Hart photographs an amorphous crowd with no single action conveying a context for the event. The title, however, provides specificity and evokes the occasion of the Reverend Dr. John Todd's prayer at the beginning of the formal activities and the attachment of the telegraph wire to Stanford's spike hammer. The latter was particularly important to the mythological narrative that would grow up around the ceremonies at Promontory. The plan called for Stanford to tap the last spike, which would signal telegraph stations simultaneously across the United States of the unification of the country by railroad.

The ceremonies were interrupted once for the photographers to capture the important event on film. Russell and Savage lined up the railroad officials on the track between the two locomotives and moved their cameras far back from the rails to include as many participants as possible (fig. 25). *Laying the Last Rail, and Driving the Last Spike* was the most important photograph of the day for Russell and Savage. Made shortly before the driving of the last spike, it was captured on three different negatives.[75] It was the only subject that Russell made in both large and stereographic format, and it invites multiple

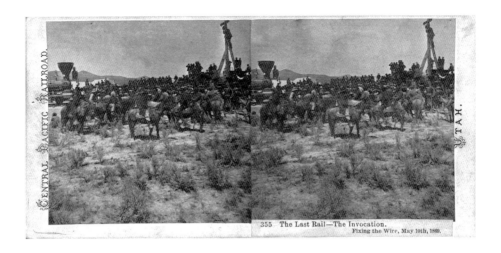

FIG. 24
Alfred Hart, *The Last Rail—The Invocation. Fixing the Wire, May 10th, 1869* (no. 355). Albumen
stereograph, 3½ × 7 inches. Library of Congress Prints and Photographs Division.

readings. The most obvious is its honorific role celebrating the railroad directors and
important officials. But it may also have served as a reminder of the theme of unity,
symbolized by the equality of representation. Both Union Pacific and Central Pacific
dignitaries, engineers, and foremen intermingle, standing level along the track, with
the last railroad tie lying in front of the assembly. From a practical standpoint, the large
number of individuals included in the image allowed the photographers to sell their
photographs as souvenirs to those who attended the ceremony. Consequently, the more
people included the better. Despite the attention Russell and Savage gave to this com-
position, it fails to deliver. The camera's leveling effect negates the honorific aspect of
the photograph. It makes the assembled crowd equal in stature, and one must strain to
find Stanford and Durant, notable for their presence in the front row center and because
a sledgehammer rests on Stanford's shoulder. The lack of individualization may also
have lessened the interest in purchase. Instead of offering specificity, this photograph
becomes a generic image of a crowd at a ceremonial occasion—albeit the completion of
North America's first transcontinental railroad.

When it came time to make his negative, Hart created a different, and ultimately
more successful, composition. He aligned himself and his subjects along the railroad
track and climbed onto a locomotive to elevate his camera, looking down on the partici-
pants and the Union Pacific locomotive, and providing a panoramic backdrop. For *The
Last Rail is Laid. Scene at Promontory Point, May 10th, 1869*, Hart pushed the crowds to
either side of the track, giving the photograph a more dynamic dimension and utilizing
the strengths of the stereographic medium to enhance depth (fig. 26). The crowd stand-
ing alongside the track serves as a faceless vector leading the eye back to the towering
locomotive and a small group of prominent friends and employees of the Central Pacific

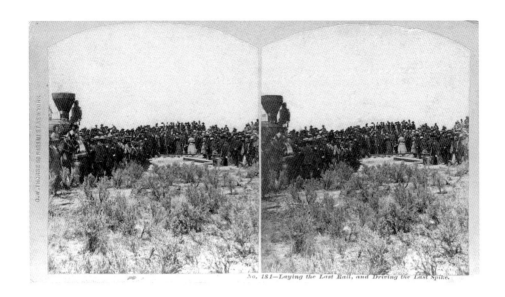

FIG. 25

Andrew Russell, *Laying the Last Rail, and Driving the Last Spike* (no. 181), 1869. Albumen stereograph, 3½ × 7 inches. Private collection.

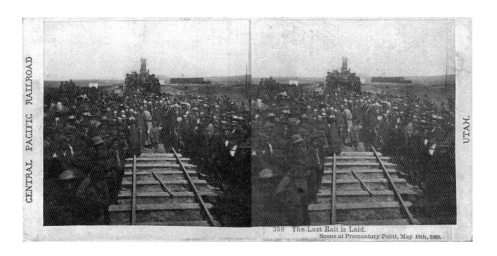

FIG. 26

Alfred Hart, *The Last Rail is Laid. Scene at Promontory Point, May 10th, 1869* (no. 356). Albumen stereograph, 3½ × 7 inches. Courtesy Barry A. Swackhammer Collection.

Railroad. At the apex of the perspective, in the center of the track, Stanford raises the silver-headed sledgehammer to signal his presence and, perhaps, to remind viewers of the driving of the last spike.[76]

The tick of the wire announcing the completion of the railroad set off celebrations in large cities throughout the Northeast and West. Thanks to the technology of the telegraph and the foresight of the organizers, for the first time in history, the citizens of the United States received word of an event as it happened. In New York, a one-hundred-gun salute announced the moment; in San Francisco cannons were fired; in Philadelphia the bells of Independence Hall were rung; in Chicago there was a huge procession, fireworks, and bonfires; in Buffalo a gong announced the driving of the last spike, prayers were offered, and a large crowd sang the *Star Spangled Banner;* and in Scranton cannons were fired, bells rung, and locomotive whistles blasted. In these, and many other locations, special religious services were conducted to offer thanksgiving for the success of the transcontinental railroad. Eastern press reports about the completion of the transcontinental characterized the railroad as a national and patriotic project rather than a corporate enterprise.

Russell and Savage continued to work long after the ceremonies concluded and the Union Pacific and Central Pacific Railroad officials had adjourned to enjoy the shade and champagne in their special passenger cars. The two men had spent the entire morning making formal portraits of the financiers and officials of the Union Pacific; now they turned their attention to the workers. *East and West Shaking Hands at Laying Last Rail* shifts attention away from the directors and politicians and to a more egalitarian conception of the transcontinental railroad (see pl. 1). As one of the last of the photographs that Russell made on May 10, 1869, it has an appealing sense of spontaneity. Calculated to convey the elation over unifying the East and West Coasts, *East and West Shaking Hands* displaces the differences that marked the years of construction and before. The two railroad engineers, Grenville Dodge of the Union Pacific and Samuel Montague of the Central Pacific, shake hands, a symbol of the unity of the two railroads and, by extension, of the country itself. This gesture would have been familiar, as it was a common visual trope in the period immediately following the war. J. L. Giles's lithograph *Reconstruction* is just one example of the handshake as a symbol of harmony and renewal (fig. 27).[77] Here the government is represented by a large circular canopy beneath which masses of people, all of whom appear to be shaking hands, gather. The roof is held up by columns representing the states. The bases of the Southern columns, "foundations of slavery," are being replaced by bases representing justice, liberty, and education. Everywhere figures representing the North and the South clasp hands in a sign of unity. This gesture becomes a sign of redemption when it is repeated in the clouds hovering above the earthly tumult.

In both print and photograph, the handshake may have been intended as a sign of harmony, but it was not so much a representation of a new unity as it was nostalgia. It is true that the two engineers shake hands, but they do so warily. Neither man smiles,

FIG. 27

John L. Giles, *Reconstruction,* 1867. Lithograph, 20⅞ × 25⅜ inches. Library of Congress Prints and
Photographs Division.

nor does Dodge face Montague; he turns away from his competitor, preferring to con-
front the camera. Above the engineers, the funnel-shaped smokestack of the Central
Pacific and the narrow stovepipe smokestack of the Union Pacific give physical form to
the tension of the handshake. These locomotives express the competition and hostil-
ity between the two companies—in technology, organization, construction technique,
corporate culture, and individual style. The Union Pacific and Central Pacific waged a
bitter competition for government subsidies during the years of construction, at one
point going so far as to grade parallel road beds and place dynamite charges close to rival
work crews. Reminiscent of the surrender of the Southern armies four years earlier,
the engineers' handshake signals a cessation of corporate hostilities, but it can hardly
conceal the smoldering animosity that remained.

This tension between Union Pacific and Central Pacific engineers indicates a dis-
tinction between the attitudes of the East and the West Coasts toward the railroad.
The golden spike that Stanford brought to the ceremony included the inscription: "May

God continue the unity of our country as this railroad unites the two great oceans of the world." The Reverend Dr. Todd's invocation at the ceremony called on attendees to "render thanks that thou hast by this means brought together the East and the West, and bound them together by this stronger bond of union."[78] For Americans on the East Coast, unity meant an opportunity to break with the past. Any concept of a bright and promising future demanded the erasure of the horrors of the Civil War and its challenge to American ideals of exceptionalism. The day after the laying of the last rail, the *Chicago Tribune* reported on the celebratory seven-mile procession: "It [the celebration] was free from the atmosphere of warlike energy and the suggestions of suffering danger and death which threw their oppressive shadow over the celebrations of our victories during the war for the Union. On the contrary it was full of the inspiration of peace and glorious in its promise of enlarged prosperity and happiness. It brought home to every mind that—'Peace hath her victories no less renowned than war.'"[79]

The *Chicago Tribune*'s comparison of the railroad completion ceremony with celebrations at the end of the Civil War is significant. For many Americans, the internecine destruction of the Civil War represented Americans' fall from grace. The successful construction of the transcontinental railroad, judged by most to be an impossible engineering feat, represented a sign of redemption. The contrast between the "prosperity and happiness" promised by the railroad, and the "danger and death" that cast its shadow over all aspects of American life during the Civil War, positioned the railroad as a change agent, a new inspiration, and a symbol of both redemption and future prosperity. The *National Republican* made the connection between the transcontinental railroad and the Civil War explicit in its report on the celebration in Philadelphia: "Joy was expressed in every face at the completion of the great work of the century. The sudden flocking of people to the State House reminded one of the reception of the news of the surrender of Lee's army, when a similar scene was enacted."[80]

On the West Coast, newspapers mentioned unification in reporting the ceremonies at Promontory, but few referred to the Civil War. Instead of looking back at the Civil War, Leland Stanford's speech at the ceremony outlined an imagined future of economic prosperity:

Gentleman—The Pacific Railroad Companies accept, with pride and satisfaction, these golden and silver tokens [spikes] of your appreciation of the importance of our enterprise to the material interests of the sections which you represent on this occasion, and the material interests of our whole country, east and west, north and south. . . .

The day is not far distant when three tracks will be found necessary to accommodate the commerce and travel which will seek transit across this continent. Freight will then move only one way on each track, and at rates of speed that will answer the demands of cheapness and time. Cars and engines will be light or heavy, according to the speed required and the weight to be transported.

In conclusion, I will add that we hope to do ultimately what is now impossible on long lines, transport coarse, heavy and cheap products, for all distances, at living rates to the trade.[81]

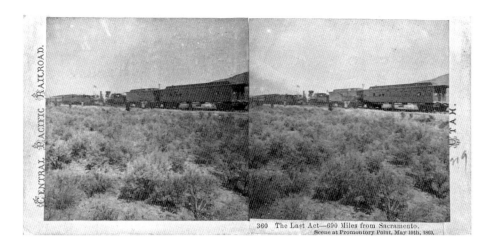

FIG. 28

Alfred Hart, *The Last Act—690 Miles from Sacramento. Scene at Promontory Point, May 10th, 1869* (no. 360). Albumen stereograph, 3½ × 7 inches. Courtesy Barry A. Swackhammer Collection.

As history has shown, the opening of the Suez Canal the same year meant that the promise of commerce between Europe and Asia was not fulfilled. Stanford's vision of the railroad as an engine of commercial profit was accurate for the men who owned the railroad, but not for many of the people living within its reach.[82]

Hart alluded to this commercial future in his stereographic coverage of Promontory. *The Last Act—690 Miles from Sacramento. Scene at Promontory Point, May 10th, 1869* captured what appears to be the moment when the two trains ceremonially moved back and forth across the track laid by the rival company, symbolizing the joining of the rails. His stereographic image, however, is ambiguous (fig. 28). The significant movement is frozen in time and place and relegated to the background, where the two locomotives that are at the center of the railroad narrative are tiny and barely distinguishable. The sky is blank, and the sagebrush in the foreground distracts the viewer from imagining the activity of the trains. In short, *The Last Act* has very little direct visual connection to the celebration at Promontory. What connection it does have with the events of May 10, 1869, is made in the title. *The Last Act—690 Miles from Sacramento* frames our understanding of the place and the event that signaled the railroad's completion. Unlike Russell, who celebrates the men who built the railroad, Hart celebrates the machines that will carry the commerce that Stanford described in his speech.

The railroad offered Americans on the East Coast a chance to transcend the past; it presented Americans in the West with an opportunity to envision a future of new economic prosperity and to embrace the past. The railroad promised to reconnect westerners to the friends, family, and a past that they had left behind when they moved west. J. D. B. Stillman articulated this social import of the railroad in the opening paragraph of his eyewitness account of the ceremonies at Promontory:

When we stood for the first time on the iron-bound shores of the Pacific a generation ago and looked upon their desolate mountains, after a voyage of more than half a year, we thought in our forlorn hearts that the last tie that bound us to our native land was broken. We did not dream that the tie that was to reunite us, and make this our native land forever, was then flourishing as a green bay tree in our woods; but even so it was, and here, in the month of May, it lay before us, a polished shaft, and whose alternate veins of light and shade we saw symbolized the varied experience of our California life.[83]

Punning on the word *tie,* Stillman asserts the value of the railroad as a bridge to friends and family in the East and to a past that had been forfeited. For Stillman, the speed and ease of the railroad erases the isolation and loneliness of western immigration.[84]

Hart captured the twin implications of the railroad during a Central Pacific excursion to the Great Salt Lake a day earlier. In *Poetry and Prose. Scene at Monument Point, North end of Salt Lake,* a line of wagons stretches across the center of the stereograph, curving slightly as it meets the train, contrasting the technologically sleek locomotive with the slow-moving awkwardness of the wagons (fig. 29). Although the image implies that the wagons are pioneer wagons, research indicates that they are wagons used by Central Pacific railroad workers and shippers.[85] The suggestion of an emigrant wagon train is clearly intentional, however. Hart's stereograph is about commerce, communication, speed, and ease of travel; his alignment of old and new technology represents the present, recalls the past, and suggests an idealized future. *Poetry and Prose* modernizes the conceit of Durand's *Progress*—America as a land of change—and updates it for the newly emerging corporate and industrial world.

The technological imperative, inherent in the composition of the stereograph, is dramatically cast by the title. *Poetry and Prose* marks this stereograph as an image of railroad mythology, not the hard-bitten reality of track-laying mileage and geographical distance found in most of the Central Pacific Railroad stereograph titles. Seeing both three-dimensional image and text in the same visual field established a relationship between the first word, *poetry,* and the first object, the wagons. Describing the wagon train as "poetry" suggests romantic nostalgia for a past that would soon be replaced by train travel. Characterizing the locomotive as "prose" implies the language of technology—straightforward, factual, and scientific. The combination of "poetry" and "prose" conveyed not only the nostalgic past and the technological present but also an implied future in which invention and machines would bring new commercial and social connections and would transform the American West and the nation.

The composition of *Poetry and Prose* carries other countermessages as well. Most obviously, the landscape does not invite any thoughts of local commerce. The salt lake, the dry land, and the stunted sagebrush all indicate an inhospitable landscape. In an even more troubling slippage, the train does not merely contrast with the earlier mode of transportation—Hart had captured that juxtaposition first in 1867, when he photographed a locomotive alongside a Wells Fargo stage coach—it stops the wagons from

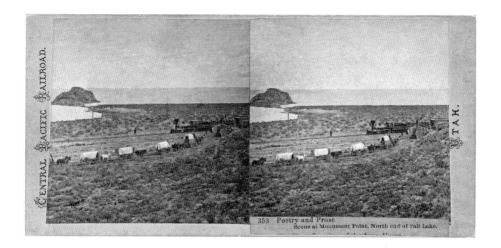

FIG. 29

Alfred Hart, *Poetry and Prose Scene at Monument Point, North end of Salt Lake* (no. 353), 1869. Albumen stereograph, 3½ × 7 inches. Library of Congress Prints and Photographs Division.

advancing. Viewers, then, can read this stereograph not only as a symbol of technological progress but also as an allegory for the monopolistic capitalism that the Central Pacific had begun well before the completion of the railroad, and which saw Huntington's railroads dominate rail transportation in the West throughout the nineteenth century. Crocker makes these intentions explicit and signals his frustration with Huntington's economic rapaciousness: "Now about controlling the Pacific end of all the railroads. It is a grand scheme, a big thing, but if we accomplish it, it will tie us down to slavish work the rest of our lives. The detail of our already immense business falls heavily on me, & I am breaking down under it. . . . The mental strain, & the lack of physical exercise will soon use me up, & then what good is it all."[86] In a rereading of *Poetry and Prose*, the term *poetry* includes nostalgia for an earlier, imagined age of simplicity and moderation. In this reading, the ceremony at Promontory was not the final act but only the latest skirmish in a monopolistic war over the control of rail commerce in the West.

PHOTOGRAPHY AFTER PROMONTORY

After the celebration at Promontory, Hart returned to Sacramento, but with the railroad completed, the Central Pacific added no new negatives to its archive. Russell, in contrast, remained in the West until fall, documenting the railroad landscape that he had failed to cover in 1868—from Omaha to Cheyenne and from Salt Lake City to Sacramento. Finding a flat, treeless landscape, Russell faced a much greater pictorial challenge than that encountered by Hart, who had the mountains as a backdrop. For his documentation of the railroad, he established a consistent pictorial formula. Whenever possible, he

elevated his camera to provide a panoramic scope and a sense of geographic space. This was not easy on the prairie alongside the Platte River in Nebraska. At Fremont, he set his camera on the third-story balcony of the Fremont Hotel. He climbed onto a railroad water tank at Columbus, Nebraska, and on top of the train in Cheyenne, Wyoming.[87] After presenting the town and the surrounding landscape from a distance, Russell photographed the buildings close up, placing his camera in the center of the main street and capturing the buildings on either side of the road.[88] He included noteworthy structures at each site—churches in Omaha, a girl's school in Fremont, a windmill in Columbus, a gristmill in Grand Island, the legislative halls in Cheyenne, a hospital in Laramie, and machine shops in Rawlings. Although Russell's stereographs are seemingly an objective report of the railroad route, an analysis of them shows how subjectivity can be located within the evidentiary.

The photographer's ostensibly objective description of the land in the West was framed by a subjectivity shared by Russell's railroad sponsors, who had been awarded alternate sections of land along the railroad right-of-way. Whereas Hart used titles such as *Advance of Civilization* (see fig. 42) to convey the idea of the railroad as a precursor to prosperity, Russell illustrated it literally in his photographic coverage. The distant perspectives Russell employed convey only minimal information about the towns or landscape. In many cases, the viewer must imagine the purpose of the buildings, the fertility of the land, and the ownership of the property. Despite the sometimes hundreds of miles between photographs, the sequence of Russell's stereographs makes these isolated railroad towns appear close together, populated, comfortable, and familiar.[89] Union Pacific advertising in the early 1870s used a similar approach, listing schools, hotels, offices, churches, court houses, and stores, among the building improvements in towns along the railroad.[90] The company needed to sell its land, and Russell's photographs of the towns adjacent to the railroad were an enticement to investors and emigrants.

This effort to convey the most positive perspective of the Union Pacific landscape was necessary to offset a public perception first articulated in Stephen Long's report earlier in the century, which characterized the land west of the Missouri River as the "Great American Desert." This description continued to be exploited by the enemies of the Union Pacific. In December 1868, the *Overland Monthly* published an article by Thomas Magee about a trip along the railroad route, in which he directly challenged Union Pacific publicity. He began by quoting a railroad pamphlet that characterized the land in glowing terms: "No finer land for agricultural purposes than this can be found. The soil is from three to ten feet deep, and wholly inexhaustible, so bountiful has nature been in her gifts." In contrast, Magee described the landscape more cynically: "Nebraska has nothing to boast of. Long droughts, grasshoppers, locusts, and distance from markets, make the immigrant's lot anything but what is above represented." In contrast to Russell's visual record, Magee represented the towns along the Platte as "hurried into existence by the railroad, and when it moved on, their sites—except in one or two instances where machine shops have been located—were as completely deserted

and almost as much given up to beasts of prey and the whoop of the savage as they were one hundred years ago."[91] Magee, on the payroll of the Central Pacific Railroad, created his written narrative to further the Central Pacific's interests, Russell's stereographs do the opposite.

Hart, Carbutt, and Russell each brought a unique approach to his subject matter. Hart created dramatic presentations of the railroad's struggle through the Sierra Nevada using a compositional approach that placed the railroad in the mountainous panorama but that did so in such a way that it showed railroad technology as a change agent, dissecting and organizing the landscape as it moved through the mountains. Representing the flat deserts of Nevada, Hart's stereographs depict the railroad bringing life to an otherwise sterile landscape and as a harbinger of European-American civilization. The only photographic project of the Union Pacific Railroad before 1868 was the documentation of a three-day excursion reserved for the press, politicians, and influential money managers in the Northeast. The stereographs of this trip appear to have been made as souvenirs, yet despite this limited intention, they served the Union Pacific for almost two years. In the spring of 1868, Andrew Russell began his photographic work in Cheyenne, Wyoming; he photographed the Union Pacific in stereography and large format for most of that year, documenting construction, work crews, and the settled landscape. He returned the next year to complete his photographic recording of the entire transcontinental railroad from Omaha to Sacramento. The agency of each of these photographers was a primary influence on their subject matter and the formal qualities of their images, but it was not the only influence. Each of these men enjoyed the patronage of the railroad and each sought to please his constituency. The desires of the Central Pacific and Union Pacific directors are located, in part, in the evidence of the curatorial control they exercised, or were unable to exercise, over their respective photographic archives.

3

CURATING THE ARCHIVE

Alfred Hart, John Carbutt, and Andrew Russell used formal means to present the railroad construction and to organize the mountains and high deserts of the North American West. They selected their subject matter, positioned their cameras, and composed their scenes. This production resulted in the creation of archives of extraordinary historical value. This process of archive creation, however, is exceptionally complicated and contested, in part because the archive cleaves the photograph from its circumstances of production and makes the image available for new interpretations. In addition to acquisition, archives require curation, and each of the two railroad companies used different means to curate their photographic archives. Both companies titled and sequenced the negatives, but Central Pacific selected negatives for purchase, while the Union Pacific did not. Because it owned the negatives, the Central Pacific had a greater ability to circumscribe photographic meaning than the Union Pacific had; but how the two companies exercised this power is open to question. The Union Pacific appears to have exercised its control through the agency of Andrew Russell, who, perhaps in consultation with the company, selected and published large format images in albums and titled and sequenced his stereographs. These curatorial archival efforts have affected the way we understand the photographic production and historical circumstances of the transcontinental railroad.

CENTRAL PACIFIC

The Central Pacific stereographs cannot be fully appreciated if we think of them as the result of only a single individual's practice; their visual and cultural force were the result

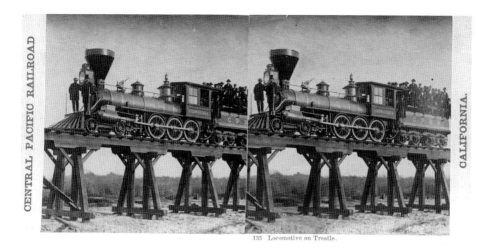

FIG. 30

Alfred Hart, *Locomotive on Trestle, near American River* (no. 135), 1865. Albumen stereograph, 3½ × 7 inches. Courtesy of the California History Room, California State Library, Sacramento, California.

of decisions by both photographer and client. A sense of the difficulty of unpacking these financial and social relationships can be glimpsed in the reportage of a March 1865 excursion on the Central Pacific Railroad (fig. 30). The company was celebrating recent state and federal government rulings by inviting leading citizens to travel the railroad to the end of the line.[1] The *Sacramento Daily Bee* reported the event:

> Yesterday afternoon, the new and powerful locomotive "Conness," bright and polished and with full armor on, left the shed at the corner of D and Sixth streets and backed down to the corner of I and Fourth. Here, the engineer extended an invitation for a number of persons who *happened* to be in that vicinity to get on and take a ride. . . . On returning, a slight delay was occasioned, in order that "our special artist," recently a Justice of the Supreme Court, might get the focus and take some stereoscopic views of the locomotives "Conness" and "C. P. Huntington," with their loads of human nature on board, as they appeared when crossing the American river bridge. The chemicals worked well and in a short space of time the "artist" waved his hat, the engineers rang their bells, the locomotives gave a grunt each, and off went the iron horse.[2]

Despite what the newspaperman wrote, Judge E. B. Crocker—the person referred to as "recently a Justice of the Supreme Court"—did not step behind the camera and expose the film. He did not "make" the photograph in the way we think of making photographs today. The reporter credited Crocker with "taking" the image because he employed the photographer and, perhaps, because he selected the subject.[3]

Crocker's rise to the Central Pacific Railroad's directorship had been rapid. He had

moved to California from Indiana in 1852 after his defense of a fugitive slave family.[4] Through Crocker's efforts the family was freed, but he was sued by their owner and forced to pay damages. With this financial setback and the premature death of his wife, Crocker left South Bend and joined his younger brother Charles in Sacramento. There, he was among the founding members of the Republican Party in California, and, when Republican candidate Leland Stanford was elected governor in 1863, he rewarded Crocker with an appointment to the California Supreme Court.[5] Crocker was an extremely active justice, writing opinions for more than two hundred of the two hundred and fifty cases heard during his eight-month stint on the bench. When his term expired, he chose not to run for election to the Supreme Court; instead he became the attorney for the Central Pacific Railroad and was named to the board of directors a year after his brother, Charles, resigned to take over as construction manager of the railroad.[6] E. B. Crocker's attention to detail and the work ethic that he displayed as a Supreme Court justice made him ideal for the Central Pacific. He represented the company in legal disputes, certified government bonds, and negotiated settlements with local landowners. In addition, Crocker handled corporate acquisitions, advised Huntington about political appointments and construction details, and attended to public relations. It was while pursuing the latter duties that he became involved with photography.

Teasing out the incongruous aspects involved in the creation and care of the Central Pacific photographic archive is difficult. The first payment the Central Pacific made for photographs was in March 1865, when it paid William Dickman forty dollars "for making one view of bridge across American River" and "one view of Bloomer Cut."[7] Dickman was an experienced photographer who had begun his practice in Sacramento as a daguerreotypist in 1856, but he was primarily a portrait photographer and never listed himself as a maker or seller of stereographs. Furthermore, forty dollars was far too great for two stereographic negatives, which were usually priced at four or five dollars. Perhaps he was paid for large format negatives, but there are none extant. It is not clear how Dickman secured this single commission to photograph the Central Pacific, or why he never worked for them again. In the summer of 1865, Crocker purchased ten sets of railroad stereographs and a large, black-walnut, tabletop stereographic viewer from the San Francisco publishers Lawrence and Houseworth.[8] In January 1866, Crocker began the creation of the Central Pacific photographic archive, purchasing first thirty-two glass plate negatives from Alfred Hart and, later in the month, fifteen negatives from Lawrence and Houseworth. Given the number of duplicate and variant negatives of the railroad, published by both Hart and Lawrence and Houseworth, and the fact that neither George Lawrence nor Thomas Houseworth was making photographs in 1865, it seems likely that Hart was the photographer of both sets of negatives. But whatever the attribution of the Lawrence and Houseworth negatives, by the summer of 1866 Crocker had settled on Alfred Hart as the Central Pacific's company photographer and purchased negatives directly from him for the next three and a half years.[9]

The question of why the Central Pacific limited the archive to stereography is open

to speculation. Stereographs were small, inexpensive to print, easily transportable, and their mounts could easily be used as vehicles for advertising. Anyone handling a stereograph from the Central Pacific would see the corporate name, Central Pacific Railroad, printed in bold letters on the left edge of the mount. The number and title of the individual image was printed on thin paper stock and pasted beneath the right half of the stereoscopic pair. This placement made the title an integral part of the viewing experience. The back of the stereographic mount reinforced the railroad's authority: "Photographed and Published for the Central Pacific Railroad Company" was printed in letterpress and framed within an elaborate border.[10]

While there were practical reasons for the railroad to favor the stereograph, the aesthetics and reception of stereography may have also been important to the Central Pacific. An album of thirty photographs could be comfortably seen in five minutes; a set of thirty stereographs took at least twice as long to examine. One lingered on the stereoscopic image.[11] Oliver Wendell Holmes described looking at a stereograph as "the mind feel[ing] its way into the very depths of the picture." He characterized the mesmerizing effect of stereographic viewing this way: "At least the shutting out of surrounding objects, and the concentration of the whole attention which is a consequence of this, produce a dream-like exaltation in which we seem to leave the body behind us and sail away into one strange scene after another."[12] Holmes's description suggests that viewers would have lingered inside the stereographic hood, reveling in the dramatic spatial recession. Hart's preference for panoramas and his dramatic compositions reinforced the tendency of prolonged examination.[13] The *Sacramento Daily Bee* humorously reported on one man's encounter with Hart's stereographs: "Last night, in this city, a little fellow was looking through a stereoscope at a lot of California views, when by and by he came to that which represents the Bloomer Cut on the Pacific Railroad. He held it to his eyes a long, long time, when those around wondered why he dwelt so extensively on that one, asked him, and he answered, 'I am waiting for the cars to come along.'"[14] For cost, ease of transportation, ability to advertise, and the extended attention that the images encouraged, stereography was the ideal format for the railroad company.

The Central Pacific's photographic archive represents a selection from a larger production of negatives depicting the railroad. There are whole categories of subject matter that could have been included in the photographic archive but were not. Long before the railroad was completed, the Central Pacific was already planning an extension to San Francisco, but none of Hart's negatives of the city were included in the archive. Neither were negatives of Yosemite and the Calaveras Big Trees, although these were major tourist destinations. Even a stereograph of the Central Pacific Depot in Sacramento was rejected and a variant sold instead to Lawrence and Houseworth. The Central Pacific purchased stereographs that conveyed a message of progress in the railroad construction; it disregarded other subject matter and suppressed any images that might suggest the difficulties of construction.

Selecting particular stereographs allowed Crocker and others to inspect the advance

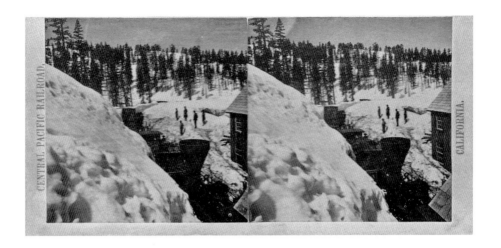

FIG. 31
Alfred Hart, *Snow at Cisco in month of May* (no. 608), 1867. Albumen stereograph, 3½ × 7 inches.
Union Pacific Railroad Museum.

of the railroad through the Sierra Nevada in the privacy of their offices, but the images also had a public role conveying the railroad's progress. Balancing these two aspirations could, at times, be challenging. One example of the conflict between the private and public can be seen in Crocker's communication with Huntington regarding the snow level in the Sierra. The heavy snowfall in the mountains was one of those awkward details that the railroad preferred to suppress publicly. In *Snow Plow at Cisco, in the month of May,* the snow towers over the train, and the tiny figures standing near the station house, the train at their feet, give a vivid sense of the depth of the problem (fig. 31). Crocker apprised Huntington:

> I send you a few stereocopies of some snow views taken at Cisco. The artist went up & took them while I was absent. *I shall not of course have any printed.* But I thought it safe to send you specimen copies. You have a good view of our largest sized snow plow, standing with 3 engines behind it near a passenger depot at Cisco. . . .
>
> The snow is now melting off rapidly, but it is still too deep to work on the line above Cisco. If the present warm weather continues it will soon be ready to put on the men. We hoped to have got on 2 or 3 weeks ago, but it was not possible, & it will be 2 or 3 weeks from now before we can. So it will be impossible to send you that report of finished work between 74 & 94 by the time I wrote before. & I hardly dare fix the time now.[15]

Crocker did not purchase or print these negatives, but he wanted Huntington to appreciate the difficulties the company faced in the Sierra. Crocker's comment that he "thought it safe" to send them to Huntington demonstrates his belief that the railroad needed to

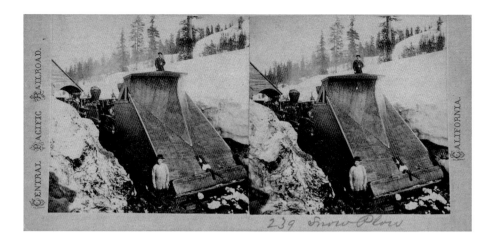

FIG. 32

Alfred Hart, *Snow Plow, at Cisco* (no. 239), 1867. Albumen stereograph, 3½ × 7 inches. Library of Congress Prints and Photographs Division.

exercise its power to control access to the archive and to certain facts about the Sierra Nevada and the railroad construction.

Huntington valued the images in part because they created a visual profile of the Central Pacific Railroad for men who had never been to California and who had never seen the construction. But to show the deep snow over the summit would have run counter to the photographic archive's messages of progress by raising concerns about the ability of the Central Pacific Railroad to complete the project expeditiously and to keep the line open during the winter months.[16] In fact, the only stereograph of the deep snow that Crocker included in the archive depicted a locomotive and snowplow. In an effort to exaggerate the plow's strength and power, Hart posed a Chinese workman next to it and another figure above and behind the plow (fig. 32).[17] On the left, the snowbank slopes away from the track to reveal a line of locomotives ready to push the huge steel wedge forward. This positioning of the camera creates an image that implies the locomotives and snowplow had cleared the track and that technology could overcome the threat of bad weather. The latter implication was demonstrably not true. In fact, winter closed the railroad so often that the Central Pacific had to build extensive wooden tunnels, called "snow sheds," to keep the track open, and yet still the railroad would sometimes be inaccessible in bad winter weather. Huntington even suggested Crocker not share information about the construction of these wooden tunnels for fear of increasing investor concerns.[18]

There were, however, limitations to Crocker's ability to manipulate the photographic record. He could manage the photographs owned by the railroad, but he could not

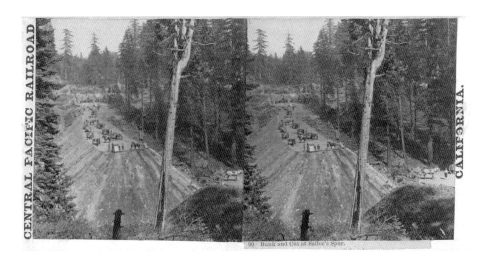

FIG. 33

Alfred Hart, *Bank and Cut at Sailor's Spur. 80 miles from Sacramento* (no. 90), 1866. Albumen stereograph, 3½ × 7 inches. Private collection.

control other outlets for Hart's stereographs. Some of the negatives Hart made of the Central Pacific construction were sold to Lawrence and Houseworth, who printed and marketed them from their store in San Francisco. For example, Thomas Houseworth and Co. published one of Hart's negatives from the trip to Cisco as *Upper Cisco in Winter, altitude 5911 feet, Central Pacific Railroad.* In this photograph, Hart moved farther away from the train station to capture the town of Cisco engulfed in snow. No locomotive can be seen, but the snow is as high as the rooftops. Fortunately for the Central Pacific Railroad, Houseworth's clientele was primarily local and regional. Unlike Houseworth and Co.'s patrons, the East Coast and European investors whom Huntington hoped to influence would have been unaware of the snow level in the Sierra Nevada.

A suggestion of the subtlety of the pictorial qualities of the photo archive, the interplay between the agency of the photographer, and the authority of archival curation can be seen in a comparison of two photographs made of a large cut-and-fill in the Sierra twenty-five miles below the summit. Crocker purchased *Bank and Cut at Sailor's Spur. 80 miles from Sacramento* for the Central Pacific archive, while a wide-angle variant, *The Cut and Fill—at Sailor's Spur, 12 miles above Alta,* was sold to Thomas Houseworth and Co. (figs. 33 and 34). In both stereographs, Hart elevates his camera, characteristically choosing a dramatic, panoramic perspective. This positioning embeds the railroad project in the landscape, conveys the adversity the company faced in the Sierra Nevada, and calls attention to the reconfiguration of space by the railroad, as work crews systematically moved earth to bridge a wide Sierra ravine. The fir tree on the left and the dead tree trunk in the center of the frame provide a foreground plane for stereographic

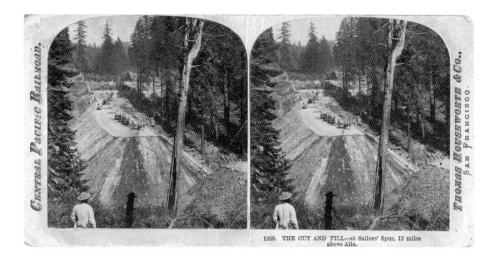

FIG. 34

Thomas Houseworth, *The Cut and Fill—at Sailor's Spur, 12 miles above Alta* (no. 1098), 1866. Albumen stereograph, 3½ × 7 inches. Courtesy of the California History Room, California State Library, Sacramento, California.

vision and exaggerate distance, while the wide swath of open space in the center of the image leads the viewer's eye along the earthen fill in the middle ground to the terraced cuts in the background. The depth in the stereograph makes the embankment and line of workers appear like ants working inexorably to bridge the gap.

Photographs like *Bank and Cut at Sailor's Spur, 80 miles from Sacramento* served multiple purposes for the railroad, conveying the monumental scale of the undertaking and proffering a future in which the embankment in the lower right corner would soon meet the earthen platform in the center of the image, creating a smooth roadway for the railroad through the Sierra. The selection of this particular negative suggests a curatorial attention that went beyond the strictly informational. In the Houseworth and Co. negative, *The Cut and Fill—at Sailor's Spur,* a figure in the lower left becomes a surrogate for the viewer. His presence anchors the spectator on a ridge above the workers. *Bank and Cut at Sailor's Spur,* on the other hand, is not as sure-footed. The Central Pacific stereograph constructs the railroad work as a spectacle and the disembodied viewer as an authority.[19] Being visually suspended in an indeterminate space overlooking the construction produces a sensation of power and total visibility for the spectator, because nothing appears to be hidden from this bird's-eye view.[20]

One of the payment vouchers states explicitly that it was Crocker who selected negatives for purchase, but we do not know if he made all the subtle choices between variant negatives.[21] In fact, it seems likely, given Crocker's workload and Hart's responsibility for the negatives, that in the case of seeking subtle distinctions like those evident in *Bank and Cut at Sailor's Spur,* it was the photographer who chose which negatives to offer to the

railroad attorney and which to pass along to Lawrence and Houseworth. It seems unlikely, however, given the importance of the stereographs in forming the public and private presentation of the company, that Crocker would have ceded this task entirely to Hart. In particular, orders regarding the precise locations, sizes of the railroad structures, depths of the cuts, and distances from Sacramento must have been supplied by the railroad company. What Crocker's letters and the evidence of the vouchers seem to indicate is that the curatorial responsibility for the photographic archive was a shared undertaking.

Curation of the archive attempted to control the meaning of the stereographs in a variety of ways: first through selection of the negatives and, later, with titles. After a negative was purchased by the Central Pacific, printed, and mounted on Central Pacific card stock, it was given a number and a title, which were printed on a separate piece of paper, cut out, and glued beneath the right half of the stereograph. To understand the impact a title can have, one need only consider an earlier printing of the negative *Bound for the Mountains, 12 mile tangent—4 miles from Sacramento* (see pl. 2) Before its acquisition by the Central Pacific, this negative was printed for Lawrence and Houseworth and titled *Central Pacific Railroad—twelve-mile Tangent, From Top of Locomotive.* This prosaic description highlights subject matter and the location of the photographer.[22] In contrast, the Central Pacific's title, by giving the train a destination and the number of miles to the mountains, engaged the viewer's imagination and characterized the transcontinental railroad project as direct and progressive. The title, *Bound for the Mountains,* conveys the railroad's sense of resolve, and the image itself presents practical information for investors who would have been pleased to see that the first sixteen miles of railroad were level and straight.

This representation of the landscape outside of Sacramento and the train's ability to reach the Sierra Nevada swiftly was not the original intention of the railroad. In 1863, Collis Huntington, vice president of the Central Pacific, lobbied to redefine the western base of the Sierra Nevada. Earlier court decisions had placed the beginning of the mountains twenty-two miles east of Sacramento, but the Central Pacific, well aware of the greater subsidy for construction in mountainous terrain, wanted to see the foot of the mountains set farther west. The precise location was critical because the Pacific Railroad Act offered loan guarantees of sixteen thousand dollars per mile for construction on flat land and forty-eight thousand dollars per mile in mountainous terrain. Leland Stanford, who was both the governor of California and president of the Central Pacific Railroad, sent the state geologist, Josiah Whitney, to accompany the railroad's attorney, E. B. Crocker, to certify a new origin of the Sierra Nevada and establish a basis for the railroad to challenge the court's ruling.[23]

Whitney, as expected, sided with the Central Pacific and argued that the base of the mountains began approximately seven miles east of Sacramento. Under pressure from the California congressman A. A. Sargent, and with the surveyor's reports in hand, President Abraham Lincoln, in 1863, signed an order setting the base of the Sierra Nevada seven miles east of Sacramento. *Bound for the Mountains* demonstrates the exag-

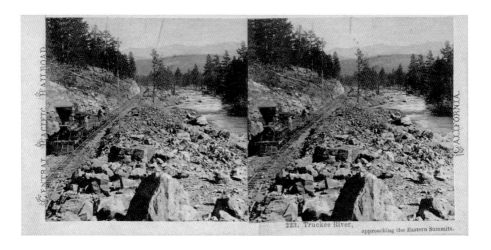

FIG. 35

Alfred Hart, *Truckee River, approaching the Eastern Summit* (no. 223), 1868. Albumen stereograph, 3½ × 7 inches. Library of Congress Prints and Photographs Division.

geration of the railroad's claim; but by 1865, it was too late to change the presidential order and, besides, the photograph was not meant for government officials. With higher federal loan guarantees assured, railroad executives turned their attention to private investors, who preferred to see a railroad built on land flat enough to allow trains to gain momentum for the climb into the mountains. *Bound for the Mountains* showed the perfect railroad landscape leading up to the Sierra, and the perspective chosen by the photographer gave viewers a sense of being carried by technology into the mountains and eastward.

A metaphoric title like *Bound for the Mountains* was not customary in the Central Pacific photographic archive. Much more common were titles that conveyed valuable information to investors, government officials, and creditors. For example, without its title, *Truckee River, approaching the Eastern Summit* is a generic photograph of a locomotive in a rocky landscape alongside a mountain stream (fig. 35). The title's modifying phrase *approaching the Eastern Summit,* however, conveys key information about the location of the locomotive on the eastern side of the lake. Halted by the difficult process of tunneling through solid granite west of Donner Lake, and desperate for funds, the railroad had carried construction materials and a locomotive over a wagon road in order to begin construction on the other side of the western summit. The stereograph and title demonstrate the success of that effort and carry the implication of impending advancement beyond the Sierra Nevada. Although this was the only locomotive available on this isolated section of the railroad, the seemingly infinite line of track curving into the distance encourages viewers to imagine that trains like this one will be soon be traveling down the mountain onto the flat deserts of Nevada.

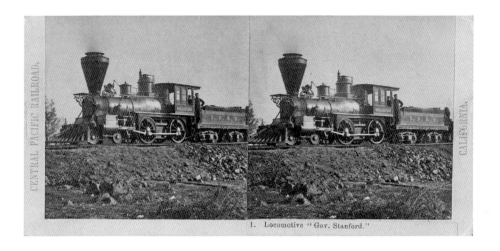

1. Locomotive "Gov. Stanford."

Alfred Hart, *Locomotive Gov[ernor] Stanford, No. 1* (no. 1), 1865. Albumen stereograph, 3½ × 7 inches. Crocker Art Museum, E. B. Crocker Collection.

The majority of titles, however, employ the precise language of science to frame stereographic viewing, locating the scenes a certain number of miles from Sacramento or at a precise elevation. They use the logic of measurement to locate the railroad within the landscape—fragmenting, dissecting, and measuring.[24] Buildings and bridges are scaled, cuts and embankments carefully measured. Sometimes this happens in a single stereograph, as in *View from Crested Peak, 8,500 ft. alt. Donner Lake 1,500 ft. below. R. R. 1,000 ft. below.* At other times the accumulation of information from adjacent stereographs of the same site, such as *Summit Tunnel, before completion—Western Summit— Altitude 7,042 feet* and *East Portal Summit Tunnel, Western Summit. Length 1,660 feet* is used to convey details about the Central Pacific construction. For the most part, this type of attention was unique to the Central Pacific titles. The title for the Hornet Hill Cut—*Hornet Hill Cut, West of Gold Run. 50 feet deep*—offers facts about the size of the cut: fifty feet deep. This information is absent from the Lawrence and Houseworth title of a variant stereograph, *Hornet Hill Cut, Central Pacific Railroad, near Gold Run.* Construction details were critical for the Central Pacific Railroad, but not for the general public that patronized Lawrence and Houseworth. The Central Pacific titles build on the visuality of the stereographs, relying on the public perception of photographs as truthful copies of reality, calling attention to facts and data not available in the images, and using the authority of scientific measurement to reinforce the photographic messages.

Because he housed and managed the Central Pacific negatives, the photographer may have given them inventory numbers, with Crocker's approval. In most cases, especially in the early years of the construction, the sequences are geographical and logical; but by 1868, the organization became fragmented. In 1866, the first thirty-two negatives in the archive visually dissect the foothills at the base of the Sierra Nevada and offer the viewer

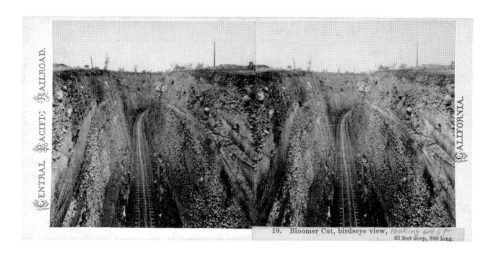

10. Bloomer Cut, birdseye view, *looking west*
63 feet deep, 800 long.

FIG. 37

Alfred Hart, *Bloomer Cut, birds eye view, 63 feet deep, 800 long* (no. 10), 1865. Albumen stereograph, 3½
× 7 inches. Library of Congress Prints and Photographs Division.

a traveler's inspection of the finished railroad. They are arranged geographically, begin-
ning thirty-one miles outside Sacramento, in the town of Newcastle, and ending thirteen
miles east, in Clipper Gap. A monumentalized portrait of the railroad's first locomotive,
Locomotive Governor Stanford, No. 1 opens the Central Pacific stereographic series (fig.
36). The locomotive, silhouetted against a blank sky, fills the frame and dwarfs the trees
on the left edge. An engineer leans out from the cab, small but in a commanding pose,
his hand resting on his hip, clearly in charge. This portrait of man and machine estab-
lishes the context for the stereographs that follow. The second photograph is another
portrait of technological power. In this case the photographer has moved away from the
track and placed the locomotive in the context of the immense Newcastle trestle. Loco-
motives physically and conceptually dominate the first two stereographs—as a close-up,
iconic, technological presence, and as a master demonstrating the trestle's reliability.

The remaining photographs in the series look toward the Sierra Nevada, propel-
ling the viewer along the thirteen miles of completed railroad, with stops to inspect
cuts, embankments, and track. Just as the Newcastle trestle demonstrated one type of
construction performance, Bloomer Cut displayed the company's ability to make deep
cuts into the mountainside. Using as many as five hundred kegs of blasting powder per
day, laborers gouged an excavation through sixty-three feet of concretized rock so that
the railroad could maintain the curve and slope necessary to sustain the speed of the
locomotive and to meet the requirements of government regulators.[25] The photographer
captured the success of this effort in an unprecedented seven stereographs (the only
time a Central Pacific photographer made more than four images of a single location),
taken from a variety of locations. One of the most dramatic was *Bloomer Cut, birds eye
view, 63 feet deep, 800 long* (fig. 37). Here, Hart balanced his camera on a water flume

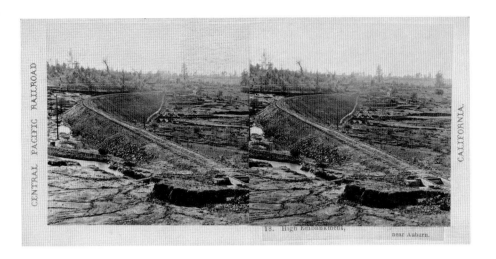

FIG. 38
Alfred Hart, *High Embankment, near Auburn* (no. 18), 1865. Albumen stereograph, 3½ × 7 inches.
Library of Congress Prints and Photographs Division.

that stretched across the open space of the cut, a viewpoint that exaggerates the depth of the excavation, highlights the hard, rocky earth through which it had been made, and centers the track so that it rushes away from the viewer and curves into the deep space of the image.

In addition to capturing the negative space of the cuts, Hart also photographed the earthen fills that maintained a level running surface for the rails. *High Embankment, near Auburn* shows the track as it leaves a deep cut, crosses an earthen embankment, and curves gently into the spatial depth of the image (fig. 38). As the eye moves into the stereographic space, the viewer perceives the gentle slope of the track. The title refers to these mounds of earth as "embankments" rather than "fills," the term preferred by the Union Pacific Railroad. The latter describes the process of moving earth into a valley to create a level surface for laying ties and track, whereas *embankment* calls attention to the effect of the earthen mound, not its construction; it invites visual inspection of the finished platform—the height, width, and slope of the completed fill.

These first thirty-two Central Pacific Railroad stereographs stress the quality of construction.[26] The pairing of distant and close-up views of bridges and trestles allows the viewer to see the structure in its topographical context and examine in detail the workmanship of the railroad crews.[27] *Rock Cut, near Auburn, Placer County* documents the regularity of the railroad ties, the smooth horizontality of the rails, and the substantial support of the ballast surrounding the recently laid track (fig. 39). Reassurance was needed for several reasons. Few could visit the construction sites, and the information available in the press was not always positive or reliable. Questions of sustainability were critical for East Coast investors, who feared slipshod construction techniques would be

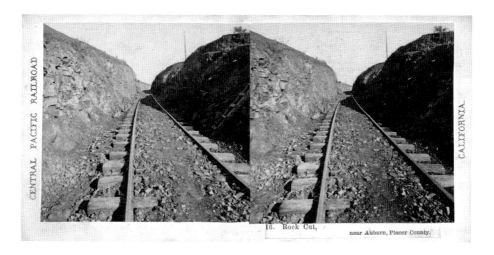

Within the image:
CENTRAL PACIFIC RAILROAD
CALIFORNIA.
16. Rock Cut, near Auburn, Placer County.

FIG. 39
Alfred Hart, *Rock Cut, near Auburn, Placer County* (no. 16), 1865. Albumen stereograph, 3½ × 7 inches. Library of Congress Prints and Photographs Division.

used in an effort to increase the track mileage and maximize government-sponsored financing. The Union Pacific Railroad had been accused of such hasty and shoddy railroad building. Furthermore, the directors of the Central Pacific Railroad could not point to any railroad experience. Charles Crocker, Collis Huntington, and Mark Hopkins sold hardware; Leland Stanford was a politician, and E. B. Crocker a lawyer.[28] Investors wanted proof that these men could manage the construction of a railroad and were capable of completing the project. Stereographs such as *Bloomer Cut, birds-eye view, 63 feet deep, 800 long; High Embankment, near Auburn;* and *Rock Cut, near Auburn, Placer County* provided evidence of what they had accomplished and testified to the high quality of the construction methods.

The stereographs announced details about the railroad construction, but they also went beyond the prosaic and engaged the imagination of the viewer by suggesting a space beyond the image.[29] The photographer made the most of the stereographs in this sequence by placing the camera above the cuts and fills that had reshaped the earth. From this position the viewer could see the topography, the railroad's direct line, and the gentle upward slope of the track moving across the picture plane and into the deep space of the foothills. The panoramic position of the viewer above the track imparted a sense of progressive movement around the next curve and into the next cut in the hillside. The solitary viewing of stereographs, their seemingly infinite representation of space, and their careful sequencing, conveyed a sense of travel and an opportunity to examine every cut, embankment, and trestle between Newcastle and Clipper Gap.

The sequence ends with *View above Clipper Gap, Placer County* (fig. 40). Here, the photographer positioned the camera high above the track and focused downward to fill

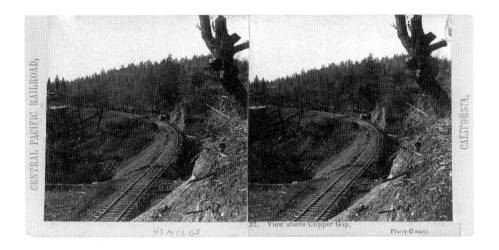

FIG. 40

Alfred Hart, *View above Clipper Gap, Placer County* (no. 32), 1865. Albumen stereograph, 3½ × 7 inches. Union Pacific Railroad Museum.

the frame with a curve that moves from the foreground through cuts and fills and into deep space. The foreground tree, its limbs hacked off by railroad workers, is reminiscent of the blasted-tree iconography in the landscape paintings of Thomas Cole and Asher Durand. When viewed in a stereographic viewer, the tree dramatically occupies its own space, apart from the mountains and the railroad, its destruction the result not of natural calamity—lightening, rot, or old age—but of railroad crews sawing limbs for ties or fuel for the voracious locomotives. As the final image of the series, *Clipper Gap, Placer County* reminds viewers of the resources of the Sierra Nevada and of the railroad's ability to harness them, radically altering the land to meet the needs of technology. These first thirty-two stereographs mapped, grounded, and composed the railroad space in the foothills from Newcastle to Clipper Gap and demonstrated the ability of the company to build a high-quality railroad over difficult terrain.

The first thirty-two stereographs appear to have been deliberately sequenced to represent a trip from the Newcastle station to the end of the rail line. Most of the archive, however, was more loosely organized. The Central Pacific stereographs reduced the scale of the massive Sierra Nevada and represented it in manageable units. The arrangement of the stereographs into geographical progression helped tell the railroad's story of landscape organization and construction progress, and it supported the truth-value of the archive. Each year the stereographs began at a western terminal and moved methodically eastward. In 1866, for example, the series opened at Colfax, a major staging area for construction supplies. Once again, Hart and Crocker foregrounded technology, opening the year with a stereograph of a locomotive optimistically named the "Nevada." From Colfax, the one hundred new stereographs are organized geographically to the

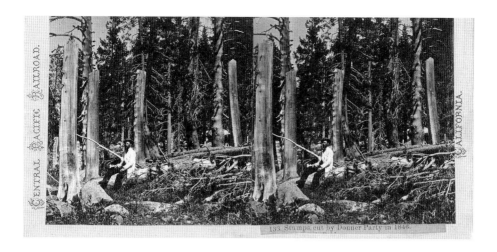

FIG. 41

Alfred Hart, *Stumps cut by Donner Party in 1846, Summit Valley* (no. 133), 1866. Albumen stereograph, 3½ × 7 inches. Union Pacific Railroad Museum.

western summit above Donner Lake. That year's sequence ends with a curious picture of a man seated beneath tall trunks of dead trees.

This unusual stereographic conclusion provides no hint of the railroad; nor is it a picturesque image of the grandeur of the Sierra Nevada. Instead, *Stumps Cut by Donner Party in 1846, Summit Valley* reminded viewers of the terrible power of unbridled nature (fig. 41). The hulking, dormant stumps are all that remain of the trees cut for firewood by members of the wagon party that was stranded in 1846. Their height marks the depth of the snow at the summit and reminds viewers of the horrible deaths of the Donner Party and of the others whose lives were lost in winter storms.[30] This uncanny image seems an odd place to end the archival sequence. There was, after all, a danger in reminding viewers, particularly on the East Coast, about the depth of the snow at the summit of the Sierra, but for the railroad it was worth the risk. The story of the emigrant wagon train and the fate of the travelers, many of whom died of starvation or exposure, was appropriated by the railroad archive. Coming at the end of the construction sequence, the railroad's organization and implied control over this previously dangerous landscape is the implicit narrative of the geographical journey along the railroad's route. The organization of the photographic archive replaced the story of the Donner Party's tragedy with a narrative of technology's success in controlling this forbidding landscape. This placement contrasts sharply with the facts on the ground, where it appeared that the railroad might end in failure as construction was stalled by the granite cliffs above Donner Lake.

While it is informative to analyze individual stereographs, the force of communication resides more in their cumulative effect than on a specific juxtaposition or progres-

sion of images. This is particularly evident after 1866, when the yearly sequences are not organized in chronological order by either the date of the negative or the date of purchase. The 1866 series, for example, is followed in the archival sequence by the set of stereographs made in 1865 and purchased from Lawrence and Houseworth.[31] The 1867 stereographs begin again in Colfax, but this time rather than a locomotive the first two stereographs offer panoramic views of the railroad town, one from the east and the other from the west. The sequence then moves into the mountains, to the new railhead at Cisco, to the construction at the summit, and briefly, to the railroad east of Donner Lake. As is appropriate for their role as devices of oversight, many of the sixty images that comprise this sequence document the unfinished tunnel construction at the western summit. The remaining twenty-six stereographs from 1867 are a mélange of subjects just south of Cisco and of bridge and track construction along the Truckee River near the eastern summit. The latter may be an update of the earlier sequence that did not include bridges or track on the Truckee. The series ends with a quick return, via five stereographs, to Sacramento and the railroad wharves where supplies, such as iron rail that Huntington ordered from the East Coast, would have been off-loaded to waiting trains.

By 1868, Crocker's letters to Huntington were preoccupied by Huntington's demands that they push the construction forward more rapidly, by Crocker's requests for more iron and heavy locomotives, and by their mutual schemes to construct a southern trans-continental railroad route and control all the railroads west of the Rocky Mountains. A rare mention of stereographs indicates that they continued to be effective in reassuring Huntington:

> I have sent you a large lot of stereoscopic pictures packed in a box & sent by Wells Fargo & Co.'s Express.
>
> I inclose [sic] herein statements of distances on the line of our R.R. Post them on a card paper & keep it on your desk, & it will be handy to refer to. . . .
>
> Mr. Magee has just got in from Overland trip. He talks plain about the miserable character of the U.P.R.R. I suppose you will see his letters in the *Herald* & *World*.[32]

Despite a dearth of references to the stereographs in the correspondence, the Central Pacific Railroad added 103 negatives to the company's photographic archive in 1868. After a few randomly organized stereographs, the series is a compendium of railroad progress beginning about twenty miles from Sacramento at the railroad engine house in Rocklin. From there, it proceeds geographically into the Sierra Nevada, where the stereographs record the construction of snow coverings and follow the track along the Truckee River past the state line and into Nevada, ending at the construction camps near Humboldt Lake—all subjects of vital interest to Collis Huntington.

It is unlikely that Crocker spent time carefully constructing precise narrative progressions within the photographic archive, but Hart may have done so, and there are

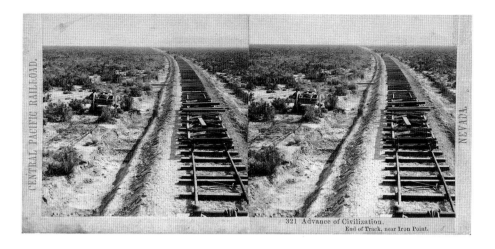

FIG. 42

Alfred Hart, *Advance of Civilization. End of Track, near Iron Point* (no. 321), 1868. Albumen stereograph, 3½ × 7 inches. Library of Congress Prints and Photographs Division.

places within the archive that seem to reflect his theatrical sensibility. In 1868, with trains running regularly over the Donner Pass and an established arrangement between photographer and client, some of the stereograph titles convey a new tone that conceptualizes the railroad as a grand, national project. One such sequence begins with two stereographs showing the end of the rail line in the Nevada desert and titled *Advance of Civilization.* The first looks west, back over the top of a line of train cars toward the Sierra Nevada and Sacramento (fig. 42); the second looks east, where workers have built a roadbed and laid wooden ties for the advancing rails. The titles of these two stereographs, *Advance of Civilization. End of Track, near Iron Point* and *Advance of Civilization. Scene on the Humboldt Desert,* set the context for the next stereograph in the sequence, *Shoshone Indians looking at Locomotive on Desert* (see fig. 10).

Here the analogy of the railroad as civilization is brought home in the contrast between technology and the primitive native inhabitants. The two stereographs that follow inject a gendered nuance into the story of progress. The first, *Shoshone Indians, Humboldt Plains,* includes no sign of the railroad—just a group of dirty and disheveled native women (fig. 43). They sit on the ground, their faces in shadow—signifiers of the remote and the primitive. They support the trope of the railroad as civilization by providing a striking contrast to the last photograph in the sequence, *Car of Superintendent of Construction. End of Track* (fig. 44). This image, one of the few stereographs to include women, is a portrait of the construction foreman James Strobridge, presumably with his wife, accompanied by two other unidentified women. They stand on the porch of the Strobridges' train-car home, the precursors of the future domestication of the wilderness. Whereas the indigenous women in the previous stereograph sit in the dirt and

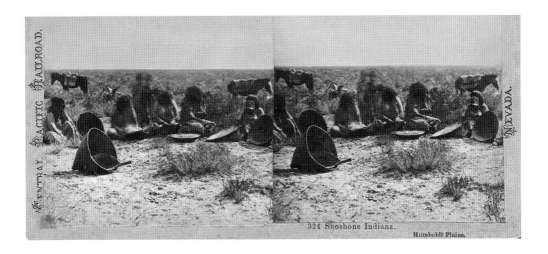

FIG. 43
Alfred Hart, *Shoshone Indians, Humboldt Plains* (no. 324), 1868. Albumen stereograph, 3½ × 7 inches. Courtesy Barry A. Swackhammer Collection.

gather roots and berries, American women dress in fine clothing and move through the landscape in specially designed railroad cars.

The information contained in individual stereographs and in the stereographic series was directed at a variety of audiences, but it appears that the primary and most immediate client for the Central Pacific stereographs was its vice president, Collis Huntington.[33] Crocker's January 1867 letter indicates Huntington's interest in construction progress and the critical role that stereographs played in keeping Huntington informed:

Friend Huntington,

By this Steamer I send you 3 packages of mounted stereoscopes amounting in all to 256. & hope to be able to send you a large lot by the next Steamer. They are universally admired here. & I am glad to see that they are there.

We also send you 300 more 1st mort. Bonds in 3 packages.

We also send you one package of unmounted stereoscopes, containing about 350. The artist had them printed. & I thought you could get them put on cards quicker and cheaper than we could here, besides they would cost less for postage. There are one or 2 sets of views of the South side of Donner Lake from the Pass down to the foot, which are intended to be cut apart & pasted together & will then make a complete view of the mountain & ridge where the R. R. is to run. They are properly marked. Some of the views are all mixed up, as we have not had time to seperate *[sic]* them from the mounted views I have sent you. The person mounting them can paste on the proper labels, sheets of which I also send. . . .

I have nearly ready a Report of the cost of work, the difficulties encountered[,] reasons why so expensive etc. which I will send you in a few days.[34]

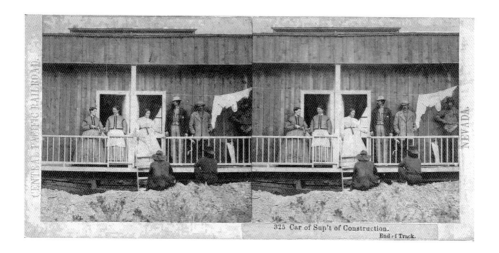

FIG. 44

Alfred Hart, *Car of Sup[erintenden]t of Construction. End of Track* (no. 325), 1868. Albumen stereograph, 3½ × 7 inches. Courtesy Barry A. Swackhammer Collection.

This letter points out that the Central Pacific stereographs did not function independently but as part of a larger archival project that included maps and reports. Where the latter gave breadth of perspective, the former offered a precise, close-up view of the railroad and the landscape. Together they communicated the railroad's efforts to measure and control the space of the Sierra Nevada, both aspects of which were of utmost importance to Huntington.

Huntington, before his involvement with the railroad, had managed one of the largest hardware businesses in the West. A skilled and domineering businessman, he moved to New York City in the winter of 1863–64 to serve as financier, purchasing agent, and Washington lobbyist for the Central Pacific. He worked long hours, aggressively promoting the interests of the railroad, and he expected others to do so as well. The correspondence between Huntington and Crocker reveals Huntington's constant irritation about the slow pace of construction. E. B. Crocker, whose brother, Charles, was the general contractor of the railroad, consistently reminded Huntington of the difficulties of building a railroad in the Sierra—long tunnels through solid rock, huge earthworks, rains, and snow. He also updated him on progress and reassured him that the railroad over the summit would soon be completed.

Huntington needed reassurance. Bonds were selling poorly, and the Central Pacific's finances were strained. They needed the government loan guarantees that only miles of new track could give them. The stereographs, particularly in 1866 and 1867, played an important role in Huntington's long-distant surveillance. In 1866 and 1867, Crocker purchased more than ten thousand of Hart's stereographs, mounted and unmounted, and mailed them to Huntington in New York City.[35] These images served a dual pur-

pose. Huntington's absence from California created not only a geographical divide but also a conceptual gap into which Huntington poured his doubts and fears about the Central Pacific operations. With financing chaotic and the company under constant monetary pressure, the scientific rationality of the stereographs projected a sense of control. The arrangement of the archive permitted Huntington to see the geographical progression of the railroad into the mountains and to appreciate the difficulties faced by the work crews.

Huntington was Crocker's primary audience, but the company vice president had his own set of clients for the stereographs. Shortly after purchasing the first thirty-two negatives, Crocker shipped the glass plates to Huntington so that he could have them printed as he needed them. Huntington did so and used them to reassure industrialists, lobbyists, and government officials.[36] According to documentary records, Huntington distributed "sets" of stereographs, rather than individual images.[37] This practice ensured that viewers experienced the Central Pacific, not in individual, disconnected segments, but as a sequential progression through the foothills or in the mountains. The stereographs, however, did more than simply record information; they conveyed it sensationally. And to be sure that individuals would see the full three-dimensional effect, Huntington sent stereographic viewers to his most important clients.

The stereographs were an extension of the Central Pacific's money and power and were one more instrument in Huntington's effort to secure the supplies and to raise the financial capital necessary to complete the railroad. Huntington gave stereographs liberally to a variety of railroad constituents, distributing at least 112 sets of thirty-two Central Pacific Railroad stereographs during 1866 and 1867.[38] The Central Pacific Railroad banking firm of Harvey Fisk and Alfrederick Hatch was the primary recipient of the stereographs. It was among the first to receive the images, on April 16, 1866, and Huntington made sure it was well stocked, leaving seventy-five sets with the Central Pacific financiers in 1868. Huntington gave individual sets to iron suppliers and manufacturers such as D. J. Dodge of the Lackawanna Iron and Coal Company; John Ellis of the Schenectady Locomotive Works; and the iron dealer John Oliphant. For these men, the pictures of completed track offered assurance that the company was successful, demonstrated the need for more rail, and implicitly promised that they would continue to be paid. Huntington pushed the images beyond his immediate circle. He sent a set of views to Spuyten Duyvel Rolling Mill Company, with the understanding that the company would forward them to business associates in England. And the thirty-three stereographs that Alfred Hart submitted to the exhibition committee of the Paris International Exposition of 1867 were to be presented to a railroad company in Paris at the close of the fair.[39]

Huntington did not treat stereographs as proprietary information; he wanted everyone to know about the Central Pacific's success. George T. M. Davis, a recipient of Huntington's photographic largess on more than one occasion, offers an example of the fluidity of railroad friends and rivals and the impossibility of strategically targeting

audiences for the stereographs. Huntington paid Davis to secure iron rail for shipment west to Sacramento. But, in addition to working for the Central Pacific, Davis was also a member of the Union Pacific's Credit Mobilier and the father-in-law of the Union Pacific Railroad lobbyist George Francis Train. Davis was one of several men involved with both the Central Pacific Railroad and the Union Pacific Railroad who received sets of Central Pacific stereographs.

Crocker, too, distributed the stereographs to friends and enemies. He sent a company representative, Lathrop Tracy, to meet with the Union Pacific's chief engineer, Grenville Dodge, in Salt Lake City, and Dodge asked about the Central Pacific stereographs. Crocker quotes Tracy's report in a letter to Huntington: "We did not have as good an opportunity of conversing with him as we expected to have. . . . He expressed great regret that he did not arrive soon enough to have had the pleasure of meeting you. He desired me to procure for him 50 of the stereoscopic views of the Central Pacific R.R. He saw a number of them at Col. Head's, & was very much pleased with them. Will you have the kindness to purchase & forward them to me."[40] Although, as noted, Huntington attempted to control the reception of the stereographs by giving them away in sets, he could not completely manage their ambiguity. The first thirty-two stereographs, for example, display the Central Pacific's skill in constructing an acceptable railroad grade, track, and trestle, but they do so in the relatively accessible landscape of the Sierra foothills. This topography, no matter how carefully the road was constructed, could not offer investors any reassurance that the Central Pacific could construct a railroad over the Sierra Nevada.

Selecting stereographs, sequencing and titling them in ways that emphasized the enormous challenge of the Sierra Nevada may have made investors and suppliers uneasy, but that message was necessary to justify high government subsidies. The importance of this framing of the railroad story can be seen in a letter from Crocker sent in March 1867:

> In one of your late [sic] letters you state that the Report made in Jan., a copy of which I sent you, was not what you wanted, that you wanted a statement of work done & to be done &c &c. Now that report was made at your special request to be used before the Pacific R.R. Com. to show the increase of cost caused by the rapid construction, & that if we went on at the present rate we ought to have more aid. You read that report in that view & I think you will say it meets the case.[41]

Although the stereographs were not mentioned in this letter, they nonetheless played an important role in Huntington's interaction with government officials. He made certain that lobbyists for the Central Pacific, such as Richard Franchot, had sets of stereographs. He also gave the images and a stereoscopic viewer to Joseph Wilson, who worked for the General Land Office and was commissioner of maps in 1866 and 1867. He sent a set of views and a viewer to John Conness, a senator from California and a key legislator in

passing the Pacific Railroad Bill in 1864.[42] He assigned yet another set to Colonel James Simpson, a government railroad inspector.[43] A letter that Huntington wrote to the office of the Treasury Department suggests the efficacy of the stereographs: "I forward to you by today's mail one of our latest reports and should take pleasure in forwarding a sett [sic] of Stereoscopic views as desired by you had I one to share, but the only sett [sic] I have at this time is intended for the Secretary of the Treasury. I expect to receive some more of these views from California and when they come to hand I will remember your request."[44] Huntington's reservation of stereographs for the secretary of the treasury, Hugh McCulloch, noted in his letter, suggests yet another function of the stereographs: they may have effected the release of the government bonds needed to finance the ongoing purchase of materials and supplies for shipment to California.

Curating Hart's production of stereographs allowed the Central Pacific to assert control over the imagery in a way that the company was unable to do over the pace of construction. While work was halted by solid rock or the chasm of a wilderness canyon, the stereographs made construction appear to be an inexorable march over the Sierra. When heavy snows interrupted work crews and threatened the future of the railroad, stereographs of snow sheds reassured viewers that nature could be circumvented by human ingenuity and technology. Privately, the images allowed Huntington, who oversaw the construction from his office in New York City, to follow the advance of the railroad over the mountains of California and across the high desert of Nevada. In the face of the financial brinkmanship that he encountered in New York, the stereographs offered signs of hope. Publicly, they served as evidence of the railroad's success and certified the railroad's progress for financial partners, industrial suppliers, and government officials.

UNION PACIFIC

Unlike the Central Pacific, the Union Pacific did not purchase its photographers' negatives. After John Carbutt returned from the excursion to the hundredth meridian, he took his glass plates back with him to Chicago. The mounted prints, however, strongly suggest the Union Pacific's patronage and influence. On the left side of the images, "Union Pacific Railroad" is printed in capital letters; beneath it is the name of the event, "Excursion to the 100th Meridian," and the date, "October 1866." On the right edge "Photographed by John Carbutt Under the Auspices the Union Pacific Rail Road" records the relationship between the photographer and the railroad company. Durant visited Carbutt's studio in Chicago after the excursion, and he purchased both stereographs and enlargements from the photographer in November 1866.[45] He does not, however, appear to have continued the relationship, nor did he use the stereographs in the same systematic way that Huntington and Crocker did. In fact, he seems to have had little more to do with photography until spring 1868, when Andrew Russell went to the end of the railroad line.

Russell's relationship with Durant and the Union Pacific appears to have been simi-

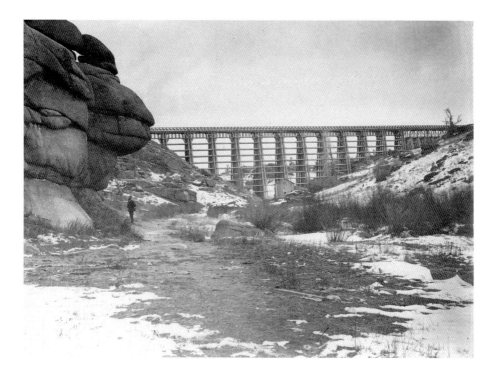

FIG. 45

Andrew Russell, *Dale Creek Bridge from Ape Rock* [no. 26], 1868–69. Albumen print, 10 × 13 inches. Yale Collection of Western Americana, Beinecke Rare Book and Manuscript Library.

lar to that of Carbutt. Checks and secondary correspondence indicate that Russell's work was sponsored by the Union Pacific, but the lack of corporate records and the absence of documentary evidence make it very difficult to trace the extent of the company's influence on Russell's production. His contemporaries recorded Russell printing his negatives during the months he lived and photographed in the West, but his negatives were also printed by Union Pacific employees.[46] Titles of the Union Pacific photographs are minimal, and the sequence of stereographs changed in 1868 and 1870.

There are other differences between the Central Pacific and Union Pacific photographic projects. The photographic archive that Russell produced is more comprehensive than that of Alfred Hart. Russell was an outstanding technician, a fact that is particularly evident in his large format photographs. He used his skills to make multiple images of particular points along the line; and with no one to select certain images for purchase, all variants became part of the archive of the Union Pacific Railroad. His photographic documentation of the Dale Creek Bridge is a case in point. More than 126 feet high and 650 feet long, it was by far the largest bridge constructed on the Union Pacific Railroad, and Russell's photographs celebrated the accomplishment in twenty-four photographs (fig. 45 is one example). He used both stereographic and large-plate

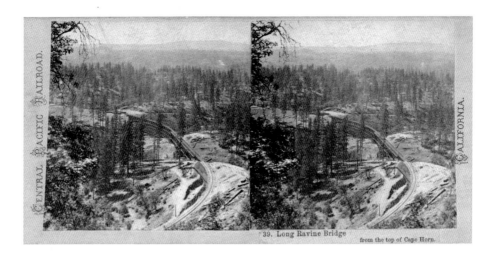

39. Long Ravine Bridge from the top of Cape Horn.

FIG. 46
Alfred Hart, *Long Ravine Bridge from the top of Cape Horn* (no. 39), 1866. Albumen stereograph,
3½ × 7 inches. Crocker Art Museum, E. B. Crocker Collection.

formats and provided "general views," views "from above," and views "from below." He included perspective views, distant views, close-up views, and views from named rock formations. Some of his photographs made the bridge seem overwhelming, while others blended it easily into the landscape. In short, he supplied a thorough documentation from a variety of positions and visual perspectives. In making this effort, Russell created photographs that were stylistically consistent with his earlier Civil War photography, and that served the needs of the Union Pacific by recording significant structures with a minimum of artifice, and in a way that allowed a choice of images for significant locations.

Because individual stereographs were chosen for the Central Pacific archive, subject matter in that photographic archive was carefully defined. For example, the Long Ravine Bridge was one of the more heavily documented structures in the archive, yet was represented by only four stereographs. They are precise images that appear to examine the structure scientifically—from a distance and close-up, from east and west, from above and below (figs. 46–49). Hart went to great lengths to compile this record, climbing high above the bridge and hiking down into the canyon. Russell's photographs of the Dale Creek Bridge are more inclusive and seemingly unedited. Along with this lack of editing was the question of control. The Central Pacific exercised a certain authority over Hart's photographic production by purchasing certain negatives. In contrast, it would have been very difficult for Durant to exercise the same type of control over Russell's production. Russell worked thousands of miles from the Union Pacific vice president, and while Durant may have met with Russell and given him instructions before he left for the West, Russell appears to have worked independently.[47] Nonetheless,

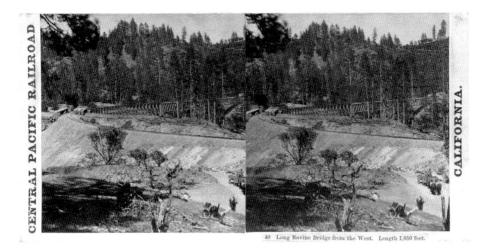

FIG. 47

Alfred Hart, *Long Ravine Bridge from the West, 56 miles from Sacramento* (no. 40), 1866. Albumen stereograph, 3½ × 7 inches. Courtesy of the California History Room, California State Library, Sacramento, California.

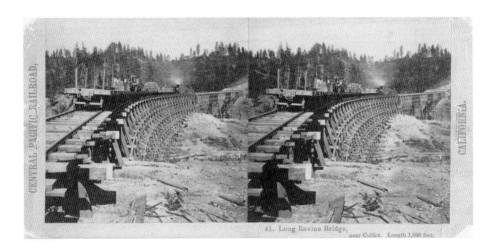

FIG. 48

Alfred Hart, *Long Ravine Bridge, near Colfax. Length 1,050 feet* (no. 41), 1866. Albumen stereograph, 3½ × 7 inches. Courtesy of the California History Room, California State Library, Sacramento, California.

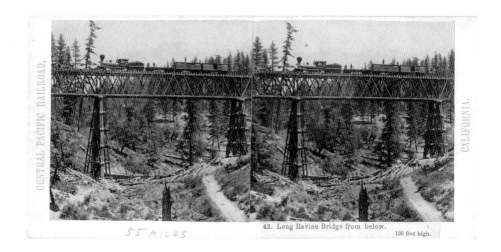

FIG. 49

Alfred Hart, *Long Ravine Bridge from below. 120 feet high* (no. 42), 1866. Albumen stereograph, 3½ × 7 inches. Courtesy of the California History Room, California State Library, Sacramento, California.

there is evidence that the company exerted some degree of control over Russell's production. To get some sense of the interplay between photographer and railroad company, one must look at the material remnants of that interplay: the card stock mounts for the stereographs and the albums of the large format prints.

Russell's first stereographic mounts, printed in 1868 and early 1869 and documenting the landscape between Cheyenne and Salt Lake City, were similar to those used by the Central Pacific. The images were glued on card stock, on which a letterpress number and title had been printed directly, but there were no other identifying marks on the front of the stereograph.[48] Unlike the Central Pacific, the Union Pacific stereographs minimized the photographer's name and used Union Pacific boilerplate language as a descriptor on the back of the card. The verso incorporated linear flourishes surrounding a script identifier: "Union Pacific R.R. Views/Across the Continent,/West from Omaha" and in small letters: "A. J. Russell, Artist." The phrases "Across the Continent" and "West from Omaha" were company favorites used in a variety of Union Pacific advertising to project an enthusiastic boosterism.[49] This identification of the stereograph with the company, rather than the photographer, indicates a corporate authority over the photographic production of stereographs; the titling and sequencing of the cards also suggest the influence of corporate interests.

The titles of Russell's stereographs tend to be dry and only minimally informative. They lack the specific engineering data and geographic measurement characteristic of so many of the Central Pacific stereographs; nor do they convey a narrative flourish. Instead, they are simple descriptions of the geographical setting (*Approach to Dale Creek Bridge from the west, Echo Cannon looking down RR grade*), subject matter (*Western*

FIG. 50

Andrew Russell, *Construction Department laying track, Bitter Creek Valley* (no. 4), 1868. Later known as *Laying Track, Green River, Teams for Transporting Material in Foreground* (no. 199). Albumen stereograph, 3½ × 7 inches. Library of Congress Prints and Photographs Division.

Portal Tunnel No. 2, Green River side cut, general view), or the fantastic geological formations along the railroad route (*Giant's Club, Witches Rocks, Devil's Post Office*). For example, Hart's stereograph marking the end of the track in Nevada is titled *Advance of Civilization. End of Track, near Iron Point* (see fig. 42); when Russell photographed the same subject in Wyoming, he titled his stereograph with the more prosaic *Construction Department laying track, Bitter Creek Valley* (fig. 50). In this particular comparison, Russell's description is tied to location and surveillance, while Hart's engages a more poetic sensibility.

Russell's titles are unique for one important characteristic, however: his inclusion of the names of the contractors who were responsible for the work. Unlike the Central Pacific, whose entire construction was the responsibility of Charles Crocker, the Union Pacific subcontracted different sections of the rail line. In one way, Russell's stereographs appear to have served a purpose similar to those of Hart—they permitted men living in plush offices in New York and Boston, thousands of miles from the construction sites, to oversee the work. But while Hart's stereographs point to a generalized progress of the railroad through the Sierra, Russell's record the individual contractors' achievements—*Chesebro and Magee's works, Green River; Miller and Patterson's Tunnel at Head of Echo Canon;* or *Carmichael's Cut, Looking East, Promontory*. This naming plays a double role: the images also permitted Durant and the Union Pacific directors to track each contractor's performance.

It would seem that, for the contractors, being photographed carried a certain danger—of pitting one work crew against another, encouraging them to build faster than other contractors and exceed corporate expectations. The evidence in Russell's photo-

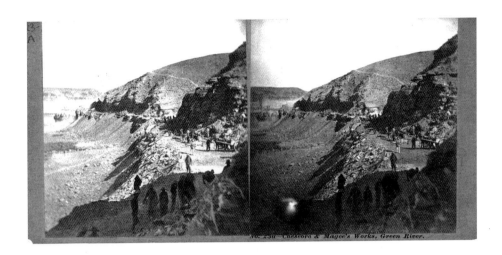

FIG. 51
Andrew Russell, *Chesebro and Magee's works, Green River* (no. 23a), 1868. Later known as *Side Cut Green River Instantaneous View* (no. 196). Albumen stereograph, 3½ × 7 inches. Private collection.

graphs, however, indicates a different intention. In both stereographic and large format, Russell's images seem to honor the hard work of the men in the field. For example, *Chesebro and Magee's works, Green River* shows the jagged hillside cut and men preparing the roadbed for the advancing graders (fig. 51). The work is in process, and it may be days or weeks before the ground is ready for the tracklayers. Men crowd the foreground cleaning up debris from the hillside, while in the middle ground the work crews clear the rock from the next cut and a cart gathers the largest debris to dump over the edge of the fill. Russell has the men stop and pose for the photograph. In this image and many others like it, the process of altering the landscape reinforces the railroad's progressive march through Wyoming and Utah. Russell's photographs celebrate the workers and contractors who were responsible for that transformation. In fact, when Russell renumbered his negatives in 1870, long after the railroad was completed, he added contractors' names to several otherwise unidentified stereographs.

Despite the fact that Russell's negatives were not selected for purchase, and that titles were short and descriptive, certain aspects of the archival sequence are consistent with Union Pacific promotional efforts. The numerical sequence of the 1868 stereographs is neither chronological nor geographical.[50] It begins with one of the first negatives Russell made for the Union Pacific—a view of the Dale Creek Bridge. The next stereograph is a portrait of the lead track-laying contractor, Jack Casement, several hundred miles west of the Dale Creek Bridge; the sequence then returns to the bridge and continues to survey a series of construction sites. The first fifty stereographs encompass the geography from the Dale Creek Bridge, in the east, to Salt Lake City, in the west. Although it is difficult to make any judgments without a clear pattern, the majority of these first stereographs

capture the transformation of the land by the railroad work crews by showing the labor of cutting through hillsides and leveling roadbeds, or by showing empty track leading off into the distance.

The numbering of the 1868 Union Pacific stereographs appears to be structured to convey the evidence of landscape alteration and to conduct a form of directorial surveillance; it also suggests the future promise of the railroad. The sequences of railroad labor are interrupted six times by single stereographs of Salt Lake City—Brigham Young's residential compound, the Salt Lake City theater under construction, the Great Tabernacle, a panoramic view of the city's commercial district, the Deseret trading store, and a street view of Brigham Young's home. By interspersing images of Salt Lake City bustling with commercial production and economic potential within a narrative of landscape transformation and railroad progress, the Union Pacific stereographs underscore the imagined promise of the railroad—that construction will mean new settlement and new cities in the wide-open spaces of the central United States. Russell wrote in glowing terms about this imagined future:

> The casual observer in passing across the vast plains traversed by the Pacific Rail Road, will suppose that they are barren. But a closer examination will show that the soil is productive and only requires water to make them blossom as the rose. . . .
>
> This has all been fully demonstrated in the Territory of Utah. The valley of Salt Lake has been made a marvel of productiveness by this system of irrigation. This Valley is no better and no different from hundreds of miles lying between Salt Lake City and Omaha. Industry has recovered the one from barrenness and desolation and can and will the other.[51]

The message of wilderness transformation and economic progress in the West would have been particularly powerful to observers in the Northeast after the devastation and displacement of the Civil War. These stereographs remind viewers that, just as the Mormons had been driven out of eastern cities and had found a home in the West, so current residents of the East and South might rebuild their lives in land west of the Missouri River.[52]

These themes receded in 1870, when Russell reorganized the Union Pacific archive into a strict geographical sequence beginning in Omaha and ending in Sacramento. These changes divorced the stereographs from their immediate interpretive framework of railroad construction and settlement, freeing the images to represent the journey from Omaha to Sacramento. This modification in the organization of the stereographs also brought about new modes of presentation. Russell made new mounts and divided the archive into fifteen groups of approximately thirty negatives.[53] In contrast to mounts for the earlier stereographs, the front of the 1870 card stock suggests a break between the photographer and the Union Pacific. These stereographs no longer include the name of the railroad or the titles under the images. Instead the stereographic images are framed by the promotional titles "Stereoscopic Views" and "Rocky Mountain Scenery,"

while the back of each card carries the series title and a list of individual stereographs, divided geographically, with Russell's name and New York address at the bottom edge. The sequencing naturalized the organization of the archive. By maintaining this strict geographic progression, the photographic archive displaces the photographs' association with the Union Pacific and the original construction of the archive for financiers and investors. Instead, it popularizes the pictures and presents a touristic journey along the length of the transcontinental railroad.

Turning to Russell's large format photographs, one finds a similar reduction of railroad influence between 1868 and late 1870. *The Great West Illustrated* and *Sun Pictures of Rocky Mountain Scenery* both selected particular images from the Union Pacific photographic archives to convey a precise interpretation of the railroad landscape. When Russell returned to New York in late 1868, he produced an album of large format photographs that became the most famous visual production of the transcontinental railroad and one of the most important photographic representations of the American West in the nineteenth century. *The Great West Illustrated,* published in April 1869, had thick, heavy covers, a preface, and a six-page introduction of annotated titles, followed by fifty large-format photographs mounted on heavy card stock. Its pages were almost three-eighths of an inch thick, more than thirteen inches high, and eighteen inches wide. Bound in half leather, with marbled end papers, *The Great West Illustrated* was a sumptuous production of original photographs and weighed more than fifteen pounds.

The brief preface, written in the third person, presents the album as a disinterested report about the North American West: "The artist who photographed the views contained in this work, while recently passing through the Great West, became fully convinced that the most comprehensive manner in which a positive and substantial knowledge could be offered on a subject which heretofore has given data only vague and insignificant, was in presenting to the public a series of PHOTOGRAPHIC VIEWS ACROSS THE CONTINENT, with an Annotated Table of Contents. THE GREAT WEST ILLUSTRATED is a result of this idea." The objective, scientific tone of the preface supported the truth-value of the photographs as honest representations of the West. The Union Pacific Railroad is listed as publisher, but the title page suggests that Russell is the author. This distancing of the company from the production creates an impression of the album as independent of corporate interests, although the text and photograph combinations suggest otherwise.[54]

The preface continues with an outline of the album's scope: "The Views prepared for the present Volume are of scenes and localities along the line of the UNION PACIFIC RAILROAD, which stretches from Omaha on the Missouri River to Sacramento on the Pacific Coast, a distance of one thousand seven hundred and twenty-one miles."[55] In fact, the album was a selection from Russell's negative archives of fifty photographs representing the approximately 450 miles between construction west of Cheyenne, Wyoming, and Salt Lake City, Utah. The photographs were organized geographically, a panorama of linear travel that is akin to riding a train between the two cities and stopping at particular locations.

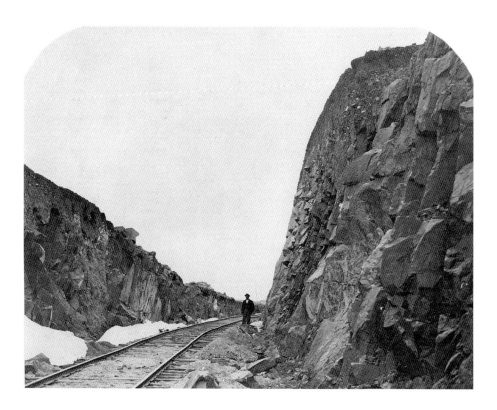

Andrew Russell, *Carmichael's Cut, Granite Canon* (no. 8), 1868. Later known as *Entering Black Hills, Carmichael's Cut Granite Cannon*. Albumen print, 10 × 13 inches. Yale Collection of Western Americana, Beinecke Rare Book and Manuscript Library.

There is no documentary record of who was responsible for the selection or arrangement of the photographs, but given the Union Pacific's financial support and the album's theme of investment in railroad lands, it seems likely that it was a collaborative effort between the photographer and the Union Pacific directorate. A comparison of different copies of the album demonstrates that subject matter, annotations, and titles are consistent in each album, but in certain cases the imagery is not consistent. Dale Creek Bridge, for example, is represented by one image in one album and a different image in a second album. This fact suggests that the purpose of the album was didactic, that it was the selection of locations and the annotated captions, rather than specific photographs, that was of primary importance.

The Great West Illustrated opens with opposing negative and positive spaces, with the finished track confirming the railroad's success. *Carmichael's Cut, Granite Canon* is a straightforward image of a railroad cut through solid rock (fig. 52). The placement of the camera to the far right accentuates the height of the rock wall, causing it to loom over

Andrew Russell, *Granite Rock, near Beaufort Station* (no. 15), 1868. Later known as *Camel Rock near Beaufort Station U.P.R.R.* Albumen print, 10 × 13 inches. Yale Collection of Western Americana, Beinecke Rare Book and Manuscript Library.

the figure standing alongside the track. The title's identification of the man, however, and his standing beside finished track announce the railroad's accomplishment. The next photograph in the album, another sign of railroad progress, is the earthen fill at Granite Canyon (see fig. 19). Cuts into the earth create a negative space, then the "fill," seen in this photograph, creates a positive space—a level grade on which to lay track. The album, then, opens with opposing negative and positive spaces and with finished track confirming the railroad's achievement. Next in the sequence, *Granite Rock, near Beaufort Station* (fig. 53) is photographed close up, increasing the scale of the rock outcropping so that it dominates the picture space. Here, no human form offers a sense of scale; there are only the imposing shapes and impenetrability of the granite rocks. In this opening sequence, culture and nature meet. The first two photographs show nature being inspected, measured, and controlled by the forces of the railroad. The third photograph, *Granite Rock near Beaufort Station*, reminds viewers of the overpowering presence and sublime power of the wilderness.

One of the most surprising things about *The Great West Illustrated* is the paucity of photographs of the railroad. Unlike the stereographic sequences of 1868, a majority of the photographs in *The Great West Illustrated* are landscape views without any sign of

track or technology. These photographs point to the land as a source of abundant natural resources such as water, timber, and minerals. The caption for *Valley of the Little Laramie River*, for example, describes the land as already fertile, "richly covered with luxurious grass and wildflowers," and the river as having enough water for the railroad to float hundreds of thousands of logs on its current.[56] This is followed by, and paired with, a photograph of heavily forested mountains at the head of the river. The caption locates the scene and describes the available timber stock and potential for mining: "This locality is on the borders of the Great Timber District, which is nearly one hundred miles long and twenty-five miles wide. A number of gold mines were discovered in the canons and quartz beds on the mountain range in this vicinity, during the summer of 1868."[57] Many photographs in the center of the album include rivers, lakes, and wells, making water seem abundant.[58] The suggestion that water was readily available supported the Union Pacific's desire to sell land to emigrants and investors.

In some of the album's photographs, buildings, water tanks, windmills, and telegraph poles crowd out the landscape horizon, dramatically replacing the wilderness with a developed and growing place of habitation. They offer a vision of the West, its resources, and its potential for transformation. *Laramie Hotel, Laramie City* shows the large building constructed by the Union Pacific Railroad alongside the railroad tracks; the caption advises the reader that the hotel is able to rely on water brought from the mountains (fig. 54). *The Wind Mill at Laramie* displays a huge windmill and water tank; the two structures dwarf the locomotive beneath them (fig. 55). Here the technology of the windmill, characterized as "ingenious in construction," taps into an existing subterranean water source and transforms an otherwise arid region. The last photograph in this series shows the Laramie machine shops. The caption describes the potential for the hardworking and industrious by telling the reader that buildings were constructed using brick made from local materials.

Russell's personal feeling seem to be similar to those of his railroad employers. Although he does not mention *The Great West Illustrated* by name, he endorses the cant of the album and articulates one of the seminal late-nineteenth-century myths about the Great Plains:

> There are many things in the history of that country [Utah] which are as curious and interesting as they are strange and unaccountable and cannot fail to attract the attention of all thinking persons. . . .
>
> Since the settlement of that country rain has increased in proportion to the growth of the country and the spread of agriculture. Where until a few years back there was no rain, frequent showers now refresh the earth. Fresh water Springs *[sic]* are constantly breaking out in unthoughtof *[sic]* places, and what were barren hills and plains are now covered with luxuriant natural vegetation.[59]

Like the sequences of stereographs, *The Great West Illustrated* concludes with six photographs of the area around Salt Lake City and a glimpse into an imagined future of

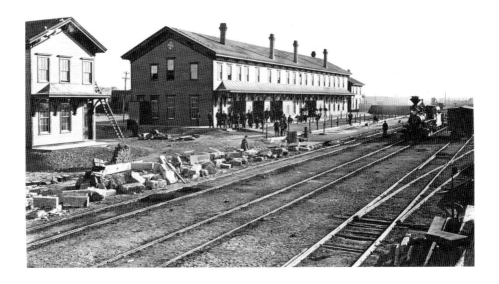

western settlement and collective prosperity. The first two photographs are a pair, one of them an overview of the city (fig. 56). *Salt Lake City, from the Top of the Tabernacle* is followed by one of the most picturesque landscapes in the album. A small waterfall cascading over rocks and into the foreground of the image, leading viewers, once again, to think of the West as having abundant supplies of water. The caption informs the reader that this stream supplies all the water for Salt Lake City. The remaining three photographs—a tree-lined street, a woolen factory, and the immense Mormon Tabernacle—underscore the success of the Mormons and the potential of the North American West for industrious settlers.

The last four photographs in the album offer an ambiguous view of life under Mormon authority. The first pair presents a contrast of prosperity and transformation. The homesteaders' sod house suggests the struggle to survive on the land (see fig. 22), but the photograph of Brigham Young's Salt Lake City house surrounded by tree-lined streets embodies the potential of the West (fig. 57). The final two photographs in the album reinforce this message of promise and plenty. *Brigham Young's Cotton and Woolen Factories* and *Great Mormon Tabernacle* are in keeping with the promotional intention of the album (fig. 58). These photographs call attention to the success of Mormons, rep-

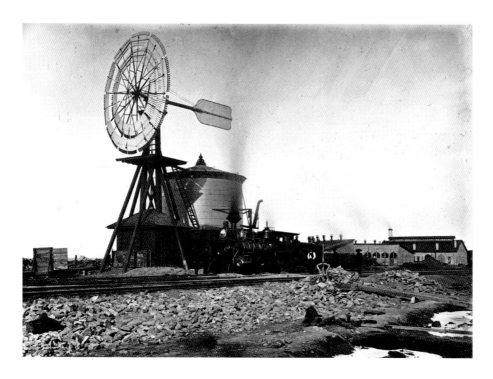

FIG. 55
Andrew Russell, *The Wind Mill at Laramie* (no. 51½), 1868. Albumen print, 10 × 13 inches. Yale Collection of Western Americana, Beinecke Rare Book and Manuscript Library.

resented by the suggestion of herding, a factory in the wilderness, and a monumental building; the caption tells the reader that the tabernacle can accommodate more than ten thousand people.

This message of achievement and progress, however, is problematized by a second reading of the images, two of which juxtapose the wealth and power of Brigham Young with the poverty of his followers. While the Mormon family group poses outside a rustic single-room log cabin that does not seem capable of accommodating the six adults and four children, the caption for Brigham Young's house states that it takes up an entire city block, is visible to anyone entering the city, and is surrounded by a fifteen-foot wall. Similarly, the juxtaposition of these last two photographs explicitly links commerce and religion and reminds readers about Brigham Young's authoritarian control. While outwardly holding out Salt Lake City as a model for others, these photographs also suggest the unorthodox nature of the Mormon culture.

In the eyes of the public, *The Great West Illustrated* celebrated railroad engineering and portrayed an American West brimming with promise. To railroad executives, however, the album told a more disconcerting story. One of the most famous photographs in the album, a group portrait of Generals Grant, Sherman, Sheridan, and Harney, is

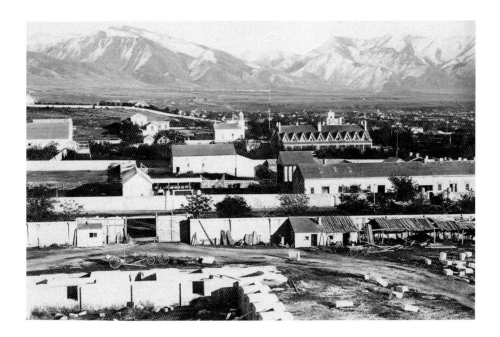

FIG. 56
Andrew Russell, *Salt Lake City, from the top of the Tabernacle* (no. 166), 1868. Albumen print, 10 × 13 inches. Yale Collection of Western Americana, Beinecke Rare Book and Manuscript Library.

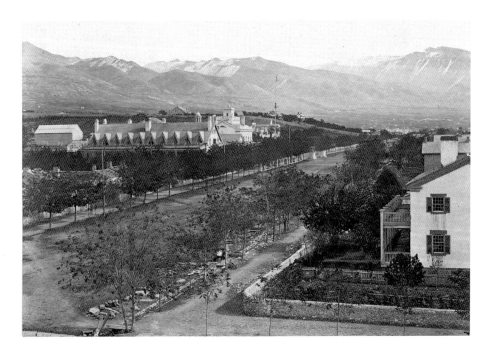

FIG. 57
Andrew Russell, *Residence of Brigham Young* (no. 165), 1868. Albumen print, 10 × 13 inches. Yale Collection of Western Americana, Beinecke Rare Book and Manuscript Library.

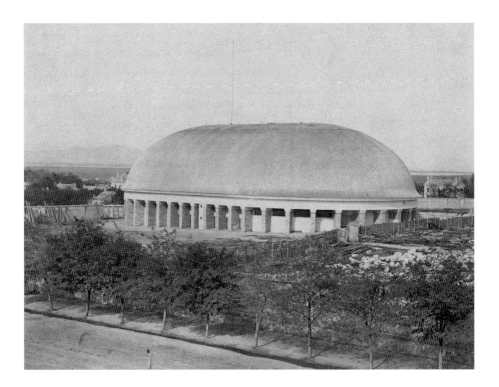

FIG. 58
Andrew Russell, *Great Mormon Tabernacle* (no. 164), 1868. Later known as *Mormon Tabernacle No. 2*. Albumen print, 10 × 13 inches. Yale Collection of Western Americana, Beinecke Rare Book and Manuscript Library.

another indication of the complicated ideological nature of a photographic production like *The Great West Illustrated* (fig. 59). The gathering of uniformed officers reminds the viewer of the railroad's military importance, yet the caption downplays the presence of the military and instead describes Fort Sanders, where the meeting took place, as being constructed out of local timber and supporting several gardens. The image underscores this promotional focus, suggesting that the West is a suitable location for ladies and important generals. What these readings overlook, however, is the reason for the gathering at Fort Sanders. The railroad directors, and the men pictured in the photograph, would have understood that the railroad was of such national importance, and that dissention within the Union Pacific was significant enough, that the generals came to Fort Sanders to mediate a dispute between Durant and the Union Pacific's chief engineer, Grenville Dodge. This reading of the image would have been unavailable to the general public. Durant can be seen on the right side of the photograph, behind the phalanx of military men, sitting awkwardly on the fence. For those inside the Union Pacific hierarchy, this photograph would have been a reminder of Durant's obstinacy and the resulting problems within the corporation.

FIG. 59
Andrew Russell, *Gen[eral] Grant and Party at Fort Sanders* (no. 37b), 1868. Albumen print, 10 × 13 inches. Yale Collection of Western Americana, Beinecke Rare Book and Manuscript Library.

The private subtext of *The Great West Illustrated* may also have included the financial fears of the railroad directors. There is no documentation of the reason for the railroad's financial support of this sumptuous album, nor is the intended audience clear. While it appears to be designed for promotion, its price, fifty dollars, would have placed it out of the reach of all but the wealthiest Americans. If the album was intended for Union Pacific investors and bondholders, to memorialize the great achievement of building the railroad, it must have invoked their anxieties as well as their hopes. The opening photograph, *Carmichael's Cut, Granite Canon,* for example, can be understood as a celebration of railroad success, but it can also evoke feelings of anxiety and insecurity. The figure in this photograph, like others in similar images in the album, is placed in the middle ground and overshadowed by the huge rock wall in the foreground of the photograph. Bringing to mind the public perception of the West as the "Great American Desert," the figure is insignificant in a broad, desolate, and arid wilderness. Photographs such as these, in which men are dwarfed by an overwhelming and arid landscape, are reminders of the precarious position of the Union Pacific itself—haunted by money problems,

beset by internal fights among the directorate, and preoccupied by an impending government investigation.

A year later some of these same photographs, in reduced format, were published by geologist Ferdinand V. Hayden in *Sun Pictures of Rocky Mountain Scenery*. Hayden was an acclaimed scientist who had done extensive geological work in the West and would lead the first full-scale exploration of Yellowstone in 1871. He had begun plans for the album in 1868, when he returned from a geological exploration of Wyoming and Colorado. Russell accompanied him on at least a portion of that survey, and Hayden wrote to Union Pacific Railroad vice president Thomas Durant from Fort Sanders, Wyoming: "It has been my earnest desire for more than a year past, to aid in preparing a book or album illustrated with photographs of the wonderful scenery along the line of the U.P.R.R. I have just been examining some of the fine views taken by Mr. Russell and in conversation with him I find that the scheme is perfectly feasible with your permission and encouragement. . . . I beg your permission for Mr. Russell to print from his negatives, the pictures needed . . ."[60] In addition to signaling the Union Pacific's control over Russell's photographic production, Hayden's correspondence foreshadows the publication of *The Great West Illustrated*. There is no record of Durant's response, or of why two years passed before *Sun Pictures* was published. Perhaps Durant refused to let Hayden use Russell's photographs; but Hayden's note to Durant suggests that the album was Russell's idea. If that is the case, then the most likely reason for the delay is that the publication of *The Great West Illustrated* made Hayden's publication superfluous. In 1870, however, Hayden's interest allowed Russell to pursue a new outlet for his photographic archive.

Whether or not the Union Pacific supported Hayden's publication is not documented. It seems unlikely that they did, given the fact that they did not underwrite a second volume of *The Great West Illustrated* and that, in 1870, they appear to have dissociated themselves from Russell and his photographs. Russell, however, seems to have taken an active interest in Hayden's publication. The introduction credits him as the photographer and locates his studio: "The construction of the Pacific Railroad led to the production of a large number of fine photographic views, taken by Mr. A. J. Russell, of New York, who spent more than two years along the line of the road in the employ of the Union Pacific Railroad Company."[61] In addition to the explicit advertisement of Russell's Union Pacific photographs, Russell's involvement seems to be signaled in the second half of the title, "Rocky Mountain Scenery," which is a phrase Russell used on all his stereographic cards printed after 1870.[62]

Sun Pictures is smaller than *The Great West Illustrated* and more booklike in format, measuring twelve and a half by ten inches rather than thirteen by eighteen inches. It includes a photograph as a frontispiece, a 150-page text, and twenty-nine additional plates of Russell images reduced in size to six by eight inches. The photographic plates in the back of the album begin with the granite rock outside Beaufort Station, which Russell had published earlier in *The Great West Illustrated*. In both publications, *Granite Rock, near Beaufort Station* conveys the mass and power of nature (see fig. 53). Hayden's

text reinterprets it, reading the photograph as a document of western geological formation: "Picture II forms an excellent rock study, and it is a fine illustration of the style of weathering in the feldspathic granites."[63] This scientific content added a new layer of meaning to the photographs. The editors of the *American Journal of Science and Arts* considered *Sun Pictures* scholarly enough to publish excerpts from the text and to comment on the photographs: "The volume will contain thirty photographic views along the line of the Pacific railroad from Omaha to Sacramento, and besides a description of the geographical and geological features of the country, by Dr. Hayden, whose researches over the Rocky Mountains have often been chronicled in this Journal. We understand that the views selected for publication are generally those that illustrate the geographical and geological features of the region, and are interesting to the student of science as well as to the artist and lovers of the picturesque in nature."[64] Hayden's text barely acknowledges the presence of the railroad in the photographs, rendering the selected views as scientific evidence.

Citadel Rock Green River Valley is an example of how this transformation played out in *Sun Pictures* (fig. 60). When Russell made the image, he titled it *Temporary and Permanent Bridge near Green River, Citadel Rock in the Distance* because it provided evidence of the new construction that made the Union Pacific a more stable and substantial railroad. Hayden removed all references to the bridge, however, and retitled the photograph. Completely ignoring the locomotive in the foreground, he described the photograph of Citadel Rock in geological terms: "I have called the formation along Green River, the 'Green River Shales,' from the fact that the sediments are arranged in regular layers, mostly thin, like shales, varying, however, from the thickness of a knife blade to several feet. This laminated character, with the slight variations in color, gives to the hills the peculiar branded appearance as shown in Photographs XI. and XII. of 'Citadel Rock' and 'Castle Rock.'"[65] Despite this geological text, the presence of the locomotive cannot be ignored. It is a subtle reminder of the fact that the railroad opened up these new lands for exploration by scientists and travelers.[66] Hayden's album, as this excerpt demonstrates, used the authority and precise discourse of science, but within this disciplinary language Hayden also promoted railroad interests.

The album served as an advertisement for Russell and his archive of railroad photographs, but at the same time it met the needs of the Union Pacific Railroad: "Thirty views have been chosen, and the preference has been given, in most cases, to those which illustrate some peculiar feature in the geology or geography of that interesting country. The pictures have been arranged so as to commence with the first range of mountains west of Cheyenne, and to continue thence to Salt Lake Valley, with the view, that the book may be used as a guide by those who will avail themselves of the grand opportunities for geological study, which a trip across the continent affords to every intelligent mind."[67] Whether or not he had financial assistance from the Union Pacific, Hayden wanted to curry favor with the company. In a letter from Hayden to Henry

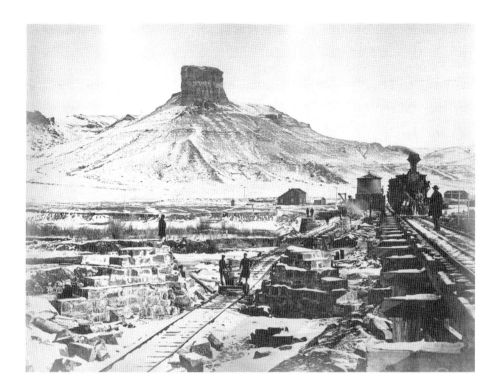

Andrew Russell, *Citadel Rock Green River Valley*, from *Sun Pictures of Rocky Mountain Scenery* (New York: Julius Bien, 1870), plate XI. Albumen print, 6 × 8 inches. Private collection.

Crane, Durant's personal secretary, Hayden thanks Durant for his support and reminds him of the valuable service he provided the railroad:

> I have just sent to you a copy of a Mining Journal in which a paper of mine on the geology of the U.P.R.R. route is printed in part. Please read the article and call the attention of Dr. Durant to it if you think best. I believe the information in regard to the coal along the route of the Railroad will do much toward giving stability and permanent value of [sic] the bonds of the great enterprise[,] for without that coal the road would certainly be a failure in the end, as it seems to me. I am getting all the information I can in regard to the coal mines, and this year I propose to re-examine every point carefully along the road. . . . What I now wish is the facilities that were furnished me last year. . . . I shall not fail to lend what little support I can to the road[,] and for the great kindness of Dr. Durant and the officers of the road in the past. I shall even be glad to [give] my services should they ever be needed in any way. I am now and have been giving lectures at the University & the Learned Societies here in regard to the resources of that region with the most excellent effect.[68]

Following the lead of *The Great West Illustrated,* Hayden's introduction outlined a dynamic economic future for a landscape made accessible by the railroad. Interspersed within the geologic description are echoes of Russell's photographic campaign to make the West appear settled. Hayden commented on the way in which settlement had followed the railroad: "If we now take the cars[,] we shall pass over a similar plain country until we reach Cheyenne, an important and rather remarkable city, near the foot of the mountains, 516 miles west of Omaha, 1,259 miles east from Sacramento and 110 miles north from Denver. . . . On the 4th day of July, 1867, there was but one house in this place; within three months there were at least 3,000 inhabitants with the bustle and confusion of a city of 10,000. It is now improving rapidly, and promises a successful future."[69] In addition to extolling the development of towns along the railroad line and implying further growth, Hayden's text calls the reader's attention to the vast mineral resources, the abundance of timber, and the fascinating geology and beautiful scenery that could be seen from the train car.

Sun Pictures concludes with Russell's photograph of hydraulic mining in the Sierra foothills and a brief description of the many gold mines near the railroad. The photograph serves as a promotion for a second volume that would examine the landscape from Ogden to Sacramento. This album was never published, perhaps because the Central Pacific was unwilling to support its production—and with good reason. *Sun Pictures* was a hybrid text that combined geologic description and railroad promotion. The scientists who were its primary audience were not the men Durant and Huntington sought as investors, and the book's cost, twenty-five dollars, did not make it readily available to the general public.

By hiring Russell, the Union Pacific had laid the groundwork for an extensive set of photographs that would quickly surpass the size of the Central Pacific photographic archive. But, unlike the Sacramento railroad, the Union Pacific did not purchase the negatives and did not seem to want photographs exclusively for the purpose of documenting the railroad's progress. Long after the railroad had been completed, the Union Pacific continued to support Russell's photographic work. The company hoped that the presumed objectivity of photography could be used to persuade investors to purchase stock in the company and to entice emigrants to move west and develop the railroad land. While Russell's albums were intended to appeal to a well-heeled clientele, the Union Pacific used the popular press to engage a broad public. Ultimately, however, the fact that the company did not own the negatives frustrated the Union Pacific efforts. Russell maintained tight control over his photographic production after 1870, with the result that, while wood engravings from the Central Pacific stereographs were prominent in the travel guides that proliferated after the completion of the railroad, Union Pacific images were more likely to be derived from artist's sketches or stereographs by C. R. Savage.

4

REPRODUCING THE IMAGE

The directors of the Central and Union Pacific Railroads did not gather photographs simply for historical or self-congratulatory purposes. They used their photographic archives to further the interests of their companies. In the hands of the railroads, particularly the Central Pacific's, the representational force of the photographic archive was used to exercise a type of soft power. Less overt than lawsuits, threats, and bribes, the photographs persuaded rather than compelled. By mining their archives for images to reproduce in the popular press, the railroad companies hoped to influence the American and European public to support the project and to invest in their corporations. The problem the companies faced was how to control the press's interpretation of the images. As individual images were freed from the restraints of sequence and title, the photographs were reinterpreted to meet the needs of a variety of audiences. This new outlet for conveying corporate messages offered possibilities and perils. In the case of the transcontinental railroad, not all press coverage was equal.

Both Huntington and Crocker sent stereographs to members of the press. We know from his ledgers that Huntington sent a set to Uriah Painter, a reporter for the *Philadelphia Inquirer* and a disreputable lobbyist.[1] A year later, Huntington responded to an editor of the *Alta California:* "I should be very glad if I were able to accede to your personal request for the 'views' but regret to say that I have not any sets by me at present. I am expecting some more views from California soon and when they arrive shall take pleasure in forwarding them at your request."[2] There are no known examples of Durant

giving away Union Pacific stereographs to reporters, but he did oversee their reproduction in the illustrated press.

As the railroads struggled to raise capital, success depended as much on information and trust as it did on iron and equipment.[3] Between 1866 and 1869, the Central Pacific used stereographs to characterize its successes—the completion of a bridge, the depth of an excavation, or the progress of the rails into the mountains—and to distract from its failings. The Union Pacific chose not to document its construction in photography until 1868, save for a handful of stereographs made during the excursion to the hundredth meridian. In 1867, however, both companies placed favorable images in the press in an effort to increase public visibility, bolster the railroads' ability to sell securities, and exert political pressure. Although their efforts were most intense during the years of construction, the images continued to be published in the illustrated press and travel guides after the completion of the railroad.

For publications to serve the needs of the railroad effectively, however, the companies depended on the patina of accuracy and objectivity in the images and accompanying stories. If the public knew that the information was coming from the Central Pacific or Union Pacific, it would be, at best, suspect. Consequently, one of the challenges the corporations faced was how to place the photographs and information where they could do the most good but also shield the companies' role from the public. They accomplished this in a number of ways. They could directly pay the papers or reporters to publish the information or they could expand their advertising in the papers or, conversely, threaten to withdraw it. Alternatively, they could secretly hire freelance reporters favorable to the railroads, who submitted stories under their bylines. When it came to imagery, though, the scientific basis of photography made it an ideal medium to convey the railroads' message to the public. The veracity of the photographic image, even when translated to a wood engraving, was widely accepted by the public; by choosing which images to submit for publication, the railroads hoped to affect the content of the accompanying stories. These illustrations were particularly effective when paired with text from a favorable reporter. But even with all these controls, the Central Pacific and Union Pacific were not able to determine absolutely the meaning of the images when they left the archives and were published in the press. Removing a photograph from archival confines and placing it in the hands of a distant editor opened the image up to a variety of interpretations, and the farther away the editor, the more difficult it was to limit meaning.

THE ILLUSTRATED PRESS: THE CONSTRUCTION YEARS

The Union Pacific Railroad was the first to publish archival photographs in the popular press. In June 1867, *Harper's New Monthly Magazine* printed a travel narrative introduced by a remarkable wood engraving (fig. 61).[4] Titled *The Course of Empire*, it set the tone for the story and, ultimately, for the railroad as well. In the foreground, Indians and a dog move out of the picture plane as white settlers in covered wagons advance from

the center of the picture. Alongside these figures are other signs of European-American civilization: herds of cattle, and surveyors who measure, calculate, and divide the land. Behind them, wagons, a train whose smokestack is sending out a billowing black cloud, and the telegraph join the march west. The message is similar to the one Asher B. Durand had painted fourteen years earlier (see pl. 3)—the displacement of indigenous peoples by European-American progress and civilization—but here the movement is more aggressive. The Indians do not look on passively from wilderness perches as settlers alter the landscape; instead technology drives them off the land and forces them to flee to a space outside the frame.

The textual narrative that *The Course of Empire* introduces begins with two friends taking a train from Chicago to Fort Kearny, Nebraska. From there they ride in a stagecoach to Denver, characterizing the land in Nebraska as "destitute of trees and cultivation" and lacking both buffalo and elk. After the men arrive in Denver, the author awkwardly interrupts the story to insert a description that serves as a narrative advertisement for the Union Pacific Railroad. The facing pages that carry the railroad story are marked by four illustrations, three derived from Carbutt's stereographs: Durant standing on the track, the construction train, and the work crew laying rail (fig. 62). These images were relatively unimportant as souvenirs for the excursionists in October 1866, but they were the most useful images for the Union Pacific. The final image, an overview of Denver, suggests a future in which the broad, flat plain is sectioned and populated by townscapes. The four images together can be read as an imagined chronology from inspection of the roadbed, to railroad construction, to settlement.

But the generalized celebration of progress was only one of the messages carried by *Harper's Monthly*. Originally, the introductory image, *Westward, the Monarch Capital Makes its way* (see fig. 18), was a challenge to financiers to board the metaphorical train by investing and controlling the West through the agency of the railroad. In *Harper's Monthly*, however, Durant is identified and the stereograph is given a much more prosaic title, *The Vice-President Viewing the Work*. It conveys a message about authority: that Thomas Durant, the vice president of the Union Pacific, is directly involved in the construction of the railroad. The first sentence of the accompanying story makes this reading unambiguous: "The great Pacific Railroad, leading westward from Omaha, under the direction of Thomas C. Durant, Vice-President of the road, and General Granville M. Dodge as Chief Engineer, is being constructed up the Valley of Platte River with a rapidity hitherto unequalled in railroad building in America."[5] This was a gratuitous claim that was demonstrably untrue. Durant had been the de facto president of the company during the service of the former Union Pacific president, John Dix, but things had changed by 1867. Desperate for funds, in 1865 Durant sought new investors, among whom were the brothers Oliver and Oakes Ames and their circle of Boston-area capitalists. After Dix was appointed minister to France in 1866, the Union Pacific Board elected Oliver Ames president of the company. It was a position that Durant coveted, and he quickly found that he could not manipulate Ames as easily as he had John Dix. The

implication of the image, and the phrase "under the direction of Thomas C. Durant," can be understood, then, as a challenge to the recent election of Ames and as an assertion of authority that Durant no longer possessed.[6]

The text characterizes Durant as the power broker of the Union Pacific Railroad, and the picture layout supports this assertion by surrounding Durant with railroad work. At the bottom of the page, the editor has positioned an engraving of three men carrying rails. The image's placement visually associates Durant with the laborer's hard work, and his solitary figure, standing alone on the prairie, conveys the gravity of his responsibility. Directly opposite *The Vice-President Viewing the Work* is a reproduction of Carbutt's stereograph of the construction train. The final wood engraving on this double page spread, the fledgling town of "Denver City," plays a dual role. It implies that, under the direction of Thomas Durant, the Union Pacific Railroad is moving forward into the vast interior of America, and it brings the reader back to the primary narrative of the story about the two travelers.[7]

While the *Harper's Monthly* story appears to have served Durant's needs unambiguously, both the Union Pacific and Central Pacific struggled to control their messages in the popular press. Positive stories about construction, especially in East Coast newspapers, gained the attention of investors; negative stories certainly decreased confidence— and bond sales.[8] A November 16, 1867, *Harper's Weekly* article showed how directly newspaper stories could be managed. Titled "The Union Pacific Railroad," its opening paragraph characterized the transcontinental construction project as an effort by a single company:

> Attention has been frequently called in this journal to the marvels of engineering skill accomplished in the construction of the *Union Pacific Railroad*. No road of its length and magnitude was ever before contemplated, much less attempted. . . . Few roads were ever built in a country of greater natural difficulties, for it crosses the two highest ranges of mountains in the country. And yet, in spite of these natural, social, and financial obstacles five hundred miles of the road have been completed in an incredibly short period of time, at once astonishing the scientific and laboring world.[9]

The author makes no mention of the Central Pacific Railroad and suggests that the Union Pacific is the only company engaged in construction. A concluding sentence recommending Union Pacific Railroad bonds is evidence that the company subsidized

HARPER'S
NEW MONTHLY MAGAZINE.

No. CCV.—JUNE, 1867.—VOL. XXXV.

THE COURSE OF EMPIRE.

OVER THE PLAINS TO COLORADO.

WISHING to examine the mines of Colorado, and being also urged to do so by certain Eastern gentlemen, in order to see if capital could safely and profitably be invested there, two of us New Englanders, and a Mississippian, recently from California, left Boston together, bound for the El Dorado of the West, thus far the land of disappointment to the East —the far-famed Colorado Territory — to examine its gold and silver mines, or rather to ascertain if there really was such a country; and, if it did exist, to learn if any mines were there, as in the East both were being seriously doubted.

The month of August found us in Chicago, where the cholera had made its appearance; and although we had been but a few hours in the city, yet one of our number, while walking along one of its principal avenues, was so violently taken with symptoms of the disease as to require prompt medical attention. We were urged to leave the city immediately, which we

THE VICE-PRESIDENT VIEWING THE WORK.

boats are owned and many chartered by the Company for transportation purposes, and for 60 miles below and 150 miles above Omaha the banks of Missouri River are being depleted of timber for ties for the track; and all are sent forward to its terminus, together with construction materials of every kind, by regular freight trains, run for that purpose only. The track is laid in a substantial manner with long ⊥ rails.

no buffalo. Indeed, I have never seen a new country so destitute of game; and have seen more in one day in former years in Illinois, or in Northern New York or Maine, than one would be likely to see here in a year, unless the buffalo and elk resume their old stamping-ground.

From a description given in the work entitled "Across the Continent," by Mr. Bowles, who had seen Switzerland and the Alps, I had anticipated much pleasure from a view of the scenery. It was indeed a beautiful panorama of mountain scenery, with Long's Peak on the right, and far off to the south Pike's Peak, both towering to an elevation of more than 13,000 feet above the ocean, while Grey's Peak between them, far in the back-ground, appeared even higher than either, and all connected by mountains little inferior to these peaks in height; but they lack one very prominent feature of Swiss scenery—the snows and glaciers which add such infinite beauty and sublimity to the Alps.

The great Pacific Railroad, leading westward from Omaha, under the direction of Thomas C. Durant, Vice-President of the road, and General Granville M. Dodge as Chief Engineer, is being constructed up the Valley of Platte River with a rapidity hitherto unequaled in railroad building in America, even surpassing the Northwestern railroad in Iowa; for here have been laid 2½ miles of track in a single day, and 150 miles in 100 consecutive days. More than 12,000 hands are employed upon the road, procuring ties, grading, and track-laying. Nine saw-mills are owned by the Company, and more than a dozen hired, which are all constantly employed in getting out lumber. Steam-

Boarding-houses for construction parties are very appropriately placed on wheels. Some are constructed like a dwelling-house, with windows, doors, etc., on three platform cars, one being fitted up for a dining-room, another for a kitchen at one end and a reception-room at the other, and the third for sleeping berths. When all are run upon a temporary track for use, the middle or kitchen-car is placed transversely across the track, the truck-wheels being detached and the two other cars are brought against its opposite sides; all combined forming a comfortable dwelling-place.

The road is well supplied with engines and cars from our best Eastern works, and to meet the rapidly-increasing demand more are constantly being transported at heavy expense to Omaha. The necessary buildings at Omaha have been substantially constructed, as well as dépôts along the line of the road. The gradation for the reception of the track is fast being prepared, and by June of 1867 not more than

LAYING THE RAILS.

180 miles of staging will be required between Denver and Boston, whereas 15 months since there were some 800 miles, 600 in Colorado and Nebraska and 200 in Iowa. Onward is the destiny of this great Pacific Railroad until it meets the California division now being rapidly constructed, when our vast continent will be bound with iron bands.

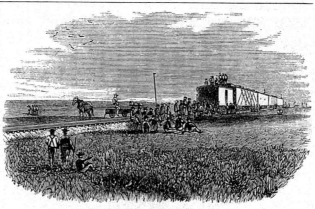

CONSTRUCTION TRAIN.

We remained but one night at Denver, which is located on the plains, on the South Branch of the Platte River, about 16 miles from the base of the mountains, and is being substantially built with brick structures on wide and well located streets; and with a branch railroad leading to it from the great Pacific line, and perhaps another from the Union Pacific road, over the Smoky Hill route, one of which without doubt will be extended up Clear Creek, it will become a flourishing place.

Again we found ourselves on Ben Holladay's stage-coach bound for Central City, which is situated about 35 miles westward by the traveled road from Denver, among the mountains on the gold mining belt of Colorado. Over undulating prairies covered with innumerable herds of cattle and horses grazing on the nutritious bunch-grass now unusually luxuriant on account of the great quantity of rain that has fallen this summer, our road lay, until we came to Golden City, a small place located where Clear Creek, a rapid stream of nearly 100 feet in width pours from its mountain home. Turning to the left our road soon entered a deep valley, on both sides of which rose abrupt, rocky hills, or rather mountains, in some places almost perpendicular, and often covered with peculiar pine-trees resembling the yellow pine of New England, and named the "Cembra Pine," by Nuttall. Up this valley and over the abrupt

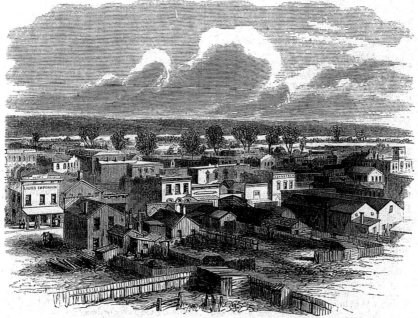

DENVER CITY.

the article and influenced the details of the text—as it had done earlier with an article in *Harper's Monthly*.

Presumably, *Harper's Weekly*'s misrepresentation was noticed by Central Pacific interests, because three weeks later the newspaper published a correction illustrated by four wood engravings derived from Central Pacific stereographs (fig. 63).[10] The *Harper's Weekly*'s editor arranged the images on a single page with a contour map and profile map of the railroad geography in the center.[11] The large-size images make a strong visual impact. Their meaning, however, is ambiguous. Undoubtedly, the Central Pacific hoped that the sequence would be read as the triumph of the railroad over the Sierra Nevada. In the upper left, Chinese laborers haul rock from the summit tunnel, the last substantial barrier to the successful completion of the railroad in the mountains. The accompanying text notes that more than ten thousand Chinese were at work on the Central Pacific construction. The next two pictures put a positive spin on railroad progress: the first was a stereograph from the Sierra that looked down the American River canyon into "Giant's Gap," and the second was a view of a locomotive at Cape Horn, silhouetted fourteen hundred feet above the American River canyon. In the stereographic original of the latter, the three-dimensional qualities of the stereograph exaggerated the distance between the foreground locomotive and the deep canyon beyond (see fig. 9). The wood engraving based on it, however, flattened this spatial drama into a simple backdrop. Without the stereoscopic depth, and competing for attention with the other images, Hart's photograph of the locomotive loses much of its pictorial power. Nonetheless the presence of a locomotive in the Sierra Nevada offered reassurance to those who had doubted the competence of the company. The pictorial arrangement concluded with a picturesque engraving of Donner Lake.

One could read the *Harper's Weekly* picture sequence of workers, landscape, locomotive, and wilderness as affirming the success of the railroad, but it also reminded readers of nature's destructive power and of the formidable obstacles that remained. In fact, the Central Pacific was about to complete the tunnel above Donner, but there were no photographs of the event. Instead, the image of the Chinese, exhausted, draws attention to the granite rock at the western summit, a fact supported by the engraving of Donner Lake and the *Harper's Weekly* text, which commented upon "the Herculean nature of the work" that required excavation though solid granite. Even more destructive to the railroad's message of progress, the story does not call the reader's attention to the triumphal locomotive above the American River. Instead, it characterizes the engraving of "Giant's Gap" as "a gigantic opening in the mountains, [showing] the rugged nature of the country," and the profile map delineating the dramatic and sharp incline of the Sierra Nevada.

Comparing the Central Pacific's four-image spread to the wood engravings of the Union Pacific published six months earlier, one understands why Huntington distrusted the press. In the *Harper's Monthly* layout, the company vice president oversees the work. Train cars carrying equipment and supplies support gangs of laborers, who work efficiently

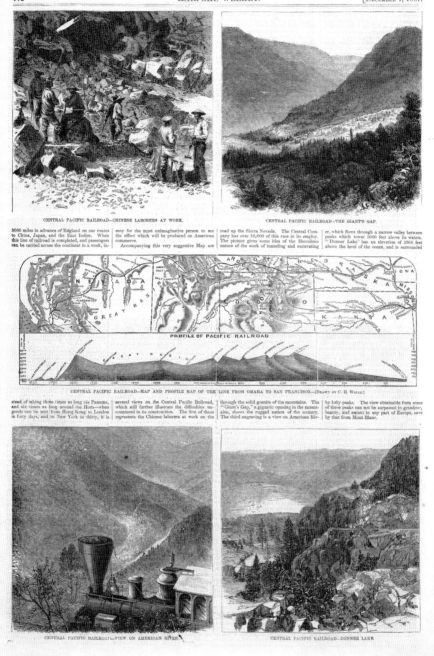

CENTRAL PACIFIC RAILROAD—CHINESE LABORERS AT WORK.

CENTRAL PACIFIC RAILROAD—THE GIANT'S GAP.

3000 miles in advance of England on our routes to China, Japan, and the East Indies. When this line of railroad is completed, and passengers can be carried across the continent in a week, instead of taking three times as long via Panama, and six times as long around the Horn—when goods can be sent from Hong-Kong to London in forty days, and to New York in thirty, it is easy for the most unimaginative person to see the effect which will be produced on American commerce.

Accompanying this very suggestive Map are several views on the Central Pacific Railroad, which still further illustrate the difficulties encountered in its construction. The first of these represents the Chinese laborers at work on the road up the Sierra Nevada. The Central Company has over 10,000 of this race in its employ. The picture gives some idea of the Herculean nature of the work of tunneling and excavating through the solid granite of the mountains. The "Giant's Gap," a gigantic opening in the mountains, shows the rugged nature of the country. The third engraving is a view on American River, which flows through a narrow valley between peaks which tower 5000 feet above its waters. "Donner Lake" has an elevation of 5964 feet above the level of the ocean, and is surrounded by lofty peaks. The view obtainable from some of these peaks can not be surpassed in grandeur, beauty, and extent in any part of Europe, save by that from Mont Blanc.

PROFILE OF PACIFIC RAILROAD

CENTRAL PACIFIC RAILROAD—MAP AND PROFILE MAP OF THE LINE FROM OMAHA TO SAN FRANCISCO.—[Drawn by C. H. Wells.]

CENTRAL PACIFIC RAILROAD—VIEW ON AMERICAN RIVER.

CENTRAL PACIFIC RAILROAD—DONNER LAKE.

FIG. 63

Illustrations for "The Central Pacific Railroad," *Harper's Weekly,* December 7, 1867, 772. Wood engraving, 16¼ × 12¼ inches (page). This item is reproduced by permission of the Huntington Library, San Marino, California.

in teams laying track on straight, flat prairie. In contrast, the Central Pacific workers are few, scattered, and seemingly disorganized. They rest, weary of their backbreaking task of tunneling through solid granite. And the railroad-building project is shown surrounded by a vast, mountainous landscape, not by equipment and supplies. These problematics of publication, however, did not deter E. B. Crocker, who actively sought venues for the publication of images from the Central Pacific photographic archives.

Both Huntington and Crocker understood the importance of news coverage, but they differed on the best way to use the power of the media. Huntington feared he could not control meaning and, consequently, distrusted the press. If stories could not be avoided, he wanted to maintain tight control over the facts, releasing them grudgingly and only when it served the direct interests of the company. Crocker, on the other hand, courted press coverage. In 1867, he asked Leland Stanford to pass along a story to the Associated Press agent in San Francisco and, presumably, paid the newsman as an incentive to send the report on the wire to the East Coast. When Stanford failed to act, Crocker took it upon himself to provide the agent with information.[12] Two months later, Crocker acted even more decisively, writing to Huntington:

> There is a Mr. Thos. Magee in San Francisco who is quite a good writer and he has been
> writing a good many articles for papers here and in NY. I presume you have noticed those
> in the NY papers. We pay him for what he writes about our road. I see that he gets it cor-
> rect. He would like to correspond for the *Tribune* and would notice our road from time to
> time in his letters. If you could manage in any way to get him appointed or authorized to
> act as correspondent it would be a good point for us. He writes well, brief, and honestly
> and entertainingly. . . . I think I will get him to write a letter for the *Tribune* from which
> they can judge his ability.[13]

Crocker understood that the railroad's reassuring messages would be undercut if the publication or the public realized they were produced by the company. Consequently, he advised Huntington about introducing Magee's work to the *Tribune:* "Perhaps if you applied personally they might think that you had a RR object, but I know you can find someone to do it."[14] For Huntington, press coverage was a necessary evil; for Crocker, it was a new possibility for framing the railroad project and, by extension, for influencing the financial markets critical to the Central Pacific's success.[15]

Magee soon became an agent for the Central Pacific, writing frequent stories about the importance of the transcontinental railroad, the successes of the Central Pacific, and the deficiencies of the Union Pacific. His public relations efforts included the Central Pacific stereographs, as can be seen in his 1867 letter to Mark Hopkins:

> Sir
> Enclosed is a letter for the *New York Tribune* which if you will take the trouble to forward
> to Mr. Huntington and ask him to get presented to the editor of the *Tribune,* by some

acquaintance of the latter, either by letter or in person, I think will be acceptable. I hope it will please you. . . .

I received a letter from Judge Crocker yesterday and 14 photographs of scenes along the line of your road, the boldest of which he wished me to send to the *London News;* but, as you are aware, I have already sent specimen pictures to this paper and *Harper's Weekly.* The pictures the Judge sent me I will leave with Mr. Richardson.[16]

Magee's inability to place the photographs in the paper did not stop Crocker's efforts. Frustrated by his inability to get illustrated press coverage in New York or London, Crocker turned to the local press. He wrote to Huntington:

The proprietors of the *Sunday Mercury,* a literary paper in S.F., propose to illustrate it with Cal. views, & want to put in views of the R.R. & they say they can or have arranged it to send on the engraved blocks to *Harper* or *Leslies* where they will be republished. We [are] to pay cost of engraving $40 each. We think of trying 10 or 12 views. Of course there will be a proper descriptive article with each. They may not be able to get them re-published in N.Y. Do you think you could—you furnishing the engraving & the descriptive article?[17]

Huntington, his eye always on the bottom line, dismissed the idea. "I think it would not pay, as we are not selling any securities in Cal. and the paper is not taken on this side, and I do not think that the *Harper's* would republish it, and *Leslie* is only taken by women and children."[18]

Huntington was right about the uselessness of publicizing the transcontinental project in the West. Few bonds were selling on the West Coast; San Francisco bankers knew all too well the financial difficulties the company faced. But Crocker proceeded anyway. He paid the cost of engraving, and the *California Mercury* agreed to print them. By overseeing the publication of the images and the accompanying text, Crocker hoped to control the meaning, just as Durant had done in *Harper's Monthly.* The wood engravers based their work on Hart's stereographs, but each reproduction included subtle changes, adding a locomotive, completing a railroad line, or minimizing the effect of the construction on the surrounding landscape.[19]

One of the men Crocker hired was the California landscape painter William Keith.[20] Keith's *Donner Lake and Donner Pass* offers an example of how an engraver transformed stereographs into publishable images (fig. 64).[21] The composition is based on Hart's 1867 stereograph *Railroad on Pollard's Hill, 1,100 feet above Donner Lake* (fig. 65), but the new medium engaged a different audience.In the stereograph, tree stumps lie in the foreground plane while the lake occupies the middle ground. In the distance, a straight line has been cut into the mountainside. The cascade of earth marks the location of the company's construction crews and the direction of the track. Keith's wood engraving naturalizes the railroad's presence in the mountainous panorama by eliminating the foreground detail and minimizing the effect of construction on the mountainside,

FIG. 64

Donner Lake and Donner Pass, in *California Weekly Mercury,* October 13, 1867, 1. Wood engraving, 20½ × 13¼ inches (page). Courtesy of the California History Room, California State Library, Sacramento, California.

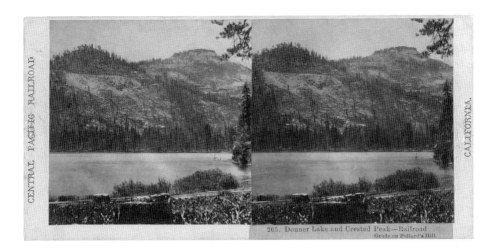

CENTRAL PACIFIC RAILROAD

CALIFORNIA

205. Donner Lake and Crested Peak—Railroad
Grade on Pollard's Hill.

FIG. 65
Alfred Hart, *Railroad on Pollard's Hill, 1,100 feet above Donner Lake* (no. 205), 1867. Albumen stereograph, 3½ × 7 inches. Union Pacific Railroad Museum.

offering a thin straight line instead of a wash of whitened debris. The engraved land-scape is aestheticized in other ways as well. Clouds billow in the sky, the surface of the lake reflects the mountains, and boaters float quietly on the lake's placid, glassy surface. The engraving also completes what was under construction in the stereograph. A train, as tiny and nondescript as Durant's locomotive in *Progress,* speeds above the boater's heads, a creative fiction that belies the fact that the track had not yet been completed. Echoing the stereographic sequencing from a year before, the wood engraving refashions the fearsome natural forces associated with the summit of the Sierra Nevada and transforms them into a location for recreational boating.

Between October 13 and December 29, 1867, the *California Weekly Mercury* published ten stories about the Central Pacific Railroad on the front page of the paper, each with a large engraved illustration accompanying a lengthy text, all of which had been care-fully supervised by the Central Pacific. *Horse Ravine Wall, and Grizzly Hill Tunnel,* for example, reproduces the composition found in the stereograph of the same name (see fig. 17), but the published engraving adds a train, which alters the scale of the landscape (fig. 66).[22] One of the intentions behind the stereograph was to demonstrate the high quality of the Central Pacific construction by showing the massive retaining wall that held up the track bed and would soon be hidden beneath the earthen slope. Published in the *California Weekly Mercury,* however, the message is one not of process but of prod-uct. The engraver failed to understand the temporary nature of the half-filled earthen retaining wall, representing a finished railroad with an engine and six cars emerging from the tunnel. The train is tiny and out of proportion, making the mountains, cut, and wall appear more imposing than they actually were. In this case, the exaggeration

FIG. 66

Horse Ravine Wall and Grizzly Hill Tunnel, in *California Weekly Mercury*, December 1, 1867, 1. Wood engraving, 20½ × 13¼ inches (page). Courtesy of the California History Room, California State Library, Sacramento, California.

of scale supports the textual narrative, which, in turn, justifies the corporate profits that, by late 1867, were beginning to attract public attention. The article describes the railroad's challenges:

> The adjoining picture, like those which have preceded it, illustrates the difficulties which had to be overcome in building a railroad over the Sierra Nevada. The pictures which we have given of striking scenes on the road better illustrate the obstacles overcome than any description could. The exhibition in the MERCURY of the scenes named, has not succeeded in one of the objects we wished to accomplish if it has failed to awaken admiration of the enterprise, the energy, and the industry, which have characterized those who took the great work in charge of building our half of the continental railroad.[23]

For the Central Pacific, both the difficulty of construction in the Sierra and the company's success were important. But also important, and evident in the wood engravings, was the ability of the railroad to blend into the surrounding landscape.

The Central Pacific struggled to exert some control over the character of illustrated stories, mining the archive to change meaning to suit different audiences. The translation of stereographs into wood engravings, the addition of text, and the relationship among images on the page, all contributed to new potential meanings for the company's stereographs. On January 11, 1868, the *Illustrated London News* printed two wood engravings and a short article, "The Central Pacific Railway, North America" (fig. 67).[24] The text provided seemingly objective information about the railroad and described a landscape few had seen. The story was illustrated with two wood engravings based on two Hart stereographs: *Long Ravine Bridge from the Top of Cape Horn* and *Donner Lake*. The top engraving showed a large wooden trestle in the panoramic mountainous landscape. The particular stereograph on which it was based was the first of four sequential images in which the bridge is carefully surveyed, detailed, measured, and given substance in a series of views (see figs. 46–49).[25] In the archive, the images provide evidence of the quality of construction, the progress of the railroad, and the Central Pacific's success in meeting the geographical challenge of the mountains.

The accompanying text, presumably written by Thomas Magee, signals a shift in interpretation, telling the reader that the illustration of the Long Ravine Bridge gives evidence of the railroad engineers' ability to construct trestles of "economical proportions and great stability." The proportions and stability were evident in the stereographic sequence, but this image is too distant to permit the reader to judge either. In the *Illustrated London News*, the particular qualities of the Central Pacific construction are replaced by the reading of the image as "type"—an interchangeable example of bridges built by the Central Pacific in the Sierra. The intended meaning in this case is carried by the combination of text and image. In addition to conveying details about the progress and quality of construction, the elevated, panoramic perspective provides information for investors about the availability of raw materials near the railroad landscape.

THE CENTRAL PACIFIC RAILWAY, NORTH AMERICA.

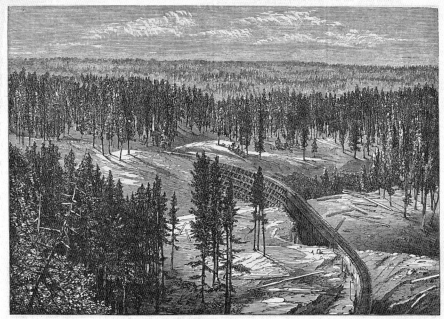

LONG RAVINE BRIDGE.

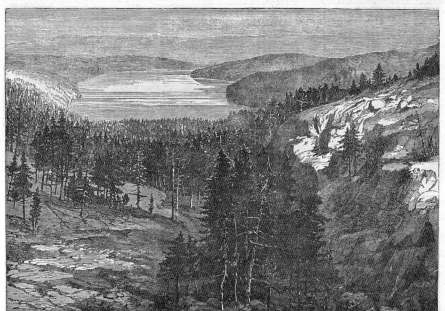

DONNER LAKE.—SEE PAGE 42.

FIG. 67

Illustrations for "The Central Pacific Railway, North America," *Illustrated London News,* January 11, 1868, 37. Wood engraving, 15½ × 11½ inches (page). George A. Smathers Libraries at the University of Florida.

A less subtle shift of meaning occurred when readers juxtaposed the Long Ravine Bridge with the image of Donner Lake. When Hart made the stereograph, Donner Lake represented a milestone and a challenge in building a railroad over the Sierra Nevada. In *Harper's Weekly,* Donner Lake carried a similar message about the sublimity and power of nature. In the *Illustrated London News,* however, the engraver cropped the stereographic model to bring the viewer closer to the lake, collapsing space and allowing the eye to sweep through the center of the picture to the mountains in the background.[26] Ignoring the significance of the lake as a milestone for the railroad, the text framed the reader's response to the images, providing details about the geography, geology, and the fauna of the mountains: "The second view is from the summit of Donner Pass, in the Sierra Nevada looking eastward. Donner Lake lies below, and the Washoe silver-mining regions are seen in the distance."[27] In this description, the lake is secondary, an aestheticized foreground for the main story—the mineral wealth of the Comstock Lode—which cannot be seen and which lies on the other side of the mountains. This interpretation of the image seems calculated to aid the Central Pacific Railroad in its search for investment capital in England. The image-text combinations in the *Illustrated London News* reveal a landscape managed by an aggressive and competent corporation and forecasts a lucrative return on investment.[28]

A month later the Parisian newspaper *L'Illustration* published the first of a series of illustrated articles portraying the entire length of the transcontinental railroad in an unprecedented series of nine stories illustrated by fifty-two wood engravings.[29] How these came to be published is not certain, but it appears that the Union Pacific Railroad supported them either directly or indirectly. The author of the texts was Wilhelm Heine, who immigrated to the United States in 1849 and is best known for his work as the official artist of Commodore William Perry's expedition to Japan in 1853.[30] He served as a topographer and officer in the American Civil War, after which he returned to Europe. There he found work as a secretary at the American consulate in Paris, where John Dix, the titular president of the Union Pacific Railroad from 1863 to 1868, was the American minister. Given these circumstances, it seems likely that, like Magee, Heine was a railroad man.[31]

The first installment of the *L'Illustration* articles includes six wood engravings, five of which were based on Carbutt's stereographs (fig. 68).[32] The text describes the Union Pacific excursion, but the images serve a different purpose. They were originally commissioned to act as keepsakes of a particular event, but in the pages of the newspaper they are transformed into projections of an imagined future. The picture at left center, the only image not derived from a photograph, is an imagined view of the Omaha train station after the railroad is in full operation. Spread across the surface of the image is an array of eastern and western "types"—men in top hats and women in gowns, squaws with papooses, well-dressed traders, and mountain men in buckskin jackets, all of them crowding the train platform. The train station bustles with commercial activity as men unload bales and bundles into a building identified as the Union Pacific Railroad Depot.

LE

CHEMIN DE FER

du

PACIFIQUE

Le chemin de fer du Pacifique !.. Voilà, à l'heure qu'il est, le grand œuvre qui attire toute la sérieuse attention de l'Amérique du Nord. Il n'y a sur ce point ni divergence d'opinion, ni division entre les États, ni incertitude dans les esprits. D'un bout à l'autre de l'Union, une même pensée, une même ardeur pousse les populations vers le même point, et jamais les Américains n'ont dit avec une conviction plus profonde : *Go ahead!*

Ouvrir le chemin de fer qui unira l'Atlantique au Pacifique, telle est l'entreprise nationale, grandiose, civilisatrice qui s'accomplit avec une activité qui tient du prodige, et nous sommes heureux de pouvoir mettre sous les yeux des lecteurs de l'*Illustration* tous les faits importants qui se rattachent à ce gigantesque travail, car le chemin de fer du Pacifique est une de ces conquêtes qui

Vue générale de la ville d'Omaha.

La station d'Omaha.

n'intéressent pas seulement un peuple. Sans doute, pour les raisons les plus graves, les États-Unis éprouvent le besoin de se mettre en communication directe avec le grand État de Californie, où ils ne pouvaient se rendre que par le Cap Horn ou par l'isthme de Darien. Mais indépendamment de cet intérêt national et patriotique pour les États de l'Union, le chemin de fer du Pacifique est appelé à jouer un rôle prédominant dans les relations de tous les peuples. Par l'influence qu'il est appelé à exercer sur les rapports de l'ancien et du nouveau monde,

par l'immensité des régions qu'il va rattacher au mouvement de la grande république américaine, par les voies rapides qu'il va incessamment ouvrir à travers le Pacifique, vers la Polynésie, le Japon, la Chine et les Indes, on peut dire que cette percée de toute l'Amérique du nord se rattache au progrès général du monde et qu'il sera l'un des plus puissants moteurs de notre civilisation moderne. On dirait qu'il est comme le dernier corollaire de cette loi providentielle qui pousse toujours vers l'Occident les peuples civilisés. De l'Orient à la Méditerranée, de la Mé-

LE CHEMIN DE FER DU PACIFIQUE — *Préparation des traverses.*

FIG. 68

Illustrations for W. Heine, "Le Chemin de Fer du Pacifique," *L'Illustration*, February 29, 1868, 132–33. Wood engraving, 14¾ × 10½ inches (each page). Getty Research Institute, Los Angeles (84-S259).

diterranée à l'Occident, de l'Occident en Amérique et de l'Amérique au Pacifique pour retourner au berceau des Indes, telle a été la marche de l'humanité, et les États-Unis, en jetant un chemin de fer à travers tout un continent, ne font que lui obéir en lui ouvrant sa dernière voie.

Cette entreprise est donc, à tous les points de vue, attachante, curieuse, digne de fixer l'attention de l'Europe comme de l'Amérique, autant que le canal de Suez. Tout est nouveau, tout est intéressant, tout est saisissant

Le débarcadère des bateaux à vapeur, à Omaha.

dans ce chemin de fer qui s'exécute en dehors des conditions communes des autres lignes. Immensité de la voie, — 1,800 milles! Énormité du capital engagé, — 750 millions de francs! — Activité déployée dans les travaux, nouveaux procédés d'exécution, forêts vierges, pays inconnus, régions inhabitées, clairières occupées par les tribus sauvages, travaux d'art, tout, dans cette vaste opération, porte le cachet de ces créations hardies qui font honneur au génie de l'homme. L'Europe peut apprécier la

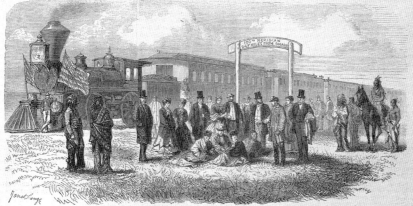

Une station dans la Prairie: Le centième méridien.

grandeur de l'œuvre par un seul terme de comparaison : de Omaha, dans l'État de Nebraska, point extrême de la civilisation américaine, à Sacramento, en Californie, il y a, nous l'avons dit, 1,800 milles, soit environ la distance comprise entre Lisbonne et Saint-Pétersbourg.

Et cette trouée immense s'accomplit à travers des pays inhabités. Il y a sans doute entre Omaha et la Californie quelques points intermédiaires. On a, par exemple, la ville de Denver, située sur le territoire de Colorado, au sud de la rivière Platte. Ce territoire

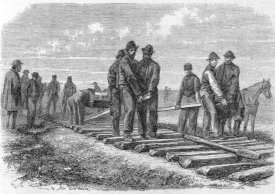

LE CHEMIN DE FER DU PACIFIQUE. — La pose des rails.

est peuplé d'environ 50,000 habitants, attirés par les riches mines d'or et d'argent de ces régions. Après Denver on trouve encore Salt-Lake City, capitale du territoire de l'Utah, dans le Grand-Bassin et Carson City, capitale du territoire de Nevada, à l'est de la Sierra-Nevada.

Mais ce ne sont là que des points imperceptibles dans le champ de cette vaste opération, et l'on peut dire que le chemin de fer du Pacifique s'ouvre, sur presque toute sa longueur, à travers un désert habité seulement par des sauvages et des bêtes fau-

Although Indians are at the center of the composition, the engraver marginalizes them. Amid the clamor of enterprise, the Indians stand and sit passively, as out of place and anachronistic as the trapper in buckskin with whom they seem to converse.

The marginalization of indigenous inhabitants is also the implicit message of the center image on the right, where the wood engraver altered Carbutt's stereograph of celebrating excursionists posing beneath the sign of the hundredth meridian (see fig. 14). Reducing the number of excursionists and collapsing the space between the group and the locomotive has given the train greater pictorial power. The most noticeable change, however, is the addition of Indians, their poses borrowed from other Carbutt stereographs, on the right and left sides of the excursionists. They stand apart, physically and conceptually framing the posing tourists; they look not at the camera but at the group of railroad dignitaries gathered under the sign. The Indians' banishment to the edges of the composition, their passivity in the face of these new invaders, and their gaze at the tourists all suggest European-American ascendancy and the transformation of this landscape by the railroad. On the pages of *L'Illustration*, Carbutt's celebratory images of progress become future projections of commercial enterprise and native displacement.

The implication that the railroad would push out indigenous inhabitants had multiple precedents in American painting and in wood engravings published in the illustrated press, such as "The Course of Empire" in *Harper's Monthly*. How this message would have been understood in Europe is less clear. For Parisians reading the *L'Illustration* story, the prominence of Indians may well have highlighted how exotic and primitive the North American West was in the 1860s. The accompanying text appears to acknowledge the problem that readers might interpret the images as depicting scenes so alien that investment would seem foolhardy. Seeking to mitigate the exoticism of locomotives and Indians, the passage explains to its French readers that, unlike in Europe, where the railroad links existing populations and large cities, in the United States the train precedes settlement, and that farms, industry, and cities will follow the railroad.[33]

The March 14 installment of "Le Chemin de Fer du Pacifique" reiterates this idea of the railroad as a precursor to commercial and economic development.[34] The text that introduces the picture spread discusses the importance of Cheyenne as a new city that grew because of the railroad, and it stresses the mineral wealth in the surrounding area. Turning the page to the illustrations, the reader finds that Salt Lake City stands in for Cheyenne, for which the author states he has no photographs. This transposition works well for the railroad; Salt Lake City was a much more developed urban space than was Cheyenne. This time a double-page spread of nine illustrations, without text, juxtaposes images of emigrants, scenes in and of Salt Lake City, and an unpopulated wilderness.[35] These images present the transformation of wilderness into a thriving and productive civic space.

Although generally positive about the Central Pacific, *L'Illustration* confined most of the images to a single page, rather than the two pages allotted to the majority of the Union Pacific narrative. In contextualizing the Central Pacific images, the text and image combinations are less involved with the theme of the railroad leading to settle-

ment than they are in promoting the mineral wealth of Nevada and California. In his article of April 11, for example, Heine appropriates a variation of the oft-reproduced stereograph of Cape Horn (fig. 69).[36] Instead of technological triumph, this time the image is used to suggest the mineral wealth of the North American West: "It is on the banks of the American River, at the same site that we have illustrated, that one of the greatest events in the history of America—in the history of the world—came about a short time ago. In 1847, a poor Mormon miner, who had nothing at all for a weapon except his pick and shovel, discovered gold."[37] The author ignores the locomotive perched fourteen hundred feet above the American River, choosing instead to discuss the advances of gold-mining technology. Although the details are incorrect, Heine unites the text and the wood engraving by explicit references to the American River and its association with John Marshall's discovery of gold. The interpretation of this image in terms of the mineral wealth in the West is reminiscent of the *Illustrated London News'* reframing of the stereograph of Donner Lake, and it supported both railroad companies' attempts to sell corporate bonds in Europe.

Not all the stories were so positive. The first article in *L'Illustration* to include the Central Pacific squeezes four wood engravings onto a single page: a scene of the Sierra wilderness, a train in the broad panorama of the mountains, a snow shed under construction, and wagons at Cisco. Heine expresses admiration for the ingenuity of the snow sheds, but the knowledge that the snow was so deep that it required mitigation must have made investors uneasy. Even worse for the Central Pacific's attempts to raise capital in Europe, many of the stories mentioned the problem of deep snow in the Sierra. For example, *L'Illustration*'s story on April 4 included an illustration of a railroad snowplow; as a lead-in to discussing the snowplow's effectiveness, Heine recounts Fremont's exploration in 1843–44 and the heavy Sierra snowfall that almost stranded and killed the exploration party. Heine goes on to exaggerate the scale of the trees and mountains, and the text describes the Sierra Nevada landscape as "savage and austere."[38]

Like the photographers who created the images and the manufacturers who sold rail and equipment, newspaper reporters worked for hire. In spring 1868, shortly after *L'Illustration* published its picture stories about the transcontinental railroad, Heine made an appointment to meet with E. B. Crocker in Sacramento. Crocker described the encounter in a letter to Huntington:

> Friend Huntington,
> Inclosed [sic] I send you [a] letter recently received from Wm. Heine which explains itself. I also inclose copy of my reply [?].
>
> The papers & pamphlets he sent me have ably written articles relating almost entirely to the Union Pacific R. R. with only brief allusions to our Co. As you see by his letter the Union Pacific Co. pay him for these things. You can judge best whether he can serve the Union Co. & ourselves at the same time and do us justice and what his services in that line may be worth to us.[39]

lonnées tout le long de son parcours. Enfin, au lieu de se contenter de prendre dans les placeros le sable, c'est-à-dire la roche triturée par l'action des agents atmosphériques, on broie le quarz que l'on va chercher dans les profondeurs de la terre. L'industrie d'habiles ingénieurs fait en quelques heures ce que la nature abandonnée à elle seule aurait mis peut-être des centaines de siècles à accomplir!

Aussi les riches Californiens n'ont-ils point tardé à avoir leurs lieux de plai-

LE CHEMIN DE FER DU PACIFIQUE. — Le lac de Cristal.

sance, surtout depuis l'ouverture du chemin de fer. Quoique la station se trouve à quelque distance, Crystal Lake est devenu un rendez-vous de sportsmen. Les conifères qui enveloppent de toutes parts la surface argentée de ce lac ont un aspect grandiose. Ces géants forment comme une espèce de bordure autour de cette nappe d'une transparence merveilleuse. Car jamais cristal n'a mieux mérité son nom que ces eaux fraîches peuplées de truites délicieuses. Une route, praticable

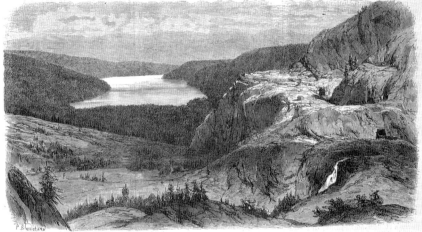

Donner Lake.

pendant toute la belle saison, permet aux chariots d'apporter tous les objets nécessaires à la vie civilisée, raffinée même. On trouve dans ce joli cottage, dont la Suisse pourrait être jalouse, une cuisine délicieuse, des lits parfaits, un ameublement presque somptueux, des pianos assez bons et quelquefois d'accord. Les prix ne sont même point trop californiens. Sans s'y ruiner, un touriste européen peut décemment y aller en villégiature.

Tous les lacs, qui sont nombreux dans cette contrée, n'ont point la même fortune. Donner Lake, situé dans un district plus rude, a gardé entièrement tout son aspect sauvage. Il n'y a point de maison de plaisance qui égaie ses bords, à peu

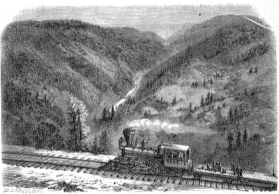

American Canyon, vue prise du remblai de Cape Horn. — (Voir page 235.)

près aussi déserts qu'ils l'étaient du temps des sauvages.

Nous avons essayé de donner, dans notre dessin, une idée de cette nature grandiose, austère. A droite, on voit l'entrée de deux tunnels, séparés l'un de l'autre par un immense ravin, au fond duquel on a heureusement trouvé moyen de tracer la voie. La proportion que nous avons donnée aux locomotives qui roulent sur le premier plan fera juger ce que sont les arbres géants qui cachent une partie des bords du lac, surtout ce qu'est le lac lui-même, dont les eaux se perdent dans un interminable horizon.

W. Heine.

(La suite prochainement)

FIG. 69

Illustrations for W. Heine, "Le Chemin de Fer du Pacifique," *L'Illustration*, April 11, 1868, 237. Wood engraving, 14¾ × 10½ inches (page). Getty Research Institute, Los Angeles (84-S259).

Huntington replied, as he had to all of Crocker's questions about the press, that he didn't think paying Heine to write stories for the Central Pacific would do the company much good. He told Crocker he would give the reporter a pass on the railroad, but nothing more.[40]

As the stereographs were removed from the photographic archive and published in new contexts, different meanings emerged that often could not be constrained by the corporation. As Huntington feared, even well-meaning reports contained information potentially damaging to investor confidence. E. B. Crocker kept abreast of the published reports, asking Huntington to clip stories and send them to Sacramento so that he could paste them in a scrapbook. He seemed to feel that press coverage, like photographic coverage, could be controlled by selecting the right person, tracking the stories, and publishing often. If there was a misunderstanding, like a mention of snow sheds, the wealth of information about the progress of the railroad and the promise of future economic prosperity easily overcame any narrow misinterpretation. The Union Pacific Railroad also paid for press coverage, but until late 1868 that company had a much smaller archive of photographs from which to draw. Besides, Durant seems to have been preoccupied by the immediate problems of asserting his power within the organization and of maximizing railroad mileage to assure government largess. With the completion of the railroad and the availability of Russell's photographs, Union Pacific photographs found their way more often into the illustrated press.

THE ILLUSTRATED PRESS: PROMONTORY

None of Alfred Hart's images of Promontory were reproduced in the papers, but Russell's and Savage's were used. *Frank Leslie's Illustrated Newspaper*, for example, reproduced two of Russell's photographs on the front cover of its June 5, 1869, issue (fig. 70; see fig. 25 for the source of the top image).[41] Editors selected Russell's photograph of the dignitaries posing before the ceremonies, placing the image directly beneath the newspaper's banner. The engraver rendered only the center of the photograph in order to give the reader a much closer view of the faces of the directors and dignitaries gathered around the last tie, which can be seen in the foreground. To the right of the woman in the center, a man holds an immense spike, a topic taken up by the text inside the newspaper. The caption identifies Durant and Stanford and reinterprets the photograph as the moment of the driving of the last spike. The engraver eliminated any reference to the locomotives and added a mountainous landscape in the background; *Leslie's Illustrated* was interested in men, not machines. This image reinforced the idea that individuals were the primary factors in the successful battle against the mountains, which differed significantly from the Central Pacific's implicit glorification of the locomotive as the symbol of transformation.

If the top image presents the managers of the corporations responsible for the success of the railroad, the bottom image associates that effort with divine sanction. The

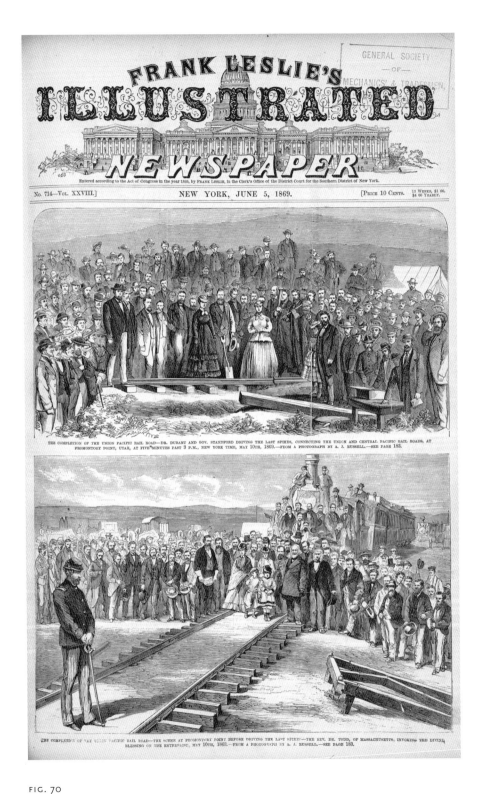

FIG. 70
Frank Leslie's Illustrated Weekly, June 5, 1869, 179. Wood engraving, 15¾ × 11¼ inches (page). This item is reproduced by permission of the Huntington Library, San Marino, California.

photograph was one of several group portraits of Union Pacific and Central Pacific officials posed after the ceremonies. The caption in *Leslie's Illustrated*, however, creates a new narrative for the image: "The Completion of the Union Pacific Railroad—The Scene at Promontory Point before the Driving of the Last Spike—The Rev. Dr. Todd, of Massachusetts, Invoking the Divine Blessing on the Enterprise, May 10, 1869." The caption provides a meaning for the image, as the representation of a particularly dramatic moment, but this was an editorial creation. In this engraving, and in Russell's photograph, the track and ties appear complete, an indication that the photograph was made on a different section of track or after the ceremonies and the laying of the last tie. Furthermore, eyewitness accounts suggest that the invocation and the ceremonies were chaotic and crowded (see fig. 24). The presence of the military also suggests this is a photograph made later in the day. In the photograph a group of soldiers stands at attention on the left side of the image. Although most of these figures were removed by the engraver, one can still see the military presence in the figure standing in the foreground and in the smaller figures on the right side. One participant, Captain John Currier, noted in his diary that the soldiers lined up for their picture after the speeches and ceremony ended.[42] This textual framing of the image as a moment of prayer, and the prominent inclusion of the military, reminded *Leslie's* readers of the war and the railroad's role as a socially curative force.

A week earlier, *Leslie's Illustrated* had published a small wood engraving that portrayed a handshake between two locomotives labeled "San Francisco" and "New York" (fig. 71).[43] In a motif that had become commonplace, buffalo and Indians run away from the trains and out of the picture. The caption interprets the gesture of friendship between the two trains with a question of national importance: "Does not SUCH a Meeting Make Amends?" The emphasis on *such* reminds readers what an engineering triumph the transcontinental railroad was. The idea of amends refers not only to the struggles between the two railroad companies but also to the reconciliation of the Union after the Civil War. This implicit reference suggests that the success of the transcontinental railroad served as a sign of national redemption. The center of the June 5 issue of *Leslie's Illustrated* echoed these themes with a large double-page image of Russell's photograph *East and West Shaking Hands at Laying Last Rail* (see pl. 1) and its implicit reference to the end of hostilities and the unification of the country.

Harper's Weekly struck a similar theme and also highlighted the railroad's potential as national economic engine.[44] A large central image is spread across two pages and reiterates the themes explored in the stereographs, popular prints, and the illustrated press during the years of railroad construction (fig. 72).[45] The artist depicts a train moving from right to left, east to west, about to cross a bridge and move directly into the viewer's space. On the right side of the train, Indians leave their teepees, staring in awe at the locomotive, as they move into the background and out of the picture. They cede their space to the oncoming civilization represented by the train. On the left, miners wave and gesture at the locomotive, welcoming the benefits promised by the new railroad technol-

FRANK LESLIE'S ILLUSTRATED NEWSPAPER. [May 29, 1869.

SAN FRANCISCO

NEW YORK

"DOES NOT SUCH A MEETING MAKE AMENDS?"

FIG. 71

"Does Not such a Meeting Make Amends?" Frank Leslie's Illustrated Newspaper, May 29, 1869, 176.
Wood engraving, 4 × 6⅞ inches (image), 15¾ × 11¼ inches (page). George A. Smathers Libraries at
the University of Florida.

ogy. The progressive force that the train represents is not domestication, however; no
women join in the celebration. Commerce and the brutal, extractive force of mining
welcome the onrushing train. Merchants from Europe and Asia frame the image and
flow upward along the right and left sides, meeting at the top center where Columbia,
with the shield of the United States at her feet, joins the hands of the two continents.
The promise of trade, technology, and culture can be seen in the background behind
the procession of merchants—minarets, Hagia Sophia, and the Acropolis on the right,
and factories, office buildings, and steamboats on the left. At the bottom of the image, a
banner with the word *Commerce* summarizes the activity in the image.

The program for this pictorial of the transcontinental railroad can be found in a
sermon delivered by the Reverend Dr. Francis Vinton at Trinity Church the day of the
railroad's completion. It was quoted at length in the *Harper's Weekly* reportage: "When
camels—those ships of the desert—were the means used for transportation, for the
furtherance of commercial traffic, it was found that whenever the caravans stopped
there would spring up cities, and there would be evidences of civilization. So with this
great work. It will populate our vast territory, and be the great highway of the nations;
their merchants will cross it to trade with us." Vinton compared the transcontinen-
tal railroad to the discovery of the sea route to Asia. Both, he said, confirmed God's
favor. The engraving illustrated this analogy in its contrast between the old seaborne
trade, seen along the bottom of the engraving, and the new overland business of the

FIG. 72

Commerce, Harper's Weekly, May 29, 1869, 344–45. Wood engraving, 16¼ × 24½ inches (double page). George A. Smathers Libraries at the University of Florida.

transcontinental railroad. In addition to invoking the rewards of increased commerce and new settlements, the sermon directly connected the railroad and the Civil War: "This is, indeed, a great event of the world: it is one of the victories of peace—a victory grander than those of war, which leave in their track, desolation, devastation, misery, and woe. . . . It [the transcontinental railroad] began when the nation was agitated by war, and is finished now when we enjoy a reign of peace."[46]

Harper's Weekly foregrounded commerce in its story, but the *New York Times* provided greater depth regarding the services at Trinity Church and the railroad's redemptive implications. The *Times* reported that the service began with hymns and readings, one of which was from the seventh chapter of Deuteronomy, a verse addressed to the Israelites freed from bondage in Egypt.[47] It recited the favors of God and reminded the Israelites that they were his chosen people.

> And he will love thee, and bless thee, and multiply thee: he will also bless the fruit of thy womb, and the fruit of thy land, thy corn, and thy wine, and thine oil, the increase of thy kind, and the flocks of thy sheep, in the land which he swore unto thy fathers to give thee. Thou shalt be blessed above all people . . . The great temptations which thine eyes saw, and the signs, and the wonders, and the mighty hand, and the stretched out arm, whereby the LORD thy God brought thee out.[48]

This passage in Deuteronomy and its explicit reference to the trials of the Israelites during the Exodus must have reminded those at Trinity Church of their own trials during the four years of Civil War. The special service that day used the success of the railroad as justification for rekindling Americans' belief in their exceptionalism and their divine mandate. For Vinton, as for many Americans in 1869, the transcontinental railroad represented a new beginning, with God's blessing and hope for a peaceful, prosperous future of commercial enterprise.

Civil War artist Alfred Waud's two illustrations in the same issue of *Harper's Weekly* presented a more cynical, albeit realistic, view of the transcontinental railroad (fig. 73).[49] The lower image shows railroad workmen blasting rock and hauling out the debris to create a level roadbed for the track. The caption reinforces the theme of national unity, telling readers that the engraving is an image of Irish and Chinese workmen working together to build the last mile of the transcontinental railroad. The idea that the Union Pacific and Central Pacific Railroads, represented by the ethnicity of their workers, joined forces in the final days of the construction was patently false. The blast, however, was real. Shortly before the decision to meet at Promontory, the Union Pacific Railroad work crews, working parallel to the Chinese workers of the Central Pacific Railroad, set off a dynamite charge that injured several Central Pacific Railroad workers.

The implications of the engraving, however, are multifaceted, a rewriting of history to support a sanitized narrative of racial harmony. The writer of the accompanying story uses the ethnicity of the workmen to symbolize the coming together of Asia and

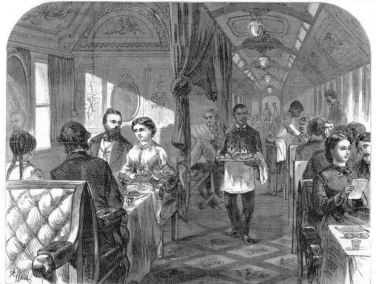

INTERIOR OF A PALACE HOTEL CAR USED ON THE PACIFIC RAILROAD.—SKETCHED BY A. R. WAUD.—[SEE PAGE 341.]

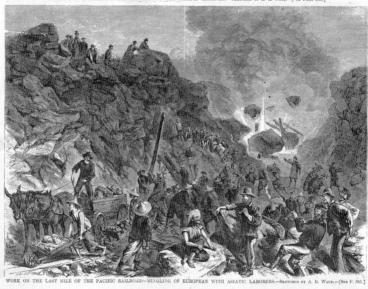

WORK ON THE LAST MILE OF THE PACIFIC RAILROAD—MINGLING OF EUROPEAN WITH ASIATIC LABORERS.—SKETCHED BY A. R. WAUD.—[SEE P. 341.]

FIG. 73

Illustration for "The Pacific Railroad," *Harper's Weekly*, May 29, 1869, 348. Wood engraving, 16¼ × 12¼ inches (page). George A. Smathers Libraries at the University of Florida.

Europe "grasping hands across the American continent" and, by implication using the American transportation system to transport their goods.[50] In the aftermath of the Civil War, the peaceful commingling of ethnic difference also offered northern audiences a model for the social integration of African-American freedmen in the South and their European-American neighbors. Alfred Waud, having witnessed the racism and horrors of the Civil War, contradicts the erasure of racial difference suggested by the text. In his engraving, two grotesquely caricatured men, one Chinese and the other Irish, eye each other warily. Behind the standing Irishman, one of his countrymen pulls on the pigtail of a Chinese laborer while his colleagues laugh and encourage him.[51]

The top image made an even more direct reference to the racial politics of post–Civil War America. Well-dressed, white, upper-class men and women sit at tables covered with linen tablecloths in the most lavish railroad accommodation, the Pullman Palace car. They travel on the railroad in luxury while a uniformed African-American waiter serves them. In this engraving, the new black citizens freed by the Civil War are indentured anew, serving white passengers as they had their white masters before the war. Unlike the racial conflict one finds in the image of the railroad laborers, here the cultural force of the train creates harmony by reinforcing America's prewar social and racial hierarchy. Although the text stresses the function of the railroad as a great unifier, the message of the engravings proves to be the more accurate depiction of the tensions and inequality that would continue throughout the nineteenth and into the twentieth century.

THE ILLUSTRATED PRESS: AFTER COMPLETION

Few of the illustrated stories that proliferated after the completion of the railroad conveyed an attitude as critical as the Waud illustrations did in *Harper's Weekly* on May 29, 1869. Each of the major illustrated newspapers, eager to capitalize on the novelty of the railroad and to give their readers firsthand information, published serialized stories of the journey west. Blending the timeliness of contemporaneous reportage with the authority of photography, these stories supplemented eyewitness sketches with photographs from the archives.

In this effort, the railroad companies, particularly Russell and the Union Pacific, took advantage of the opportunity to promote their interests. Shortly after the completion of the railroad, the *Illustrated London News* published articles that bear the stamp of the Union Pacific. The first in the series carried illustrations based on drawings by Frederick Whymper.[52] The illustrations were published on two different pages, with the first depicting Omaha and identifying it as the location of the headquarters of the Union Pacific and the eastern terminus of the railroad (fig. 74). Whymper's sketch may have been a pastiche of photographs showing Omaha as a settled town with multistory buildings and wide boulevards leading to a bustling commercial waterfront.[53] The editors contrast the city with an illustration that could not have been captured in

THE UNDERGROUND SURVEY OF JERUSALEM.

Our readers will recollect that, in the Number of this Journal for April 24, we gave a series of Illustrations, drawn by our Special Artist, of the important discoveries beneath and around the basement wall of the ancient Jewish Temple on Mount Moriah, now called the Haram, which has been diligently explored during the last two years by Lieutenant Charles Warren, R.E., and his assistants, in the employment of the Palestine Exploration Fund Committee. Some more recent discoveries have since been announced in the reports issued by the Committee, one of which is the subject of an Illustration engraved this week. It is a passage found at the north-east angle of the Haram, adjoining the Birket Israel, or Pool of Bethesda. The Haram wall on the east side is continued some length beyond the angle, so though an external tower had stood there, rising above the old city wall. A small opening, 18 in. wide and only 4 in. high, was found in this wall; and, by enlarging the slit till men could squeeze through, a passage was entered, which runs westward to the east end of the great tank, called the Birket Israel. This passage, 3 ft. 9 in. high and 2 ft. wide, is 46 ft. in length; its direction is nearly horizontal, but there is a steep, downward shoot, falling 12 ft. in it advances 12 ft., to enter the passage from the narrow slit in the Haram wall. On the south side of it is a staircase cut in the masonry, but now blocked up with stones. West of this staircase the bottom slopes down rapidly; and at the farther end of the passage is a large perforated stone, closing it up towards the Birket Israel, and showing that it was a concealed aqueduct for the overflow of that reservoir, at a height of 26 ft. above the present bottom of the pool. This stone, which is shown conspicuously enough in our Illustration, has a niche or recess cut in it, 4 in. deep, and in the niche are cut three circular holes, each 5½ in. in diameter, arranged so as to form a triangle; below which there seems to have been a basin to collect the water, but it has been removed. It is probable that the soldiers defending the wall or tower above, in time of siege, would come down the staircase into this passage to get water. Some attempts have been made to open another channel for the water, at a lower level; and the workmen engaged in this job have left their mark on the wall, in the shape of a Christian cross of the Byzantine type. It is to be hoped that these interesting researches will not be stopped for want of pecuniary means to carry on the enterprise so well begun under the management of the Palestine Exploration Fund Committee, which we commend to the liberality of our readers.

THE UNION PACIFIC RAILROAD OF AMERICA.

The recent completion and opening for common traffic of the entire system of railways across the whole breadth of the North American Continent, which is a distance from New York, on the Atlantic coast, to San Francisco, on the Pacific, of more than 3000 miles, is one of the marvellous achievements of our time. We have received from Mr. Frederick Whymper, who lately travelled all the length of this line, stopping at several places on his way in order to make sketches and to ask for local information, an interesting series of Illustrations to be engraved and published in our Journal. Two of these Illustrations appear in the present Number. It must first be understood that the newest portions of railway, finished in the spring of this year, and now joined to each other so as to form a complete line of railway communication from sea to sea, are called the Union Pacific Railroad and the Central Pacific Railroad; but it is the former which really occupies the most central position. The "Union Pacific" line, which is about 1600 miles long, starts from the city of Omaha, in the State of Nebraska, on the Missouri river, at the boundary of Nebraska and Iowa, near the 19th deg. of west longitude. It meets the "Central Pacific Railway of California," in the territory of Nevada, somewhere beyond the Mormon land of Utah, on the farther side of the Rocky Mountains. Both the Union Pacific and the Central Pacific Companies have been stimulated by grants of money and lands, from the Federal Congress of the United States, besides the assistance given to the later by the State of California, which

THE PALESTINE EXPLORATIONS: NEWLY-DISCOVERED PASSAGE IN THE OLD WALL
OF THE HARAM, AT JERUSALEM.

exceed all previous example. A bonus varying from 16,000 dols. to 48,000 dols. per mile, according to the local difficulties of construction, with half the land, divided into equal sections of convenient saleable size, lying on each side of the railway within twenty miles of the line, amounting altogether for fourteen million acres, must be reckoned a very liberal remuneration for such a work. There were grants of timber, stone, and other commodities, being public property, which were needful to the construction of the railway. With these magnificent prospects the work was undertaken, in great haste, immediately after the conclusion of the Civil War. The laying of the track from Omaha was commenced in July, 1865, and the first section of the Union Pacific line, one hundred miles in length, was finished and opened within a twelve-month. A great railway bridge across the Missouri at Omaha is now in course of construction, which will connect together the

Chicago and North-Western and the Union Pacific Railways. This bridge is to have twelve piers—eleven of them being 'row of tubular construction and the twelfth being of stone. The river at this point runs between the two rival towns of Council Bluffs and Omaha: it is but a muddy, shallow, and shifting stream. At the present moment the traveller is conveyed by omnibus and steam-boat between the opposite railway termini; and the steam-boat carries the omnibus, or sometimes as many as a dozen waggons and omnibuses, horses and all, bodily across the stream. The city of Omaha has now a population of 16,000 people—one fourth of the whole number of inhabitants in the State of Nebraska, of which it is the principal town. It is not, however, the legislative capital, though it formerly was; and our Artist's sketch is taken from the "Capitol," a building now turned into a school-house. The city of Lincoln is now the seat of Government and State capital of Nebraska. The city of Omaha has twelve churches, at one of which—the Roman Catholic—the pews were lately sold by auction, on a Sunday, for 200 dols. each; there are also good schools, a theatre, and newspapers. The Union Pacific Railway Company has erected large machine-shops and carriage-factories here. Omaha, as the eastern terminus of this great line of continental travel and traffic, is destined to become an important place.

The Union Pacific line, traversing the vast prairies of the Far West, rises quite imperceptibly to a high level, the gradients not being more, on the average, than 30 ft. in a mile, and nowhere steeper than 90 ft. to the mile throughout a length of 600 miles. It seems like a boundless plain; at first of grass, then of alkaline sand. Few buffaloes are now to be seen; but a herd of antelope now and then, and plenty of the little animals called prairie-dogs.

Our second Illustration shows a prairie on fire, as seen at night from the Union Pacific Railroad. The grass is almost annually burnt off in some sections of the country. The lurid flames, the overhanging smoke, an occasional tree or settler's homestead standing up blackly against the light, the stars looking down calmly over all, make a scene not easily forgotten. A curious fact has been observed in connection with these prairie fires. In spots where the progress of settlement has prevented such conflagrations as the one above mentioned, trees of many varieties spring up spontaneously, in what was before considered a treeless district. It appears that there were living roots of trees in the ground before; and, though burnt off when shooting, the vitality of the roots has remained intact.

PARIS FASHIONS FOR AUGUST.

The fashions, so far as the form of the robe is concerned, have undergone very little change of late, the chief novelty being in the choice and combination of materials. Although robes entirely of one colour are still much in favour, there is an evident disposition towards those striking combinations which every now and then are sought to be introduced. Flounces are, of course, de rigueur, and the greater their number the stricter their accordance with the mode. Fringes are also prevalent. Puffs are perhaps a trifle less voluminous than formerly; still, there is no evidence of any inclination to relinquish them, as the natural contour of the female figure, in these degenerate days, is evidently not to the taste of Parisian modistes. Unbleached materials of various descriptions are very much in favour, and white robes have been largely in fashion during the recent hot weather. Altogether, hardly anything else is to be seen in the Boulevards and in the Bois except toilettes de campagne, as they are styled, composed of jupes courtes in light, though frequently very bright-coloured, materials, ornamented with puff and flounces, and worn in connection with coquettish-looking little hats smothered almost beneath the towering bouquets of flowers and the large gauze veils with which they are trimmed. If robes have undergone very little transformation, it is not the same with chapeaux, for these are of endless variety, ranging from the chapeau diadème the chapeau fanchon, and the chapeau bébé, which still retain their hold on female favour, to chapeaux ronds and chapeaux ovales, and the last-great novelty created, the chapeau Patrie (named after Sardou's popular drama), a some-

THE UNION PACIFIC RAILROAD OF AMERICA: OMAHA, NEBRASKA, EASTERN TERMINUS OF THE RAILWAY, VIEWED FROM THE CAPITOL.

FIG. 74

Illustration for "Union Pacific Railroad of America," *Illustrated London News,* July 31, 1869, 120. Wood engraving, 15½ × 11½ inches (page). George A. Smathers Libraries at the University of Florida.

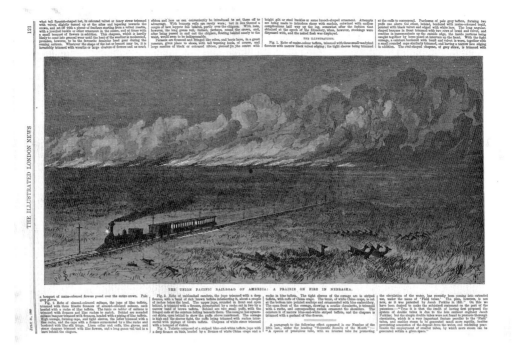

FIG. 75

Illustration for "Union Pacific Railroad of America," *Illustrated London News,* July 31, 1869, 121. Wood engraving, 15½ × 11½ inches (page). George A. Smathers Libraries at the University of Florida.

a photograph—a train set against a raging prairie fire (fig. 75). In this dramatic image, antelope in the foreground desperately race away from the fire while the train moves across the picture plane secure in its ability to outrace the flames. The fire presents a frightening spectacle, but one that is viewed from the safety of a train window.[54] Rather than mention the spectacular effect of the conflagration, the accompanying text tells readers that, when fires end, trees emerge in previously treeless plains. It goes on to suggest that fires are not inevitable, and that settling the land is a preventative. Framed by this context, the engraving of the prairie fire carries with it the idea of landscape transformation and the agricultural potential of the Nebraska plains.

The *Illustrated London News* article also lists the Union Pacific's assets and the monetary and land grants given to the railroad company by the federal government. It repeats what had become common misinformation provided by the Union Pacific:

It must first be understood that the newest portions of railway, finished in the spring of this year, and now joined to each other so as to form a complete line of railway communication from sea to sea, are called the Union Pacific Railroad and the Central Pacific Railroad; but it is the former which really occupies the most central position. The "Union

Pacific" line, which is about 1600 miles long, starts from the city of Omaha, in the State of Nebraska, on the Missouri river, at the boundary of Nebraska and Iowa, near the 19th deg. of west latitude. It meets the "Central Pacific Railway of California," in the territory of Nevada, somewhere beyond the Mormon land of Utah, on the farther side of the Rocky Mountains.[55]

The misinformation about the length of the Union Pacific rail line, the erroneous location of the meeting point of the two companies, and the characterization of the Union Pacific as more important than the Central Pacific, all suggest that the company influenced the story and, most likely, the other seven articles in the series.[56] Nonetheless, there were instances in the series where the meaning of the image expanded beyond the intentions of the railroad.

The third story in the series is introduced by an illustration of Sherman, Wyoming.[57] It relates a familiar railroad theme: "Fifteen months ago nothing but bare hills and crags marked the spot. Now there is a little town, containing a large machine-shop, a 'Wells Fargo's express office,' newspaper-shops, and even a millinery store. Its two hotels, of shingle, are of a rough kind, but good meals are to be obtained in them." In the illustration, the engraver turns a desolate outpost into a more inviting destination by adding signage to the clapboard buildings identifying hotels, a bakery, and the train station. The following page carries two large wood engravings based on Russell photographs, both of which had been published earlier in *Sun Pictures* and *The Great West Illustrated*. The top image, *Skull Rock*, retains a small human figure in the foreground to emphasize the immensity of the granite formation. The close cropping of the photograph and the removal of a figure atop the rock transform the image from an oversize landmark and a spot for touristic recreation into an intimidating monolith and metaphor for the force and power of nature. This shift of meaning is important because the newspaper contrasts this engraving of raw nature with the image directly below it—a railroad tunnel through solid rock. In this context, it becomes a reminder of the power of railroad engineers and railroad labor. The sense of triumph found in *Weber Valley, Tunnel*, however, is offset by the caption, which states that some tunnels have not been finished, necessitating temporary track, some parts of which are "very dangerous."[58]

Harper's Weekly republished each of the transcontinental series from the *Illustrated London News* shortly after its publication in Europe. But a comparison between the two newspapers indicates subtle changes in the versions that *Harper's* ran, which suggests the different corporate allegiances of the two newspapers. When *Harper's Weekly* printed the introductory story about Omaha and the Nebraska plains, for example, the editors did not include the text that compared the two companies, nor did they repeat misinformation about the length of the Union Pacific line.[59] Furthermore, *Harper's Weekly* added an additional story to the series.[60] A large wood engraving, based on Hart's stereograph *First Construction Train passing the Palisades, Ten Mile Canyon*, introduced the Central Pacific into the cross-country narrative (fig. 76). When Hart made the photograph, it

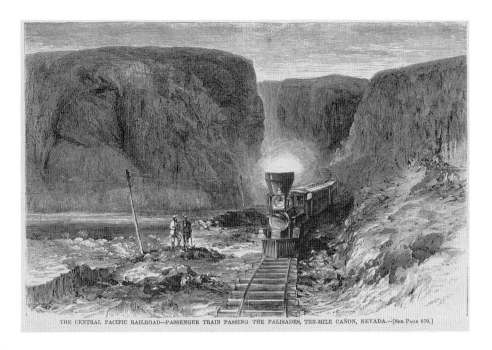

THE CENTRAL PACIFIC RAILROAD—PASSENGER TRAIN PASSING THE PALISADES, TEN-MILE CAÑON, NEVADA.—[SEE PAGE 670.]

FIG. 76

Illustration for "View on the Central Pacific Railroad," *Harper's Weekly*, October 16, 1869, 669. Wood engraving, 16¼ × 12¼ inches (page). George A. Smathers Libraries at the University of Florida.

celebrated the progress of construction past a ten-mile canyon in Nevada. For the pages of *Harper's Weekly*, however, the engraver altered and updated the interpretation of the stereograph by extending the length of the train so that it seems to pull an endless line of passenger cars. The change in title to *Passenger Train Passing the Palisades, Ten-Mile Cañon, Nevada* signals a shift in the condition of the railroad from construction to full operation. Revising the message of the stereograph from surveillance over construction to advertisement is a reminder of the variability of photographic meaning within the railroad archives. The text was brief, but it supported the image and the advocacy of the Central Pacific, providing glowing financial statistics and claiming the Central Pacific had gross earnings of almost two million dollars in gold in the first three months of operation.[61]

In January 1870, *Leslie's Illustrated* published a series about the transcontinental railroad that seems to have been independent of corporate money. Unlike other newspaper coverage, the first images and stories in *Leslie's Illustrated* diverge from the optimistic characterization of the railroad as wondrous economic opportunity.[62] A wood engraving of a Pullman Palace car introduces the first story in the series (fig. 77). It presents a scene similar to that published by *Harper's Weekly* on May 29, 1869 (see fig. 73). In

both, the light fixtures overhead and the paneled ceiling offer no suggestion that this is a train car. Rather, it appears to be a well-appointed hotel parlor. The text describes luxurious travel:

> A Western paper says that Pullman's dining or hotel-car is five stories high, with an elevator, billiard and bar-room, a croquet-ground in front, and a court-yard for the reception of carriages. This may be an exaggeration; but the sober fact is, that the hotel train is one of the greatest improvements of the day to make railway travel comfortable. . . . Who would have dreamed in 1848, when overland travelers required six months, with many hardships and sufferings, to journey from the Mississippi to the Sacramento, that we would now be traveling in six days from Hudson River to the Golden Gate, and with all the comfort and luxury that the Pacific Railway can boast?[63]

The engravings in both *Harper's Weekly* and *Leslie's Illustrated* project a sense of opulence, but *Leslie's Illustrated* presents a space that differs from that of its competition. In the *Leslie's Illustrated* engraving, men and alcohol predominate. In the foreground a man pours champagne for the only woman in the Pullman car. Behind the couple, single men eat off china or read newspapers in comfort, while in the background a black porter serves dinner and a bartender removes a wine bottle from a shelf. In the *Leslie's Illustrated* image, the railroad is a male-dominated space of pleasure and relaxation where one could behold the geological wonders or slip off to the Pullman Palace car for male camaraderie.

The *Leslie's Illustrated* articles and images offer another side of train travel that is suppressed by Russell's 1869 stereographs. In the Union Pacific photographs, two- and three-story hotels tower over the surrounding landscape.[64] For example, stereographic images show the Laramie Hotel in terms that would have been familiar to city travelers, with its formal dining room and white linen tablecloths, and the two-story hospital that served railroad employees and travelers.[65] Both the subject matter and the format were likely chosen deliberately. The size, portability, and cost of the stereograph allowed these images of tourist facilities to be distributed liberally as advertisements or purchased by tourists as souvenirs. The editor of *Leslie's Illustrated*, however, contrasts the image of the culturally refined eastern travelers with the crude inhabitants of the West:

> The street fronting the railway, which is represented in our picture, is a row of shanties—most of them canvas-backed, like the delicious ducks from Chesapeake Bay—bearing such attractive names as "Pacific Hotel," "Echo Hotel," "Club House," "Sunnyside House," and "Omaha." . . .
>
> In a country so sparsely settled as that between Omaha and the Sierra Nevada Mountains, one could hardly expect all the comforts of the East at the villages and stations along the route.[66]

FRANK LESLIE'S
ILLUSTRATED
NEWSPAPER

Entered according to the Act of Congress in the year 1870, by FRANK LESLIE, in the Clerk's Office of the District Court for the Southern District of New York.

No. 746—VOL. XXIX.] NEW YORK, JANUARY 15, 1870. [PRICE, 10 CENTS. $4 00 YEARLY. 13 WEEKS, $1 00.

DO THE PEOPLE GOVERN?

THE administration of General Grant cannot stand up much longer under the discontent and opprobrium caused by its course on the question of Cuba. This discontent is intensified by the popular conviction that the heart of the President in this matter is right, and his impulses in the right direction; but that he permits himself to be swayed and directed by his Cabinet, against his own judgment and inclination. For that Cabinet the public has little respect.

with neither the prestige of public service or great names, it is absolutely without influence in the nation. Not one man in a dozen can call their names, and not one in a thousand cares a straw for their opinion on any subject, except, perhaps, that of the patronage they may have it in their power to dispense.

If General Grant were surrounded with statesmen, or even soldiers of repute, the people might feel disposed to defer to the judgment of the Government on a question of national policy, and to accept the course of the President as probably judicious and right, even

if taken against their own inclinations. But it is vexatious, and is getting to be intolerable, that the Government shall be administered, its Executive swayed, his reputation and that of the nation imperiled, by a set of incapables, without experience or influence, whose judgment is without weight, and who are not amenable, through regard for present or future reputation, to the bar of public opinion.

It is humiliating to think it possible that a man who advised and was ready to undertake a war against France on behalf of Mexico, should be frightened from a national and just

policy as regards Cuba by the qualms which rise in the stomach of the excellent old lady who presides in the State Department about a possible war with Spain.

It is still more humiliating to think it possible that a humane, manly, and sound continental policy in Cuba should not be adopted, lest it should somehow put us in a wrong position in our Alabama controversy with Great Britain. We have shown, time and again, that the question as regards Cuba has no sort of parallelism with that which arose as regards the South; and even if it had, we have the

ACROSS THE CONTINENT, ON THE PACIFIC RAILROAD.—DINING SALOON OF THE HOTEL EXPRESS TRAIN.—SEE PAGE 301.

FIG. 77

Across the Continent on the Pacific Railroad—Dining Saloon of the Hotel Express Train, in *Frank Leslie's Illustrated Newspaper*, January 15, 1870, front page. Wood engraving, 15¾ × 11¼ inches (page). This item is reproduced by permission of the Huntington Library, San Marino, California.

Rather than Russell's images of churches, hotels, and schools, the illustration in *Leslie's Illustrated* shows western towns consisting of clapboard storefronts and canvas tents. This representation of the West was exactly the type of perception that Russell's photographs were intended to contest.[67]

The newspaper's critical tone continues in four stories in February, but shifts abruptly in March. Although the newspaper does not endorse the railroad, its picture stories assume an ambiguity that its earlier stories did not. These changes correspond to the newspaper's reproduction of wood engravings based on Russell's photographs.[68] In the March 12 edition, the editorial writer presents the photograph as a faithful and truthful witness: "Photographers have been busy, and already the stereoscopic views on the great overland route of America are for sale in the principal European cities. Everywhere they are exciting wonder and admiration. . . . It is fortunate for us that we have the unflattering photograph to assist us. Many foreigners who have looked at photographs of the giant trees [Calaveras Big Trees] of California—where men, on horseback, are riding through prostrate trunks, and cotillion parties are dancing upon a stump—have said, that if the pictures were anything but photographs, they would not believe them accurate."[69] Unlike the paper's earlier treatment of the railroad, this article supports train tourism by suggesting that the traveler can find many striking rock formations along the rail line that are equally remarkable. The first illustration is Russell's oft-reproduced image *Monument Rock*.[70] Originally, the photograph was made to acknowledge a significant advance of the railroad. It was called a "monument" because of its shape and isolation, but also because it was located approximately a thousand miles from Omaha and marked the final stretch for the Union Pacific before the railroad reached the flat plains of the Salt Lake Valley. But rather than use this image to call attention to railroad milestones, the author of the *Leslie's Illustrated* story transforms *Monument Rock* into a tourist curiosity, highlighting the similarity of the upper part of the rock to the head of a dog.

The railroad companies were successful in placing photographs from their archives in the illustrated press, and they attempted to control the interpretations of the images. Cropping, adding figures or train cars, and shifting the scale, the illustrated newspapers in the United States and Europe remade images of the first transcontinental railroad. A close look at the reproduction of the stereographs and at the texts that interpret the images suggests an alignment of media and moguls. The illustrated press produced stories that were, for the most part, favorable to their railroad clients. But while the Central Pacific and Union Pacific devised ways to place their images in the popular press, they appear to have been less directly involved when it came to the illustrated travel guides that were published shortly after the completion of the railroad.

Initially, neither the Union Pacific Railroad nor the Central Pacific Railroad published its own travel guide; instead they appear to have supported the publications of others. They supplied direct assistance to some of the writers and publishers, but indirect assistance was more common and equally effective.[71] Full-page advertisements, for example, could make the difference between profit and loss for these competitive publications. In sampling the railroad's photographic archives, travel guide editors altered the meaning of the images as they strained to entertain tourists, entice emigrants, and encourage investment in the West.[72] For the general public, they provided an educational service, offering armchair adventurers a glimpse of both the broad panorama of the newly opened territories and the intimate details of towns and western geography.[73] Early travel guides used the nationalism and militarism of the 1860s to encourage settlement and offered a new, commercialized version of "Manifest Destiny." Four major illustrated travel guides competed for the public's attention in the two years following the completion of the railroad: *Great Trans-Continental Railroad Guide* (1869), *The Traveler's Own Book: A Souvenir of Overland Travel* (1870), *Nelson's Pictorial Guide-Books* (c. 1870), and *Alta California Pacific Coast and Trans-Continental Rail-Road Guide* (1871).[74] These guidebooks shared certain characteristics: they concentrated their attention on the landscape between Omaha and Sacramento, were lavishly illustrated, and promoted tourism, emigration, and investment. But each balanced these demands differently. Although the guides are all labeled as "tourist guides," analysis of the images selected by each of the publishers, and the text that accompanies the illustrations, suggests that each booklet targeted a particular subset of the potential audience.

The railroad wanted its photographs to appear to be objective and detached, but the travel guide editors preferred images that were dramatic and evocative. Consequently, they freely reinterpreted some stereographs when they reproduced them, either by physically altering the image for the wood engraving or by writing a text that provided a new context for understanding the image. For example, in Hart's *First Crossing of the Truckee River, 133 miles from Sacramento*, the Central Pacific used the depth inherent in the stereographic viewing process to contrast the simple wagon bridge in the foreground with the more substantial and technologically advanced railroad bridge in the background (fig. 78). The two boys fishing off the wagon bridge convey a bucolic quality not found in most of the Central Pacific stereographs. When the draftsman created the engraving, however, he added a woman and a little girl (fig. 79). One of the few images that is not addressed in the guidebook's text, *Crossing the Truckee River, Six Miles East of Boca* pushes the sense of the pastoral further, creating a domesticated landscape, a settled space of family leisure and recreation.

The first travel guide was published just three months after the Promontory celebration and, most likely, with railroad support. One year earlier, its publisher, George Crofutt, forfeited a government appointment because he could not obtain the necessary

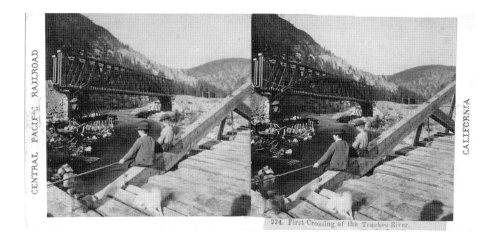

FIG. 78

Alfred Hart, *First Crossing of the Truckee River, 133 miles from Sacramento* (no. 224), 1867. Albumen stereograph, 3½ × 7 inches. Crocker Art Museum, E. B. Crocker Collection.

Crossing Truckee River, six miles east of Boca, C. P. R. R.

FIG. 79

Crossing Truckee River, six miles east of Boca, C.P.R.R., *Crofutt's Trans-Continental Tourist's Guide* (Chicago: George A. Crofutt, 1873), 107. Wood engraving, 4⅞ × 6⅝ inches (page). Collection of R. R. Gustafson.

five hundred dollars for his bond.[75] Later in the same year, he and several partners were unable to raise the capital necessary for the construction of a small railroad in Colorado. Yet within months of the opening of the transcontinental, Crofutt had produced a publication. Support of later editions seems to have come, in part, from advertising. Earlier in his career, Crofutt had been an entrepreneur who characterized himself as an "advertising agent," publishing an early free newspaper and relying on advertising to cover costs and profit.[76] He used the same model for the early editions of the *Great Trans-Continental Railroad Guide*. In subject matter and presentation, Crofutt's book paralleled the messages of the Union Pacific and Central Pacific photographic archives: it provided information about the growth of cities, noting buildings of specific social importance such as churches and schools and framing the illustrations in the context of commerce.

Both the Union Pacific and the Central Pacific were prominent advertisers in Crofutt's guides. The railroads bought copies of his books, supplied passes for free travel to Crofutt's employees, and affirmed the guides' value for tourists. A testimonial from a Union Pacific agent hints at the mutually beneficial relationship between the railroad and Crofutt.

> You want our opinion of the new "Crofutt's Trans-Continental Tourists' Guide." We think you had a pretty substantial indorsement *[sic]* of its merits when the Union and Central Pacific Companies ordered thousands of the copies of it for circulation in Great Britain and on the Continent, as an advertisement of our line. I have no hesitation in saying we give our unqualified approval of your book, as the first, most complete and reliable work ever published to illustrate and describe the wonderful scenery, agricultural and grazing districts, mining resources, &c. of the vast country and the Pacific coast.[77]

As this recommendation makes clear, Crofutt may have been an independent publisher, but the railroad companies played an important role in selling and publicizing his travel guide.

The folksy, anecdotal style of the text of Crofutt's publications suggests that the guides were intended as much to entertain travelers and the general public as they were to educate. Almost all of Crofutt's illustrations were based on stereographs; however, the book included none of Andrew Russell's Union Pacific images.[78] Consequently, the majority of wood engravings of the Union Pacific landscape came from stereographs by C. R. Savage or William Henry Jackson. For the western section of the railroad, Crofutt used some images published by Thomas Houseworth and Co., but the vast majority of the engravings for this section derived from the Central Pacific stereographs by Alfred Hart. It should be noted that the visual power of the photographs was significantly diminished in Crofutt's publications, not only because they lost their three-dimensional depth but also because they were simple wood engravings, small, black-and-white, and lacking detail. These shallow, flattened images change the stereographic photograph

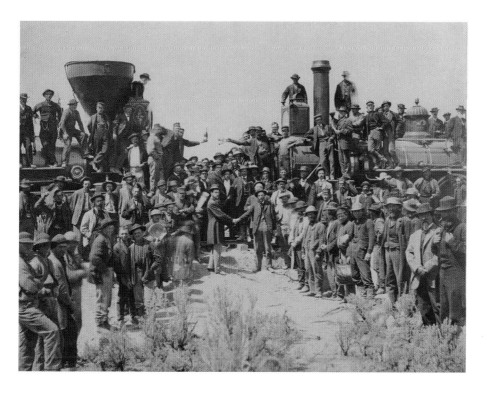

PLATE 1

Andrew Russell, *East and West Shaking Hands at Laying Last Rail* (no. 227), 1869. Also known as *Meeting of the Rails, Promontory, Utah*. Albumen print, 10 × 13 inches. Yale Collection of Western Americana, Beinecke Rare Book and Manuscript Library.

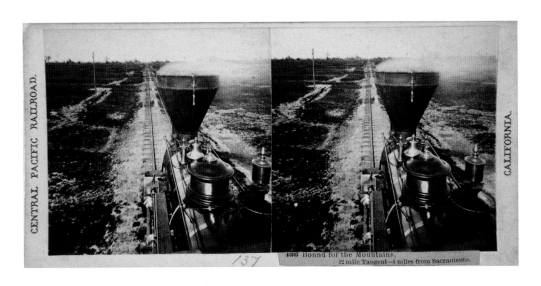

PLATE 2

Alfred Hart, *Bound for the Mountains. 12 mile Tangent—4 miles from Sacramento* (no. 137), ca. 1865. Albumen stereograph, 3½ × 7 inches. Courtesy of Andrew Smith, Andrew Smith Gallery.

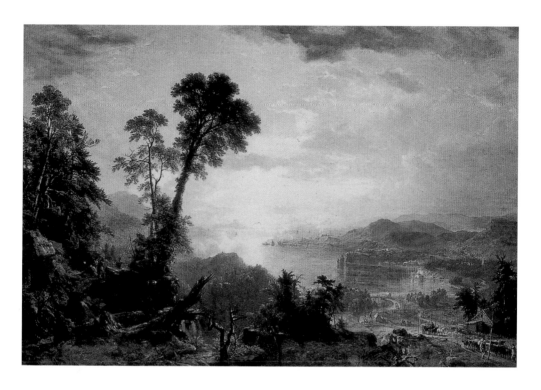

PLATE 3

Asher B. Durand, *Progress (The Advance of Civilization)*, 1853. Oil on canvas, 48 × 72 inches. Private collection.

PLATE 4

Alfred Hart, untitled [The Last of the Mohicans], 1866. Oil on canvas, 29¾ × 24⅝ (framed). Collection of Andrew Moore.

PLATE 5
Fortunato Arriola, untitled [Twilight, Donner Lake, 1868]. Oil on canvas, 30 × 39½ inches. Private collection.

PLATE 6
William Keith, *Mountain Cascade near Cisco*, 1867. Watercolor on paper, 16 × 24 inches. Collection of the Hearst Art Gallery, St. Mary's College of California. College purchase.

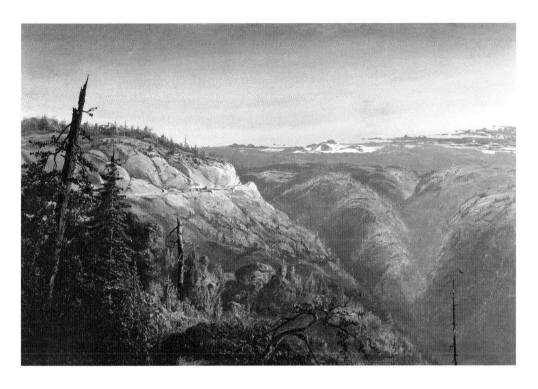

Norton Bush, *Cape Horn*, 1868. Oil on canvas, 16 × 24 inches. Collection of Drs. Thomas and Jane McLaughlin.

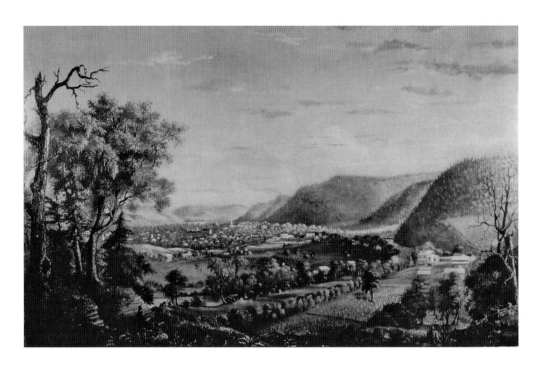

Andrew Russell, *View of Bath from the West*, 1859. Oil on canvas, 27 × 42 inches. Courtesy of the Steuben County Historical Society, Bath, New York.

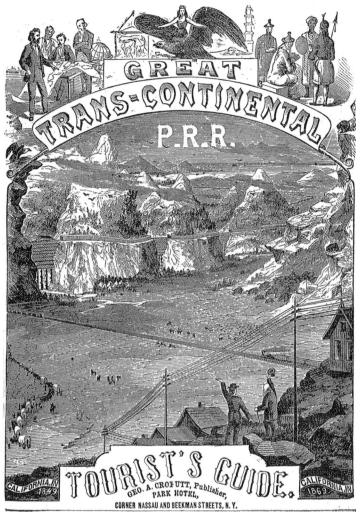

FIG. 80
Cover of *Great Trans-Continental Tourist's Guide* (Chicago: George A. Crofutt,
1870). Wood engraving, 4⅞ × 6⅝ inches (page). Collection of R. R. Gustafson.

from an object of contemplation to a visual decoration, something quickly consumed
as one flipped through the pages of the guidebook, a visual sensation not unlike the
experience of looking at the landscape out the window of a moving train.[79]

The pictorial cover of the guidebook situates the publication in the broad ideological
terms of American progress and Manifest Destiny (fig. 80).[80] Adapting the motif used
by Currier and Ives in *Across the Continent* (see fig. 11), the image contrasts two titles in
the lower left and lower right corners. "California in 1849," is directly below a wagon

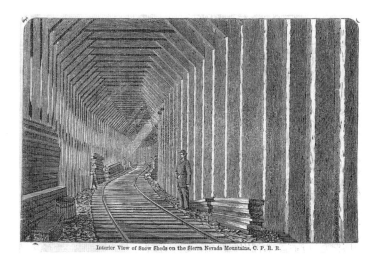

Interior View of Snow Sheds on the Sierra Nevada Mountains, C. P. R. R.

FIG. 81

Interior View of Snow Sheds on the Sierra Nevada Mountains, C.P.R.R.,
in *Great Trans-Continental Railroad Guide* (Chicago: George A. Crofutt,
1869), frontispiece. Wood engraving, 4⅞ × 6⅝ inches (page). Collection
of R. R. Gustafson.

train that makes its serpentine way into the picture space. To the right, a locomotive
speeds away above the "California in 1869" banner. Echoing this comparison of past and
present, Crofutt shows two men, one with a cane and white hair, the other young and
energetic. They stand on a hillside beside houses and telegraph wires and wave approv-
ingly at the sweeping panorama below them. In the open country below, a train's sharp
diagonal divides the composition and pushes an Indian village to the edges of the plains
and against the high mountains, leaving the vast middle ground uninhabited and await-
ing settlement by restive pioneers represented by the youthful figure in the foreground.

The first edition of Crofutt's *Great Trans-Continental Railroad Guide* included only
three wood engravings, and it announced beneath the first image: "This is one of a
series of 32 Views which are being engraved expressly for the Great Trans-Continental
Railroad Guide."[81] The frontispiece of the first edition of the *Great Trans-Continental
Railroad Guide* was a full-page wood engraving made from Hart's stereograph of a snow
shed (fig. 81). When published as a stereograph, this image—which the Central Pacific
titled *Snow Gallery around Crested Peak. Timbers 12 × 14 in., 20 in. apart*—displayed the
quality and strength of the Central Pacific's construction techniques and its determina-
tion to be operational year-round. Crofutt was not interested in the details of construc-
tion but selected it because of its enigmatic power. Placed at the beginning of the tourist
guide, the snow shed becomes a dark passageway to adventure and an unfamiliar land-
scape. The man who acted as a scale figure in the stereograph here beckons travelers

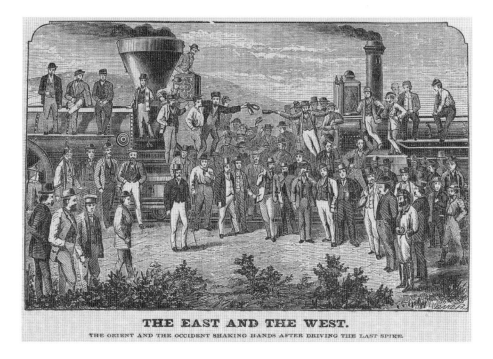

THE EAST AND THE WEST.

THE ORIENT AND THE OCCIDENT SHAKING HANDS AFTER DRIVING THE LAST SPIKE.

FIG. 82

THE EAST AND THE WEST. *The Orient and the Occident Shaking Hands after Driving the Last Spike* in *Great Trans-Continental Railroad Guide* (Chicago: George A. Crofutt, 1869), 132. Wood engraving, 4⅞ × 6⅝ inches (page). Yale Collection of Western Americana, Beinecke Rare Book and Manuscript Library.

to enter the artificial tunnel and experience the adventure of train travel to the great West. When Crofutt brought out a new edition of the guide in 1870, he changed the frontispiece to an image more favorable to the railroad and one that invited a different audience to make the journey. The image *Luxury of Modern Railway Travel* offered an entirely different perspective on train travel. Also derived from a Hart stereograph, this wood engraving showed an inviting perspective of a dining car, linen tablecloths, fresh flowers, and champagne awaiting the traveler. It changed the sense of train travel from wild adventure to a luxurious odyssey.

The only illustration to be included in every edition of Crofutt's travel guides was an engraving (fig. 82) based on C. R. Savage's variant of Russell's *East and West Shaking Hands at Laying Last Rail* (see pl. 1). Savage had photographed alongside Russell at Promontory and had established connections with *Harper's Weekly* and other East Coast media outlets. Made at the same location as Russell's large format photograph, Savage's stereograph shows men standing in front of the locomotives idly facing the camera. Crofutt's title—THE EAST AND THE WEST. *The Orient and the Occident Shaking Hands after Driving the Last Spike*—makes for an awkward marriage of image and text.

One looks in vain for anyone actually shaking hands. The accompanying text bridges the gap between image and title, anthropomorphizing the locomotives. Within the narrative retelling of the celebration, the author explains that, after the ceremonies, the locomotives met at the location of the final railroad tie where "the Jupiter, a locomotive of the CPRR Co., and locomotive No. 116 [sic], of the UPRR Co., approached from each way, meeting on the dividing line, where they rubbed their brown noses together, while shaking hands, as illustrated above."[82] The image-text combination recalls the cartoon in *Frank Leslie's Illustrated Newspaper* (see fig. 71) and foregrounds engines rather than engineers. The metaphor appears to have been powerful enough to influence Russell, who was still photographing in the West when Crofutt published his travel guide. Most of the titles of Russell's negatives from the Promontory celebration are brief, didactic descriptions of his subject. The one exception is *East and West Shaking Hands at Laying Last Rail* (see pl. 1), a title that he seems to have derived from Crofutt's *Great Trans-Continental Railroad Guide*. This example demonstrates the cross-fertilization of media and meaning. Not only does the archive serve as raw material for the travel guide editors, but also the publications reinterpreted the photographs in ways that could influence the photographer, the curator of the photographic archive, or the historian.

Following the lead of the press coverage of the Promontory celebration, the introduction to the *Great Trans-Continental Railroad Guide* frames the transcontinental railroad within the context of the Civil War. The author of the Crofutt's guide, San Francisco newspaper man H. William Atwell (a.k.a. Bill Dadd, the scribe), outlined the history of the transcontinental railroad and alluded to the Pacific Railroad Surveys of 1853–54:

> Government, with its usual red tape delays and scientific way of how *not to do it,* heeded not the appeal until the red hand of war, of rebellion, pointed out to it the stern necessity of securing, by iron bands, the fair dominion of the West from foreign or domestic foe.
>
> . . . Under this pressure [of necessity to defend the Pacific Coast] was the charter granted, and it may truly be said that the road was inaugurated by the grandest carnival of blood the world has ever known; for without the pressure of the rebellion the road would probably be in embryo to-day.[83]

Dadd describes the ceremonies at Promontory and characterizes the event as symbolizing a new national unity in which participants came from "the four quarters of the Union" to "be partakers in the glorious act" of unifying the country by rail. The military, and the memory of war, is part of the narrative: "There were the lines of the blue-clad boys, with their burnished muskets and glistening bayonets, and over all, in the bright May sun, floated the glorious old stars and stripes, an emblem of unity, power, and prosperity."[84] Like the engineers' clasped hands in Russell's photograph, the locomotives' handshake, in the author's description, signified the successful end of the project and the cessation of hostilities between the two companies, framed, in Dadd's dramatic retelling, by the Civil War and its "carnival of blood."

The importance of this reference to the war and to national unity diminished within a few years, and Crofutt's guidebooks soon focused exclusively on commerce. In the 1878 edition, the caption for the Promontory picture was changed to *The Orient and the Occident Meet after Driving the Last Spike*. The image retained its proper and prominent place in the guide, but the editor moved the inflammatory text connecting the railroad and the Civil War to an appendix in the back of the book. This simple adjustment of text and image shifted the context of the engraving and signaled a change in the focus of the publication away from post–Civil War nationalism and toward an exclusive promotion of tourism and corporate capitalism.

Buoyed by the success of his railroad guide, Crofutt began a second publication, an illustrated newspaper titled *Crofutt's Western World,* which he "devoted to the railroad and to kindred interest of the Great West; and to information for tourists, miners, and settlers beyond the Mississippi." Although he relied on stereographs for most of his illustrations, Crofutt was not able to find a photograph that adequately evoked a sense of the prosperous future of settlement and progress that was at the core of his publications. Consequently, he created his own. The front page of his inaugural edition carried a large single image entitled *Progress* (fig. 83).[85] This wood engraving was the prototype for what would become an iconic representation of Manifest Destiny and one of the best-known images in popular culture. It shows an oversized, winged female figure in midstride, a book in one hand and telegraph wire in the other.[86] At the feet of this colossus the ground is covered with men engaged in a variety of modes of transportation—wagon, stagecoach, train, steamboat—all of them, like the winged figure, moving from east to the west. In the background, a hot-air balloon rises above the scene. Ahead of the onrushing crowd, Indians and buffalo herds flee out of the picture space. The presentation of the displacement of indigenous peoples by advancing American settlers is a summary of many earlier representations of this theme. Paintings such as Asher Durand's *Progress* (1854); prints such as Currier and Ives's *Rocky Mountains* (1866) and *Westward the Course of Empire* (1868); wood engravings found in *Harper's Monthly* (1867) and *Harper's Weekly* (1869) and on the cover of the *Crofutt's Trans-Continental Railroad Guide* (1869)—all depict the encroachment of European-American civilization on the wilderness and the concomitant removal of the native tribes and wildlife.[87] The Central Pacific sequences and stereographs such as *Shoshone Indians looking at Locomotive on Desert;* and *Indian Viewing Railroad from top of Palisades* (see figs. 10, 42, and 86) also suggest a similar displacement of native tribes.

The basic arrangement of figures in Crofutt's *Progress* is adapted from *The Course of Empire,* the wood engraving published by *Harper's Monthly* in 1867 (see fig. 61).[88] Both images show European-Americans moving from the right side of the image into the foreground and pushing Indians off the left edge of the picture plane. Specific details such as the prominence of the wagons, the train following behind the advancing buckboards, and the travois carrying a woman with a papoose strapped to her back can all be found in both engravings. His inclusion of an oversize winged figure was a marked

Devoted to the Railroad and Kindred Interests of the Great West; and to Information for Tourists, Miners, and Settlers beyond the Mississippi.

Vol. 1. No. 1. New York, November, 1871. Price $1.00 per Year.
10 Cents per Copy.

PROGRESS.

FIG. 83

Progress, in *Crofutt's Western World,* November 1871, front page. Wood engraving, 11½ × 13½ inches (image). Stanford Family Scrapbooks (SC0033F). Department of Special Collections and University Archives, Stanford University Libraries, Stanford, Calif.

addition to this motif. She appears to be based on earlier depictions of Miss Liberty/ Columbia/Freedom, and in these guises she represents nineteenth-century gender ideologies of white, middle-class women's civilizing capacities.[89] The wood engraving published in the inaugural edition of *Crofutt's Western World* was, however, only a preliminary version. Crofutt had the composition reworked a year later into the image that we know today, in part, because he distributed it in *Crofutt's Western World* and *Crofutt's Trans-Continental Tourist.*

Crofutt commissioned the new image from a painter and illustrator named John Gast.[90] In the October 1872 issue of *Crofutt's Western World,* the publisher announced in chauvinistic prose his plan to create what he characterized as "a great national picture" (fig. 84):

CROFUTT'S WESTERN WORLD.

Devoted to the Railroad and Kindred Interests of the Great West; and to Information for Tourists, Miners, and Settlers beyond the Mississippi.

New Series } Vol. 3. | Whole } No. 4. | No. 18 } MONTHLY. **New York and Chicago, April, 1873.** IN ADVANCE. { Price $1.50 a Year, With Chromo.

Entered according to Act of Congress, in the year 1873, by Geo. A. Crofutt, in the office of the Librarian of Congress at Washington.

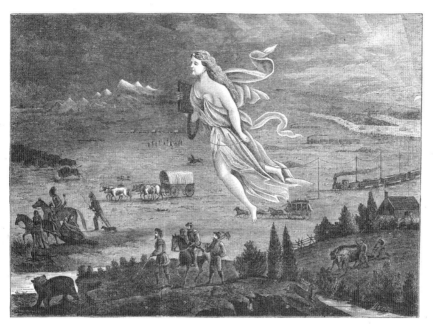

The above rough Wood Illustration of "AMERICAN PROGRESS" is only about **one-third** the size of the Oil Chromos, and conveys but a faint idea of the Beauty of the Magnificent Picture when Painted in *Nineteen Colors.*—[See Page 63.]

TABLE OF CONTENTS.

WRITTEN FOR CROFUTT'S WESTERN WORLD.

THE GLORIES OF AMERICA.

BY PROF. S. J. SEDGWICK.

No. VI.

Here is a shaft carved in imitation of the oak, and whose capital is draped with ever-greens. American-tinted leaves frame his exploits:—born in Virginia,—emigrated early to North Carolina:—thence determined to cross the Cumberland mountains, and penetrate the wilderness beyond in quest of the rich lands of Kentucky,—engraved his name all over the Western Slope of the Alleghanies. And by virtue of his labors, his daring deeds, captivities by the Indians, and escapes therefrom, heroism, love of nature and unyielding fortitude, must be ranked among the first of Pioneers. The scenes and the column are Boone's. His name is given to *fifteen* towns.

Next is a column as blue and as transparent as the waters of Erie in its calmest days. And the scenes grouped around it are wreathed in thunder clouds. They commemorate Perry, bearing the flag of his ship, on which are inscribed the words of the dying Lawrence, "*Don't give up the Ship,*" in an open boat, through the rain of the enemy's balls, from his disabled ship, the Lawrence, which had contended for two hours alone, with two vessels each of nearly equal force, and saw it again gleaming above the deck of the Niagara, as the combat raged with undiminished fury.

At 4 o'clock P. M. on the 10th Sept. 1813 he sent his laconic letter to General Harrison, "We have met the enemy and they are ours."

Not only did he receive, at the time, the most flattering proofs of the Nation's love and gratitude, from every place he visited, but his name is daily honored, by being identified with 63 towns. And 60 towns are honored with the name of this very Harrison, to whom Perry sent the letter, as he is no other than the hero of Tippecanoe. He stands there, tall, slender, showing lines of great bodily vigor. His dark eye, remarkable for its keenness and intelligence, is fixed upon the statue before him, which is reared the symbol of a savage with gleaming tomahawk, whose edge was whetted by British intrigue and with British gold.

We have seen the estimation placed on Arnold. The names of Hull and Burr are clothed with detestation as often as they are dragged forth from their merited obscurity; while that of the victim of the latter, Alexander Hamilton, lives in the appellation of 20 towns, and National Cornucopias crown his quill-shaped shaft.

Even Enoch Crosby, serving his country in the guise of a shoemaker, and stabbing, in imagination, Tories and British, as he sinks his awl through

The publisher of "Crofutt's Western World" announces that he has in course of preparation a magnificent Chromo representing the History Civilization and Settlement of the American Continent. It will be executed on American soil, painted and chromoed *[sic]*, in eighteen colors, by the best American artists; and in no particular will it be inferior to the finest and most costly foreign production. It will be a painting that should be in the parlor, or library, of every home and institution in the land. In fact, it will be a *Great National Picture,* entitled AMERICAN PROGRESS.[91]

Like the stereographs that he used as the basis for his wood engravings, the painting that Crofutt commissioned, newly titled *American Progress,* was a step toward the desired chromolithographs and wood engravings. The chromolithographs would be given away as promotional gifts to new subscribers to *Crofutt's Western World,* and the wood engraving of *American Progress* became the new frontispiece for *Crofutt's Trans-Continental Tourist,* the name he chose for the latest revision of his travel guide.

Gast's painting provides a greater sense of space than the earlier engraving, but the biggest change is in the allegorical figure. Unlike the wood engraving, Gast's female is neither rigidly vertical nor earth-bound. Removing the celestial wings, he places his allegorical female in the sky, overlooking the land. Her flowing diaphanous gown wafts behind her and implies swift movement between the bright light of New York City at her back and the semidarkness of the western shores of the Pacific in front of her. With her elevated perspective, she reenacts the omniscient view that the railroad photographers produced in works such as *Granite Canon* or *Bank and Cut at Sailor's Spur* (see figs. 19 and 33).

In her right hand she holds a schoolbook, and from the crook of her arm dangles a telegraph wire. The wire originates from the Brooklyn Bridge, which, although eleven years from completion, was a reminder of technological accomplishment and an insinuation that forces directing American progress flow out of New York.[92] The spatial proximity between the telegraph wire and the book reinforces the relationship between education and technological progress, but it also juxtaposes the relatively slow pace of the printing press and the speed of the telegraph. Gast's final composition idealizes the advancement from east to west by resurrecting American types: the pioneer family, the miner, and the frontier homesteader. These figures were, however, anachronistic by the early 1870s, replaced by corporate capitalism that would overtake the West with the help of the railroad and promotional newspapers like *Crofutt's Western World* and guidebooks like *Great Trans-Continental Railroad Guide.*

Although Crofutt's *Great Trans-Continental Railroad Guide* appears to have been a national promotional effort supported at least in part by railroad interests, other guidebooks were more regionally targeted. The Central Pacific photographer Alfred Hart published one such booklet, *The Traveler's Own Book: A Souvenir of Overland Travel.* This guide, printed in Chicago, is small, approximately four by six inches, and elongated to fit easily into a coat pocket. Its short, thirty-four-page descriptive text is accompanied by

twelve chromolithographs, three maps, and blank pages for mounting souvenir photographs or recording personal observations. One difference between *The Traveler's Own Book* and the *Trans-Continental Railroad Guide* is that the former has far fewer illustrations, all of which are gathered behind the text rather than interspersed throughout the book.[93] But these illustrations are an impressive set of colorful chromolithographs rather than crude woodcut engravings.[94] Printed with several stones, which overlaid colored inks on clay-based board, the chromolithographs were the most refined illustrations in any of the early travel guides. Although the images were all credited to Hart as photographer, some of the prints were based on stereographs by Savage and, perhaps, Thomas Houseworth and Co.

Hart's selection of illustrations includes few images of the railroad. *The Traveler's Own Book* has no image of Cape Horn or the snow sheds, for example, although both were favorites for tourist guidebooks. Instead, Hart foregrounds the picturesque landscape and manipulates the photographic model, broadening the foreground, adding vegetation, and adding or removing figures. *Donner Lake, and Railroad Around Western Summit,* for example, is a pastiche of two Central Pacific stereographs: *Railroad Around Crested Peak* and *Boating Party on Donner Lake.* The former was likely selected for its lush composition, and the latter places emphasis on the beautiful, the scenic, and the touristic. Five of the twelve chromolithographs are picturesque views of Donner Lake, Yosemite, and the Calaveras Big Trees, even though Yosemite and the Big Trees were nowhere near the transcontinental railroad. This preference for harmonious landscape views in California suggests that *The Traveler's Own Book* was intended to promote visits to California by displaying remarkable sites.

The Traveler's Own Book was financed not by the Central Pacific but by the Burlington Railroad in Chicago.[95] The railroad's support was not acknowledged in the text, but Hart took great pains to promote the company, writing in his addendum: "Of the three railroads from Chicago to Omaha, the Burlington has been taken as a representative, because of its fine scenery and variety." This passage attempts to disguise the railroad's involvement, but the origin of the journey in Chicago, the unique lack of advertising in the guidebook, the use of Burlington's printing company for the book, and the inclusion of a map published by Burlington and illustrated with images from Hart stereographs, all suggest financing by the Burlington Railroad.[96]

Unlike Crofutt's *Trans-Continental Railroad Guide,* Hart's book and text are not organized by town or written in a journalistic, anecdotal manner. The book delivers cursory information in a quick, telegraphic writing style that mimics the speed of the locomotive, with miles covered between each sentence: "From Church Buttes to Bridger is the country for moss agates. They can be bought from persons who have them for sale, at or between these stations. Fort Bridger is in a section of country where there is fine hunting and fishing. Between Bridger and Church Buttes, we have to the southward, some splendid views of the snow-capped Uintah Mountains. Around Piedmont the country is rough and broken. We are once more among snow-sheds and fences."[97] The text is

less entertaining and lacks the narrative qualities of the Crofutt's travel guides; it is a different type of booklet, more an advertisement or personal souvenir than a companion for the transcontinental journey. A sophisticated and detailed map, however, which provides an excellent and comprehensive overview of the landscape—including towns, stage connections, rivers, elevations, geographic descriptions, and the locations of exploitable natural resources—offsets the unimaginative and somewhat breathless writing.

Thomas Nelson and Sons published three transcontinental guidebooks in the early 1870s that were similar in size to Hart's booklet.[98] A clue to their intended audience can be found in one of the three, *Salt Lake City, and the Way Thither,* copublished in England with Salt Lake City photographer C. R. Savage and his partner George Ottinger. It contains twelve simple chromolithographs based on Savage's stereographs.[99] The booklet purports to be a transcontinental railroad guide, but the chromolithographs and text concentrate on Salt Lake City. The author describes the first glimpse of the Salt Lake Valley: "Everything, observes a recent writer, and the statement is confirmed by the scene before us—everything bears the impress of handiwork, from the bleak "benches" behind us to what was once a barren valley in front. Truly the Mormon prophecy has been fulfilled; and already the howling wilderness—in which two-and-twenty years ago a few Ute Indians dragged out a weary and wretched existence, and aroused the echoes with their war-cries—has blossomed like the rose, and teems with golden abundance."[100] The zealous description and the publication as a whole give the impression that the booklet is calculated to encourage English Mormons to immigrate to Salt Lake City, as Savage had done fifteen years earlier.[101]

Nelson and Sons published two other booklets directed toward a more general audience but still with Mormon emigration in mind. *Nelson's Pictorial Guidebook: Union Pacific Railroad* and *Nelson's Pictorial Guidebook: Central Pacific Railroad* sought national and international audiences. Most of the images can be identified as derived from stereographs by Savage.[102] A few of the chromolithographs, such as *Prairie Dog City, Departure from Omaha,* and *View of Salt Lake from an Observation Car,* have no known photographic equivalent. These were most likely made from sketches by Savage's partner, the painter George Ottinger.[103] For the most part, these chromolithographs are unremarkable reproductions of generic views of geologic formations or sights along the railroad. Using fewer colors than those in Hart's *Traveler's Own Book,* these chromolithographs are noteworthy primarily for Ottinger's addition of trains, Indians, and figures to enliven them.

The accompanying text incorporates passages and anecdotes plagiarized from Crofutt's *Great Trans-Continental Railroad Guide,* highlighting the railroad and the economic potential of the landscape. But just as he did in *Salt Lake City, and the Way Thither,* the author saves his most complimentary testimony for the Mormon settlements.[104] London editors revised Savage's description but retained the information and flavor of the earlier publication. For example, *Nelson's Pictorial Guidebook: Union Pacific*

WEBER CANYON, UTAH TERRITORY.

From a Drawing by Fred. Whymper. Engraved by G. W. Shourds.

FIG. 85

Weber Canyon, Utah Territory, in *The Alta California Pacific Coast and Trans-Continental Rail-Road Guide* (San Francisco: MacCrellish, c. 1871). Wood engraving, 7 × 5½ inches (page). Yale Collection of Western Americana, Beinecke Rare Book and Manuscript Library.

Railroad ended with a lengthy text about "Mormondom" and six pages of gushing praise for the landscape and the Mormon transformation of the wilderness. It concluded with this description of the Salt Lake City area: "This extraordinary region, where human industry, in despite *[sic]* of insurmountable obstacles, has converted the wilderness into luxuriant garden-ground."[105]

Utah was not the only territory to employ transcontinental guidebooks to beckon emigrants west. The publisher of *Alta California Pacific Coast and Trans-Continental Rail-Road Guide* began with 130 pages devoted to a theme that Leland Stanford had emphasized in his Promontory speech—the commerce of California and its centrality in trade with Australia, New Zealand, China, and Japan.[106] The book included an extensive text (almost three hundred pages) and eleven black-and-white wood engravings. Published in 1871, the guidebook featured illustrations drawn from a variety of sources—sketches by Frederick Whymper and by Charles Christian Nahl and Hugo Wilhelm Nahl of the Nahl Brothers firm, Central Pacific stereographs by Alfred Hart (credited to Carleton Watkins), and images by C. R. Savage.[107] One of Whymper's wood engravings in the book, first published in the *Illustrated London News,* serves as an example of why editors turned to sketch artists rather than relying on photographs alone, and how even wood engravings could be co-opted to convey a new narrative (fig. 85).

The *Illustrated London News* had used Whymper's sketch of Weber Canyon to provoke

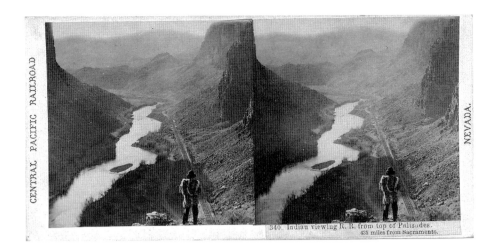

FIG. 86

Alfred Hart, *Indian Viewing R.R. from top of Palisades. 435 miles from Sacramento* (no. 340), 1868.
Albumen stereograph, 3½ × 7 inches. Library of Congress Prints and Photographs Division.

the romantic imagination of viewers in a way that photography could not. The wood
engraving shows the train entering the canyon at night, with the full moon surrounded
by clouds, and looming, sharp cliffs on either side of the railroad and river. The text
notes certain aspects not seen in the illustration but that add to the dramatic impact of
the landscape: the river's rapids, the difficulty of constructing the Weber tunnel, and
the claim that it was excavated "by a party of industrious saints, under the personal
direction of Brigham Young himself."[108] When the same wood engraving was published
in the *Alta California Pacific Coast and Trans-Continental Rail-Road Guide,* the writer
disregards these details, imagining an old emigrant wagon road, not seen in the engrav-
ing, and comparing it to the iron path of the railroad: "Hallowed by so many memories
of dear ones, who, in the long weary journey westward, have succumbed to the trials
and privations they were unable to bear ... How many brave hearts have passed along
that beaten track!—hearts that in spite of failure and disappointment elsewhere, have
followed the Star of Empire glittering in the west."[109]

Like Hart's stereographs *Indian Viewing R.R. from top of Palisades. 435 miles from
Sacramento,* and *Poetry and Prose Scene at Monument Point, North end of Salt Lake,* Cur-
rier and Ives's *Across the Continent,* and the cover of Crofutt's *Great Trans-Continental
Tourist's Guide,* this passage reiterates the idea of progress and the ideology of American
Manifest Destiny, and it encourages emigration by juxtaposing the present ease and
speed of railroad travel with the past difficulties of earlier wagon transport (fig. 86;
see also figs. 11, 80). For example, in the Hart stereograph, the Indian's body is located
between the meandering wagon road and the direct line of the railroad track. More
subtly, the *Alta California Trans-Continental Guide*'s narrative describes passage *through*

the landscape, rather than *to* the landscape; whereas Currier and Ives and Andrew Russell created the image of progressive settlement—first wagons, then the railroad, then cabins and farms. The *Alta California Trans-Continental Guide* creates a sense of the land as a place of transition and insinuates that people should use the railroad to bypass the central plains and move directly to California as the wagon trains had done in the decades before.

Travel guides offered a new and public outlet for the stereographs made during the construction of the transcontinental railroad; their appropriation of instrumental railroad images reinterpreted the stereographs for new audiences. Competition among the travel guides was fierce, and none, save Crofutt's, was significantly updated and republished. Finding success was not easy, even for Crofutt. *Crofutt's Western World* was bankrupt within three years. His *Trans-Continental Railroad Guide* continued to be printed into the 1880s, but it, too, struggled in the face of the many new competitors. Alfred Hart's *Traveler's Own Book* may have been more typical; he simply stopped printing copies as fewer and fewer were sold. Other guides, such as *Nelson's Pictorial Guidebooks* and the *Alta California Pacific Coast and Trans-Continental Rail-Road Guide,* addressed emigrants in an effort to persuade Americans and Europeans to settle in Utah or California. These publications gave new life to the railroad photographs, creating fresh narratives of emigration, investment, and land speculation. This rosy picture of the opportunities in the West came to a crashing halt, however, when railroad speculation and overbuilding led to the panic of 1873 and a national economic depression for the remaining years of the decade.

EPILOGUE

Interest in Russell's and Hart's photographs appears to have gradually faded over the next decade. In the early 1870s, the stereographs seem to have sold well; but within a year of the opening of the transcontinental railroad, other photographers, such as William Henry Jackson, Eadweard Muybridge, C. R. Savage, and an unknown photographer working for E. and H. T. Anthony, had all made stereographs of the rail line.[1] With a plethora of imagery and increasing access to travel, the West was, by 1880, a less mysterious place. The strange and exotic geological features Russell had photographed alongside the transcontinental railroad, and which had been singled out in the illustrated press and travel guides, were diminished by the marvelous wonders of Yellowstone, captured in photographs by William Henry Jackson and in paintings and chromolithographs by Thomas Moran. Social pressures such as labor strikes, the 1873 depression, and vicious conflicts over shipping rates may also have affected interest in the stereographs. In the late 1870s and 1880s, the railroads produced new images of their lines and marketed them in brochures and travel guides, further diminishing the uniqueness of the early photographs. In the face of declining interest, new publishers took over the Central Pacific and Union Pacific negatives and marketed the photographs to the public in fresh and exciting ways.

Alfred Hart gave up the Central Pacific negatives soon after the completion of the railroad, and it seems likely that the resignation of his patron, E. B. Crocker, played a role in that decision. Six weeks after the Promontory celebration, Crocker suffered a massive

stroke that left him incapacitated and forced him to resign from the company. In August 1869, Crocker traveled with his family to Germany, where they hoped relaxation and the mineral baths would aid in his recovery. While in Europe, he purchased paintings and drawings that formed the basis of a collection of fine art. When he returned in 1872, he had an elaborate gallery built adjacent to his home in Sacramento, and he continued to collect works of art, including many paintings by California artists. Although Crocker never again worked for the Central Pacific, his service had earned him a share of the company and allowed him to devote his remaining years to philanthropy and art. He died on June 24, 1875, at the age of fifty-six. His widow, Margaret Crocker, gave the home, which they had purchased during the height of the railroad construction, and the collection of art, which they had accumulated with railroad dividends, to the city of Sacramento in 1885; it was the first public art gallery west of the Mississippi River.[2] Although Crocker was a primary force in the success of the Central Pacific Railroad construction effort, his impact on the railroad was largely lost to history because he was no longer involved when newspapers and politicians focused public attention on the railroads during the panic of 1873; nor could he testify before the United States Pacific Railroad Commission in 1877. Instead, he is remembered for his art collection, housed at the Crocker Art Museum in Sacramento.[3]

The loss of Crocker's patronage may have been sufficient reason to end the railroad's documentation, but there were other explanations for the railroad's declining interest in photography. With Crocker no longer able to serve as an antidote to Huntington's fears about bad publicity, the Central Pacific had less need for a corporate photographic archive. Besides, Hart's stereographs played a specific but time-bound role for the Central Pacific. The photograph's veracity had carried the company's message of progress during the years of construction. With the completion of the line, this service was no longer necessary. The photographs showed land that was mountainous or dry, so they were not effective promotional instruments for land speculators or emigrants. Nor did the company appear to have been particularly interested in tourism. Huntington preferred to attract investors with the Central Pacific's control of western railroads and the potential profits from freight charges for ore, agriculture, and manufactured goods. Shipping facts were more easily conveyed with charts and graphs than in photographs. But this disinterest on the part of the company did not stop the press and publishers of travel guides from sampling the Central Pacific's photographic archive and interpreting the photographs for their own purposes.

Little information exists about Alfred Hart in the years after his work for the railroad. Shortly after its completion, he entered his photographs in the state fair and was awarded the gold medal for the best exhibition of uncolored photographs. He appears also to have worked to revive his career as a painter. For one large project, he tried to combine his skills as a painter with his experience on the railroad, writing to Jack Casement of the Union Pacific Railroad:

I am getting up a Large Picture of the Laying of the Last Rail at Promontory, May 10th, 1869, and would be obliged to you for your Carte De Visite so that I may have a correct likeness of yourself, as otherwise I cannot make the Picture perfectly correct. I have many faces which show in the Picture, and wish to make them perfect, as I intend this for a Historical Picture. Please do so immediately, and oblige,

Yours,
Alfred A. Hart,
65 J Street, Sacramento,
Artist to the C.P.R.R. of Cal.[4]

It is not known whether Hart followed through with his plans to produce a large history painting of the transcontinental railroad, but no record of such a painting exists. If it was ever begun, he likely abandoned it quickly. Large history paintings with multiple portraits were time consuming and difficult to produce, and an artist needed firm patronage to complete such a commission.[5] If E. B. Crocker was the intended patron, his stroke and departure for Europe would have ended any hope Hart had for Crocker's support for the painting.

Hart sold his last stereographic cards to the Central Pacific in October 1869. In 1870, he published *The Traveler's Own Book* in Chicago, where he also marketed his stereographs.[6] In 1871 or 1872 he established himself as a painter in San Francisco, where he enjoyed some brief success, winning the gold medal for portraiture and the first prize for the "Most Meritorious Exhibition of Paintings" at the 1872 California State Fair.[7] Hart also exhibited his paintings at the San Francisco Art Association during the 1870s, but he seems to have had little critical success. If, as seems likely, the untitled painting of the trapper and the Indian was indicative of his best work, his technique was stiff and his aesthetic passé by the 1870s (see pl. 4).[8] During the next twenty-five years, he held a variety of jobs but was most often listed as an artist in both the San Francisco and New York City directories. Like many pioneer photographers, Alfred Hart died in poverty in 1908.

In late 1869 or early 1870, Hart turned over his business, including the right to print the Central Pacific Railroad negatives, to Frank Durgan.[9] Little is known about Durgan's life, except that he was originally from Maine and came to California in the late 1860s.[10] The extant Central Pacific stereographs bearing Durgan's imprint, however, offer some insight into the details of the transfer of the negatives from Hart to Durgan. The label pasted on the verso of Durgan's stereographs indicates that he took over Hart's studio at 65 J Street in Sacramento. He seems to have also acquired a large number of mounted stereographs with Hart's imprint. To advertise the change in ownership, Durgan had large labels printed with his name and address and pasted them over Hart's logo on the verso of the cardboard support. He later mounted prints of the Central Pacific on specially designed card stock that included his name and studio address. Although no invoices indicate sales to the Central Pacific, Durgan enjoyed a close relationship with

the railroad, selling the stereographs from his studio on J Street and at the Central Pacific Railroad station, at No. 3 Front Street, Sacramento.[11]

Durgan's access to the negatives was short-lived. In late 1870, Collis Huntington gave the Central Pacific negatives to Carleton Watkins, whom he had known when the latter was a young man in Oneonta, New York, and who had worked in Huntington's store in 1851.[12] Shortly after, Durgan left California and moved to Lewistown, Maine, but before he left, he seems to have taken unmounted stereographic prints of the Central Pacific Railroad and mounted them on new card stock with his Lewistown, Maine, address.[13] Like Durgan, Watkins printed the Central Pacific Railroad negatives under his name and without crediting Hart, who was largely lost to history. Watkins did not become wealthy from this windfall, however, in part because he did not enjoy the image monopoly that had favored Hart.[14] In 1870, no one photographer controlled the market the way Hart had. The Central Pacific Railroad, which had purchased more than thirty thousand stereographs from Hart during the years of construction, purchased far fewer from Watkins; and although he may have been given preferential placement in Central Pacific Railroad stations, the sales of railroad stereographs did not save Watkins from bankruptcy in 1874. The ability of Hart's stereographs to provide government inspectors and private investors with empirical evidence of railroad construction made them a useful tool in the hands of shrewd men like E. B. Crocker and Collis Huntington, but the construction views were apparently of less interest to tourists.

Over the next two decades, Watkins acted as the Central Pacific's official photographer, making large format photographs of the Central and Southern Pacific Railroads.[15] These images, though picturesque, do not seem to have been intended for commercial sales, but were bound in deluxe albums and given to his benefactor, Collis Huntington. As the nineteenth century wore on, Watkins became increasingly feeble and was forced to abandon his work as a photographer. He was nearly blind in 1906, when the San Francisco earthquake and fire destroyed his studio and all his negatives. Presumably, that loss included the Central Pacific Railroad stereographic negatives. He and his family lived for a time on a Yolo County ranch that Huntington had given him. Watkins, however, never recovered from the trauma of the loss of his studio, and, in 1910 he was committed to the Napa State Hospital for the Insane, where he died six years later.[16] Watkins's friend and biographer, Charles Turrill, was the first to acknowledge that Hart made the Central Pacific Railroad negatives. Turrill compiled a list of the Hart stereographs and deposited it at the California State Library, and he published the information along with a plea for attention to Watkins's photographic work in a short biography that he wrote soon after Watkins's death in 1916.[17]

The fate of the Union Pacific Railroad photographs is more complicated. There is no record of either the business relationship between Russell and the railroad or the reason it ended. One possibility is that the Union Pacific needed no more photographs and simply stopped purchasing his prints. It is true that Thomas Durant, Russell's presumed patron, was forced to resign from the Union Pacific Railroad Board in late 1869, and

that Durant spent most of the 1870s engaged in lawsuits with the company and its board members.[18] Consequently, he would have had no time to use Russell's photographs to further promote the Union Pacific, or interest in doing so. But it is also possible that it was Russell, not the railroad, who ended the relationship. There is circumstantial evidence that Russell felt proprietary about his Union Pacific negatives and, unlike many of his contemporaries, including Alfred Hart, insisted on receiving credit.[19] In the 1870s, when other people were printing Russell's negatives, selling albums of his photographs, and advertising his stereographs, they always characterized themselves as "publishers" not photographers. Durant and the Union Pacific appear to have violated this principle in 1869, when Russell was making his final set of photographs in the West. Durant's check receipts show that he hired a man named Robert Pittman to do "photographic work" during the summer and fall of 1869. Unfortunately, there are no details of exactly what work Pittman performed, but Durant's account book records photographs sold and money deposited in Union Pacific accounts. The historical record also shows new stereographic mount boards with general information on the verso and no credit as to photographer. Russell may have decided to assert his claim on his negatives, and that is when he reorganized them and began to print them for himself.

Regardless of the reason for the break, in December 1869, when he returned to New York City from the West, Russell opened up a photographic studio with O. C. Smith.[20] Smith had worked in a variety of jobs until 1868, when familial ties to Union Pacific Railroad director Sidney Dillon helped him secure a position as cashier for the Union Pacific. Smith met Russell when both men were staying in Cheyenne, and he assisted Russell when he photographed the Dale Creek Bridge in April 1868.[21] The two men became friends later that summer, when Smith moved to Echo City and Russell used the railroad town as a base of operations. They renewed their acquaintance the following year, when Russell came west again to photograph the rail line. After the completion of the transcontinental railroad, Smith oversaw the sale of the Union Pacific Railroad equipment when it was abandoned; he then returned to his home to Massachusetts. Soon, though, he joined Russell in New York, where they printed the Union Pacific Railroad negatives, sold copies of Russell's album, *The Great West Illustrated,* and marketed the stereographs.

When Russell and Smith began to sell the stereographs independently of the railroad, he had new stereograph mounting board printed that signaled this shift of audience. No longer aiming his work at the Union Pacific Railroad personnel, who understood the stereograph as a vehicle for corporate promotion, Russell pitched it to the general public, for whom he re-created westward travel from Omaha to Sacramento with his labels advertising his stock of images and inviting potential buyers to his place of business. Judging from the number of stereographs extant, Russell seems to have done a lively business in the years immediately following the completion of the railroad. In 1870, George W. Thorne, at 60 Nassau Street, New York City, advertised "Views on the Pacific Railroad Route" and offered Russell's stereographs for sale in his store. New

York stationary dealers H. Ropes and Co. and James W. Queen, whose advertisement boasted "a fine assortment of stereoscopes and stereoscopic views," also carried Russell's stereographs.[22] Russell had hoped to produce a second volume of *The Great West Illustrated*, but this did not happen. No one on the Union Pacific Railroad Board seems to have been willing to underwrite such a lavish production. Although he did not create a second volume of that album, he was able to work with Hayden on *Sun Pictures of Rocky Mountain Scenery*.

By mid-1870, the photographic studio appears to have been a sideline for both Russell and Smith. In spring, Russell began work for *Frank Leslie's Illustrated Newspaper*.[23] Because Russell's photographs so rarely appeared in publications that printed images from the transcontinental railroad archives—newspapers, travel guides, and so on—it seems likely that *Leslie's Illustrated* had exclusive rights to publish Russell's Union Pacific views. Russell made new images for *Leslie's Illustrated* and engaged in independent pursuits, including a return to his first love, painting.[24] In 1872, he painted decorations at a New York hotel and listed himself at various times during the 1870s as an artist, designer, treasurer, and photographer.[25] He died in Brooklyn, New York, in 1902.

Russell's partner in the photography business, O. C. Smith, took a job working as a railroad contractor in New Orleans for at least part of 1870. Smith's journal indicates that during his short stay in the South, he also sold stereographs, large format prints, and photographic albums.[26] In addition to making these sales, on his way back to New York City he purchased additional negatives to add to the firm's photographic stock. When he returned to New York in June 1871, he took charge of the photography business and moved the studio from New York City to Brooklyn, where he went into business with his uncle, Asa, and created an inventory.[27] Smith's move of the archive and its subsequent organization had tragic consequences for historians. Smith complained in his journal: "I am trying to get everything at office sorted and filed. They never have been filed and we find a large number. We destroy old U.P. bills, and also A. J. Russell's private papers."[28] Documentation about the transfer of ownership of the negatives does not exist, but a journal entry notes that Smith paid down a debt of $1,000 that he owed to Russell. This price seems in line with the value that Smith placed on the studio contents. He noted in his inventory: 12,000 stereographs, 400 large format prints, two albums, and negatives. The value he placed on the "views" and albums ($1,025), the negatives ($500), and of the "other goods" ($1,000) suggests that his $1,000 payment to Russell may have been a partial payment for the inventory.[29]

One thing that complicates the idea of a straightforward sale of the negatives and the studio contents is that Russell seems to have retained an interest in the archive. He had negatives sent to him for reproduction in *Leslie's Illustrated,* and he remained involved in the business. On October 31, 1871, Smith noted in his journal: "Write Asa [Smith's uncle who ran his Brooklyn gallery] and order pictures sent to Russell."[30] A further indication of Russell's continued involvement is that, unlike Durgan, Watkins, and Houseworth

in California, Smith did not assume photographic credit. The verso of the Union Pacific stereographs listed his Brooklyn address and characterized Smith as "publisher" rather than "photographer."[31] Smith's labels were vague as to authorship, but they were clear about their intended audience. "Important Scenery between the Missouri River and the Pacific Ocean. Those who have been over the Railroad to California need these views so they can show and explain to their friends the wonders they have seen."[32] Smith expected to sell the stereographs as visual souvenirs to travelers who made the western journey, just as postcards are sold to tourists today. In the summer of 1871, he received a pass on the Union Pacific Railroad and traveled from Chicago to Salt Lake City, selling stereographs to passengers on the trains and to dealers in cities along the railroad route.[33] He also sold at least one copy of Hayden's album *Sun Pictures of Rocky Mountain Scenery*. When he returned from this trip, he was enthusiastic enough about the results to make plans to issue a second volume of *The Great West Illustrated*.

Before he had time to complete this project, however, Smith's attention was diverted to a different photographic venture that offered him a new way to market the photographs. On Friday, September 22, 1871, Smith noted in his diary: "Asa and self go to Brooklyn Athenaeum and see a stereopticon [magic lantern], the first time I ever saw one. Views show well but he has poor views."[34] Approximately two months later, Smith decided to produce magic lantern slides from the Union Pacific photographs. Magic lanterns, or stereopticons, used a camera with two lenses to project slides onto a screen at the front of a room.[35] Unlike a stereoscope, the stereopticon did not create three-dimensional images. In this case, the two lenses were mounted on top of each other and used to dissolve one view into the next. A gas flame within the camera apparatus illuminated the slides, and a lecturer provided details about the projected images. For audiences of the 1870s, the stereopticon show was popular entertainment, the equivalent of the modern motion picture. Smith notes in his diary: "At night we take slides and instrument to Asa's house and show up our slides about 6 ft. square. They look very nice. I learned much about views by seeing them shown in the stereopticon."[36]

If Smith thought that magic lantern shows would be a way to earn money from the photo archive, he was mistaken. He hoped that these entertainments would allow him to use his knowledge about the railroad and the North American West to bring enthusiastic crowds to his magic lantern shows and, perhaps, allow him to sell stereographs and albums afterward. He had some successful "exhibitions" of magic lantern slides, but most of Smith's lectures drew only modest crowds and were beset by technical problems. The difficulties of the magic lantern show are evident in his diary entries:

> Asa and self are at home until 2pm. We then ride to Montague and tonight we give our last show at that place. We have a small audience and take about $4.00. I also sell 18 stereoscopic views for $5.00. We take our traps and shake the dust from our feet and leave that town. We get home at 11pm.[37]

We go give our second exhibition at Shutesbury. We get ready and we try our gas but Asa does not put enough pressure on and the fire runs back into the oxygen gas bag and that bag explodes and tears a hole in the bag. We come home as quickly as possible.[38]

We raise our banner [advertising the magic lantern show] 6 × 12 [feet]. Get a lot of boys to carry it and one to go ahead and ring a large bell. Have a show tonight and take in the two nights 11.70 nearly enough to pay for the hall.[39]

Discouraged, Smith and his uncle, Asa, gave up the magic lantern shows after about three months. In April 1872, a regional New York railroad hired Smith to act as its agent, a job that he held until November. His work for the railroad did not allow him time at the studio, and he hired a second man to help Asa print the Union Pacific negatives. In November he took a job with the Canadian Southern Railroad and stayed until 1875, when he moved to Rock Springs, Wyoming, where he gave up the photography business and managed the Union Pacific company store.[40] Before he left, Smith transferred the railroad negatives to Stephen J. Sedgwick.

Sedgwick was an entrepreneur who had founded a gymnasium in New York City in the late 1850s and had been a speaker on the Lyceum circuit for more than a decade.[41] He gave lectures on a variety of topics; his lecture titles included "Manifestations of God in History" and "World Religions." For his theological lectures Sedgwick assembled a personal collection of engravings that he used as illustrations. By 1867, however, he had begun to use magic lantern projections to enliven his public instruction. This work was sporadic, and he unsuccessfully sought positions in high school and college adminis- tration before seizing on an idea that would combine his skills as a lecturer with the soon-to-be-completed transcontinental railroad.[42]

In March 1869, Sedgwick reached out to friends for an introduction to the principals of the Union Pacific Railroad. Richard Kimball wrote to William Shattuck that Sedg- wick "has a suggestion to make a furtherance of plans of the Pacific Railroad, on which he would like your aid. If you deem the project a good one, I beg you to receive this gentleman as my friend, one of high scientific achievement and moral worth."[43] George Opdyke, a bank president and an original investor in the Union Pacific Railroad, eagerly wrote to Durant and told him that Sedgwick would like to meet with him to discuss an idea "to make an arrangement with the Union Pacific Railroad Co. to deliver illustrated lectures on the line of the road."[44] No record indicates whether Sedgwick met with Durant, but he did go west as Russell's assistant in 1869, where he printed his negatives and became friends with O. C. Smith.[45]

Sedgwick returned to New York City before Russell, in October 1869, and quickly began to organize magic lantern lectures based on his travels in the West.[46] All the while, he worked to expand the photographic archive he used to illustrate his lectures. In December 1869, he wrote to both Thomas Houseworth and Alfred Hart with a request to purchase negatives and magic lantern slides of the Central Pacific Railroad and

scenes in California, which Houseworth sold to him.[47] Shortly afterward, in February 1870, Sedgwick wrote a script for a presentation about the Central Pacific Railroad; the lecture text was copied from Crofutt's and Nelson's travel guides.[48] His earliest known lecture on the West was given in May 1870, and he followed with many more. His illustrated talks were popular enough that, in 1871, Sedgwick had special stationery with the lecture series title "Across the Continent" printed boldly across the top of the page.[49]

In July 1873, Sedgwick stopped lecturing and traveled west again, this time as the agent for George Crofutt, publisher of the *Great Trans-Continental Railroad Guide* and *Crofutt's Western World*. Crofutt hired Sedgwick to gather information about cities and towns for a new edition of the guide, to promote the sale of Crofutt's publications, and to seek out new advertisers. For acting as his representative and salesman for the publications, Crofutt agreed to pay Sedgwick a hundred dollars a month, a 33 percent commission on all ads, and a 45 percent commission on all sales. During his three-month trip Sedgwick wrote articles for *Crofutt's Western World*, sold *Crofutt's Trans-Continental Tourist Guide* and newspaper subscriptions, promoted advertising in the two publications, and published stories in local newspapers along the route. Although the total number of guidebooks sold is not known, in three months Sedgwick secured at least eighty-two new subscriptions to *Crofutt's Western World* and acquired new advertising for the newspaper.[50] He failed, however, to bring back sufficient information and colorful anecdotes for Crofutt's revision of his transcontinental railroad guide, and as a result, Crofutt refused to pay Sedgwick the salary owed to him.

When Sedgwick returned from this western excursion, O. C. Smith was preparing to leave for Rock Springs, Wyoming, and Sedgwick became the sole caretaker of Russell's negatives. One can only speculate about the exact circumstances surrounding the transfer of the negatives or the understanding of ownership. Although one is tempted to assume that Sedgwick purchased the negatives from Smith, it does not seem to have been a simple or complete transfer of authority, which continued to reside with Russell. In April 1876, Russell wrote to Sedgwick:

> Friend Sedgwick,
> Will you please Send by Bearer a print from the negative I took from the top of the Mormon Tabernacle looking towards Camp Douglas. If you have not the print send the negative as Mr. Leslie wishes to use it in the paper.
> Yours, AJ Russell[51]

Given the continued friendship and correspondence between Russell, Smith, and Sedgwick, it seems that, at least during the 1870s, they shared control over the negatives and print sales.[52]

Smith had not been successful at using magic lantern shows to market the photographs, but Sedgwick was. When he took over the archive, Sedgwick published a catalogue that advertised his lectures and Russell's photographs. The cover title, *Announce-*

ment of Prof. S. J. Sedgwick's illustrated course of lectures and catalogue of stereoscopic views of scenery in all parts of the Rocky mountains, between Omaha and Sacramento, foregrounded Sedgwick's lectures, but inside the booklet the title page advertised only the photographs.[53] The booklet functioned as a catalogue of Russell's Union Pacific stereographs, with half the pages featuring reproductions of the labels printed exactly as they were on the verso of Russell's stereographic mounts. The title page characterized Sedgwick as "a member of the Union Pacific photographic corps" and listed titles from Omaha to Sacramento, but without including any mention of Andrew Russell. In all, Sedgwick listed 613 titles, "the only complete series ever taken, and now offered to the public." Throughout the booklet there are numerous advertisements for stereographs and photographic albums intermixed with a synopsis of each of Sedgwick's six lectures, a list of the cities where he had spoken, testimonials regarding his skills as an orator, and comments about the high quality of his projected images. The booklet also includes fourteen wood engravings, incongruously not from Russell's photographs but from engravings published in Crofutt's tourist guides. Smith marketed Russell's photographs directly to transcontinental travelers; Sedgwick found his audience among those who would only make the journey vicariously.

Sedgwick appears also to have marketed albums of Russell prints, reduced in size from ten by thirteen inches to approximately five by seven inches. In the years immediately following the completion of the railroad, the Far West was of great enough interest to Americans that Russell's photographs were effective vehicles for advertising local businesses. Sedgwick sold individualized, unique albums of Russell's photographs alongside advertisements for local companies and their products. The albums vary slightly in size but have similar covers with gilt titles and decorative borders, which suggests that they were produced by the same person and sold at approximately the same time. Each photograph is mounted on an elaborate presentation board with gilt corner designs and edging, a large block title, and a brief description borrowed from the annotated titles from *The Great West Illustrated*.[54]

One of the most elaborate of these advertising vehicles is an album of twenty-five photographs opposite advertisements for twenty businesses in New Haven, Connecticut (fig. 87).[55] Turning the album pages, one finds a Russell image on the right-hand page and a lavish, full-page business advertisement printed on the left. George W. Williams and Co., from Charleston, South Carolina, commissioned a similar album with identical mount decoration.[56] Williams's agricultural fertilizer company used twenty Russell images on the left side of the page, juxtaposed with a photograph of the same advertising image showing prehistoric amphibians and skeletons of dinosaurs buried beneath the earth, presumably soon to turn into fertilizer. Beneath each of these advertisements was a testimonial by a cotton farmer about the high quality of Williams's product. In the case of Russell's photographs, the reduced size and uneven quality of the prints suggest that, unlike the lavishly produced *Great West Illustrated,* these albums were utilitarian vehicles for advertising, not aesthetic presentations.

FIG. 87

Andrew Russell, *Union Pacific RR Views*, c. 1872. Albumen prints, 7⅞ × 20 inches (double page), 5 × 6½ inches (photograph). Yale Collection of Western Americana, Beinecke Rare Book and Manuscript Library.

It is difficult to pinpoint exactly how these albums were marketed, but it seems likely that the primary agent was Stephen Sedgwick. His travels along the East Coast as a magic lantern lecturer, and the salesmanship he demonstrated when he worked for Crofutt, suggest that he was responsible for the commission, compilation, and sale of these unusual albums. He can be tied directly to two of them. Sedgwick gave his "Across the Continent" lecture in New Haven the same year that the New Haven album was produced.[57] The second album, sponsored by the South Carolina firm of George Williams' and Co., also can be linked to Sedgwick through family connections. Correspondence in Sedgwick's papers indicates that several members of his wife's family lived in Charleston, South Carolina, and at least one of them had a business relationship with George Williams and Co.

By the mid-1870s, things had changed. When Sedgwick republished his catalogue in 1879, he conceived of it as a new hybrid, a pastiche of earlier efforts at railroad promotion. *Announcement of Prof. S. J. Sedgwick's illustrated course of lectures and catalogue of stereoscopic views of scenery in all parts of the Rocky and Sierra Nevada mountains, between Omaha and San Francisco* borrows its pictorial cover from a Union Pacific promotional booklet and uses iconography and motifs associated with commerce and economic wealth (fig. 88).[58] The image displays the familiar motif of the allegorical figure of liberty, representing the United States, who shakes hands with a female representing Asia. The gesture is reminiscent of the handshake at the top of the engraving in *Harper's Weekly* that celebrated the completion of the railroad in 1869 (see fig. 72). The image joins the railroad and prosperity visually, showing a locomotive framed by the clasped hands and a cornucopia of coins at the feet of the two figures. Inside the booklet, Sedgwick borrows the format of the travel guide, moving the reader geographically west from Omaha, adding extensive description of sites of commerce along the railroad route, and

FIG. 88

Front cover of *Announcement of Prof. S. J. Sedgwick's illustrated course of lectures and catalogue of stereoscopic views of scenery in all parts of the Rocky and Sierra Nevada mountains, between Omaha and San Francisco* (Newtown, NY: Sedgwick, 1879). Steel engraving, 8⅝ × 5¾ inches (page). Yale Collection of Western Americana, Beinecke Rare Book and Manuscript Library.

highlighting the scenic locations that Sedgwick would review at his magic lantern entertainment. Despite an expanded textual description reminiscent of the text included in tourist guides, Sedgwick insisted upon the importance of viewing the images:

> A description, minutely and accurately written, not questioning its value, would fail to convey to the mind an image like that made by the photograph addressed to the eye.
>> "Segnius irritant animos demissa per aurem,
>> Quam quae sunt oculis subjecta fidelibus."
>
> Where each picture furnishes a text for a discourse, close attention is required, lest a description should develop itself into a dissertation; in which case our pamphlet would readily swell into a volume of 2,000 pages! To those beholding the photograph, a brief verbal description gives life and completeness to the scene not to be obtained in any other way, and impresses it indelibly on the mind.[59]

The list of images in Sedgwick's photographic archive expanded to include stereographs of Yellowstone, Yosemite, and other western sites, as well as Union Pacific railroad images. Most important, however, Sedgwick removed all references to stereographic sales and the preface expresses "his obligations to Captain A. J. Russell, foremost among the landscape photographers in this country." One can only speculate about the reason for these changes. It is possible that there was not enough of a market for the stereographs to make it worth advertising them, but it seems more likely that Russell objected to the implication in the 1874 catalogue that Sedgwick had been the person who made the photographs, and Russell asserted his authorship of the negatives.[60]

Regardless of whether or not he owned the Russell negatives, Sedgwick had them in his possession when he passed away in 1920. They remained at his home in the care of his daughter who, in her old age, gave them to her physician, Abbott C. Coombs. Dr. Coombs never printed them but kept them safe until 1940, when he gave them to the American Geographical Society; they, in turn, stored them without apparently knowing their provenance, subject matter, or the name of the photographer who made them.[61] In the early 1960s, William Pattison, a history professor from the University of California, Los Angeles, wrote an article about Sedgwick's magic lantern presentations. Russell's *East and West Shaking Hands at Laying Last Rail* had been misattributed to Savage on the basis of the 1869 reproduction in *Harper's Weekly*, but Pattison established Russell as the photographer.[62]

The existence of the negatives soon came to the attention of J. S. Holliday, the director of a new museum in Oakland, California. Holliday arranged for their purchase in 1969 and added them to the museum's history department. To celebrate the acquisition, the museum and American West Publishers printed *Westward to Promontory*, a book honoring the centennial of the completion of the railroad and illustrated by Russell's photographs.[63] Coincidental to the publication, the United Transportation Union and the Oakland Museum jointly organized a traveling exhibition of modern prints made from

the negatives. A few of Russell's negatives made one last entry into the market. When Dr. Coombs gave the negatives to the American Geographical Society, a small number were overlooked or rejected because of problems with their condition. These, along with some of Sedgwick's personal papers, remained with the Coombs family, who cared for them and generously made them available to researchers. When the family sold their large home, however, the heirs decided to put the thirty-one remaining negatives and a group of Sedgwick papers up for auction. They were sold in April 2008.

The story of the railroad negatives, however, is just one part of the historical arc of the transcontinental railroad archives. Soon copy prints replaced negatives and photographic reproductions of the transcontinental railroad images were found in several different archives. History books drew images from the print archives of photo agencies and from the Union Pacific and Southern Pacific railroads, among others. In this situation, the transcontinental railroad photographs were stripped not only of their original value as tools of the railroad corporations but also of the agency of the photographer. Shorn of all contexts save their subject matter, the modern reproductions were easily appropriated by individuals who created new stories using the photographs to illustrate their arguments. These interpretations of the images provide almost as much insight into the historical moment of their publication as they do about the instant captured in the image.

Exactly how an author might adapt the transcontinental railroad photographs for his or her own purposes can be seen in a brief consideration of the publication of *East and West Shaking Hands at Laying Last Rail* in American history textbooks during the twentieth century (see pl. 1).[64] When *Our Country: A First Book of American History* used Russell's photograph, it credited the image not to Russell or the Union Pacific but to Ewing Galloway. Galloway had opened a photo agency in New York City in 1920; by 1928, when *Our Country* was published, he had amassed a large enough archive to expand his service to several cities in the United States and Europe.[65] Similar to photographic publishers in the nineteenth century, Galloway wanted his name, not the photographer's, associated with the images. Clients could reproduce a photograph from the archive without his credit line, but such action resulted in increased reproduction fees. In this publication, *East and West Shaking Hands at Laying Last Rail* follows a discussion of the effect of the Civil War on the South. The accompanying text falsely claims that only one railroad company, the Union Pacific, built the transcontinental railroad, and it stresses the importance of the railroad as evidence of the power of industrial capitalism to make a better world. Published at the height of capital expansion in the 1920s, *Our Country* states that the railroad was built by "a few leading men" who, acting in the national interest, connected the Pacific Coast more closely to the East Coast and unified the country.[66]

In contrast, *Living Geography, Book One, How Countries Differ* was published in the 1930s at the height of the Depression; it reproduced two images of the railroad. The first is a drawing of men laying track on the plains; the second is *East and West Shaking Hands at Laying Last Rail*. Neither draftsman nor photographer is named. Credit for

both is given to the Southern Pacific Historical Collection. By the 1870s, the Central Pacific had been subsumed into the Southern Pacific Railroad. *Living Geography* makes no mention of "leading men" and only passing reference to either railroad company. Instead, it describes the transcontinental railroad as an example of the power of communal action pointed toward a common goal of national unity. *Living Geography* interpreted the photograph as celebrating the culmination of a massive project that required "huge piles of ties, poles, and rails[,] . . . mountains of coal and giant heaps of kegs full of spikes and bolts," all of which were shipped by steamboat to Omaha. Although it is not true that coal or ties were shipped to the Union Pacific, the enormity of the task, the marshaling of a national effort, and the social benefits derived from worker productivity all served to support the communal ideology of New Deal programs.[67]

A decade later, with Germany's assertion of racial purity and the integration of the American Armed Forces as prominent social topics, *East and West Shaking Hands at Laying Last Rail,* was reproduced to characterize American society as a melting pot. *The United States in the Western World* used an earlier published text to draw the reader's attention to the crowd gathered in front of the camera, finding diversity where there was none: "Then, simultaneously, the Orientals from the West and the Caucasians from the East advanced toward each other, placing the missing links of steel. At their heels followed the spectators, edging forward step by step. Some six hundred people composed the throng, which included white Americans, Irish workmen, Chinese in blue blouses, negroes, and Mexicans in tall sombreros. There was also a little group of Indians."[68]

America's History used the photograph to exemplify the great potential of amicable labor and management relations. Reproduced in 1950 from a print in the Union Pacific Railroad archives, the text described the photograph as a gathering of a harmonious workforce in which management, "the engineers who conceived [the railroad]," and the laborers "who by sweat and blood transformed dreams into reality," worked toward a common goal. The result was a celebration in which, "surrounded by grimy workmen, silk-hatted gentlemen drove golden spikes into the connecting rails while the telegraph carried the news to Americans everywhere throughout the United States."[69] This utopian reading of *East and West Shaking Hands at Laying Last Rail* ignored the reality of the contentious management and labor relations during railroad construction and stood in direct contrast to labor stoppages in the United States at the time of its publication.[70] These examples of the ways in which *East and West Shaking Hands at Laying Last Rail* was treated as historical palimpsest have marked not only this photograph but also most historical treatments of the photographs and archives of the transcontinental railroad.

Texts reproducing *East and West Shaking Hands at Laying Last Rail* as an objective historical document interpreted the photograph in a variety of ways; art history has made different claims about the railroad images. For example, Beaumont Newhall did not select *East and West Shaking Hands at Laying Last Rail*, despite its notoriety, for his history of photography text in 1949. Rather than reproduce this image rich with historical resonance, Newhall chose Russell's photograph *Granite Canon, from the Water Tank,*

here retitled *Union Pacific Railroad West of Cheyenne, Wyoming* (see fig. 19).[71] *East and West Shaking Hands at Laying Last Rail* did not fit Newhall's project because the image is full of information, and its specificity yokes it to a particular historical moment. *Granite Canon, from the Water Tank*, on the other hand, is a stark image of a barren landscape whose formal characteristics could be understood to echo contemporary photographic aesthetics and, therefore, to further Newhall's attempts to gain recognition for photography as fine art. The minimal subject matter of *Granite Canon, from the Water Tank* illustrated the abstract qualities of the composition. In the context of Newhall's *History of Photography*, it marked Russell as a precursor to the fine art aesthetics of the photographers of the 1920s and the 1930s. One need only look at Paul Strand's *Window, Red River, New Mexico* or Edward Weston's *Dunes, Oceano*—both reproduced in the same edition of *The History of Photography*—to see examples of a similar formalist aesthetic.[72] Setting this context for *Granite Canon, from the Water Tank* tied the photograph and the photographer, whom Newhall identified by name, to contemporary "masters of photography." Abstracted from history, isolated from other photographs of the railroad, and subject to Newhall's art historical project, *Granite Canon, from the Water Tank* provides twentieth-century photographers with a historical precedent in a way that *East and West Shaking Hands at Laying Last Rail*, because of its rich historic texture, could not.[73]

The history of the transcontinental railroad photographs reveals the ways in which photographic archives, even ones as historically significant as the photographs of the first transcontinental railroad, shift positions as they become products of individual and institutional frameworks.[74] Like a vapor trail, photographs project historical arcs though time, leaving traces of their presence. They appear in one moment and context, disappear in another, and suddenly reappear decades later with a new rhetorical force. Research and analysis fills these historical ruptures in an effort to understand the cultural life of the object and the social conditions that create meaning and value. Photographic prints of the transcontinental railroad could not be confined as easily as glass plate negatives, and consequently they were quickly appropriated and further distanced from their origins as the work product of the photographer or as discursive objects within the space of the archive. The Central Pacific Railroad and the Union Pacific Railroad archives shifted from corporate commodities to private resources and, in the case of the Union Pacific negatives, to public artifacts. Tracing these prints and negatives for almost a century and a half demonstrates the vicissitudes of nineteenth-century photography in America and points out how much can be learned from attending to photographs as the product of the photographer's labor and to the archive as a distancing mechanism subject to curatorial decision-making and appropriation by others.

NOTES

INTRODUCTION

1. *Meeting of the Rails, Promontory, Utah* is the title as it has been published in Beaumont
 Newhall, *The History of Photography* (New York: Museum of Modern Art, 1982); Naomi
 Rosenblum, *A World History of Photography* (New York: Abbeville Press, 1984); Mary
 Warner Marien, *Photography: A Cultural History* (Upper Saddle River, NJ: Prentice
 Hall, 2011); and others. *Meeting of the Rails, Promontory, Utah* is also the title recorded
 in the Union Pacific Railroad archives.

 George Kraus, *High Road to Promontory* (Palo Alto, CA: American West Publishing,
 1969), and Barry Combs, *Westward to Promontory* (Palo Alto, CA: American West Pub-
 lishing, 1969), make extensive use of the photographs of the transcontinental railroad.
2. Details of this event can be found in David Bain, *Empire Express: Building the First Trans-
 continental Railroad* (New York: Viking, 1999), 649–50.
3. Of the approximately thirty-five photographs made at the ceremonies at Promontory,
 only one includes the Chinese: Andrew Russell, *Chinese Laying the Last Rail* (no. 539).
 Martha Sandweiss also mentions the omission of the Chinese as evidence of the con-
 structed nature of the photograph, in *Print the Legend* (New Haven, CT: Yale University
 Press, 2002), 158–61.
4. The literature describing the construction of the transcontinental railroad is vast and
 includes photographs or wood engravings from the railroad archives. Among the rel-
 evant titles are Henry White, *History of the Union Pacific Railway* (Chicago: University
 of Chicago Press, 1895); Edwin Sabin, *Building the Pacific Railway* (Philadelphia: J. B.
 Lippincott, 1919); John Galloway, *The First Transcontinental Railroad* (New York: Sim-

mons-Boardman, 1950); Wesley Griswold, *A Work of Giants* (New York: McGraw-Hill, 1962); Maury Klein, *Union Pacific: Birth of a Railroad, 1862–1893*, 2 vols. (Garden City, NY: Doubleday, 1987); John Hoyt Williams, *A Great and Shining Road: The Epic Story of the Transcontinental Railroad* (New York: Times Books, 1988); and Bain, *Empire Express*.

5. This point is also taken up in Sandweiss, *Print the Legend*, 2–14.

6. For a contemporary review in which this aesthetic reading of the photographs is articulated, see Barbara Novak, "Landscape Permuted: From Painting to Photography," *Artforum* 14 (October 1975): 40–45.

7. Weston Naef, in collaboration with James Woods; with Therese Thau Heyman, *Era of Exploration* (Boston: New York Graphic Society, 1976). Technically, Russell's photographs had been made public earlier in Combs, *Westward to Promontory*. The latter text, however, was primarily a picture book with minimal text. It was not a historical or art historical publication of Russell's work or the Union Pacific Railroad photographs.

8. Among exhibition catalogues, the most noteworthy are Ian Kennedy, *Art in the Age of Steam* (New Haven, CT: Yale University Press, 2008); Anne Lyden, *Railroad Vision* (Los Angeles: J. Paul Getty Museum, 2003); Sandra Phillips, ed., *Crossing the Frontier: Photographs of the Developing West, 1849 to the Present* (San Francisco: San Francisco Museum of Modern Art, 1997); Martha Sandweiss, ed., *Photography in Nineteenth-Century America* (Fort Worth, TX: Amon Carter Museum, 1991); and Susan Danly and Leo Marx, eds., *The Railroad in American Art* (Cambridge, MA: MIT Press, 1988), which traced the iconography of the railroad in the fine arts through the nineteenth and twentieth centuries. These catalogues are insightful and sensitive treatments of the railroad and the western landscape, but the transcontinental railroad plays only a small part in their much larger projects. *The West as America* is an early and notable exception to the anesthetization of photographs of the American West. William Truettner, ed., *The West as America* (Washington, DC: Smithsonian Institution Press, 1991).

9. *Carleton Watkins: The Art of Perception*, at the San Francisco Museum of Modern Art, was one of the most ambitious attempts to include stereographs in a museum context. The exhibition's use of digital technology allowed visitors to see a large number of stereographs with relative ease. Douglas Nickel, *Carleton Watkins: The Art of Perception* (San Francisco: Museum of Modern Art, 1999).

10. How later generations inscribe meaning on historic photographs is taken up in Alan Trachtenberg, "From Image to Story: Reading the File," in *Documenting America*, ed. Carl Fleischhauer and Beverly Brannon (Berkeley: University of California Press, 1988), 43–73; and Sandweiss, *Print the Legend*.

11. For examples of the interpretation of the photographs of the transcontinental railroad as signs of progress, see Sandweiss, *Print the Legend*, 156–80; Patricia Hills, "Picturing Progress in the Era of Westward Expansion," in *The West as America*, ed. William Truettner (Washington, DC: Smithsonian Institution Press, 1991), 96–147; Nancy Anderson, "The Kiss of Enterprise," in *The West as America*, ed. William Truettner (Washington, DC: Smithsonian Institution Press, 1991), 236–83; and Susan Danly, "Andrew Russell's *The Great West Illustrated*," in *The Railroad in American Art*, ed. Susan Danly and Leo Marx (Cambridge, MA: MIT Press, 1988), 93–112.

12. *Frank Leslie's Illustrated Newspaper*, June 5, 1869, 184–85.

13. E. B. Crocker to Collis Huntington, September 30, 1867, *The Collis P. Huntington Papers, 1856–1901* (Sanford, NC: Microfilming Corporation of America, 1979).

14. Rosalind Krauss, "Photography's Discursive Spaces," *Art Journal* 42 (Winter 1982): 311–19.

15. Allan Sekula, "Photography between Labor and Capital," in *Mining Photographs and Other Pictures, 1948–1968*, ed. Benjamin Buchloh and Robert Wilkie (Nova Scotia: Press of the Nova Scotia College of Art and Design, 1983), 193–268.

16. Joel Snyder argues that aesthetics and function cannot be separated, in *The Documentary Photograph as a Work of Art* (Chicago: David and Alfred Smart Gallery, 1976) and "Documentary without Ontology," *Studies in Visual Communication* 10 (Winter 1984): 78–95.

17. Sekula, "Photography between Labor and Capital," 201.

18. Allan Sekula, "The Body and the Archive," *October* 39 (Winter 1986): 3–64.

19. Sandweiss, *Print the Legend*.

20. Robin Kelsey, *Archive Style* (Berkeley: University of California Press, 2006).

21. Ibid., 10.

22. Three studies that also consider a broad range of media in their study of photography of the West are Kelsey, *Archive Style*; Sandweiss, *Print the Legend*; and Anne Farrar Hyde, *An American Vision: Far Western Landscape and National Culture, 1820–1920* (New York: New York University Press, 1990).

1. PREPARING THE GROUND

1. A tangent is a long line of straight track that allowed a train to cover long distances quickly. In the context of the transcontinental railroad, it afforded the locomotive a chance to gather speed before beginning the climb into the mountains.

2. For a discussion of the deceit and sleight of hand that lay at the center of the transcontinental railroads in the nineteenth century, see Richard White, *Railroaded: The Transcontinentals and the Making of Modern America* (New York: W. W. Norton, 2011).

3. Davis quoted in William Goetzmann, *Army Exploration in the American West, 1803–1863* (New Haven, CT: Yale University Press, 1959; reprint, Austin: Texas State Historical Association, 1991), 262.

4. Long quoted in Edwin James, *Account of an expedition from Pittsburgh to the Rocky Mountains*, vol. 2 (Philadelphia: Carey and Lea, 1823), 361.

5. John Fremont, *Report of the exploring expedition to the Rocky mountains in the year 1842 and to Oregon and North California in the years 1843–'44* (Washington, DC: Blair and Rives, 1845), 274.

6. John Wilford, *The Mapmakers* (New York: Knopf, 1981), 201.

7. For a contemporary account of the Donner Party tragedy, see Eliza Farnham, *California, in-doors and out; or, How we farm, mine, and live generally in the Golden State* (New York: Dix, Edwards, 1856).

8. New Orleans (with a railroad through Central America), Memphis, Chicago, and St. Louis all advanced proposals in the 1840s and 1850s for transcontinental rail lines running west from their cities. James Ward, "Promotional Wizardry: Rhetoric and Rail-

road Origins, 1820–1860," *Journal of the Early Republic* 11 (Spring 1991): 69–88. For a discussion of proposals that predated Whitney's 1844 suggestion to Congress, see Richard Francaviglia and Jimmy Bryan, "'Are We Chimerical in This Opinion?' Visions of a Pacific Railroad and Westward Expansion before 1845," *Pacific Historical Review* 71 (May 2002): 179–202.

9. For an overview of the efforts of the South to gain approval of a southern route for the railroad, see Jere W. Roberson, "The South and the Pacific Railroad, 1845–1855," *Western Historical Quarterly* 5 (April 1974): 163–86. Roberson argues that the failure to gain a southern transcontinental railroad in the 1850s was as much a product of the inability of the South to agree on a route as it was a lack of northern support.

10. The importance of these issues is persuasively presented in David Potter, *Impending Crisis, 1848–1861* (New York: Harper and Row, 1976). This text also provides an authoritative overview of the period. For a response to Potter's thesis, see William Freehling, *The Road to Disunion, 1776–1854*, vol. 1 (New York: Oxford University Press, 1990).

11. Robert Johannsen, *Stephen A. Douglas* (New York: Oxford University Press, 1973), 390-400.

12. Robert Russel, *Improvement of Communication with the Pacific Coast as an Issue in American Politics, 1783–1864* (Cedar Rapids, IA: Torch Press, 1948), 107.

13. The standard resources for the army explorations of the West are Goetzmann, *Army Exploration*, and William Goetzmann, *Exploration and Empire* (New York: Knopf, 1966; reprint, New York: History Book Club, 1993).

14. See, for example, Russel, *Improvement of Communication with the Pacific Coast*, 168–201; Goetzmann, *Army Exploration*, 266–74; and Frank Schubert, *Vanguard of Expansion: Army Engineers in the Trans-Mississippi West, 1819–1879* (Washington, DC: Historical Division, Office of Administrative Services, Office of the Chief of Engineers, 1980), 95–113.

15. Lynda Lasswell Crist, Mary Dix, and Kenneth Williams, eds., *The Papers of Jefferson Davis*, vol. 5, *1853–1855* (Baton Rouge: Louisiana State University Press, 1985), discusses the political pressure that was brought to bear on Davis. This volume contains several letters lobbying for appointments. See, for example, Davis to Randolph Marcy, May 16, 1853, 16–17.

16. Jefferson Davis to Millard Fillmore, February 21, 1851, in *The Papers of Jefferson Davis*, vol. 4, *1849–1853*, ed. Lynda Lasswell Crist, Mary Dix, and Kenneth Williams (Baton Rouge: Louisiana State University Press, 1983), 165.

17. For the Gadsden Treaty, see Paul Garber, *The Gadsden Treaty* (Philadelphia: Press of the University of Pennsylvania, 1923). For Davis's influence on the treaty, see pp. 112–14.

18. There is disagreement about the relative importance of the railroad in Douglas's support for the bill. Potter, in *The Impending Crisis*, writes that Douglas's desire for the railroad was a major factor in his promotion of the Kansas-Nebraska Act. Freehling, in *The Road to Disunion*, argues that it was less important than Douglas's desire to open up the territories to white settlement. Undoubtedly there was no single reason for Douglas's sponsorship of the Kansas-Nebraska Act, but it seems clear that his desire for a central route for the railroad played an important role in his decision. Even if one accepts Freehling's assertion that Douglas's ultimate desire was white settlement and

new Democratic Party voters, the railroad was widely acknowledged to be the most efficient way to encourage that settlement.

19. Jefferson Davis to William R. Cannon, December 7, 1855, in *The Papers of Jefferson Davis,* vol. 5, *1853–1855,* 142.

20. For a discussion of the publication history of the Pacific Railroad Reports, see Ron Tyler, "Illustrated Government Publications Related to the American West, 1843–1863," in *Surveying the Record: North American Scientific Exploration to 1930,* ed. Edward C. Carter II (Philadelphia: American Philosophical Society, 1999), 147–72. This essay was revised and reprinted as "The Most Picturesque and Wonderful Scenery: Illustrations from the Pacific Railroad Surveys," *Railroad Heritage* 14 (2005): 57–65.

21. "Report of the Secretary of War," in *Reports of Explorations and Surveys, to ascertain the most practicable and economical route for a railroad from the Mississippi River to the Pacific Ocean* (Washington, DC: Beverley Tucker, 1855), 1:29.

22. "Report by Lieutenant E. G. Beckwith, Third Artillery, upon the Route near the Thirty-Eighth and Thirty-Ninth Parallels, Explored by Captain J. W. Gunnison," in *Reports of Explorations and Surveys, to ascertain the most practicable and economical route for a railroad from the Mississippi River to the Pacific Ocean* (Washington, DC: Beverley Tucker, 1855), 2:38.

23. For an overview of the illustrations of the Pacific Railroad Reports, see Robert Taft, "Illustrators of the Pacific Railroad Surveys," *Kansas Historical Quarterly* 19 (November 1951): 354–80. For a discussion of general expeditionary art practice, see Roger Balm, "Expeditionary Art: An Appraisal," *Geographical Review* 90 (October 2000): 585–602.

24. The production history of the lithographs is complicated. The original drawings were the work of Richard Kern, the artist for the survey. In October 1853, however, Pahvant Indians killed Kern, Captain John Gunnison, who was the leader of the survey, and other six other members of the exploration in the area around Sevier Lake in Utah. Mormon traders recovered Kern's sketches over the next year and turned them over Lieutenant Beckwith, who became the new leader of the survey party. Once back in Washington, Beckwith transferred the drawings to John Mix Stanley, the most accomplished artist on the Pacific Railroad Surveys. Stanley prepared Kern's drawings for publication and turned them over to a lithographer, who translated the sketches into the lithographic images that accompanied Beckwith's written text in volume 2 of the Pacific Railroad Reports. On Kern's practice as an expeditionary artist, see David J. Weber, *Richard H. Kern: Expeditionary Artist of the Far Southwest, 1848–1853* (Albuquerque: University of New Mexico Press, 1985), 252–81.

25. These were common motifs used to represent the deserts in the Southwest, as can be seen in the illustrations accompanying the report of the Mexican border survey. Major William Emory, *Report on the United States and Mexico Boundary Survey* (Washington, DC: C. Wendell, 1857). Several of the plates are reproduced in Robin Kelsey, *Archive Style* (Berkeley: University of California Press, 2006).

26. "Report by Lieutenant E. G. Beckwith, Third Artillery, upon the Route near the Thirty-Eighth and Thirty-Ninth Parallels, Explored by Captain J. W. Gunnison," 2:63.

27. A contemporaneous review of the reports can be found in "The Pacific Railroad," *North American Review* 82 (1856): 211–36.

28. *Reports of Explorations and Surveys . . . ,* vol. 3 (Washington, DC: Beverley Tucker, 1856); and *Reports of Explorations and Surveys . . . ,* vol. 4 (Washington, DC: Beverley Tucker, 1856). Three men made illustrations used in volume 3. Heinrich Mollhausen was the official artist of the expedition, but John Tidball and Albert Campbell also contributed to the visual representation of the reconnaissance. On Mollhausen, see Baldwin Moll-hausen, *Diary of a Journey from the Mississippi to the Coasts of the Pacific with a United States Government Expedition,* trans. Mrs. Perry Sinnett (London: Longman, Brown, Green, Longmans and Roberts, 1858); and Robert Taft, "Heinrick Baron Mollhausen," *Kansas Historical Quarterly* 16 (August 1948): 225–44. On Tidball, see Eugene Tidball, *Soldier-Artist of the Great Reconnaissance: John C. Tidball and the 35th Parallel Pacific Railroad Survey* (Tucson: University of Arizona Press, 2004).

29. "Report of the Secretary of War," 1:21.

30. For a brief contemporaneous review of the painting characterizing it as "purely Ameri-can," see "Exhibition at the National Academy of Design," *Knickerbocker* 42 (July 1853): 95. The most extended treatment of Durand's painting can be found in Angela Miller, *The Empire of the Eye* (Ithaca, NY: Cornell University Press, 1993), 154–65.

31. Angela Miller has pointed out that *Progress* "shrewdly reconciled Gould's interests in the American wilderness as a subject for a native artistic tradition with his professional activities in transportation." *Empire of the Eye,* 157–58. Kenneth Maddox responds, ar-guing that Gould had minimal influence over the composition, in "Asher B. Durand's *Progress:* The Advance of Civilization and the Vanishing American," in *The Railroad in American Art,* ed. Susan Danly and Leo Marx (Cambridge, MA: MIT Press, 1988), 51–69.

32. For the debate over the transcontinental railroad before the war, see Russel, *Improve-ment of Communication with the Pacific Coast.*

33. White, *Railroaded,* 1–16.

34. Leonard Curry, *Blueprint for Modern America: Nonmilitary Legislation of the First Civil War Congress* (Nashville: Vanderbilt University Press, 1968).

35. Regardless of photographer, Brady printed the negatives under his name and organized them into a pictorial archive titled "Incidents of the War." So common was this practice that the Anthony firm listed Brady as the photographer when it published a series of Civil War views it had obtained in a dispute over Brady's unpaid bills. On the Anthony firm, see William Marder and Estelle Marder, *Anthony: The Man, the Company, the Cameras* ([Plantation, FL]: Pine Ridge Publishing, 1982).

36. "Photographs of the Virginia Campaign," *Harper's Weekly,* August 6, 1864, 499.

37. "Brady's Photographs: Pictures of the Dead at Antietam," *New York Times,* October 20, 1862, 5.

38. Keith Davis, "A Terrible Directness," in *Photography in the Nineteenth-Century America,* ed. Martha Sandweiss (Fort Worth, TX: Amon Carter Museum, 1991), 141–43. Approxi-mately 80 percent of the negatives made at Antietam and Gettysburg were stereo-graphs according to Davis.

39. For a critical discussion of nineteenth-century viewing practices using the stereoscope, see Jonathan Crary, *Techniques of the Observer: On Vision and Modernity in the Nineteenth Century* (Cambridge, MA: MIT Press, 1990), 116–36. Douglas Nickel applied Crary's

theoretical approach to the photographs of Carleton Watkins in *Carleton Watkins: The Art of Perception* (San Francisco: San Francisco Museum of Modern Art, 1999).

40. For a discussion of the phenomenology of stereographic viewing, see Nickel, *Carleton Watkins.*

41. O.W. Holmes, "The Stereoscope and the Stereograph," *Atlantic Monthly* 3 (June 1859): 744.

42. O.W. Holmes, "The Doings of the Sunbeam," *Atlantic Monthly* 12 (July 1863): 12.

43. Details about distribution can be found in Davis, "A Terrible Directness," 159. According to Davis, between March 1863 and early 1864 Russell made almost six thousand prints of military railroads and engineering; another three thousand were on order.

44. Herman Haupt, *Photographs Illustrative of Operations in Construction and Transportation As Used to Facilitate the Movements of the Armies of the Rappahannock, of Virginia, and of the Potomac, including Experiments Made to Determine the Most Practical and Expeditious Modes to be Resorted to in the Construction, Destruction and Reconstruction of Roads and Bridges* (Boston: Wright and Potter, 1863).

45. Russell was assigned to the United States Military Railroad on March 3, 1863, according to Davis, "A Terrible Directness," 177n101. For a discussion of Russell's work during the Civil War, see Susan E. Williams, "'Richmond Taken Again': Reappraising the Brady Legend through Photographs by Andrew J. Russell," *Virginia Magazine of History and Biography,* 110 (2002): 437–60; Thomas Fels, *Destruction and Destiny: The Photographs of A. J. Russell:* (Pittsfield, MA: Berkshire Museum, 1987); Alan Trachtenberg, *Reading American Photographs* (New York: Hill and Wang, 1989), 107–10; and Davis, "A Terrible Directness," 157–59.

46. Trachtenberg, *Reading American Photographs,* 107–11. He argues persuasively that this trend toward protoindustrial modernization is found in the photographs of the Civil War.

47. Frank Luther Mott lists several illustrated newspapers that went out of business in the 1850s. *A History of American Magazines* (Cambridge, MA: Harvard University Press, 1938–1968), 2:43–44. *Harper's Weekly* and *Frank Leslie's Illustrated Newspaper* were strong rivals and gave equal coverage to the war. The *New York Illustrated News* ran a distant third in readership and was taken over and renamed by W. J. Demorest in January 16, 1864. Its last issue as a pictorial newspaper was published on August 13, 1864. Although the South published *Southern Illustrated News* briefly in 1862, the newspaper did not send a sketch artist into the field, and so it contained few illustrations. Illustrations of the Southern perspective on the war were published in the *Illustrated London News.* For a discussion of these illustrations, see *The Civil War: A Centennial Exhibition of Eyewitness Drawings* (Washington, DC: National Gallery of Art, 1961).

48. Jan Zita Grover, "The First Living-Room War: The Civil War in the Illustrated Press," *Afterimage* 11 (February 1984): 8–11; Davis, "A Terrible Directness,"147–52.

49. The *Leslie's Illustrated* editor is quoted in Mott, *History of American Magazines,* 460.

50. Approximately 11 percent of the pictures in *Leslie's Illustrated* came from photographs, 10 percent of which were portraits; for *Harper's Weekly,* the numbers were 16 percent and 13 percent. These statistics come from *The Civil War: A Centennial Exhibition of*

Eyewitness Drawings and its very helpful appendix listing sources of Civil War illustrations, p. 108.

51. "Bread and the Newspaper," *Atlantic Monthly* 8 (September 1861): 348. The article, which was published anonymously, is reprinted in Oliver W. Holmes, *Pages from an Old Volume of Life* (Cambridge, MA: Riverside Press, 1892).

52. Nathaniel Hawthorne, "Chiefly about War-Matters," *Atlantic Monthly* 10 (July 1862): 44–45.

53. Ibid., 46.

54. For a biography of Leutze, see Barbara Groseclose, *Emanuel Leutze, 1816–1868* (Washington, DC: Smithsonian Institution Press, 1975). Contemporaneous references to Leutze's lobbying for the commission can be found in Montgomery Meigs's journals; see Wendy Wolff, ed. *Capitol Builder: The Shorthand Journals of Montgomery Meigs,* Senate Document 106–20 (Washington, DC: U.S. Government Printing Office, 2001).

55. There are multiple interpretations of the iconography of Leutze's mural. See, for example, Jochen Wierich, "Struggling through History: Emanuel Leutze, Hegel, and Empire," *American Art* 15 (Summer 2001): 52–71; Daniel Clayton Lewis, "Emanuel Leutze's *Westward the Course of Empire Takes Its Way,*" in *United States Capitol: Designing and Decorating a National Icon,* ed. Donald Kennon (Athens, OH: Ohio University Press, 2000), 239–55; J. Gray Sweeney, *The Columbus of the Woods* (St. Louis: Washington University Gallery of Art, 1992), 61–68; Patricia Hills, "Picturing Progress in the Era of Westward Expansion," in *The West as America,* ed. William Truettner (Washington, DC: Smithsonian Institution Press, 1991), 96–147.

 Leutze's statement about his intentions for the painting is reprinted in Justin Turner, "Emanuel Leutze's Mural 'Westward the Course of Empire Takes Its Way,'" *Manuscripts* 18 (Spring 1966): 14–16. Other early treatments of the historical details regarding this painting can be found in Raymond Stehle, "'Westward Ho!': The History of Leutze's Fresco in the Capitol," *Records of the Columbia Historical Society* 60–62 (1960–62): 306–22; and Raymond Stehle, "Five Sketchbooks of Emanuel Leutze," *Quarterly Journal of the Library of Congress* 21 (January 1964): 81–93.

56. "Leutze's New Picture," *New York Home Journal,* December 14, 1861. Citation courtesy of Merl M. Moore, Smithsonian American Art Museum.

57. *Boston Transcript,* December 8, 1862, 4. The reception of the painting was widespread and enthusiastic. Walt Whitman called it "the best thing I have seen in Washington." For his full reaction, see Edward Grier, ed., *Walt Whitman: Notebooks and Unpublished Prose Manuscripts* (New York: New York University Press, 1984), 2:563–64. For the contemporary newspaper reception, see *New York Home Journal,* July 6, 1861, 2; *New York Evening Post,* November 13, 1861, 1; *Boston Transcript,* March 20, 1862, 2; "Art Items," *New York Evening Post,* June 11, 1862, 2; "Letter from Washington," *Philadelphia Daily Evening Bulletin,* December 2, 1862, n.p.; *New York Home Journal,* December 14, 1862; "Leutze's New Picture at the Capitol," *New York Evening Post,* December 17, 1862, 2. Citations courtesy of Merl M. Moore, Smithsonian American Art Museum.

 After the war, however, critical reception turned against the painting; see *Boston Daily Evening Transcript,* August 24, 1868, 3; *Boston Daily Evening Transcript,* October 20, 1869, 1 (citations courtesy of Merl M. Moore, Smithsonian American Art Museum),

and James Jackson Jarves, *Art Thoughts* (New York: Hurd and Houghton, 1869; reprint, New York: Garland Publishing, 1976), 297–98.

58. Barbara Wolanin, "Mythology, Allegory, and History: Brumidi's Frescos for the New Dome," in *American Pantheon: Sculptural and Artistic Decoration of the United States Capitol,* ed. Donald Kennon and Thomas Somma (Athens: Ohio University Press, 2004), 192–94. See also patriotic envelopes in the Manuscripts Collection of the Huntington Library.

59. The 1864 act was amended to encourage construction of the transcontinental railroad by directly benefiting the companies. For a description of these changes see Maury Klein, *Union Pacific: Birth of a Railroad, 1862–1893* (Garden City, NY: Doubleday, 1987), 1:12–16 (Pacific Railroad Act of 1862) and 1:27–35 (Pacific Railroad Act of 1864); and David Bain, *Empire Express: Building the First Transcontinental Railroad* (New York: Viking, 1999), 104–18, and 176–80.

60. White, *Railroaded,* 1–38.

2. MAKING THE PHOTOGRAPHS

1. For a full description of the difficulty of producing a wet-plate negative, see Doug Munson, "The Practice of Wet-Plate Photography," in *The Documentary Photograph as a Work of Art* (Chicago: David and Alfred Smart Gallery, 1976), 33–38.

2. For a biography of Alfred Hart, see Glenn Willumson, "Alfred Hart: Photographer of the Central Pacific Railroad," *History of Photography* 12 (January–March 1988): 61–75. Reprinted in Mead Kibbey, *The Railroad Photographs of Alfred A. Hart, Artist* (Sacramento: California State Library Foundation, 1996).

3. Little has been written about itinerant portrait painting in the United States. One of the few scholarly treatments of the subject is David Jaffee, "'A Correct Likeness': Culture and Commerce in Nineteenth-Century Rural America," in *Reading American Art,* ed. Marianne Doezema and Elizabeth Milroy (New Haven, CT: Yale University Press, 1998), 109–27.

4. *The Union* (Saco, Maine), June 3, 1846. This advertisement is consistent with those Hart published in the 1860s as a photographer. Citation courtesy of Tom Hardiman.

5. *New York Herald,* October 16, 1852, 7.

6. Although untitled, the scene may be referring to *The Last of the Mohicans.* A painting with this title was included in Hart's prize-winning exhibition at the California State Fair, and a San Francisco newspaper commented: "A. Hart, San Francisco, has six paintings, mostly familiarized by Cooper's works. The most noteworthy, 'The Last of the Mohicans.'" *Daily Evening Bulletin* (San Francisco), September 28, 1872, 1.

7. [California] State Agricultural Society, "Statement of A. Hart," *Transactions* (Sacramento: N.p, 1872), 175–76.

8. His advertisement states, "Alfred Hart, Photographic Artist, will remain a short time at Laporte." This advertisement suggests that Hart had a wagon and was traveling from one town to the next in the summer of 1863. *La Porte Mountain Messenger* (La Porte, CA), June 20, 1863. Citation courtesy of Mead Kibbey.

9. For more information about Lawrence and Houseworth and its successor, Thomas

Houseworth and Co, see Peter Palmquist, *Lawrence and Houseworth/Thomas House-worth and Co.: A Unique View of the West, 1860–1886* (Columbus, OH: National Stereo-scopic Association, 1980).

10. Ibid., 42n24, is the source for the assertion that Lawrence and Houseworth used pri-marily one photographer before 1868.

11. Ibid., 13.

12. George Lawrence retired in late 1867, and Thomas Houseworth and Co. began opera-tions in January 1868. I have discovered twenty-three duplicate negatives that were published by both Alfred Hart and Lawrence and Houseworth and more than fifty-six close variants of Hart's stereographs that were part of the Lawrence and Houseworth photographic archive. Within in the Central Pacific Railroad series, see, for example, Hart, *Bank and Cut at Sailor's Spur* (no. 90), and Lawrence and Houseworth, *Grading the Central Pacific Railroad* (no. 1097); Hart, *Stumps Cut by the Donner Party in 1846* (no. 133), and Lawrence and Houseworth, *"Starvation Camp"* (no. 778); and Hart, *All Aboard for Virginia City* (no. 217), and Lawrence and Houseworth, *Arrival of the Central Pacific Passenger Train at Cisco* (no. 1256). For examples of variants outside the Central Pacific Railroad series, see Hart, *Mount Diablo from Benicia* (n.n.), and Lawrence and Houseworth, *Mount Diablo, from Benicia, Solano County* (no. 573); Hart, *Meadow Lake* (n.n.), and Lawrence and Houseworth, *Meadow Lake, Summit City, Knickerbocker Hill and Old Man Mountain* (no. 1288); and Hart, *Yosemite Valley, Mirror Lake* (no. 1004), and Lawrence and Houseworth, *Mirror Lake and Reflections, Yo-Semite Valley, Mariposa County* (no. 1118).

13. See, for example, the advertisement in the *Placer Herald* (Auburn, CA), July 4, 1868, 3. Although Hart is identified only as "an artist employed by the railroad company," an exhibition of stereographs is noted in "Fine Views," *Daily Territorial Enterprise* (Virginia City, NV), January 16, 1868, 3. Citation courtesy of Carol Johnson, Library of Congress.

14. Advertisement in *Reno (NV) Crescent,* August 1, 1868, 2.

15. Some Hart stereograph mounts carry his earlier address at 135 J Street, Sacramento. Evi-dence of Hart's sales in San Francisco through Thomas Houseworth and Co. is found in a stereograph in the Yale Collection of Western Americana, Beinecke Rare Book and Manuscript Library. The verso of Hart, *Sacramento City from the new Capitol Building, looking Southwest* (no.1215), carries a Houseworth and Co. stamp dated July 25, 1868.

16. Stereographic titles in the Central Pacific Railroad series vary slightly. For this book, I have chosen to use the titles under the half-stereographs in the Hart album in the Department of Special Collections and University Archives, Stanford University. This album contains the most complete collection of Hart images, beneath which are ste-reograph label captions with the most comprehensive information. It is available on-line at http://purl.stanford.edu/nj339gb1246#.

17. An artist's excursion along the railroad line is mentioned in "Local Art Gossip," *San Francisco Bulletin,* August 22, 1867, 3. Citation from Northpoint Gallery archives. See Janice Driesbach et al., *Art of the Gold Rush* (Berkeley: University of California Press, 1998), for a history of the gold rush images. Overviews of painting in the San Francisco area in this period can be found in Raymond Wilson, "Painters of California's Silver Era," *American Art Journal* 16 (Autumn 1984): 71–92; and Dwight Miller, *California*

Landscape Painting, 1860–1885: Artists around Keith and Hill (Stanford, CA: Stanford Art Gallery, 1976). For the seminal role played by Albert Bierstadt, see Alfred Harrison Jr., "Albert Bierstadt and the Emerging San Francisco Art World of the 1860s and 1870s," *California History* 71 (Spring 1992): 74–87.

18. Although this painting is currently untitled and undated, there are several reasons for suggesting that its subject is Donner Lake, and that its date is 1868. Although the lake in the painting is smaller than Donner Lake, its shape, the foreground grasses, submerged tree trunks with branches jutting above the surface, the jutting peninsula on the left, and the distant mountain ranges are all characteristics of Donner Lake and can be seen in contemporary photographs. Furthermore, William Gerdts has pointed out that the subject matter of a California scene is rare for Arriola. "Revealed Masters, Nineteenth Century American Art," *American Art Review* 1 (November–December 1974): 78 and 81. Arriola sold a painting on December 23, 1868, titled *Twilight, Donner Lake*. Citation from Northpoint Gallery archives. Plate 5 includes a crescent moon in the upper left and pink clouds suggesting sunset. *Twilight, Donner Lake* would seem to be an appropriate title for this painting.

19. *California Weekly Mercury* (San Francisco), October 13, 1867, 1.

20. The idea of the Sierra Nevada as a place of recreation had been advanced earlier in the popular press in articles such as "Cisco," *San Francisco Daily Times,* December 1, 1866, 1.

21. This stereograph may be the first photograph in the West to record clouds and landscape. Because of the collodion emulsion's sensitivity to blue, the sky tended to be overexposed. As a result, clouds were seldom found in landscape photographs of the nineteenth century. For an explanation of this problem see "Technical Appendix," in Joel Snyder, *American Frontiers: The Photographs of Timothy O'Sullivan, 1867–1874* (Millerton, NY: Aperture, 1981), 111. This issue was addressed by Eadweard Muybridge's invention of a "skyshade" in 1867 or 1868. This device allowed for differential exposure of a negative by shielding half the plate. Muybridge published details about the skyshade in *Philadelphia Photographer* 5 (May 1868): 142–44.

22. E. B. Crocker to Collis Huntington, August 2, 1867, in *The Collis P. Huntington Papers, 1856–1901* (Sanford, NC: Microfilming Corporation of America, 1979). A. G. Richardson was the man sent by the Central Pacific to be their agent in Salt Lake City.

23. "Views of Mountain Scenery—Interesting Exploration," *San Francisco Bulletin,* July 1, 1867, 3. The watercolor is also mentioned in "New Pictures," *Alta California* (San Francisco), August 25, 1867, 1. Citations from Northpoint Gallery archives. For a scholarly discussion of Keith's life and his paintings, see Alfred Harrison Jr., *William Keith: The Saint Mary's College Collection* (Moraga, CA: Saint Mary's College of California/Hearst Art Gallery, 1988). In this text, Harrison discusses this watercolor of the Yuba River.

24. When George Lawrence retired from the firm in 1868, Thomas Houseworth assumed ownership of the company's archive of negatives.

25. The standard text on the aesthetic of the railroad in the landscape is Leo Marx, *The Machine in the Garden* (New York: Oxford University Press, 1964). See also Susan Danly and Leo Marx, eds., *The Railroad in American Art* (Cambridge, MA: MIT Press, 1988). For a consideration of conflict between ideologies of nature and ideologies of progress

in American landscape painting in the eastern United States, see Martin Christadler, "Romantic Landscape Painting in America: History as Nature, Nature as History," in *American Icons: Transatlantic Perspectives on Eighteenth- and Nineteenth-Century American Art,* ed. Thomas Gaehtgens and Heinz Ickstadt (Chicago: University of Chicago Press, 1992), 93–117.

26. Biographical details about Norton Bush can be found in Miller, *California Landscape Painting,* 19–25. For more about Bush and the early painters in California, see Benjamin Avery, "Art Beginnings on the Pacific, Part 1" *Overland Monthly* 1 (July 1868): 28–34, and "Art Beginnings on the Pacific, Part 2," *Overland Monthly* 1 (August 1868): 113–19.

27. Although newspapers in 1868 report Bush painting in the Sierra and Donner Lake, none mention Cape Horn. An 1866 article in *The Californian* comments on Bush and his painting *Cape Horn,* "Art Items," *The Californian* (San Francisco) November 17, 1866, 8. Citation from Northpoint Gallery archives. For a discussion of the painting, see Alfred Harrison Jr., "Images of the Railroad in Nineteenth-Century Paintings," *Walpole Society Notebook* (1995–96): 71.

28. The theme of the railroad and the pastoral is a common reference in texts about nineteenth-century American landscape painting. For a recent consideration, see Kenneth Maddox, "The Train in the Pastoral Landscape," *Railroad Heritage* 14 (2005): 41–47.

29. See also "Over the Plains to Colorado," *Harper's New Monthly Magazine* 35 (June 1867): 1.

30. For a general biography of Frances Palmer, see Harry Peters, *Currier & Ives, Printmakers to the American People* (Garden City, NY: Doubleday, Doran, 1929; reprint, New York: Arno, 1976), 1:110–16. For her early life and work, see Charlotte Rubinstein, "The Early Career of Frances Flora Bond Palmer (1812–1876)," *American Art Journal* 17 (Autumn 1985): 71–88.

31. In her preliminary sketch, Frances Palmer drew the railroad emerging from the right side of the picture space and curving gently into the distance. This representation was in keeping with her composition of the wagon train in *Rocky Mountains,* which curves and fords valleys in its movement west. For the finished version of *Across the Continent,* however, Palmer activated the railroad with a straight and level diagonal flashing away from the viewer and the present moment of settlement and into the future. For a discussion of the editorial changes to the composition, see Peters, *Currier & Ives,* 114. Palmer's two preliminary sketches are reproduced in Peters, illustration numbers 18 and 19.

32. *The Great Union Pacific Railroad Excursion to the Hundredth Meridian* (Chicago: Republican Company, 1867). Among the excursionists were six directors of the UPRR, three government commissioners, five senators, two European noblemen, and several governors, congressmen, judges, and members of the press. The trains left New York on October 15, 1866, and arrived in Omaha on October 22.

33. Maury Klein, *Union Pacific* (Garden City, NY: Doubleday, 1987), 1:19–23.

34. On the financial and political machinations of the railroad during the second half of the nineteenth century, see Richard White, "Information, Markets, and Corruption: Transcontinental Railroads in the Gilded Age," *Journal of American History* 90 (June 2003): 19–43.

35. William Brey, *John Carbutt: On the Frontiers of Photography* (Cherry Hill, NJ: Willowdale Press, 1984).

36. *Philadelphia Photographer* 2 (January 1865): 4–6.

37. Carbutt's photographs are reviewed in "Union Pacific Railroad," *Journal of the Franklin Institute* 53 (March 1867): 148.

38. Silas Seymour, *Incidents of a Trip through the Great Platte Valley* (New York: D. Van Nostrand, 1867), 104–5. Emphasis in the original. Other contemporaneous accounts of the excursion can be found in *The Great Union Pacific Railroad Excursion* and the newspaper account produced by the excursionists, *Railway Pioneer* (Platte City, NE: Union Pacific Railroad Company, October 25, 1866). The latter, like the stereographs, appears to have been produced as a souvenir for those who participated in the excursion; it includes a listing of the participants. It is reproduced in *The Great Union Pacific Railroad Excursion to the Hundredth Meridian*, 43–44. An original of *Railway Pioneer* can be found in the Manuscripts Collection of the Huntington Library.

39. Reed discusses his concern about completing the bridge at North Platte in letters to his wife and to Thomas Durant. See abstracts of those letters on the website Railroads and the Making America: Letters of Samuel B. Reed, University of Nebraska, Lincoln; see letters between September 23 and November 29, 1866, http://railroads.unl.edu/topics/transcontinental.php.

40. Durant can be found in wearing the same gray hat in the following Carbutt stereographs: *Excur[sion] Party 275 m[ile]s W[est] of Omaha, Oct. 24 [18]66* (no. 206); *Headquarters, Platte City Oct. 25th 1866* (no. 215); and *The Directors of the U.P.R.R. at the 100th Mer[idian]* (no. 219). Durant carrying a rifle strapped to his back can be seen in the stereographs *Commissioners and Directors of the U.P.R.R.* (no. 213) and *Gro[u]p of distin[guished] guests of the U.P.R.R. at 100[t]h mer[idian]* (no. 221).

41. The one exception was Carbutt's trip with the Union Pacific's Editorial Rocky Mountain Excursion in October 1867. Afterward, he continued to Cheyenne and spent about a month photographing in Wyoming and Colorado. He made very few stereographs of the railroad, and there is no evidence that the Union Pacific purchased any of these stereographs. Described in *Philadelphia Photographer* 5 (January 1868): 34; and Brey, *John Carbutt*, 58–59.

42. The titles of Russell's large format photographs vary slightly. Russell's album, *The Great West Illustrated,* is the standard source for the early titles. Later titles were scratched into the negatives and are used for those photographs not included in *The Great West Illustrated*. The stereographic numbers and titles contain more dramatic changes between 1868 and 1870. In *Iron Muse* the early titles are used for the 1868 negatives; the 1870 titles are included in the caption information. The 1870 numbers and titles are taken from the negatives in the collection at the Oakland Museum of California.

43. The stretcher bar is inscribed: "Painted by A. J. Russell Esq. For Robt. VanValkenberg [sic] Oct. 2nd 1859 View of Bath from the West." Robert Van Valkenbergh served in the New York State Assembly and, shortly after the end of the Civil War, became the United States minister to Japan. The conservator who worked on the painting, John Sutton, has provocatively suggested that it is painted on a ground layer and indicated the possibility of a photosensitive ground. See http://westlakeconservators.com/russell.htm.

My thanks to John Sutton for sharing information from the conservation of Russell's painting.

44. *Buffalo (NY) Express,* quoted in *Nunda (NY) News,* December 15, 1860, 3.

45. "Panorama of the War," *Nunda (NY) News,* December 14, 1861, 3; and an advertisement titled "Russell's Great Panorama of the War of 1861," *Nunda (NY) News,* February 8, 1862, 3.

46. A contemporary report about his work as a photographer in the Civil War can be found in "Capt. Russell Photographing Battle Scenes," *Nunda (NY) News,* June 12, 1863, 1.

47. Robert V. Hine and John Mack Faragher, *The American West: A New Interpretive History* (New Haven, CT: Yale University, 2000), 285–86.

48. Russell's biographer, Susan E. Williams, has stated that Silas Seymour introduced to Durant the idea of Russell taking photographs of the Union Pacific Railroad. While her article contains a great deal of interesting new biographical information, it unfortunately does not include footnotes or bibliography. "The Great West Illustrated: A Journey across the Continent with Andrew J. Russell," *Streamliner* 10 (1996): 5.

49. For the payments to Russell, see folders titled "Durant, Thomas C. Accounting Records Checkbooks 1866–1869," and "Durant, Thomas C. Accounting Records Checkbooks 1869," box 12, Papers of Levi O. Leonard, MsC 159, Special Collections, University of Iowa Library (hereafter Papers of Levi O. Leonard). Unfortunately, there are few check records for 1868, and 1869 records are incomplete. For the Western Union charges, see the folder titled "Vail, William H. Western Union Telegraph Co. 1869 Accounts," box 33, Papers of Levi O. Leonard.

50. F. V. Hayden to Dr. Durant, September 1, 1868, folder titled "Hayden," box 18, Papers of Levi O. Leonard. After cleaning up Russell's studio in 1871, O. C. Smith noted, "Destroyed old U.P. bills." O. C. Smith diary (transcription), June 1871 (hereafter O. C. Smith diary). I was able to read portions of O. C. Smith's diaries in their original, handwritten form, while others were available only in a transcription made by a Patricia Morris in 1976. I have noted the difference between typescript and original in parentheses after each citation, in cases where I had access to both.

51. See, for example, Hart's stereograph *Emigrant Gap, looking East, Yuba Mountains in distance* (no. 167), where Hart's wagon can be seen on the flatcar being carried through the Sierra Nevada.

52. An article in the *Nunda News* notes that Russell stayed in the camp of construction foreman Michael Dowling for three months. "Personal," *Nunda (NY) News,* September 3, 1870.

53. This habit can be traced back to his working method during the war. A. J. Russell, "Photographic Reminiscences of the Late War," *Anthony's Photographic Bulletin* 13 (July 1882): 212–13.

54. O. C. Smith diary (transcription), April 12–18, 1868. The original diary has been lost, but Mrs. Morris's transcription reads, "I assist a J. P. Roberts in taking 4 views of Dale Creek Bridge today." Because this is the first mention in the diaries of a photographer and the last mention of Mr. Roberts, I assume that the transcribed name is a misunderstanding. The following week, and throughout the year, Smith refers only to Russell. The diaries were handwritten in script, and it is my assumption that Mrs. Morris

misread this first mention of the name, and that "A. J. Russell" was misunderstood as "J. P. Roberts."

55. It is not known whether Russell accompanied him for the entire survey or only for particular parts of it. For a discussion of Hayden and the survey, see Mike Foster, *Strange Genius: The Life of Ferdinand Vandeveer Hayden* (Niwot, CO: Roberts Rinehart, 1994), 172–75.

56. For biography of C. R. Savage, see Bradley Richards, *The Savage View: Charles Savage, Pioneer Mormon Photographer* (Nevada City, CA: Carl Mautz, 1995). Savage's partnership with Ottinger ended in 1869, which provides an ending date for stereographs carrying the "Savage and Ottinger" title on their verso.

57. The examples of scholarly monographs and exhibition catalogues suggesting the solitary nature of photographic work are too numerous to mention. This scholarship emerges from painting traditions and was used to establish the bona fides of photography as a fine art. Arguably the most important early work in this effort was Weston Naef in collaboration with James Woods, with Therese Thau Heyman, *Era of Exploration* (Boston: New York Graphic Society, 1976). Although photography is now widely accepted as worthy of serious scholarly attention, the monographic, traditional art historical approach still holds sway. With some photographers this is justifiable, but not with all. Scholars would do well to consider nineteenth-century photography as, at least in some cases, a collaborative effort.

58. Russell's photograph of Savage is titled *Temporary Blacksmith's Shop, Mouth of Weber Canon* (no. 55) and was later known as *Old Stage Station at Echo* (no. 357a). It is reproduced in Richards, *The Savage View*, 50. Savage's photograph of Russell is unnumbered, as are all of Savage's early stereographs, but it is titled *Engineer's Camp*. Although Savage kept extensive diaries, unfortunately none of them record his activities in 1868.

59. For an example of this working method, see Savage and Ottinger's stereograph of the construction of tunnel no. 3 in Weber Canyon and Russell's *Tunnel No. 3, Weber Canon* (no. 73), later known as *Building Tunnel No. 3* (no. 375).

60. C. R. Savage diary, May 18, 1869, Mss. 1424, Special Collections and Manuscripts, Harold B. Lee Library, Brigham Young University (hereafter C. R. Savage diary). My thanks to Dr. Bradley Richards for calling my attention to this entry.

61. The stereograph with a Savage and Ottinger stamp on the verso can be found in the Yale Collection of Western Americana, Beinecke Rare Book and Manuscript Library. Ottinger was a painter and Savage's partner until 1869. After they dissolved their partnership, Savage printed his stereographs with his name alone. Unlike most of the other Russell negatives in the collection at the Oakland Museum of California, there is neither number nor title scratched into this glass negative.

62. The sensational quality of the image for East Coast viewers can be seen in a review of Russell's photographs in the *Philadelphia Photographer*. The photograph of the Mormon family is the only photograph singled out for comment. "Report of a Meeting of the Photographic Section of the American Institute, February 2, 1869," *Philadelphia Photographer* 6 (1869): 89.

63. After the railroad was completed, there were further negotiations, and in September,

the Union Pacific agreed to sell to the Central Pacific the track from Promontory to Ogden, Utah. This arrangement allowed the Union Pacific Railroad to dispose of shoddy track, and it gave the Central Pacific Railroad an eastern terminus in an advantageous location. My thanks to Robert Spude for clarifying this agreement.

64. Collis Huntington to Mark Hopkins, April 14, 1869, in *Huntington Papers*.

65. Hewes claimed in "Hewes Genealogy" that he urged Stanford to organize the celebration. This private, family document is quoted in an unpublished typescript, "Historical Catalogue, Union Pacific Historical Museum" (1949), 879. The typescript can be found in the collection of the Union Pacific Railroad Museum, Council Bluffs, Iowa.

66. Robert Spude, "Reporters at Promontory Summit, May 10, 1869," appendix A of "Tents of Golden Spike," report for Cultural Resources Management, Intermountain Region, National Park Service, 2005, www.nps.gov/history/history/online_books/gosp1/promontory_summit.pdf.

67. An example of one of the Sunday sermons that refers to Stanford's speech is "The Highway thro' the Desert. Sermon on Pacific R. R. Oakland May 9, 1869," in the folder "Sermons 1869," box 1, Hamilton Collection, Huntington Library.

68. J. D. B. Stillman published his account of the trip and the celebration, "The Last Tie," *Overland Monthly* 3 (July 1869): 77–84.

69. Although the full title of the stereograph is *The First Greeting of the Iron Horse, Promontory Point, May 9th, 1869* (no. 354), I am persuaded by Robert Spude's argument that this stereograph was made on May 7, 1869. See "Alfred Hart's First Photograph of Promontory, May 7 or May 9?" appendix C of "Tents of Golden Spike," report for Cultural Resources Management, Intermountain Region, National Park Service, 2005. http://www.nps.gov/history/history/online_books/gosp1/promontory_summit.pdf.

70. Two reasons have been given for the postponement. Workmen were reported to have delayed Durant's train because they were owed back wages. In addition, rain had swollen the Weber River and made the newly constructed Devil's Gate Bridge unsafe for travel. As a result, Union Pacific officials were forced to wait in Echo City while work crews shored up the failing bridge.

71. Thomas Durant to H. C. Crane (telegram), April 22, 1869, folder titled "Crane, Henry C. 1869–77," box 8, Papers of Levi O. Leonard. Russell does not seem to have been in a hurry. He stopped in his hometown of Nunda, New York. "Nunda News/Local," *Nunda (NY) News,* May 1, 1869, [3]. Savage notes Russell's arrival in Casement's camp at Blue Creek, just east of Promontory, on May 8, 1869. C. R. Savage diary, May 8, 1869.

72. Savage records Seymour's visit and his advance of ten dollars for expenses but, unfortunately, says little about their arrangement. C. R. Savage diary, May 4 and 5, 1869.

73. An article in the *Deseret Evening News* states that Russell was assisted by Savage. "The Proceedings at Promontory Summit," *Salt Lake City Deseret News,* May 19, 1869, 1. Although only eight stereographs of the Promontory celebration are on Savage mounts, Savage noted in his diary that he "worked like a nigger all day and obtained some nice views of the scenes connected with laying the last rail. . . . Saw little of the actual driving of the gold spike as I was very busy." C. R. Savage diary, May 10, 1869. In contrast there are six large format and nine stereographic negatives of the ceremony credited to

Russell. There seems to be little doubt that Russell made all the large plate negatives, but Savage may have helped him with the stereographic production.

74. No two accounts of the details of the ceremonies at Promontory, Utah, seem to agree. The best standard reference is J. N. Bowman, "Driving the Last Spike at Promontory, 1869," *Utah Historical Quarterly* (Winter 1969): 78–101. His research and conclusions have been reviewed and updated by Robert Spude, "A Commentary on J. N. Bowman's article 'Driving the Last Spike at Promontory, 1869,' Fifty Years Later," appendix H of "Tents of Golden Spike," report for Cultural Resources Management, Intermountain Region, National Park Service, 2005. www.nps.gov/history/history/online_books/gosp1/promontory_summit.pdf. Current research on the sequence of the photographs can be found in Robert Spude, "Chronology of Photographers and Photographs," appendix B of "Tents of Golden Spike," report for Cultural Resources Management, Intermountain Region, National Park Service, 2005. www.nps.gov/history/history/online_books/gosp1/promontory_summit.pdf; Michael Johnson, "Rendezvous at Promontory," *Utah Historical Quarterly* 72 (Winter 2004): 47–68; Michael Johnson, "Historic Photograph Study of the Golden Spike Ceremony" (manuscript, n.d.), a report for the Golden Spike National Historic Site, Promontory, Utah.

75. The large format photograph is numbered and titled *Laying the Last Rail* (no. 225a). Russell's stereographic photograph is not among the negatives in the Oakland Museum of California. Extent stereographs are numbered and titled with 1868–69 numbers: *Laying the Last Rail and Driving the Last Spike* (no. 181). Savage's stereograph is titled *Jubilee on Laying the Last Rail*.

76. This stereograph, although not reproduced in the popular press, was a favorite of Stanford, who suggested it as a model for Thomas Hill's painting *The Last Spike*.

77. Patriotic envelopes produced during the Civil War also carried the handshake iconography. See examples in the Manuscripts Collection of the Huntington Library. The railroad celebration in Sacramento included an image of two trains, each with a man sitting on the cowcatcher, and the two men shaking hands. Undated and uncredited newspaper article, Stanford Scrapbook B, 26, Leland Stanford Papers, Special Collections and University Archives, Stanford University (hereafter Leland Stanford Papers).

78. Published in the *Alta California* (San Francisco), n.d. Clipping can be found in Stanford Scrapbook B, 18, SC33F, Leland Stanford Papers.

79. *Chicago Tribune,* May 11, 1869, 2.

80. *National Republican,* May 11, 1869. Quoted on note cards in the Farnum Papers, Union Pacific Railroad Museum, Council Bluffs, Iowa.

81. Quoted in the *Salt Lake (UT) Daily Telegraph,* May 11, 1869, and *New York Times,* May 12, 1869. http://cprr.org/Museum/Ephemera/Salt_Lake_Tel_Ads_1869.html.

82. For a thorough discussion of the financial manipulations of the railroad, see Richard White, *Railroaded: The Transcontinentals and the Making of Modern America* (New York: W. W. Norton, 2011).

83. Stillman, "The Last Tie," 77. The "bay tree" to which Stillman refers was the tree from which the laurel tie, used in the ceremonies at Promontory, was made.

84. Several newspaper stories about the celebration at Promontory also allude to the ability to visit friends and relatives. See, for example, "The Great Event of the Age," uncred-

ited and undated, Stanford Scrapbook B, 24, Leland Stanford Papers. For a discussion of the positive expectations for the railroad in California, see William Deverell, *Railroad Crossing* (Berkeley: University of California Press, 1994), particularly 12–24. For a more general treatment of the railroad as representing particular aspects of progress, see David Nye, *America as Second Creation* (Cambridge, MA: MIT Press, 2003), 147–203.

85. David Miller identifies the freight wagons—often misidentified in the literature as an emigrant wagon train—in *The Golden Spike* (Salt Lake City: University of Utah Press, 1973). This was confirmed to the author by S. Lyman Taylor and, more recently, by Robert Spude.

86. E. B. Crocker to Collis Huntington, May 21, 1868, in *Huntington Papers*.

87. See Russell's stereographs: *Distant from [t]op [of] Hotel* (no. 31a) [Fremont, NE]; *Columbus, from Tank* (no. 36); *Bird's Eye View of Cheyenne* (no. 64); *Hospital, Looking over Plains* (no. 136) [Laramie, WY].

88. See, for example, Russell's stereographs *Main Street of Fremont* (32); *16 Street Cheyenne* (no. 65); *Second Street, Grand Island* (no. 43); and *Front Street, North Platte* (no. 54).

89. For the importance of making the land look familiar, see J. F. Davis, "The Role of the Railroad in the Settling of Nebraska," in *Frontier Settlement*, ed. R. G. Ironside (Edmonton: University of Alberta, 1974), 164–77.

90. *Crofutt's Western World*, February 1872, 24, and June 1872, 93.

91. Thomas Magee, "A Run Overland," *Overland Monthly* 1 (December 1868): 510 and 512.

3. CURATING THE ARCHIVE

1. While the Central Pacific was waiting to qualify for federal bond guarantees, the State of California agreed to guarantee the interest on company bonds. This ruling was challenged in court, and the State Supreme Court decision in favor of the railroad was handed down in January 1865. Two months later, the federal government authorized the company to sell bonds as much as one hundred miles in advance of the rails. It also subordinated its mortgage on the property to protect company-issued bonds. My thanks to Wendell Huffman for sharing this information with me.

2. "Trial Trip," *Sacramento (CA) Daily Bee*, March 17, 1865, 3. Citation courtesy of Kyle Wyatt of the California State Railroad Museum. Emphasis in the original.

3. Although the first purchase of negatives by the company would not take place until January 1866, a year earlier a brief note in the *Sacramento (CA) Daily Bee*, on January 25, 1865, states that the Central Pacific Railroad was having photographs made along the railroad line. Citation courtesy of Kyle Wyatt, California State Railroad Museum.

4. For a biography of Crocker, see Glenn Willumson, "Grand Schemes and Big Things: E. B. Crocker and the Transcontinental Railroad Legacy," in *The Crocker Art Museum Collection Unveiled,* ed. Scott Shields (Sacramento, CA: Crocker Art Museum, 2010), xi–xx.

5. Crocker was appointed to complete the term of Supreme Court Justice Stephen Field when President Lincoln named Field to the United States Supreme Court.

6. Charles Crocker resigned from the board in July 1863; E. B. Crocker was first listed as

a member of the board in a Central Pacific publication dated October 1864. My thanks to Wendell Huffman for bringing this information to my attention.

7. Dickman's invoice was submitted two days after the excursion; see Voucher 249, March 25, 1865, Central Pacific Railroad Voucher Series, Southern Pacific Collection, California State Railroad Museum (hereafter Central Pacific Railroad Voucher Series). In December of 1865, Dickman left Sacramento and opened a studio with the company Nahl Brothers, in San Francisco. For details about Dickman's life, see Peter Palmquist and Thomas Kailbourn, *Pioneer Photographers of the Far West: A Biographical Dictionary, 1840–1865* (Palo Alto, CA: Stanford University Press, 2000), 203–4.

8. Although there is no documentation revealing which twenty-two stereographs Crocker purchased, nine images labeled as "Central Pacific Railroad" are listed in Lawrence and Houseworth's 1865 catalogue (CPRR series numbers 134–41).

9. An entire set of 364 stereographs that constitute the Central Pacific photographic archive are reproduced in Mead Kibbey, *Railroad Photographs of Alfred A. Hart* (Sacramento: California State Library Foundation, 1996). Because of the number of variant images, however, exactly which negatives were part of the photo archive and which were variants is subject to debate. The most authoritative document is an album of half stereographs that was owned by Leland Stanford ("The Alfred Hart Album," ca. 1869, Leland Stanford Papers). Because the Kibbey publication is based on his personal collection, there are some discrepancies between the images in this album and those reproduced by Kibbey.

10. The printed trademark on the verso of the stereograph described here was one of several logos used between 1866 and 1869.

11. For a scholarly consideration of the viewing the stereoscopic image, see Jonathan Crary, *Techniques of the Observer: On Vision and Modernity in the Nineteenth Century* (Cambridge, MA: MIT Press, 1990), especially 124–36.

12. Quoted in Rosalind Krauss, "Photography's Discursive Spaces," *Art Journal* 42 (Winter 1992): 314.

13. This solitary act of sustained attention is manifest in Crocker's own performance of the stereographs. He did not use a small, handheld viewer, but rather a large tabletop stereographic viewer called a graphoscope. He purchased this equipment at the same time that he bought his first set of stereographs of the Central Pacific Railroad. Voucher 734, June 27, 1865, Central Pacific Railroad Voucher Series.

14. *Sacramento (CA) Daily Bee,* April 17, 1867. Citation courtesy of Wendell Huffmann.

15. E. B. Crocker to Collis Huntington, May 3, 1867, in *The Collis P. Huntington Papers, 1856–1901* (Sanford, NC: Microfilming Corporation of America, 1979). Emphasis is mine.

16. The problem of snowfall at the summit of the Sierra Nevada was frequently mentioned in the press. The reference was usually accompanied by a reassurance that this problem had been overcome. For an example of reporting during this time, see "The Pacific Railroad—Its Several Grand Divisions," *Scientific American* 16 (May 18, 1867): 318.

17. This stereograph was made in 1867 but not added to the Central Pacific photographic archive until 1868.

18. Collis Huntington to E. B. Crocker, November 26, 1867, in *Huntington Papers.*

19. The theatrical presentation of the visual was not an idea confined to the stereograph or to photography. Nineteenth-century painters, too, encouraged special visual practices on the part of their audience. See, for example, Kevin Avery, "*The Heart of the Andes* Exhibited: Frederic E. Church's Window on the Equatorial World," *American Art Journal* 18 (Winter 1986): 52–72.

20. This characterization of stereographic vision is adapted from Alan Wallach's description of the panorama. "Making a Picture of the View from Mount Holyoke," in *American Iconology,* ed. David Miller (New Haven, CT: Yale University Press, 1993), 80–91.

21. Crocker's active participation in the selection of the negatives is evident from a Central Pacific Railroad voucher that reads, "50 Negatives 'photo views' to be selected by Judge Crocker from a lot taken by A. A. Hart." Voucher 513, July 15, 1867, Central Pacific Railroad Voucher Series. It is likely that the Central Pacific Railroad was Hart's primary client from 1866 to 1869 because they were willing to pay for the privilege. The Central Pacific Railroad paid Hart a premium for his negatives. When they purchased railroad negatives from Lawrence and Houseworth, they paid four dollars for each glass plate; they paid Hart five dollars for each of his stereographic negatives.

22. Lawrence and Houseworth copyrighted this stereograph in 1865. The next year Crocker purchased the negative and added it to the Central Pacific Railroad photographic archive.

23. Charles Crocker testified to Congress that he was the person who accompanied Whitney to establish the mountains' base. *Report . . . of the United States Railway Commission [and testimony taken by the Commission]* (Washington, DC: Government Printing Office, 1887–88), 3680. Governor Frederick Low, however, remembered that it was E. B. Crocker who met with Whitney. Robert H. Becker ed., *Some Reflections of an Early California Governor* (Sacramento, CA: Sacramento Book Collectors Club/Grabhorn Press, 1959), 38–39. This book publishes an 1883 interview with Governor Frederick Low by Herbert Howe Bancroft. Logic would suggest that for a legal issue as important as this, it would be the attorney who would make the argument for the location of the base of the Sierra Nevada. Details of the establishment of the western base of the Sierra Nevada can be found in David Bain, *Empire Express: Building the First Transcontinental Railroad* (New York: Viking, 1999), 136–38.

24. For an excellent analysis of the way in which maps enter into relational systems with other representational practices, see Richard Helgerson, *Forms of Nationhood: The Elizabethan Writing of England* (Chicago: University of Chicago Press, 1992), 105–49.

25. These statistics are reported in Bain, *Empire Express,* 174 and 176.

26. These stereographs were first published in New York City by Whitney and Paradise, with a line crediting Alfred Hart.

27. For another example, see *Trestle Bridge, 120 feet high, 600 feet long, Clipper Ravine* (no. 30) and *Trestle Bridge, Clipper Ravine, near view* (no. 31).

28. For a biography of Stanford, see Norman Tutorow, *The Governor: The Life and Legacy of Leland Stanford,* vol. 1 (Spokane, WA: Arthur H. Clarke, 2004).

29. Cultural geographers use the term *imagined landscapes* to describe this phenomenon. See David Lowenthal and Martyn Bowden, eds., *Geographies of the Mind: Essays in Historical Geosophy* (New York: Oxford University Press, 1975), for a definition of *imagined*

landscape. For a specific consideration of the social function of imagined landscapes, see Joan Schwartz and James Ryan, eds., "Introduction: Photography and the Geographical Imagination," in *Picturing Place* (London: I. B. Tauris, 2003), 1–18.

30. The story of the tragedy that befell these pioneers in 1846 was a subject that held fascination throughout the nineteenth century and would certainly have been in the minds of most, if not all, of the viewers of the Central Pacific Railroad stereographs in 1866. In addition to numerous newspaper and magazine stories, several books were published about the Donner Party. Among the earliest were Edwin Bryant, *What I Saw in California* (New York: D. Appleton, 1848); J. Quinn Thornton, *Camp of Death: The Donner Party Mountain Camp, 1846–47* (New York: Harper Brothers, 1849); Eliza Farnham, *California, in-doors and out* (New York: Dix, Edwards, 1856); and Charles McGlashan, *History of the Donner Party* (Truckee, CA: Crowley and McGlashan, 1880). Thomas Houseworth and Co. related the story of the Donner Party in their catalogue of stereographs: *Catalogue of Photographic Views of Scenery on the Pacific Coast* (San Francisco: H. S. Crocker, 1869), 46.

31. It is impossible to know exactly which fifteen negatives the Central Pacific Railroad purchased from Lawrence and Houseworth. My research has uncovered seventeen nonsequential stereographs from Hart's Central Pacific Railroad series mounted on Lawrence and Houseworth card stock, bearing the San Francisco firm's copyright, and dated 1865.

32. E. B. Crocker to Collis Huntington, June 9, 1868, in *Huntington Papers*.

33. For a biography of Collis Huntington, see David Lavender, *The Great Persuader* (Niwot: University Press of Colorado, 1998).

34. E. B. Crocker to Collis Huntington, January 9, 1867, in *Huntington Papers*.

35. The shipment of stereographic photographs is a frequent topic in letters between Crocker and Huntington. Although it is impossible to know exactly how many Crocker shipped east between November 9, 1866, and October 6, 1869, we do know that the Central Pacific purchased at least 36,974 stereographs from Alfred Hart.

36. These were numbered 1–32 in the Central Pacific Railroad photo archive. These images were printed in New York at the direction of Collis Huntington. On the verso, underneath the printed title, is the following credit line: NEGATIVES BY A. A. HART./Published by Whitney and Paradise, 585 Broadway, New York.

37. Purchasing records from 1866 and early 1867 note payments to Whitney and Paradise for "32 doz. views." Presumably, these are a dozen copies of the thirty-two negatives that Huntington had in New York, and that one finds printed on Whitney and Paradise card stock. Beginning in February 1868, however, payments begin to be made for "mounting views." Most likely, these were new, unmounted stereographs that were sent east by E. B. Crocker. *Central Pacific RR Co Journal Purchasing Agents Record July 1865 to Dec. 1868*, Southern Pacific Records, Account Record, M1010, RG 4, box 241, Special Collections and University Archives, Stanford University.

38. A list of Huntington's clients for the stereographs can be found in ibid.

39. "City Items; California Views," *Daily Alta California*, December 8, 1866, 1.

40. E. B. Crocker to Collis Huntington, September 17, 1868, in *Huntington Papers*. In his

letter Crocker identifies the individual only by last name, Tracy. Presumably, it was Lathrop Tracy, an employee of the Central Pacific and a relative of Leland Stanford.

41. E. B. Crocker to Collis Huntington, March 27, 1867, in *Huntington Papers.*

42. For a biography of Senator John Conness, see Robert Denning, "A Fragile Machine: California Senator John Conness," *California History* 85 (September 2008): 26–49.

43. Simpson was a government commissioner who reviewed the Union Pacific Railroad track. Later he joined the Union Pacific Railroad Board of Commissioners.

44. Collis Huntington to John R—— (Registrar's office of the Treasury Department), December 8, 1868, in *Huntington Papers.*

45. Correspondence between Durant and Carbutt can be found in Durant's letterpress book, box 12, Papers of Levi O. Leonard.

46. O. C. Smith notes, "Russell prints lots of pictures today." O. C. Smith diary (transcription), June 21–27, 1868. There are very few financial records for the Union Pacific Railroad from 1868, and those from 1869 are incomplete. Among Durant's checkbook records, however, are three deposits recorded as income from the sale of photographs. In the summer and fall of 1869, while Russell was in the West, Durant employed Robert A. S. Pittman, a Civil War veteran who had served in the navy. Between April and December 1869, Pittman was paid fourteen times for his photographic work. The notices are vague but include: "bill services rc photographs," "photo a/c," and "bill against Union Pacific RR photographing &c." It seems likely that Pittman made prints and sold Russell's photographs while Russell was in the West. For a time, Russell's stereographs were published on mounts that did not include his name as the photographer. These may date from the time that Pittman was printing the negatives. "Durant, Thomas C. Accounting Records Checkbooks 1869," box 12, and folder titled "Vail, William H.," box 33, Papers of Levi O. Leonard.

 There are two Russell photographs in the collection of the J. Paul Getty Museum, Department of Photographs that have the name *Pittman* written on the mount board, lower right. Pittman, however, is not recognized in the literature as a photographer. In fact, the only information extant about Robert Pittman is a letter of recommendation for Captain Robert A. S. Pittman, who was "an experienced shipmaster." James C. Bell to Silas Seymour, March 30, 1868, folder titled "Pittman, Robert A. S," box 25, Papers of Levi O. Leonard.

47. For a biographical sketch of Russell and his work for the railroad, see Susan E. Williams, "The Truth Be Told: The Union Pacific Railroad Photographs of Andrew J. Russell," *View Camera* 9 (January–February 1996): 36–43.

48. In 1869, cards included "Union Pacific R.R." on the left side of the card and "West from Omaha" on the right side.

49. These phrases seem to have come from the company, not the photographer. They can be found on Union Pacific promotional booklets and pamphlets from 1867. See, for example, *The Union Pacific Railroad from Omaha, Nebraska, across the continent* (New York: Wynkoop and Hallenbeck, 1867).

50. The stereographic camera Russell used in 1868 made a four-by-eight-inch glass plate negative; the following year he switched to a larger, five-by-eight-inch plate size. This analysis is based on the measurements of the extant negatives in the collection at the

Oakland Museum of California. With the exception of the large format photographs published in April 1869 in his album *The Great West Illustrated,* it is not possible to date Russell's large format images with certainty.

51. Andrew Russell, "The Laying of the Last Rail on the Union Pacific Road—Nunda is Honored with a Representative—Some Important Statements from Capt. Andrew J. Russell of Nunda," *Nunda (NY) News,* May 29, 1869, 4.

52. For a discussion of the overlap between the Civil War and the UPRR, see Maury Klein, *Union Pacific* (Garden City, NY: Doubleday, 1987), 1:72–75 and 385–86.

53. In this discussion I am using the final, geographical sequence of the 1868 and 1869 negatives. These are the numbers and titles scratched into the negatives housed in the Oakland Museum of California. Because not all the negatives are extent, it cannot be said definitively that all of the negatives of Nebraska are from 1869, but there is strong circumstantial evidence to support such a conclusion. The museum houses forty of the sixty stereograph negatives Russell made in Nebraska. All of these are five by eight inches. Furthermore, no stereograph of Nebraska was printed in the 1868–early 1869 printing on the stereograph cards that include a printed number and title beneath the right half of the stereographic pair.

54. "The Union Pacific Railroad of America," *Illustrated London News,* September 11, 1869, 265. This article states that Russell published the album "under the auspices of the company."

55. Andrew J. Russell, preface to *The Great West Illustrated* (New York: Union Pacific Railroad, 1869), n.p.

56. Andrew J. Russell, "Annotated Table of Contents," in *The Great West Illustrated* (New York: Union Pacific Railroad, 1869), pl. 18. The question of the aridity of the West continued to hold sway in the popular imagination; see, for example, "The American Desert," *Philadelphia Daily Evening Bulletin,* March 10, 1866, 3. Citation courtesy of Merl M. Moore, Smithsonian American Art Museum.

57. Russell, *Great West Illustrated,* pl. 19.

58. The idea of plentiful water was supported by the geologist Ferdinand Hayden, whom Russell had accompanied in 1868. Hayden suggested that rain followed settlement. Hayden quoted from his "First Annual Report" in James Cassidy, *Ferdinand V. Hayden: Entrepreneur of Science* (Lincoln: University of Nebraska Press, 2000), 98.

59. "The Laying of the Last Rail on the Union Pacific Road," 4.

60. F. V. Hayden to Dr. Durant, September 1, 1868, folder titled "Hayden," box 18, Papers of Levi O. Leonard.

61. F. V. Hayden, *Sun Pictures of Rocky Mountain Scenery* (New York: Julius Bien, 1870), [vii]. For an assessment of the historical importance of this album, see Gary Kurutz, "Rare Photographic Book Donated by the Foundation," *California State Library Foundation Bulletin* 86 (2006): 12–17.

62. These albums were being sold by Russell's studio in 1871. O. C. Smith diary (original), August 7, 1871.

63. Hayden, *Sun Pictures,* 59.

64. *American Journal of Science and Arts* 50 (July–November 1870): 125.

65. Hayden, *Sun Pictures,* 95.

66. Jeremy Vetter, "Science along the Railroad," *Annals of Science* 61 (2004): 187–211, offers an overview of scientific exploration along the railroad in the second half of the nineteenth century. He suggests that Hayden's exploration of Nebraska and Wyoming in 1868 was a great assist to the interests of the Union Pacific Railroad (see p. 202).

67. Hayden, introduction to *Sun Pictures*, [vii].

68. F. V. Hayden to Dr. Durant, May 24, 1869, folder titled "Hayden," box 18, Papers of Levi O. Leonard.

69. Hayden, *Sun Pictures*, 48.

4. REPRODUCING THE IMAGE

1. Mark Wahlgren Summers, *The Press Gang: Newspapers and Politics, 1865–1878* (Chapel Hill: University of North Carolina Press, 1994), 109–22. One of Painter's clients was the Union Pacific Railroad; see Richard White, *Railroaded: The Transcontinentals and the Making of Modern America* (New York: W. W. Norton, 2011), 104.

2. Collis Huntington to J. H. Riley, January 20, 1869, in *The Collis P. Huntington Papers, 1856–1901* (Sanford, NC: Microfilming Corporation of America, 1979). Huntington made good on his word. He sent a set of seventy-six stereographs to Riley on June 7, 1869.

3. For an extended and informative discussion of the importance of information and personal trust, see White, *Railroaded*, 93–133.

4. "Over the Plains to Colorado," *Harper's New Monthly Magazine* 35 (June 1867): 1–21. Of the twelve illustrations in the article, four are derived from Carbutt's stereographs and three from the lithographs illustrating the UPRR's 1864 engineering report.

5. Ibid., 6.

6. For a discussion of the rise of the Ames brothers and the importance of capital from New England, see Arthur Johnson and Barry Supple, *Boston Capitalists and Western Railroads* (Cambridge, MA: Harvard University Press, 1967), 195–221.

7. This wood engraving may have been based on an unknown photograph of Denver, Colorado, but there are some visual indications—such as the fence in the foreground and the trees along the river in the background—that suggest the possibility that the image in the *Harper's New Monthly Magazine* story may have been a generic version of a western town. It shares similarities with Carbutt stereographs of Omaha: *View of Omaha N.T. from Capitol Hill* (no. 230), and *View of Omaha N.T. from Capitol Hill* (no. 231).

8. For discussion of the railroad's use of the press, see White, *Railroaded*, 70-1; and White, "Information, Markets, and Corruption: Transcontinental Railroads in the Gilded Age," *Journal of American History* 90 (June 2003): 19–43.

9. "The Union Pacific Railroad," *Harper's Weekly*, November 16, 1867, 723.

10. *Harper's Weekly*, December 7, 1867, 771–73. Although the article discusses the Union Pacific Railroad as well as the Central Pacific, only Central Pacific Railroad illustrations are used to characterize the railroad.

11. *Harper's Weekly* editors were among the most sophisticated in their use of images for narrative purposes. For an extended treatment of the use of photographs in the nine-

teenth-century illustrated press in America, see William Stapp, "'Subjects of Strange and Fearful Interest': Photojournalism from Its Beginnings in 1839," in *Eyes of Time: Photojournalism in America,* ed. Marianne Fulton (Boston: Little, Brown, 1988), 1–35; and William Johnson, "Back to the Future: Some Notes on Photojournalism before the 1870s," *Views* 9 (Winter 1988): 8–12. For a brief outline of the narrative development of the picture story in the nineteenth century, see Glenn Willumson, *W. Eugene Smith and the Photographic Essay* (New York: Cambridge University Press, 1992), 7–11.

12. E. B. Crocker to Collis Huntington, January 31, 1867, in *Huntington Papers.*

13. Ibid., April 15, 1867.

14. Ibid.

15. Little is known about Magee's work for the railroad. His obituary makes no mention of it. It does state that beginning in the early 1860s he was "engaged in newspaper work in connection with the San Francisco *Ledger* and the *Bulletin.*" From the Central Pacific Railroad vouchers, however, we know that Magee was on their payroll and that he was regularly paid a hundred dollars a month for his services. For details of his lucrative real estate career in the 1870s and 1880s, see the Thomas Magee obituary, *San Francisco Call,* October 1, 1902, 2.

16. Thomas Magee to Mark Hopkins, April 25, 1867, in *Huntington Papers.*

17. E. B. Crocker to Collis Huntington, August 2, 1867, in *Huntington Papers.* Although Crocker refers to the paper as the *Sunday Mercury,* the San Francisco paper changed its title the same week that it began to publish the Central Pacific Railroad wood engravings. After October 13, 1867, it was retitled *California Weekly Mercury.*

18. Collis Huntington to E. B. Crocker, August 23, 1867, in *Huntington Papers.*

19. The artists signed seven of the wood engravings: five are by William Keith, and two by George Baker. Three are unsigned. All the engravings are based on stereographs from the Central Pacific Railroad photographic archive.

20. Keith's work for the railroad is mentioned in *San Francisco Bulletin,* October 19, 1867, 1.

21. *California Weekly Mercury* (San Francisco), October 13, 1867, front page.

22. Ibid., December 1, 1867, front page.

23. Ibid.

24. "Central Pacific Railway, North America," *Illustrated London News,* January 11, 1868, 37 (illustrations), 42 (text). The wood engravings are based on *Long Ravine Bridge, from the top of Cape Horn* (no. 39) and *Donner Lake and Eastern Summit, from the top of Summit Tunnel, Western Summit* (no. 126).

25. In the Central Pacific Railroad series, these are numbered and titled: *Long Ravine Bridge from the top of Cape Horn* (1866; no. 39); *Long Ravine Bridge from the West, 56 miles from Sacramento* (no. 40); *Long Ravine Bridge, near view. Length 1,050 feet* (no. 41); and *Long Ravine Bridge from below. 120 feet high* (no. 42).

26. Three consecutive stereographs of Donner Lake from approximately the same viewpoint are included in the Central Pacific archive. *Harper's Weekly* appears to have used for its model the stereograph *Donner Lake from Summit. Lakeview Bluff on the right* (no. 125), while the *Illustrated London News* used a slight variation: *Donner Lake and Eastern Summit, from the top of Summit Tunnel, Western Summit* (no. 126).

27. *Illustrated London News,* January 11, 1868, 42. In his article about the location of the transcontinental railroad over the Sierra, Wendell Huffman argues that the Nevada silver mines played a critical role in determining where the surveyors placed the railroad. "Silver and Iron: How the Comstock Determined the Course of the Central Pacific Railroad," *Nevada Historical Society Quarterly* 50 (Spring 2007): 3–35.

28. See Matthew Simon, "The Pattern of New British Portfolio Foreign Investment, 1865–1914," and Brinley Thomas, "Migration and International Investment," in *The Export of Capital from Britain, 1870–1914,* ed. A. R. Hall (London: Methuen, 1968), 15–44 and 45–54, respectively.

29. The title of the series was "Le Chemin de Fer du Pacifique." *L'Illustration* (Paris) published illustrated stories on February 29, 1868, 132–34; March 7, 1868, 152–54; March 14, 1868, 167–70; March 21, 1868, 183–86; March 28, 1868, 205–6; April 4, 1868, 217–18; April 11, 1868, 235, 237; April 18, 1868, 249–50; and April 25, 1868, 264–65.

30. We know from his biography that Heine was in Paris in 1868 looking for employment before returning to the United States. For a biography of Peter Bernhard Wilhelm Heine, see Andrea Hirner, *Wilhelm Heine. Ein weltreisender Maler zwischen Dresden, Japan und Amerika* (Radebeul, Germany: Reintzsch, 2009).

31. The connection of the articles to the Union Pacific is further supported by the fact that the second picture story in the series included the name and address of the Parisian bank handling Union Pacific bond sales. Heine also published an article about the transcontinental railroad a year earlier. Colonel W. Heine, "Le Chemin de Fer du Pacifique," *Bulletin de la Société de géographie* 5 (September 1867): 225–52.

32. W. Heine, "Le Chemin de Fer du Pacifique," *L'Illustration* (Paris), February 29, 1868, 132–34.

33. Ibid., 134.

34. Ibid., March 14, 1868, 167–70.

35. The two wood engravings of monolithic rock formations in the lower right are copies of Carbutt stereographs, different from those he made on the hundredth-meridian excursion. These come from Carbutt's trip with Union Pacific's Editorial Rocky Mountain Excursion in October 1867.

36. Both the more commonly reproduced close-up of the locomotive (see fig. 9) and the variant showing the entire locomotive (shown here) are included in the Central Pacific photographic archive, and both share the same number and title.

37. Ibid., April 11, 1868, 235. The translation is mine.

38. Ibid., April 4, 1868, 218. The translation is mine.

39. E. B. Crocker to Collis Huntington, June 5, 1868, in *Huntington Papers.*

40. Collis Huntington to E. B. Crocker, June 23, 1868, in *Huntington Papers.*

41. *Frank Leslie's Illustrated Newspaper,* June 5, 1869, 179, 184–85 (illustrations), and 183 (text).

42. Joseph McGowan, "The First Train West," *Sacramento County Historical Society's Golden Notes* 15 (April 1969): 27.

43. *Leslie's Illustrated,* May 29, 1869, 176.

44. "The Pacific Railroad," *Harper's Weekly,* May 29, 1869, 341–42 (text), 344–45, 348 (images).

45. Ibid., 344–45.
46. Ibid., 341.
47. The church services are detailed in the *New York Times,* May 11, 1869, 1.
48. Deuteronomy, 7:13–14, 19.
49. *Harper's Weekly,* May 29, 1869, 348.
50. Ibid., 342.
51. For a more general discussion of the treatment of the Chinese and Irish railroad work-ers in the popular press, see Herman Chiu, "When 1,000 Words Are Worth a Picture: How Newspapers Portrayed the Chinese and Irish Who Built the First Transcontinen-tal Railroad" (PhD diss., University of Missouri, Columbia, 2004).
52. "The Union Pacific Railroad of America," *Illustrated London News,* July 31, 1869, 120–21. *Harper's Weekly* (August 28, 1869, 557–58) republished the illustrations and most of the text.
53. Russell's stereograph *Old Capitol, Omaha* (no. 30) is a reversed view of the wood engrav-ing, and Russell's stereographs *Looking down Douglas Street* (no. 3), *Omaha from Old Capital* (no. 8), *Looking down Farnham Street, Omaha* (no. 9), *Omaha from Height* (no. 10), *Farnham Street from Height* (no. 12), and *General View of Omaha* (no. 14) all give bird's-eye perspectives of Omaha from the capitol.
54. Prairie fires had been a tourist fixation. In 1866, Durant had set a prairie fire for the excursionists to the hundredth meridian.
55. *Illustrated London News,* July 31, 1869, 120.
56. For a similar contrast of open and settled landscapes, see "Union Pacific Railroad of America. Salt Lake City," *Illustrated London News,* August 7, 1869, 128–29. Two of the stories in the *Illustrated London News* series advertise Andrew Russell's *Great West Il-lustrated,* which lends further credence to the Union Pacific's involvement with the newspaper.
57. "The Union Pacific Railroad of America," *Illustrated London News,* August 14, 1869, 160–61. *Harper's Weekly* republished one of the illustrations and the majority of the text on September 11, 1869, 577.
58. *Illustrated London News,* August 14, 1869, 160.
59. The *Illustrated London News* series of seven illustrated articles on the transcontinental railroad began on July 31, 1869, and ended November 27, 1869. Several months later, in April 1870, the newspaper published a wood engraving based on a fanciful sketch of a meadow and homestead in the Sierra Nevada.
60. "View on the Central Pacific Railroad," *Harper's Weekly,* October 16, 1869, 669 (im-age), 670 (text).
61. The Union Pacific Railroad seems to have had a financial relationship with the *Illus-trated London News;* the Central Pacific Railroad seems to have had a similar under-standing with *Harper's Weekly.*
62. "Overland Scenes," *Leslie's Illustrated,* January 15, 1870, 297, 302–5. *Leslie's Illustrated* published its series about the overland railroad in January through April 1870.
63. Ibid., 303.
64. The most impressive of these buildings is the hotel in Fremont, Nebraska; see Russell's stereograph *Fremont Hotel, near View* (no. 33).

65. For a similar approach in a different city, see Russell's stereographs *Looking West from Hotel Cheyenne* (no. 61) and *Dining Room RR, Hotel Cheyenne* (no. 62).

66. *Leslie's Illustrated*, January 15, 1870, 303.

67. The following week the newspaper devoted an entire page to sketches of dreadful hotel experiences along the railroad. Although not mentioning either the Union Pacific or Central Pacific by name, the writer describes unsanitary conditions. The simple illustrations present a clapboard structure with a canvas roof, spartan rooms, and a shared washbasin.

68. Russell joined the staff of the newspaper in early 1870. Russell's hiring may also have influenced the paper's coverage.

69. Thomas W. Knox, "Across the Continent, Overland Scenes," *Leslie's Illustrated*, March 12, 1870, 436.

70. Ibid., March 5, 1870, 420.

71. There are few examples of any correspondence between travel guide authors or publishers and the railroad. In the case of the Union Pacific, there is a telegram from Samuel Bowles to H. C. Crane, Durant's private secretary, asking "Where are my photographs?" And in 1869, two wood engravings based on Russell photographs were included in Bowles's *Our New West* (Harford, CT: Hartford Publishing, 1869). See Samuel Bowles to H. C. Crane, February 2, 1869, box 5, Levi O. Leonard Papers. Four years later, the Central Pacific subsidized Charles Nordhoff's *California: For health, pleasure, and residence* (New York: Harper and Brothers, 1873). My thanks to Richard Orsi for sharing this information about Nordoff with me.

72. For a discussion of tourism and transcontinental travel guides of the late 1870s, see Anna O. Marley, "The Parlor Car and the Papoose," in *Material Culture Symposium, Selected Papers, 2003–2007* (Newark: Center for Material Culture Studies, University of Delaware, 2007), 54–73.

73. There were few precedents for the illustrated transcontinental travel guides. There were illustrated travel guides for trips from New York City up the Hudson River, but these were unusual. For the most part, travel guides were not illustrated, and they provided important, practical advice, not entertainment. This was certainly true for the guides to the West. See, for example, Andrew Child, *New Guide for the Overland Route to California* (Milwaukee: Daily Steam Power Press, 1852); and John Disturnell, *The Emigrant's Guide to New Mexico, California, and Oregon* (New York: Disturnell, 1850). For an overview of similar publications, see Helen Kroll, "The Books That Enlightened the Emigrants," *Oregon Historical Quarterly* 45 (June 1944): 103–23.

74. The travel guides published between 1869 and 1871 are, in chronological order: Bill Dadd, the Scribe, *Great Trans-Continental Railroad Guide* (Chicago: Geo. A. Crofutt, 1869); Samuel Bowles, *The Pacific railroad—open: How to go: what to see* (Boston: Fields, Osgood, 1869); A. B. Elliott, *Traveller's hand-book across the continent* (Troy, NY: Troy Daily Times Book Printing House, 1870); Alfred Hart, *The Traveler's Own Book: A Souvenir of Overland Travel* (Chicago: Horton and Leonard, 1870); *Union Pacific Railroad: a trip across the North American continent from Omaha to Ogden* (New York: T. Nelson and Sons, n.d., [c. 1870]); *Central Pacific Railroad: a trip across the North American continent from Ogden to San Francisco* (New York: T. Nelson and Sons, n.d., [c. 1870]); J. L.

Tracy, *Guide to the Great West* (St. Louis: Tracy and Eaton, 1870); *Appletons' Handbook of American Travel: Western Tour* (New York: D. Appleton, 1871); J. C. Ferguson, ed., *The Alta California Pacific Coast and Trans-Continental Railroad Guide* (San Francisco: Fred MacCrellish, 1871). Although *Appletons' Handbook of American Travel: Western Tour* was the travel guide with an established reputation, this publication was not focused on the transcontinental railroad journey. The editors devoted only 26 of its 306 pages to the transcontinental railroad.

75. For a biography of George Crofutt, see J. Valerie Fifer, *American Progress* (Chester, CT: Globe Pequot Press, 1988).

76. Crofutt seems to have used a similar model for his transcontinental railroad guides, offering to send the guide "to anyone with a fifty cent stamp." This advertisement appeared in the *Idaho (Boise) Statesman,* October 7, 1869. For an example of his earlier use of this model, see George Crofutt, *The Philadelphia Merchant's Diary and Guide* (Philadelphia: H. B. Ashmead, 1856).

77. Printed on the verso of a timetable inserted in *Crofutt's Trans-Continental Tourist's Guide,* vol. 4, 3rd annual rev. (New York: Geo. A. Crofutt, 1872). Different editions of Crofutt's transcontinental railroad guides have slightly different titles. In 1870, the *Great Trans-Continental Railroad Guide* was changed to *The Great Trans-Continental Tourist's Guide.* It was adjusted again in 1871 to *Crofutt's Trans-Continental Tourist's Guide,* in 1874 to *Crofutt's Trans-Continental Tourist,* and in 1878 to *Crofutt's New Overland Tourist and Pacific Coast Guide.*

78. Crofutt may have refused to pay Russell's price, or Russell may have had an exclusive arrangement with Frank Leslie. Evidence indicates that Russell was hired by *Leslie's Illustrated* in February or March 1870, and this association may have limited his photographs to reproduction in that paper.

79. Although she does not discuss wood engravings, Elizabeth Hutchinson addresses the transformation of the photograph from an object of contemplation to tourist object, in "They Might Be Giants: Carleton Watkins, Galen Clark, and the Big Tree," *October* 109 (Summer 2004): 46–63.

80. For a discussion of the ideological underpinnings and history of Manifest Destiny, see Anders Stephanson, *Manifest Destiny: American Expansionism and the Empire of Right* (New York: Hill and Wang, 1995); and Frederick Merk, *Manifest Destiny and Mission in American History* (New York: Knopf, 1963).

81. Dadd, *Great Trans-Continental Railroad Guide,* insert page B (opposite title page). The initial edition of the *Great Trans-Continental Railroad Guide* did not have any illustrations; few of these still exist. Most of the 1869 editions include three illustrations. The thirty-two wood engravings published in the later editions were appropriated from a variety of sources, including *Harper's Weekly,* the *Illustrated London News, Frank Leslie's Illustrated Newspaper,* and photographs by Savage, Hart, Houseworth, and Watkins. Crofutt published new editions of his guide once or twice a year between 1869 and 1879. Until 1878, the publications consistently used the same illustrations, although Crofutt changed the sequencing of images.

82. *Great Trans-Continental Tourist's Guide,* 134.

83. Ibid., 19. Italics in the original.

84. Ibid., 133.

85. The first edition of *Crofutt's Western World* came out in November 1871. Published monthly, each eight-page edition included a large wood engraving on the first page and, in most cases, smaller engravings on the inside pages. For the most part these images were ones he had previously published in the transcontinental tourist guide.

86. Although it is an unlikely source, a similar out-of-scale female figure, the shield of the United States in her left hand, a staff with the cap of liberty over her left shoulder, and a crown on her head, was published in a rival travel guide. This allegorical figure, however, stands alone. The caption beneath—"There is the East. There is India"—connects the engraving to commerce, the explicit theme of *Crofutt's Western World* and the implicit premise of *Progress*. Joshua Tracy, *Guide to the Great West* (St. Louis: Tracy and Eaton, 1870), frontispiece.

87. For more examples and a discussion of these precedents, see Patricia Hills, "Picturing Progress in the Era of Western Expansion," in *The West as America*, ed. William Truettner (Washington, DC: Smithsonian Institution Press, 1991), 96–147.

88. "Over the Plains to Colorado," 1.

89. Marilyn Maness Mehaffy makes this argument for the generic figure in "Advertising Race/Raceing Advertising: The Feminine Consumer(-Nation), 1876–1900," *Signs* 23 (Autumn 1997): 143.

90. The image would later be engraved for Crofutt's transcontinental railroad guides. It was as a frontispiece to these books that *American Progress* would garner its greatest notoriety.

91. *Crofutt's Western World* (New York), October 1872, 58. Emphasis in the original.

92. For a discussion of the relationship between Crofutt, Gast, and the construction of the Brooklyn Bridge, see Richard Haw, *The Brooklyn Bridge: A Cultural History* (New Brunswick, NJ: Rutgers University Press, 2005), 97.

93. Most copies that I have seen have the illustrations gathered behind the text. There are, however, examples in the Beinecke Rare Books and Manuscript Library at Yale University in which the chromolithographs are interspersed throughout the text.

94. Chromolithographs transferred the photographic image onto the printing surface and created an image using multiple colors, each applied with a separate stone or plate. In a chromolithograph the colors are not simply hues across the print but make up the image itself. For a description and history of the chromolithograph, see Peter Marzio, *The Democratic Art* (Boston: D. R. Godine, 1979).

95. Hart, *The Traveler's Own Book*. The number of pages, the specific information in the text, the number and subject of the illustrations, and the illustrations' placement in the book vary slightly among different editions of this book. For the purposes of my discussion of the text, I used the copies in the Beinecke Rare Books and Manuscript Library, Yale University.

96. Additional evidence indicates that the Burlington supported this publication: a later printing of the booklet suggested a rail line that bypassed Omaha in favor of a new Burlington route through Lincoln, Nebraska. *The Traveler's Own Book* was published for approximately two years before it was replaced by a new publication, also sponsored by the Burlington Railroad, which incorporated some of the same illustrations and a

similar map. A. E. Touzalin was the author of the new publication, *How to Go West: Guide to Iowa, Nebraska, Kansas, California and the Great West* (Chicago: Horton and Leonard, Railroad Printer, 1872).

97. Hart, *The Traveler's Own Book,* 16.

98. The guidebooks do not carry a publication date. Because they use Savage stereographs of the Central Pacific as a basis for their illustrations, the earliest date for the Central Pacific publication would be summer 1870. Savage's diary states that he went west in April 1870 and returned no later than August.

99. *Salt Lake City, with a sketch of the route of the Union and Central Pacific Railroads, from Omaha to Salt Lake City, and thence to San Francisco* (London: T. Nelson and Sons; Salt Lake City: Savage and Ottinger, n.d. [1870]). There are variant editions of this title. This edition can be dated to 1869 or 1870 because it includes both Savage's and Ottinger's names as publishers. Their partnership ended in 1869 or 1870. In the first publication, three chromolithographs illustrate a stagecoach and Weber and Echo Canyons. The later publications list only Savage as publisher and illustrate only Salt Lake City. Evidence of Savage's connection to Nelson's firm comes from Savage's diary: "Received a letter from Nelson and Sons granting exclusive agency west of Missouri River for the large view of the city and the smaller book. They wanted to claim San Frisco, but I declined, giving them Texas, St. Louis, Missouri, Kansas in exchange." C. R. Savage diary, April 12, 1869.

100. Ibid., 12.

101. Savage's biographer, Bradley Richards, states that Savage wrote the book. *The Savage View: Charles Savage, Pioneer Mormon Photographer* (Nevada City, CA: Carl Mautz, 1995), 43.

102. Savage traveled west to California in 1870, at which time he may have made the negatives that are reproduced in the travel guide. He may also have purchased one or more of the stereographs from Thomas Houseworth & Co. Because Savage's studio burned in the late 1870s, it is difficult to know for certain which were purchased from others and which Savage may have duplicated.

103. Ottinger is listed on several of the lithographs as the draftsman who produced the image. For a biography of Ottinger, see Heber Richards, "George M. Ottinger, Pioneer Artist of Utah," *Western Humanities Review* 3 (July 1949): 209–18.

104. *Union Pacific Railroad: a trip across the North American continent from Omaha to Ogden* (New York: T. Nelson and Sons, n.d. [c. 1870]) has forty-six pages of text and twelve chromolithographic illustrations. And although *Central Pacific Railroad: a trip across the North American continent from Ogden to San Francisco* (New York: T. Nelson and Sons, n.d. [c. 1870]) has the same number of illustrations, it contains only thirty-two pages.

105. *Union Pacific Railroad: a trip across the North American continent from Omaha to Ogden,* 46.

106. J. C. Ferguson, ed., *The Alta California Pacific Coast and Trans-Continental Rail-Road Guide* (San Francisco: Fred MacCrellish, 1871). The *Alta California* was a leading newspaper in San Francisco and may have received the Frederick Whymper illustrations from the *Illustrated London News,* but it is more likely that it received them directly from Whymper, who lived in San Francisco in the 1870s and was active in the San Francisco Art Association.

107. The engraver, George Shourds, worked in Philadelphia until 1854 and then moved to San Francisco, where he worked with Nahl Brothers. He contributed one engraving to Frank Soule's *The Annals of San Francisco* (New York: Appleton, 1855). He continued engraving in San Francisco until his death in November 1875.

108. "The Pacific Railway of America, *Illustrated London News,* October 2, 1869, 336.

109. Ferguson, *The Alta California Pacific Coast and Trans-Continental Railroad Guide,* 228.

EPILOGUE

1. It is likely that the photographer for the Anthonys was Thomas Roche. He began work for them in 1862, and his obituary mentions his photographic work for the Anthonys in the West after the end of the Civil War. "Obituary: Thomas C. Roche," *Anthony's Photographic Bulletin* 26 (November 1895): 367.

2. For a history of the art collection and the E. B. Crocker Art Gallery, see William Breazeale, "E. B. Crocker, His Family, and the Museum's Early Years," in *The Crocker Art Museum Collection Unveiled,* ed. Scott Shields (Sacramento: Crocker Art Museum, 2010), xxi–xxix.

3. John Ott outlines the relationship between the Central Pacific directors and art collections in "The Gilded Rush: Art Patronage, Industrial Capital, and Social Authority in Victorian California" (PhD diss., University of California, Los Angeles, 2002).

4. "Hart," S1, Unit 1, 3761 SG 20, Nebraska State Historical Society, Lincoln. The painting is also mentioned in the *Pittsfield (MA) Sun,* September 16, 1869, 1.

5. For a discussion about the large history painting of the completion of the railroad by Thomas Hill, see Hardy George, "Thomas Hill's Driving of the Last Spike, a Painting Commemorating the Completion of America's Transcontinental Railroad," *Art Quarterly* 27 (Spring 1964): 82–93. For Hill's version of the events, see Thomas Hill, *History of the "Spike Picture" and Why it is still in my Possession* (San Francisco: privately printed, n.d. [1884]).

6. At least one Hart stereograph (private collection) has a paper stamp on the verso for E. Lovejoy, 87 So. Clark St., Chicago, advertising "Stereoscopes and Views." In one edition of *The Traveler's Own Book,* Hart includes a recommendation of Lovejoy's business establishment. Alfred Hart, *The Traveler's Own Book: A Souvenir of Overland Travel* (Chicago: Horton and Leonard, 1870), Yale Collection of Western Americana, Beinecke Manuscript and Rare Books Library (hereafter Yale Collection of Western Americana).

7. [California] State Agricultural Society, "Statement of A. Hart," *Transactions* (Sacramento: N.p, 1872), 175–76. Hart was awarded the gold medal for the best exhibition over William Keith, who had been awarded the medal for the best landscape paintings. Looking back from an art historical perspective, it is difficult to understand this decision. Hart's old patron, E. B. Crocker, was a longtime supporter of the art competition at the State Fair and may have played a role in the awarding of the gold medal.

8. The painting is dated 1866 in the lower right, and a work titled *The Last of the Mohicans* was specifically mentioned by Hart in his statement before the State Fair judges. State Agricultural Society, *Transactions,* 175.

9. Hart's last sale to the company was of 440 stereographs on October 6, 1869. Voucher 1732, October 6, 1869, *Central Pacific Railroad Voucher Series*.

10. Information from the stereograph files of Peter Palmquist, stereograph binders, Peter Palmquist Collection, MSS 429 (WA), uncataloged, Beinecke Manuscript and Rare Books Library, Yale University (hereafter Peter Palmquist Collection).

11. The versos of his later stereographic cards are printed by typeset and include the following information: "Sierra Nevada Mountains. Photographed and Published by Frank Durgan, No. 65 J Street, Sacramento. For Sale by E. S. Denison, General Agent, No. 3 Front Street, Sacramento." On his earliest stereographs, a label with this information is pasted over Hart's printed logo on the verso of the stereograph card.

12. Watkins first biographer recounts a story of Huntington "kicking out" a company photographer from the railroad darkroom and giving Hart's negatives to Watkins. Charles B. Turrill, "An Early California Photographer: C. E. Watkins," *News Notes of California Libraries* 13 (January 1918): 29–37. The story comes from a series of interviews with Watkins, but, like all reminiscences, this report is problematic. For example, Turrill incorrectly states that Watkins purchased Hart's negatives. Further, he reports that the darkroom was in the company's headquarters at Fourth and Townsend in San Francisco, the construction of which was not completed until 1873. Moreover, in October 1870, the Central Pacific purchased stereographs from Watkins, suggesting that he was acting as the company photographer at that time. For the relationship between Watkins and Huntington, see Peter Palmquist, *Carleton E. Watkins: Photographer of the American West* (Albuquerque: University of New Mexico Press, 1983), 4.

13. Having lost control of the Central Pacific negatives, Durgan worked for a short time for J. A. Todd in Sacramento. He moved to the Santa Clara area during 1872–1873, before finally moving back permanently to Lewistown, Maine. Information from the stereograph files of Peter Palmquist, Peter Palmquist Collection. The evidence for the sale of the unmounted images lies in the fact that Oliver Denny, a photographer in Marysville, California, published several of them on his card stock without crediting either Hart or Durgan. Examples of these stereographs can also be found in the Peter Palmquist Collection.

14. The first mention of Watkins in the Central Pacific Railroad vouchers is October 31, 1870, when the record states that fifty dollars had been given to Watkins "on acct. for photographic work." Voucher 963, October 31, 1870, *Central Pacific Railroad Voucher Series*. The Central Pacific Railroad's first purchase of photographs from Watkins was March 1871.

15. Watkins made photographs along the rail line in 1874 and at other times. Although he gave prints to the Central Pacific Railroad and, later, to the Southern Pacific, Watkins retained the negatives. This employment seems to have been an attempt by Collis Huntington to help his friend, rather than a commission for the corporation.

16. For the biographical details of Watkins's life, see Palmquist, *Carleton E. Watkins*.

17. Turrill, "An Early California Photographer," 29–37.

18. For the details of Durant's lawsuits, see Maury Klein, *Union Pacific* (Garden City, NY: Doubleday, 1987), 1:272–73, 292. The lawsuits that enmeshed Durant and the other

trustees are mentioned in several other locations of the book as well as in the pages cited.

19. The importance of credit seems to have been primarily associated with the Union Pacific photographs. Russell worked in July and August with Clarence King, and those photographs became part of the King Survey archive and were credited to Timothy O'Sullivan. Glenn Willumson, "'Photographing Under Difficulties': Andrew Russell's Photographs for the King Survey," in *Framing the West,* by Toby Jurovics et al. (New Haven, CT: Yale University Press, 2010).

20. *Troy's New York City Business Directory for 1870–1* lists both Russell and Smith as working at Russell's studio address of 390 Bowery Street.

21. O. C. Smith diary (transcription), week of April 12–18, 1868.

22. Several Russell stereographs have Thorne's blind stamp. The verso of a stereograph in the Palmquist collection reads "Stereoscopic Views/published and for sale by/George W. Thorne/Manufacturer and Dealer in/Albums, Photographs & Stereoscopes,/60 and 62 Nassau Street,/New York City." In the same collection there is also a stereograph with Ropes's label and an address of 78 Nassau Street. Peter Palmquist Collection.

23. This date is approximate but the result of three sources. In an 1880 lawsuit, Russell states that he had been working for *Leslie's Illustrated Newspaper* for ten years ("The Leslie Will Contest," *New York Evening Post,* April 23, 1880, 4; citation courtesy of Merl M. Moore, Smithsonian American Art Museum). Russell's hometown newspaper, the *Nunda News,* reports that he was in the area a week earlier "taking views for Frank Leslie's paper" (*Nunda [NY] News,* May 14, 1870, 3). Russell had a relationship with *Leslie's Illustrated* going back to at least 1869, when they published wood engravings based on his photographs and a story based on his reportage. The approximate month of his permanent hiring is estimated from the publication of engravings based on Russell's photographs in the paper's series "Across the Continent." *Leslie's Illustrated* used engravings based on sketches until March 5, 1870, when they began using Russell's photographs as their source material. After that date, Russell's photographs were frequently used for their illustrated reportage about the West and the transcontinental railroad. It is also telling that Russell's friend from his years in the West, C. R. Savage, switched from publishing his photographs exclusively with *Harper's Weekly* to an exclusive arrangement with *Leslie's Illustrated* in 1870. My thanks to Savage's biographer, Bradley Richards, for sharing this information about Savage.

24. O. C. Smith notes that Russell was making sketches in Utah and mentions an auction at which a large Russell painting of Echo Canyon was sold. O. C. Smith diary (transcription), August 1872.

25. Smith describes going to see Russell's "designs" and then walking with him to a Fifth Avenue hotel to see Russell's "fresco work." O. C. Smith diary, March 1872 (transcription). This list of Russell's occupations comes from *Troy's/Trow's New York City Business Directories, 1870–73.*

26. O. C. Smith diary (transcription), March 1871.

27. Smith is listed in the 1871–72 Brooklyn business directory as having his studio at 314

Washington. *The Brooklyn City and Business Directory for the Year ending May 1, 1872* (New York: Lain and Co., 1871–72), 697.

28. O.C. Smith diary (transcription), June 1871.

29. Ibid.

30. O.C. Smith diary (original), October 31, 1871.

31. There are a variety of mounts for Smith's stereographs. I am describing the most widely produced of four different stereograph cards.

32. Text is on the verso of the stereographs. See, for example, O.C. Smith stereographs in the stereograph files of Peter Palmquist, Peter Palmquist Collection.

33. O.C. Smith estimated that he traveled more than thirteen thousand miles on "cars and steamboats" in 1871. It is interesting to note that the wholesale price of the stereographs was approximately $1.20 per dozen, and the large format prints sold for $1.25 each.

34. O.C. Smith diary, September 22, 1871 (original).

35. For a description of the stereopticon or magic lantern, see L.J. Marcy, *The Sciopticon Manual*, 5th ed. (Philadelphia: Sherman, 1874).

36. O.C. Smith diary, November 23, 1871 (original).

37. Ibid., January 31, 1872.

38. Ibid., February 17, 1872.

39. Ibid., February 28, 1872.

40. O.C. Smith obituary, *Rock Springs Miner*, January 21, 1904, 1. Citation courtesy of Karen Curran.

41. Sedgwick is listed in the *New York Tribune*'s list of Lyceum lectures for 1859–60. This list is reproduced in the appendix of Angela Ray, *The Lyceum and Public Culture in the Nineteenth-Century United States* (East Lansing: Michigan State University Press, 2005). There is little published information about the illustrated travel lecture. For the later nineteenth century, see X. Theodore Barber, "The Roots of Travel Cinema," *Film History* 5 (March 1993): 68–84.

42. For an example of his promotional abilities, see the exchange of letters between Sedgwick and J.W. Miner, editor of the *Omaha Republican*, May 2, June 12, and June 27, 1875. Stephen J. Sedgwick Collection, folder 1, box 1, WA MSS S-2360, Yale Collection of Western Americana, Beinecke Manuscript and Rare Books Library (hereafter Stephen J. Sedgwick Collection).

43. Richard Kimball to William Shattuck, March 25, 1869, formerly in Abbott C. Coombs Collection, present whereabouts unknown. Shattuck was not a railroad official but a banker with Peasley & Co. and a trustee of the National Trust Company. "National Trust Company: How the Bank was Wrecked," *New York Times*, January 3, 1878, 2.

44. George Opdyke to Thomas Durant, March 24, 1870, formerly in Abbott C. Coombs Collection; present whereabouts unknown. Opdyke owned a banking firm at 25 Nassau St., New York City, and dealt in railroad securities.

45. O.C. Smith notes in his diary: "Mr. Sedgwick printing pictures." O.C. Smith diary (transcription), June 27–July 3, 1869.

46. Sedgwick left Echo Canyon for New York the week of October 10–16, 1869. O.C. Smith diary (transcription), October 10–16, 1869.

47. Sedgwick's letter to Hart is undated. A response from Houseworth to Sedgwick about the cost of lantern slides is dated December 20, 1869, Stephen J. Sedgwick Collection, folder 7, box 1.

48. Handwritten manuscript titled "Central Pacific Rail Road/February 1870/NewTown," Stephen J. Sedgwick Collection, folder 4, box 1.

49. For a discussion of the role that traveling public lecturers, like Sedgwick, played in the creation of a sense of national consciousness and culture, see Donald Scott, "The Popular Lecture and the Creation of a Public in Mid-Nineteenth Century America," *Journal of American History* 66 (March 1980): 791–809.

50. Stephen J. Sedgwick Collection, folder 2, box 1 contains a manuscript and scrapbook in which Sedgwick lists his contacts and details his work for Crofutt.

51. A. J. Russell to S. J. Sedgwick, April 8, 1876, "Letters Received 1859–1860," Stephen J. Sedgwick Papers, Special Collections, University of California, Los Angeles. Sedgwick may have sent Russell the negative. It is not in the collection of the Oakland Museum of California.

52. O. C. Smith writes in his journal about going out socially with Mr. and Mrs. Sedgwick in New York in May 1872. He also wrote to Sedgwick in November 1876, telling him how much he liked ranching in Wyoming and sending him several C. R. Savage photographs of the coal mines in Wyoming. O. C. Smith to S. J. Sedgwick, November 21, 1876, letterpress book no. 234, Stephen J. Sedgwick Papers, Special Collections, University of California, Los Angeles.

53. The title on the title page is *Catalog of stereoscopic views of scenery in all parts of the Rocky Mountains: between Omaha and Sacramento: taken by the photographic corps of U.P.R.R. of which Prof. Sedgwick was a member, for Union Pacific Railroad . . . 1000 different stereoscopic views: the only complete series ever taken, and now offered to the public . . .* (Newtown, NY: Metropolitan Printing, copyrighted 1873, printed 1874).

54. These albums can be found in the collections of Princeton University, Yale University, and the New York Historical Society. The Boston album was sponsored by Alfred Mudge and Son, who did print and book work (Yale University). The Philadelphia album was sponsored by Robert Wood & Co., who did ornamental iron work (Princeton University). My comments are based on my analysis of the three albums at Yale University.

55. *Union Pacific R. R. Views,* Yale Collection of Western Americana. Research on the businesses listed in the album suggests that the album was produced between 1870 and 1873. There is no known relationship between the architect R. C. Russell and Andrew Russell.

56. *Geo. W. Williams & Co.'s Carolina Fertilizer and Photographic Views on the Line of the Union Pacific R. R.,* Yale Collection of Western Americana. There is also correspondence between Sedgwick's family members and George Williams and Co. Formerly in the Abbott C. Coombs Collection, present whereabouts unknown.

57. The production year of the album is derived through analysis of the businesses that advertised in the album.

58. See, for example, *Union Pacific Railroad: Across the Continent West from Omaha, Nebraska* (New York: Union Pacific Railroad, 1868).

59. Sedgwick, preface to *Announcement of Prof. S. J. Sedgwick's illustrated course of lectures and catalogue of stereoscopic views of scenery in all parts of the Rocky and Sierra Nevada mountains: between Omaha and San Francisco,* 4th ed. (Newtown, NY: S. J. Sedgwick, 1879), n.p.

60. Thomas Houseworth and Co.'s shift in advertising suggests that the tourist market may not have been as strong as expected. In the 1869 edition of the *Great Trans-Continental Railroad Guide,* Houseworth advertised Central Pacific stereographs. Two years later this was replaced by an advertisement for stereographs of Yosemite.

 On the other hand, Sedgwick's proofs for his new publication show that he systematically crossed out all references to sales of stereographs. Stephen J. Sedgwick Collection, folders 9–11, box 1, and folder 12, box 2. The author expresses his appreciation to George Miles, curator of the Collection of Western Americana at the Beinecke Manuscript and Rare Books Library, for his suggestion that Russell may have objected to Sedgwick's implicit claim, in the earlier publication, of authorship of the Union Pacific negatives.

61. Dr. Coombs gave the negatives to the Geographical Society in two donations—one in 1940 and one in 1941.

62. William Pattison, "The Pacific Railroad Rediscovered," *Geographical Review* 52 (January 1962): 25–36.

63. Barry Combs, *Westward to Promontory* (Palo Alto, CA: American West Publishing, 1969).

64. Joyce Appleby and colleagues trace the history of interpretation of historical events in history books and discuss how interpretations of certain events have met social needs, in *Telling the Truth about History* (New York: Norton, 1994).

65. Ewing Galloway's archives can be found in the Special Collections at the Syracuse University Library, Syracuse, New York.

66. Elizabeth Coddington and William Long, *Our Country: A First Book of American History* (Boston: Ginn, 1929), 318–19.

67. Ellsworth Huntington et al., *Living Geography, Book One, How Countries Differ* (New York: Macmillan, 1932), 89–90.

68. Wallace Atwood, *The United States in the Western World* (1946; reprint, Boston: Ginn, 1948), 223. Although the book that is being quoted (Seymour Dunbar, *A History of Travel in America* [Indianapolis: Bobbs-Merrill, 1915]) reproduces *The Meeting of the Rails,* it is not Russell's photograph but Crofutt's wood engraving.

69. Lewis Todd et al., *America's History* (New York: Harcourt, Brace, 1950), 418–19.

70. Shelton Stromquist, *A Generation of Boomers: The Pattern of Railroad Labor Conflict in Nineteenth-Century America* (Urbana: University of Illinois Press, 1987).

71. Beaumont Newhall, *The History of Photography from 1839 to the Present Day* (New York: Museum of Modern Art, 1949), 98. Russell titled this photograph *Granite Canon, Embankment.*

72. Ibid., 151 and 156.

73. This photograph was replaced by Russell's *Meeting of the Rails* in Newhall's 1984 edition of *The History of Photography.* By the 1980s, scholars and museums had accepted photography as a fine art medium. Consequently, the construction of an art history of

photography that required images like *Union Pacific Railroad West of Cheyenne, Wyoming* was no longer necessary.

74. The transformation of cultural artifacts, particularly the way in which they are located and ordered in and by social networks, is engaged by Arjun Appadurai, ed., *The Social Life of Things* (Cambridge: Cambridge University Press, 1986); and Elizabeth Edwards and Janice Hart, eds., *Photographs Objects Histories: On the Materiality of Images* (London: Routledge, 2004).

SELECTED BIBLIOGRAPHY

ARCHIVAL COLLECTIONS

Bancroft Library, University of California, Berkeley

Beinecke Manuscript and Rare Books Library, Yale University

 Peter Palmquist Collection

 Stephen J. Sedgwick Collection

 Yale Collection of Western Americana

Brigham Young University, Harold B. Lee Library, Special Collections and Manuscripts

 C. R. Savage Papers

California Historical Society, San Francisco, California

California State Library, Sacramento, California

California State Railroad Museum, Sacramento, California

 Southern Pacific Collection

Connecticut Historical Society, Hartford, Connecticut

Crocker Art Museum, Sacramento, California

George Eastman House, Rochester, New York

Huntington Library, San Marino, California

Library of Congress, Prints and Photographs Division, Washington, D.C.

National Portrait Gallery, Washington, D.C.

Nebraska State Historical Society, Lincoln, Nebraska

Oakland Museum of California, Oakland, California

 Andrew J. Russell Collection

Sacramento History Center, Sacramento, California

 Anna Judah Album

Smithsonian American Art Museum, Washington, D.C.

Smithsonian Institution National Museum of Natural History, Washington, D.C.

Smithsonian National Museum of American History, Washington, D.C.

Society of California Pioneers, San Francisco, California
 Turrill Collection

Stanford University, Special Collections and University Archives, Stanford, California
 Southern Pacific Railroad Records
 Leland Stanford Papers
 Stanford Family Collection

Union Pacific Railroad Museum, Council Bluffs, Iowa

University of California, Los Angeles, Special Collections
 Stephen Sedgwick Papers

University of California, Santa Barbara, Special Collections
 William Wyles Collection

University of Iowa, Special Collections and University Archives, Iowa City, Iowa
 Levi O. Leonard Papers

University of Utah, Marriott Library, Special Collections, Salt Lake City

University of Wisconsin, Milwaukee, Golda Meir Library
 American Geographical Society Library

PRIMARY AND SECONDARY SOURCES

Aikin, Roger. "Paintings of Manifest Destiny." *American Art* 14 (Autumn 2000): 78–89.

Anderson, Nancy, and Linda Ferber. *Albert Bierstadt: Art and Enterprise.* New York: Hudson Hills Press, 1990.

Appadurai, Arjun, ed. *The Social Life of Things.* New York: Cambridge University Press, 1986.

Appletons' Handbook of American Travel: Western Tour. New York: D. Appleton, 1871.

Avery, Benjamin. "Art Beginnings on the Pacific, Part 1." *Overland Monthly* 1 (July 1868): 28–34.

———. "Art Beginnings on the Pacific, Part 2." *Overland Monthly* 2 (August 1868): 113–19.

Bain, David. *Empire Express: Building the First Transcontinental Railroad.* New York: Viking, 1999.

Balm, Roger. "Expeditionary Art: An Appraisal." *Geographical Review* 90 (October 2000): 585–602.

Becker, Robert H., ed. *Some Reflections of an Early California Governor.* Sacramento, CA: Sacramento Book Collectors Club/Grabhorn Press, 1959.

Best, Gerald. "Rendezvous at Promontory: The 'Jupiter' and No. 119." *Utah Historical Quarterly* 37 (Winter 1969): 70–75.

Bloemink, Barbara, et al. *Frederic Church, Winslow Homer, and Thomas Moran: Tourism and the American Landscape.* New York: Bulfinch Press, 2006.

Boime, Albert. *The Magisterial Gaze: Manifest Destiny and American Landscape Painting c. 1830–1865.* Washington, DC: Smithsonian Institution Press, 1991.

Bowles, Samuel. *Our new West.* Hartford, CT: Hartford Publishing, 1869.

———. *The Pacific railroad—open: How to go: what to see.* Boston: Fields, Osgood, 1869.

Bowman, J. N. "Driving the Last Spike at Promontory, 1869." *Utah Historical Quarterly* (Winter 1969): 78–101.

Brey, William. *John Carbutt: On the Frontiers of Photography.* Cherry Hill, NJ: Willowdale Press, 1984.

Brookman, Phillip, Rebecca Solnit, Marta Braun, and Corey Keller. *Helios: Eadweard Muybridge in a Time of Change.* London: Steidl, 2010.

Brown, Julie. *Making Culture Visible: The Public Display of Photography at Fairs, Expositions, and Exhibitions in the United States, 1847–1900.* Amsterdam: Harwood Academic Publishers, 2001.

Brown, Richard. *Modernization: The Transformation of American Life, 1600–1865.* New York: Hill and Wang, 1976.

Brunet, Francois, and Bronwyn Griffith, eds. *Images of the West: Survey Photography in French Collections, 1860–1880.* Chicago: Musée d'Art Américain Giverny/Terra Foundation for American Art, 2007.

Buchloh, Benjamin, and Robert Wilkie, eds. *Mining Photographs and Other Pictures, 1948–1968.* Nova Scotia: Press of the Nova Scotia College of Art and Design, 1983.

[California] State Agricultural Society. "Statement of A. Hart." *Transactions,* Sacramento: N.p, 1872.

California Weekly Mercury (San Francisco). "Blue Canon, 78 Miles from Sacramento." December 15, 1867.

———. "Chalk Bluffs, Sixty-seven Miles above Sacramento." November 3, 1867.

———. "Donner Lake and Donner Pass." October 13, 1867.

———. "Green Valley and Giant's Gap." November 17, 1867.

———. "Hornet Hill Cut, 65 Miles above Sacramento." November 10, 1867.

———. "Horse Ravine Wall and Grizzly Hill Tunnel." December 1, 1867.

———. "Rocky Point, near Miller's Bluff." October 27, 1867.

———. "View of American River and Canon." October 20, 1867.

———. "View of Cape Horn, Looking East." November 24, 1867.

———. "View of Cisco, 94 Miles above Sacramento." December 29, 1867.

Carter, Edward C., II, ed. *Surveying the Record: North American Scientific Exploration to 1930.* Philadelphia: American Philosophical Society, 1999.

Cassidy, James. *Ferdinand V. Hayden: Entrepreneur of Science.* Lincoln: University of Nebraska Press, 2000.

Castleberry, May, ed. *Perpetual Mirage: Photographic Narratives of the Desert West.* New York: Whitney Museum of American Art, 1996.

Central Pacific Railroad: a trip across the North American continent from Ogden to San Francisco. New York: T. Nelson and Sons, n.d. [c. 1870].

Chiu, Herman. "When 1,000 Words Are Worth a Picture: How Newspapers Portrayed the Chinese and Irish Who Built the First Transcontinental Railroad." PhD diss., University of Missouri, Columbia, 2004.

Combs, Barry. *Westward to Promontory.* Palo Alto, CA: American West Publishing, 1969.

Conzen, Michael, and Diane Dillon. *Mapping Manifest Destiny: Chicago and the American West.* Chicago: Newberry Library, 2007.

Cooper, Bruce, ed. *Riding the Transcontinental Rails: Overland Travel on the Pacific Railroad, 1865–1881.* Philadelphia: Polyglot Press, 2004.

Cosgrove, Denis, and Stephen Daniels, eds. *The Iconography of Landscape: Essays on the Symbolic Representation, Design and Use of Past Environments.* New York: Cambridge University Press, 1988.

Crary, Jonathan. *Techniques of the Observer: On Vision and Modernity in the Nineteenth Century.* Cambridge, MA: MIT Press, 1990.

Creil, Léon. "Chemin de fer Transcontinental–Memphis Pacific." *L'Illustration,* April 17, 1869.

Crist, Lynda Lasswell, Mary Dix, and Kenneth Williams, eds. *The Papers of Jefferson Davis.* 12 vols. Baton Rouge: Louisiana State University Press, 1971–2008.

Crofutt's Trans-Continental Tourist's Guide. Vol. 4, 3rd rev. New York: Geo. A. Crofutt, 1872.

Crofutt's Western World. November 1871–January 1874.

Dadd, Bill, the Scribe. *Great Trans-Continental Railroad Guide.* Chicago: Geo. A. Crofutt, 1869.

Dalton, James. *A Trip Across the Continent, by the Grand Lodge of the United States.* Cincinnati: R. N. Carter, 1870.

Danly, Susan, and Leo Marx, eds. *The Railroad in American Art.* Cambridge, MA: MIT Press, 1988.

Darrah, William. *The World of Stereographs.* Gettysburg, PA: W. C. Darrah, 1977.

Denning, Robert. "A Fragile Machine: California Senator John Conness." *California History* 85 (September 2008): 26–49.

Deverell, William. *Railroad Crossing: Californians and the Railroad, 1850–1910.* Berkeley: University of California Press, 1994.

The Documentary Photograph as a Work of Art. Chicago: David and Alfred Smart Gallery, 1976.

Doezema, Marianne, and Elizabeth Milroy, eds. *Reading American Art.* New Haven, CT: Yale University Press, 1998.

Driesbach, Janice, Harvey Jones, and Katherine Holland. *Art of the Gold Rush.* Berkeley: University of California Press, 1998.

Dwinell, Israel. *The Higher Reaches of the Great Continental Railway: a highway for our God.* Sacramento, CA: H. S. Crocker, 1869.

Earle, Edward, ed. *Points of View: The Stereograph in America: A Cultural History.* Rochester, NY: Visual Studies Workshop Press, 1979.

Edwards, Elizabeth, and Janice Hart, eds. *Photographs Objects Histories: On the Materiality of Images.* London: Routledge, 2004.

Elliott, A. B. *Traveller's hand-book across the continent.* Troy, NY: Troy Daily Times Book Printing House, 1870.

Farnham, Wallace. "Grenville Dodge and the Union Pacific: A Study of Historical Legends." *Journal of American History* 51 (March 1965): 632–50.

Fels, Thomas. *Destruction and Destiny: The Photographs of A. J. Russell.* Pittsfield, MA: Berkshire Museum, 1987.

Ferguson, Arthur Northcote. Unpublished diaries. Nebraska State Historical Society, Lincoln, NE.

Ferguson, J.C., ed. *The Alta California Pacific Coast and Trans-Continental Railroad Guide.* San Francisco: Fred MacCrellish, 1871.

Fifer, J. Valerie. *American Progress: The Growth of the Transport, Tourist, and Information Industries in the Nineteenth-Century West.* Chester, CT: Globe Pequot Press, 1988.

Fleischhauer, Carl and Beverly Brannon, eds. *Documenting America.* Berkeley: University of California Press, 1988.

Foster, Mike. *Strange Genius: The Life of Ferdinand Vandeveer Hayden.* Niwot, CO: Roberts Rinehart, 1994.

Francaviglia, Richard, and Jimmy Bryan. "'Are We Chimerical in This Opinion?' Visions of a Pacific Railroad and Westward Expansion before 1845." *Pacific Historical Review* 71 (May 2002): 179–202.

Frank Leslie's Illustrated Newspaper. "The Completion of the Pacific Railroad." June 5, 1869.

———. *Exciting Race between a Locomotive and a Herd of Deer on the Line of the Pacific Railroad, West of Omaha.* May 28, 1870.

———. "An Indian Toilet." June 18, 1870.

———. "Mixing the Waters of the Atlantic and Pacific." July 2, 1870.

———."Odd Fellow's Exercises in Echo Canon." October 9, 1869.

———. "Opening of the Pacific Railway." May 29, 1869.

———. "Overland Scenes." January 15, 1870.

———. "A Passenger Train Attacked by a War Party of Indians." July 9, 1870.

———. "The Sick Indian Girl." April 30, 1870.

———. "Snow Bound on the Rocky Mountains." April 17, 1869.

———. "The Summit Tunnel, Pacific Railroad, Sierra Nevada." January 9, 1869.

———. "The Windmills of the Union Pacific Railroad." May 8, 1869.

Fredrickson, George, ed. *A Nation Divided.* Minneapolis: Burgess, 1975.

Freehling, William. *The Road to Disunion, 1776–1854.* Vol. 1. New York: Oxford University Press, 1990.

Fremont, John. *Report of the exploring expedition to the Rocky mountains in the year 1842 and to Oregon and North California in the years 1843–'44.* Washington, DC: Blair and Rives, 1845.

Fulton, Marianne, ed. *Eyes of Time: Photojournalism in America.* Boston: Little, Brown, 1988.

Garber, Paul. *The Gadsden Treaty.* Philadelphia: Press of the University of Pennsylvania, 1923.

George, Hardy. "Thomas Hill's 'Driving of the Last Spike,' a Painting Commemorating the Completion of America's Transcontinental Railroad." *Art Quarterly* 27 (Spring 1964): 82–93.

Gerdts, William. "Revealed Masters, Nineteenth Century American Art." *American Art Review* 1 (November–December 1974): 77–93.

Glanz, Dawn. *How the West Was Drawn.* Ann Arbor, MI: UMI Research Press, 1982.

Goetzmann, William. *Army Exploration in the American West, 1803–1863.* New Haven, CT: Yale University Press, 1959. Reprint, Austin: Texas State Historical Association, 1991.

———. *Exploration and Empire.* New York: Knopf, 1966. Reprint, New York: History Book Club, 1993.

Goodyear, Frank. "Constructing a National Landscape: Photography and Tourism in Nineteenth-Century America." PhD diss., University of Texas at Austin, 1998.

Great Trans-Continental Tourist's Guide. Chicago: George A. Crofutt, 1870.

Grier, Edward, ed. *Walt Whitman: Notebooks and Unpublished Prose Manuscripts*. Vol. 2. New York: New York University Press, 1984.

Groseclose, Barbara. *Emanuel Leutze, 1816–1868*. Washington, DC: Smithsonian Institution Press, 1975.

Grossman, James, ed. *The Frontier in American Culture: An Exhibition at the Newberry Library*. Berkeley: University of California Press, 1994.

Hall, A. R., ed. *The Export of Capital from Britain, 1870–1914*. London: Methuen, 1968.

Harper's Weekly. "The Central Pacific Railroad." December 7, 1867.

———. "Central Pacific Railroad." May 30, 1868.

———. *Completion of the Pacific Railroad—Meeting of Locomotives of the Union and Central Pacific Lines: The Engineers Shake Hands*. June 5, 1869.

———. "The Pacific Railroad." May 29, 1869.

———. "The Pacific Railroad." July 10, 1869.

———. "The Pacific Railroad in Utah." February 27, 1869.

———. "The Pacific Railroads." December 14, 1867.

———. "Salt Lake City." September 4, 1869.

———. "Sherman Station." September 11, 1869.

———. "The Union Pacific Railroad." November 16, 1867.

———. "The Union Pacific Railroad." August 28, 1869.

———. "View on the Central Pacific Railroad." October 16, 1869.

———. "The Weber Canon." October 30, 1869.

Harrison, Alfred. "Albert Bierstadt and the Emerging San Francisco Art World of the 1860s and 1870s." *California History* 71 (Spring 1992): 74–87.

———. "Images of the Railroad in Nineteenth-Century Paintings." *Walpole Society Notebook* (1995–96): 64–83.

———. *William Keith: The Saint Mary's College Collection*. Moraga, CA: St. Mary's College of California/Hearst Art Gallery, 1988.

Hart, Alfred. *The Traveler's Own Book: A Souvenir of Overland Travel*. Chicago: Horton and Leonard, 1870.

Harvey, Eleanor. *The Painted Sketch: American Impressions from Nature, 1830–1880*. New York: Abrams, 1998.

Hassrick, Peter, Patricia Limerick, and Brian Dippie. *Redrawing Boundaries: Perspectives on Western American Art*. Denver: Institute of Western American Art, 2007.

Haupt, Herman. *Photographs Illustrative of Operations in Construction and Transportation As Used to Facilitate the Movements of the Armies of the Rappahannock, of Virginia, and of the Potomac*. Boston: Wright and Potter, 1863.

Hawthorne, Nathaniel. "Chiefly about War-Matters." *Atlantic Monthly* 10 (July 1862): 43–62.

Hayden, Ferdinand V. *Sun Pictures of Rocky Mountain Scenery*. New York: Julius Bien, 1870.

Hedren, Paul. "A Footnote to History: The U. S. Army at Promontory, Utah, May 10, 1869." *Utah Historical Quarterly* 49 (Fall 1981): 363–73.

Heine, W. "Le Chemin de Fer du Pacifique." *Bulletin de la Société de géographie* 5 (September 1867): 225–52.

———. "Le Chemin de fer du Pacifique." *L'Illustration*. February 29; March 7, 14, 21, 28; April 4, 11, 18, and 25, 1868.

Hersh, Lawrence. *The Central Pacific Railroad across Nevada, 1868 & 1997: Photographic Comparatives*. Hollywood, CA: privately printed, 2000.

"The Highway thro' the Desert. Sermon on Pacific R. R. Oakland May 9, 1869." Unpublished manuscript, Huntington Library.

Hine, Robert V., and John Mack Faragher. *The American West: A New Interpretive History*. New Haven, CT: Yale University Press, 2000.

Holmes, O. W. "The Doings of the Sunbeam." *Atlantic Monthly* 12 (July 1863): 1–15.

———. "The Stereoscope and the Stereograph." *Atlantic Monthly* 3 (June 1859): 738–48.

Howard, Thomas. *Sierra Crossing: First Roads to California*. Berkeley: University of California Press, 1998.

Huffman, Wendell W. "Silver and Iron: How the Comstock Determined the Course of the Central Pacific Railroad." *Nevada Historical Society Quarterly* 50 (Spring 2007): 3–35.

Hutchinson, Elizabeth. "They Might Be Giants: Carleton Watkins, Galen Clark, and the Big Tree." *October* 109 (Summer 2004): 46–63.

Hyde, Anne Farrar. *An American Vision: Far Western Landscape and National Culture, 1820–1920*. New York: New York University Press, 1990.

Illustrated London [England] News. "Central Pacific Railway of North America." January 11, 1868.

———. "Dale Creek Bridge." November 27, 1869.

———. "The Pacific Union Railway of America." September 11, 25; and October 2, 1869.

———. "The Sierra Nevada of America." April 9, 1870.

———. "The Union Pacific Railroad of America." July 31, 1869.

———. "The Union Pacific Railroad of America. Salt Lake City." August 7, 1869.

———. "The Union Pacific Railroad of America. Sherman Station." August 14, 1869.

Johannsen, Robert. *Stephen A. Douglas*. New York: Oxford University Press, 1973.

Johnson, Arthur. *Boston Capitalists and Western Railroads*. Cambridge, MA: Harvard University Press, 1967.

Johnson, Michael. "Rendezvous at Promontory." *Utah Historical Quarterly* 72 (Winter 2004): 47–68.

Johnson, William. "Back to the Future: Some Notes on Photojournalism before the 1870s." *Views* 9 (Winter 1988): 8–12.

Jurovics, Toby. *Framing the West*. New Haven, CT: Yale University Press, 2010.

Kelsey, Robin. *Archive Style*. Berkeley: University of California Press, 2007.

Kennedy, Ian. *The Railway: Art in the Age of Steam*. New Haven, CT: Yale University Press, 2008.

Kennon, Donald, ed. *United States Capitol: Designing and Decorating a National Icon*. Athens: Ohio University Press, 2000.

Kibbey, Mead. *The Railroad Photographs of Alfred A. Hart, Artist*. Sacramento: California State Library Foundation, 1996.

Kinsey, Joni. *Plain Pictures: Images of the American Prairie*. Washington, DC: Smithsonian Institution Press, 1996.

Klein, Maury. *Union Pacific*. 2 Vols. Garden City, NY: Doubleday, 1987.

Klett, Mark, Ellen Manchester, JoAnn Verburg, Gordon Bushaw, and Rick Dingus. *Second View: The Rephotographic Survey Project.* Albuquerque: University of New Mexico Press, 1984.

Knox, Thomas W. "Across the Continent: Overland Scenes." *Frank Leslie's Illustrated Press,* January 22, 29; February 5, 12, 19, 26; March 5, 12, 19, 26; and April 2, 1870.

———. "A Station Scene on the Pacific Railway." December 11, 1869.

Kraus, George. *High Road to Promontory.* Palo Alto, CA: American West Publishing, 1969.

Krauss, Rosalind. "Photography's Discursive Spaces." *Art Journal* 42 (Winter 1992): 311–19.

Kurutz, Gary. "Rare Photographic Book Donated by the Foundation." *California State Library Foundation Bulletin* 86 (2006): 12–17.

Lavender, David. *The Great Persuader.* Niwot: University Press of Colorado, 1998.

L'Illustration. "Tracé du Chemin de fer Transcontinental-Memphis-Pacific." May 8, 1869.

Lowenthal, David, and Martyn Bowden, eds. *Geographies of the Mind: Essays in Historical Geosophy.* New York: Oxford University Press, 1975.

Lowry, Richard. "Iron Frames: Reconstructing the Landscape Views of A. J. Russell's Photography." *Nineteenth-Century Contexts* 13 (Spring 1989): 41–66.

Lyden, Anne. *Railroad Vision.* Los Angeles: J. Paul Getty Museum, 2003.

Magee, Thomas. "A Run Overland." *Overland Monthly* 1 (December 1868): 507–17.

Marcy, L. J. *The Sciopticon Manual.* Philadelphia: Sherman, 1874.

Margolis, David. *To Delight the Eye: The Original Photographic Book Illustrations of the American West.* Dallas: DeGolyer Library, 1994.

Marx, Leo. *The Machine in the Garden.* New York: Oxford University Press, 1964.

McGowan, Joseph. "The First Train West." *Sacramento County Historical Society's Golden Notes* 15 (April 1969): 1–35.

Miller, Angela. "Albert Bierstadt, Landscape Aesthetics, and the Meaning of the West in the Civil War Era." *Art Institute of Chicago Museum Studies* 27 (2001): 40–59, 101–2.

———. *The Empire of the Eye: Landscape Representation and American Cultural Politics, 1825–1875.* Ithaca, NY: Cornell University Press, 1993.

———. "The Panorama, the Cinema, and the Emergence of the Spectacular." *Wide Angle* 18 (April 1996): 34–59.

Miller, David, ed. *American Iconology: New Approaches to Nineteen-Century Art and Literature.* New Haven, CT: Yale University Press, 1993.

Miller, Dwight. *California Landscape Painting, 1860–1885: Artists around Keith and Hill.* Stanford, CA: Stanford Art Gallery, 1976.

Milner, Clyde, Carol O'Connor, and Martha Sandweiss, eds. *The Oxford History of the American West.* New York: Oxford University Press, 1994.

Mitchell, W. J. T. *Landscape and Power.* Chicago: University of Chicago Press, 1994.

Moore, James. *King of the 40th Parallel.* Stanford, CA: Stanford General Books, 2006.

Mott, Frank Luther. *A History of American Magazines.* 5 vols. Cambridge, MA: Harvard University Press, 1938–68.

Myers, Amy. "Sketches from the Wilderness: Changing Concepts of Nature in American Natural History Illustration, 1680–1880." PhD diss., Yale University, 1985.

Naef, Weston, in collaboration with James Woods; with Therese Thau Heyman. *Era of Exploration.* Boston: New York Graphic Society, 1975.

Nemerov, Alexander. *Frederic Remington and the American Civil War: A Ghost Story*. Stockbridge, MA: Norman Rockwell Museum, 2006.

Nickel, Douglas. *Carleton Watkins: The Art of Perception*. San Francisco: San Francisco Museum of Modern Art, 1999.

Nunda (NY) News. "Capt. Russell Photographing Battle Scenes." June 13, 1863.

———. "Completion of the Pacific Railroad." May 15, 1869.

———. "Miscellaneous: American Artists." December 15, 1860.

———. "Nunda Men in New York City." April 18, 1868.

———. "Nunda News—Local." May 1, 1869.

———. "Panorama of the War." December 14, 1861.

———. "Personal." June 11, 1870.

———. "Personal." September 3, 1870.

———. "Russell's Great Panorama of the War of 1861." February 8 and 15, 1862.

———. "The Union Pacific Railroad—1,000 Miles Completed—The Year's Earnings Over Five Million Dollars." February 20, 1869.

———. Untitled. December 12, 1868.

———. Untitled. May 14, 1870.

———. Untitled. June 4, 1870.

Nye, David. *America as Second Creation*. Cambridge, MA: MIT Press, 2003.

Osborne, Peter. *Traveling Light: Photography, Travel and Visual Culture*. Manchester, U.K.: Manchester University Press, 2000.

Ott, John. "The Gilded Rush: Art Patronage, Industrial Capital, and Social Authority in Victorian California." PhD diss., University of California, Los Angeles, 2002.

"Over the Plains to Colorado." *Harper's New Monthly Magazine* (June 1867): 1–21.

"The Pacific Railroad." *North American Review* 82 (1856): 211–36.

Palmquist, Peter. *Carleton E. Watkins: Photographer of the American West*. Albuquerque: University of New Mexico Press, 1983.

———. *Lawrence & Houseworth/Thomas Houseworth & Co.: A Unique View of the West, 1860–1886*. Columbus, OH: National Stereoscopic Association, 1980.

Pattison, William. "The Pacific Railroad Rediscovered." *Geographical Review* 52 (January 1962): 25–36.

Perry, Claire. *Pacific Arcadia: Images of California, 1600–1915*. New York: Oxford University Press, 1999.

Peters, Harry. *Currier & Ives, Printmakers to the American People*. Garden City, NY: Doubleday, Doran, 1929. Reprint, New York: Arno, 1976.

Phillips, Sandra, Richard Rodriquez, Aaron Betsky, and Eldridge Moores. *Crossing the Frontier*. San Francisco: San Francisco Museum of Modern Art, 1996.

Pine, George. *Beyond the West*. Utica, NY: T. J. Griffiths, 1871.

Potter, David. *The Impending Crisis, 1848–1861*. New York: Harper and Row, 1976.

Prown, Jules, et al. *Discovered Lands Invented Pasts: Transforming Visions of the American West*. New Haven, CT: Yale University Press, 1992.

Ray, Angela. *The Lyceum and Public Culture in the Nineteenth-Century United States*. East Lansing: Michigan State University Press, 2005.

"Report of a Meeting of the Photographic Section of the American Institute, February 2, 1869." *Philadelphia Photographer* 6 (1869): 89.

Reports of Explorations and Surveys, to ascertain the most practicable and economic route for a railroad from the Mississippi River to the Pacific Ocean. 12 vols. Washington, DC: Beverley Tucker, 1855–1860.

Rich, Nancy. "Politics and the Picturesque: A. J. Russell's *Great West Illustrated.*" *Views* (Summer–Fall 1989): 4–6, 24.

Richards, Bradley. *The Savage View: Charles Savage, Pioneer Mormon Photographer.* Nevada City, CA: Carl Mautz, 1995.

Richards, Heber. "George M. Ottinger, Pioneer Artist of Utah." *Western Humanities Review* 3 (July 1949): 209–18.

Richardson, Albert. *Beyond the Mississippi.* Hartford, CT: American Publishing, 1867.

Roberson, Jere. "The South and the Pacific Railroad, 1845–1855." *Western Historical Quarterly* 5 (April 1974): 163–86.

Rubinstein, Charlotte. "The Early Career of Frances Flora Bond Palmer (1812–1876)." *American Art Journal* 17 (Autumn 1985): 71–88.

Rule, Amy, ed. *Carleton Watkins: Selected Texts and Bibliography.* Boston: G. K. Hall, 1993.

Russel, Robert. *Improvement of Communication with the Pacific Coast as an Issue in American Politics, 1783–1864.* Cedar Rapids, IA: Torch Press, 1948.

Russell, Andrew J. "Capt. Russell among the Indians—Interesting Account of Photographing Them." *Nunda (NY) News,* July 3, 1869.

———. "Capt. Russell's Trip to California—Adventure among the Chinese—Goes to a Celestial Theatrical Entertainment, &c." *Nunda (NY) News,* January 1, 1870.

———. *The Great West Illustrated.* New York: Union Pacific Railroad, 1869.

———. "Herding Sheep in New Mexico." *Moore's Rural New Yorker* (Rochester, NY), November 22, 1873.

———. "The Laying of the Last Rail on the Union Pacific Road—Nunda is Honored with a Representative—Some Important Statements from Capt. Andrew J. Russell of Nunda." *Nunda (NY) News,* May 29, 1869.

———. "Letter from Mormondon [sic]." *Nunda (NY) News,* August 21, 1869.

———. "A New Out-door Camera Box." *Anthony's Photographic Bulletin* 1 (July 1870): 118.

———. "On the Mountains with Tripod and Camera." *Anthony's Photographic Bulletin* 1 (1870): 33–35, 128–30.

———. "Photographic Reminiscences of the Late War." *Anthony's Photographic Bulletin* 13 (July 1883): 212–13.

———. "Rocky Mountain Adventure." *Nunda (NY) News,* September 25, 1869.

———. "A Trip to California Over the Pacific Railroad." *Nunda (NY) News,* October 30, 1869.

Salt Lake City, with a sketch of the route of the Union and Central Pacific Railroads, from Omaha to Salt Lake City, and thence to San Francisco. London, U.K.: T. Nelson and Sons; Salt Lake City: Savage and Ottinger, n.d. [1870].

Samson, John. "Photographs from the High Rockies." *Harper's New Monthly Magazine* 39 (September 1869): 465–76.

Sandweiss, Martha, ed. *Photography in Nineteenth-Century America*. Fort Worth, TX: Amon Carter Museum, 1991.

———. *Print the Legend*. New Haven, CT: Yale University Press, 2002.

Schivelbusch, Wolfgang. *The Railroad Journey: The Industrialization of Time and Space in the 19th Century*. Berkeley: University of California Press, 1986.

Schubert, Frank. *Vanguard of Expansion: Army Engineers in the Trans-Mississippi West, 1819–1879*. Washington, DC: Historical Division, Office of Administrative Services, Office of the Chief of Engineers, 1980.

Schwartz, Joan, and James Ryan, eds. *Picturing Place: Photography and the Geographical Imagination*. London: I. B. Tauris, 2003.

Scott, Donald. "The Popular Lecture and the Creation of a Public in Mid-Nineteenth-Century America." *Journal of American History* 66 (March 1980): 791–809.

Sears, John. *Sacred Places: American Tourist Attraction in the Nineteenth Century*. New York: Oxford University Press, 1989.

Sedgwick, Stephen. *Announcement of Prof. S. J. Sedgwick's illustrated course of lectures and catalogue of stereoscopic views of scenery in all parts of the Rocky and Sierra Nevada mountains: between Omaha and San Francisco*. 4th ed. Newtown, NY: S. J. Sedgwick, 1879.

———. *Catalog of stereoscopic views of scenery in all parts of the Rocky Mountains: between Omaha and Sacramento*. New York: Metropolitan Printing, copyrighted 1873, printed 1874.

Seymour, Silas. *Incidents of a Trip through the Great Platte Valley*. New York: D. Van Nostrand, 1867.

Shields, Scott, ed. *The Crocker Art Museum Collection Unveiled*. Sacramento, CA: Crocker Art Museum, 2010.

Smith, O. C. Unpublished Diaries. Private collection.

Spude, Robert. *Tents of Golden Spike*. Report for Cultural Resources Management, Intermountain Region, National Park Service, 2005, www.nps.gov/history/history/online_books/gosp1/promontory_summit.pdf.

Stehle, Raymond. "Five Sketchbooks of Emanuel Leutze." *Quarterly Journal of the Library of Congress* 21 (January 1964): 81–93.

———. "'Westward Ho!': The History of Leutze's Fresco in the Capitol." *Records of the Columbia Historical Society* 60–62 (1960–62): 306–22.

Stephanson, Anders. *Manifest Destiny: American Expansionism and the Empire of Right*. New York: Hill and Wang, 1995.

Stillman, J. D. B. "The Last Tie." *Overland Monthly* 3 (July 1869): 77–84.

Summers, Mark. *The Press Gang: Newspapers and Politics, 1865–1878*. Chapel Hill: University of North Carolina Press, 1994.

Sweeney, J. Gray. *The Columbus of the Woods*. St. Louis: Washington University Gallery of Art, 1992.

Tagg, John. "The Archiving Machine; or, The Camera and the Filing Cabinet." *Grey Room* 47 (Spring 2012): 24–37.

Trachtenberg, Alan. *Reading American Photographs*. New York: Hill and Wang, 1989.

Tracy, J. L. *Guide to the Great West*. St. Louis: Tracy and Eaton, 1870.

Trenton, Patricia, and Peter Hassrick. *The Rocky Mountains: A Vision for Artists in the Nineteenth Century*. Norman: University of Oklahoma Press, 1983.

Truettner, William, ed. *The West as America*. Washington, DC: Smithsonian Institution Press, 1991.

Truettner, William, and Alan Wallach. *Thomas Cole: Landscape into History*. Washington, DC: Smithsonian Institution Press, 1994.

Tucker, Jennifer. *Nature Exposed: Photography as Eyewitness in Victorian Science*. Baltimore: Johns Hopkins University Press, 2005.

Turner, Justin. "Emanuel Leutze's Mural 'Westward the Course of Empire Takes Its Way,'." *Manuscripts* 18 (Spring 1966): 5–16.

Turrill, Charles B. "An Early California Photographer: C. E. Watkins." *News Notes of California Libraries* 13 (January 1918): 29–37.

Tutorow, Norman. *The Governor: The Life and Legacy of Leland Stanford*. 2 vols. Spokane, WA: Arthur H. Clark, 2004.

Union Pacific Railroad: a trip across the North American continent from Omaha to Ogden. New York: T. Nelson and Sons, n.d. [c. 1870].

Union Pacific Railroad Company. *The Great Union Pacific Railroad Excursion to the Hundredth Meridian*. Chicago: Republican Company, 1867.

Vetter, Jeremy. "Science along the Railroad." *Annals of Science* 61 (2004): 187–211.

"Views of the Central Pacific Railroad." *Scientific American* 20 (May 22, 1869): 328.

Wadsworth, Nelson. *Through Camera Eyes*. Provo, UT: Brigham Young University Press, 1975.

Walther, Susan Danly. "The Landscape Photographs of Alexander Gardner and Andrew Joseph Russell." PhD diss., Brown University, Providence, RI, 1983.

Watson, Edward. Unpublished Diary. Typescript at Golden Spike National Historic Site, Corinne, UT.

Weber, David. *Richard H. Kern: Expeditionary Artist of the Far Southwest, 1848–1853*. Albuquerque: University of New Mexico Press, 1985.

White, Richard. "Information, Markets, and Corruption: Transcontinental Railroads in the Gilded Age." *Journal of American History* 90 (June 2003): 19–43.

———. *"It's Your Misfortune and None of My Own": A New History of the American West*. Norman: University of Oklahoma Press, 1991.

———. *Railroaded: The Transcontinentals and the Making of Modern America*. New York: W. W. Norton, 2011.

Wierich, Jochen. "The Domestication of History in American Art, 1848–1876." PhD diss., College of William and Mary, 1998.

———. "Struggling through History: Emanuel Leutze, Hegel, and Empire." *American Art* 15 (Summer 2001): 52–71

Williams, John Hoyt. *A Great and Shining Road: The Epic Story of the Transcontinental Railroad*. New York: Times Books, 1988.

Williams, Susan E. "The Great West Illustrated: A Journey across the Continent with Andrew J. Russell." *Streamliner* 10 (1996): 4–18.

———. "'Richmond Taken Again': Reappraising the Brady Legend through Photographs by Andrew J. Russell." *Virginia Magazine of History and Biography* 110 (2002): 437–60.

————. "The Truth Be Told: The Union Pacific Railroad Photographs of Andrew J. Russell." *View Camera* 9 (January–February 1996): 36–43.

Willumson, Glenn. "Alfred Hart." *History of Photography* 12 (January–March 1988): 61–75.

Wood, Denis. *The Power of Maps*. New York: Guilford Press, 1992.

Writing the History of the American West. Worcester, MA: American Antiquarian Society, 1991.

ILLUSTRATIONS

INDEX

Italicized page numbers refer to illustrations.

TEXT: 9.5/14 Scala
DISPLAY: Scala Sans
COMPOSITOR: BookMatters, Berkeley
PRINTER AND BINDER: CG Graphics